VICTOR BURGIN

In / Different Spaces

PLACE AND MEMORY IN VISUAL CULTURE

University of

California Press

Berkeley

Los Angeles

London

Grateful acknowledgment is made for permission
granted to reproduce the following illustrations:
Helmut Newton, *Self-Portrait With Wife June and
Models* reproduced by permission of Helmut Newton;
Robert Doisneau, *Un regard oblique* reproduced
by permission of Agence de presse photographique
RAPHO;
Balthus, *La toilette de Cathy* reproduced by permis-
sion of ARS, © 1995 Artists Rights Society (ARS), New
York/SPADEM, Paris;
Alice Springs, *Helmut Newton, Paris 1976* repro-
duced by permission of June Newton.

University of California Press
Berkeley and Los Angeles, California

University of California Press
London, England

Library of Congress Cataloging-in-Publication Data

Burgin, Victor
 In / different spaces : place and memory in
visual culture / Victor Burgin.
 p. cm.
 Includes bibliographical references and index.
 ISBN 0-520-20298-8 (alk. paper).—
ISBN 0-520-20299-6 (pbk. : alk. paper)
 1. Aesthetics. 2. Place (Philosophy)
3. Memory (Philosophy) 4. Vision. I. Title.
BH39.B35 1996
111'.85—dc20 95-48900
 CIP
Printed in the United States of America

1 2 3 4 5 6 7 8 9

Thinking anything adequate about commercial television may well involve ignoring it and thinking about something else.

FREDERIC JAMESON[1]

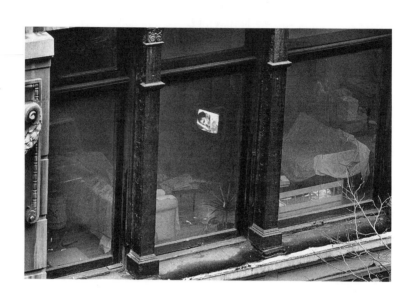

The essays collected here as chapters were written between 1987 and 1994. Some have been published previously, others appear in print for the first time. I feel justified in assembling them as "chapters" rather than "collected essays" because they share a common object, the space and time of visual representations, and a common methodology, psychoanalytic theory. Psychoanalysis is accustomed to thought that folds back on itself, repeats in order to take new directions. Some styles of writing require that such pleats in discourse be ironed flat, like the academic thesis, which, as Roland Barthes put it, "unfolds, like a tablecloth." This book is more smorgasbord than tablecloth. Occasionally, part of one chapter has spilled into another. In the electronic environment of "hypertext" two distinct lines of argument might pass through a single passage. In the linear terms of print publishing I can only "repeat myself." I prefer to conserve this stammering, in the text itself, of an inescapable condition of the representations that are its object. As the contexts differ, I hope my preference may be indulged.

There are books—philosophical and scientific works, for example—where the author may assume that her or his audience has read much the same books as he or she has, and inhabits much the same professional culture. I cannot make that assumption, as my work straddles two related but distinct professional milieus. As an academic I teach the history and theory of contemporary visual culture to university students; as a "visual artist" and videomaker I produce work for galleries, museums, screening rooms, and other public places. Introducing a previous book, in 1986, I wrote:

> Issuing from a position which faces onto both academy and gallery, these essays are simultaneously polemical, practical, and pedagogical

in intent: one of their functions has been to intervene in ongoing cultural-political debates; another has been to allow me to work out the historical and theoretical framework of my own art practice; finally, the essays are intended to be useful to students and teachers in the field of "visual representations" in general, and the visual arts in particular. It is this intention which has dictated a procedure of writing which "interrupts itself" to provide thumbnail sketches of basic theoretical concepts, and examples of their application.[2]

These conditions of my production have not changed. My shifting address is to an imaginary audience that includes not only colleagues and graduate students but also undergraduates and interested people who are not professional academics. Readers who find they are being told something irritatingly familiar, or find themselves reading something frustratingly opaque, may skip the offending passage with a clear conscience and a light heart.

I write: "I." Invoking Samuel Beckett, Michel Foucault concluded his essay of 1969, "What Is an Author," with the question: "What matter who's speaking?" In the intervening years of "identity politics" it has come to matter greatly who speaks. From time to time in the ensuing chapters I tell personal anecdotes. This is not done to celebrate my *personal* history. Meaghan Morris, an Australian, has written:

> My impression is that American culture easily encourages people to assume that a first-person anecdote is primarily oriented toward the emotive and conative functions, in Jakobson's terms, of communication: that is, toward speaker-expressive and addressee-connective activity, or an I/you axis in discourse. However, I take anecdotes, or yarns, to be primarily referential. They are oriented futuristically towards the construction of a precise, local, and *social* discursive context, of which the anecdote then functions as a *mise en abyme*. That

is to say, *anecdotes for me are not expressions of personal experience but allegorical expositions of a model of the way the world can be said to be working* [my emphasis].[3]

To misappropriate a metaphor from Jacques Lacan, I hope that the occasional personal references I make may serve in the manner of "upholstery buttons," attaching the fabric of abstract "theoretical" speech to a frame of mortal and embodied experiences: of specific places, of specific times.

The original places and times of the essays are as follows:

The first part of my introduction, "Cultures in Cultural Studies," is based on part of a paper, "The New Art History and Visual Cultural Studies," given at the Haddad Memorial Symposium, "New Directions in Art History," Los Angeles County Art Museum, 16 February 1991.

"Geometry and Abjection" was first given as a talk at the conference "Abjection, Melancholia, and Love: The Work of Julia Kristeva," Centre for Research in Philosophy and Literature, University of Warwick, May 1987. It was first published in *AA Files—Annals of the Architectural Association School of Architecture*, no. 15, (Summer 1987).

"Perverse Space" was given as a paper at the conference "Sexuality and Space," First Jean Labatut Memorial Symposium, School of Architecture, Princeton University, March 10, 1990. It was first published in William Allen and Stephen Bann (eds.), *Interpreting Contemporary Art*, London, Reaktion, 1991.

"Newton's Gravity" was written for Carol Squiers (ed.), *The Critical Image*, Seattle, Bay Press, 1990.

"Chance Encounters" first appeared in *New Formations*, no. 11, (Summer 1990).

"Seiburealism" was first published in Georges Teyssot (ed.), *Beyond the City, the Metropolis*, Milan, Electa, 1988.

"Paranoiac Space" was originally given as a talk at the conference "Displacements, Migrations, Identities," Center for Cultural Studies, University of California, Santa Cruz, 31 March 1990. It was first published in *New Formations*, no. 12, (Winter 1990).

"The City in Pieces" was first given as a paper at the conference "The Visual Arts in a Technological Age: A Centennial Rereading of Walter Benjamin," Wayne State University, 4 April 1992. It was first published in *New Formations*, no. 20, (Summer 1993).

"Barthes's Discretion" was first presented at the colloquium "After Roland Barthes," French Institute for Culture and Technology, University of Pennsylvania, 16 April 1994.

"Brecciated Time" is based on presentations given to my graduate seminar class, Board of Studies in History of Consciousness, University of California, Santa Cruz, Winter Quarter 1994.

Many thanks to those who invited me to the above events, and to all those who participated in them.

San Francisco, June 1994

Those who fail to re-read are obliged to read the same story everywhere.

Roland Barthes[1]

There is an old story in which a couple of tourists, driving on an English country road and hopelessly lost, stop to ask directions from a local inhabitant who happens to be sitting on a fence by the road. "Excuse me," they ask, "What's the best way to get to Canterbury?" He thinks for a while. "Well," he finally says, "if I were you, I wouldn't start from here." Those who sit on fences may imagine otherwise, but the directions we take unavoidably begin where we are, and in relation to where we have been. I teach history and theory of contemporary visual culture in an American university, to which I came from England. In the first part of my introduction I shall glance back at the specific history that grounds the meaning of "theory of visual culture" as I intend it here—a meaning closely allied to the project of analysis of visual images which began as (French) "semiology," and to the view of "culture" defined within the project of (British) "cultural studies." I do not provide this trace of a course taken by many of my generation simply to confess "where I am coming from." It is also offered as an aide-mémoire contribution to a history of still unresolved debates in cultural studies around identity and representations. I hope that by recalling this history we may avoid repeating it. Of the paths leading out of this history, the one I took has led me to consider the space and time of visual representations in which components of identity coalesce. Issues of the production of space have their own particular history in recent studies of contemporary culture. In the second part of my introduction I shall retrace a small part of this history in order to indicate in what way, for

me, these "two histories" come into confluence. My itinerary will include intellectual sites and monuments already familiar to readers of recent cultural theory. But to return is not necessarily to repeat, provided we approach the place we know by a different road.

PART 1: CULTURES IN CULTURAL STUDIES

> Men can see nothing around them that is not their own image; everything speaks to them of themselves. Their very landscape is alive.
>
> **Karl Marx**[2]

From Sweetness and Light to Semiotics and Psychoanalysis The expression "cultural studies," used to name an academic discipline, dates from the founding of the Birmingham Centre for Contemporary Cultural Studies—at Birmingham University, England—in 1964. In his book *Keywords*, Raymond Williams begins his account of the word *culture* by remarking that it is "one of the two or three most complicated words in the English language."[3] The particular sense of the word as it first established the horizon of British cultural studies derives from the late eighteenth and nineteenth centuries when the impact of industrialization and democracy gave rise to a conception of "culture" as something separate from and "above" civil society. Writing in the early nineteenth century, the English poet and social theorist Samuel Coleridge elevates "culture" over what he calls "civilization" in arguing the political necessity of a "clerisy" of "cultivated" men, an intellectual elite learned in the liberal arts and sciences. This "clerisy" would consciously articulate, and translate into principles of government, the human values intuitively held in common by the rest of the populace. Following Coleridge, another English poet and social theorist, Matthew Arnold, sees the essence of these supposedly universal values as embodied in the greatest works of art,

primarily literary works. In his book of 1869, *Culture and Anarchy*, Arnold gives his celebrated definition of culture as "the best which has been thought and said." Both Coleridge and Arnold wrote at a time of violent class conflict in France and Germany, and at a time when the Chartist movement was progressively politicizing the British urban working class. For Arnold it was precisely the pursuit of narrowly utilitarian class interests that threatened to lead to the "anarchy" referred to in the title of his book. Previously, religious belief had provided the primary social cement holding together the nation state. With religious belief on the wane however only culture, the source of "sweetness and light," now stood in the way of anarchy. For Arnold this "sweetness and light" was most potently distilled in great works of literature. Literature was the privileged means by which the culture of a ruling elite was to trickle downward through the class structure to secure the hegemony of the values of that elite. In Arnold's day one of the earliest professors of English Literature, George Gordon, declared in his inaugural lecture at Oxford University: "England is sick, and . . . English Literature must save it."[4] In the modern university, the English Literature department is the still enduring monument to Arnold's teaching. Art History, a relative newcomer to the university, has in the main been equally Arnoldian in its mission. So has modernist art criticism. Clement Greenberg's influential essay of 1939, "Avant-Garde and Kitsch," in spite of its professed Marxism, makes fundamentally the same argument as Arnold's book of 1869. In the title of Greenberg's essay, the term "Avant-Garde" stands in the place of Arnold's "Culture," and "Anarchy" is now represented by "Kitsch." The difference from Arnold's argument is that whereas Arnold sees "culture" as a singular and solitary thing, Greenberg sees culture as threatened by an uncanny and grotesque double—in Greenberg's words, "that thing to which the Germans give the wonderful name of *Kitsch:* popular, commercial art and literature with their chromeotypes, magazine covers, illustrations, ads, slick and pulp fiction, comics, Tin Pan

Alley music, tap dancing, Hollywood movies, etc., etc."[5] To all such manifestations of what he called "ersatz culture," Greenberg opposes "genuine culture," "art and literature of a high order." For Greenberg, as for Arnold, it is the historical mission of high culture to guarantee the stability of the social order, a mission it can only fulfill through the continuity of its traditions. His view of culture, then, is not substantially different from that of Arnold. Indeed, Arnold's book *Culture and Anarchy* remains the generally unacknowledged founding text of American cultural conservatism to this day—that which seeks to preserve the hegemony of the European Arts and Humanities "great works" tradition, and whose line passes through such otherwise disparate figures as T. S. Eliot and Alan Bloom.

Arnold's conservative theory of culture as a totalizing force, working to perpetuate the established social order, was soon opposed by another theory of the totality, that of Marxism. In a Marxist analysis, the culture that Arnold and his followers claimed as disinterested, universal, and historically transcendent is unmasked as a supremely interested, geographically local, and historically contingent *class* culture. According to this analysis there are two cultures: the official culture of the economically and politically dominant class, and the elided culture of the dominated. A corresponding cultural politics therefore sought to recover the working-class culture that had been expunged from the pages of official history, and to put the means of new cultural production into the hands of the proletariat. Historically, in the West, the 1920s and the early 1930s were richest in such initiatives: for example, the *Proletkult* movement in the Soviet Union, or the *Arbeiter-Fotograf* movement in Germany. In these and other initiatives, in both Europe and the United States, Left artists and writers taught their skills to workers. In Britain, what was to become known as "cultural studies" similarly began in Workers' Educational Association classes, and other adult-education courses run by the extramural departments of British universities. The founding figures of British

cultural studies, Richard Hoggart, E. P. Thompson, Raymond Williams, and, later, Stuart Hall, all began by teaching in such programs. Against the Arnoldian view of culture as "the best of what has been thought and said" Williams defined culture as the "whole way of life" of a social class. In his book of 1957, *The Uses of Literacy*, Hoggart, himself from the working class, had already described his own experience of working-class culture and the ways in which that culture was being transformed. The Hoggart/Williams project of the recovery of working-class culture as a "whole way of life" clearly informs the early project of the Birmingham Centre for Contemporary Cultural Studies. The Birmingham Centre was founded by Hoggart in 1964 as a research group within the English Department of the University of Birmingham. Its initial location within a department of literary studies marks its provenance out of the English Literature–based Workers' Educational Association initiatives of earlier years—which in turn may be seen as agreeing with Arnoldian priorities at least in their object of study. The work of the Birmingham Centre is today most associated with the name of its second director, Hall. As Hall's work is deservedly well known, it will serve me as a common reference point throughout this summary account. Under Hall, in 1968, the Birmingham Centre began publishing occasional papers written by its faculty and graduate students. In 1971 it published the first issue of a biannual journal, *Working Papers in Cultural Studies*. In his introduction to the first issue of *Working Papers*, Hall describes the aim of the Centre as being "to develop a critical study of the sources, direction and meaning of cultural change in Britain and other advanced industrial societies, and the forces shaping that change." At that moment these changes were in fact undermining the very premises on which the Cultural Studies movement was originally founded. As I have observed, cultural studies in Britain began with a rejection of the Arnoldian idea of culture as a *singular* accretion of "the best of what has been thought and said" in favor of the idea that there are two cultures: the culture of the oppressor and the culture

of the oppressed. Such a division between cultures could clearly be noted in British society up until the Second World War. Up to this time Britain had experienced comparative social and political stability. Unlike other European countries Britain had for two centuries experienced no social revolutions, foreign occupations, or mass immigrations. Under these conditions a certain type of Marxist assumption that cultural formations necessarily correspond to economic class formations could be easily maintained. After the war however British social formations changed. The confidence and continuity of established British culture faltered in the face of the progressive loss of Empire and declining world economic and military power. The increasingly transnational activities of the major industrial corporations, and the increasingly global nature of the money markets, further undermined national economic and political autonomy. In 1946, as part of their plan of building a new Jerusalem on the rubble of bomb-ruined Britain, the postwar Labor government had pushed through the Education Act that extended higher education to increasing numbers of working-class children, blurring—albeit not removing—the old boundaries of class. (I myself am a beneficiary of this legislation.) Later, increasing immigration from the former colonies would progressively perplex established notions of an essential national identity. Together with all of this there was the rise, mainly on the US side of the Atlantic, of a capital-intensive high-technology entertainment industry. The United States had emerged at the end of the war with three-quarters of the world's invested capital and two-thirds of its industrial capacity; it was mainly American mass-cultural products—films, television programs, and popular music—which were progressively taking the place of what indigenous popular cultural forms remained in Europe. The process was uneven (for example, in France the domestic tradition of popular song proved relatively resistant to Anglo-American "pop" music), but British culture in 1971, at the time Hall was writing his introduction to the first issue of *Working Papers in Cultural Studies*, had more in common with

the US culture contemporary with it than it had with the British culture of the 1930s. By the time, therefore, that "cultural studies" became named as such—with the founding of the Birmingham Centre and the publication of its journal—its founding project of recovering an elided working-class culture was already marked by nostalgia, effectively displaced by a "new world order" of mass-cultural production.

This change in cultural conditions would eventually lead to an effective splitting of the Cultural Studies project. A first trace of the contradiction may be read in the second issue of *Working Papers in Cultural Studies*. Published in the spring of 1972, this issue contains an article by Paul Willis on "The Motorbike Within a Subcultural Group." Based on what Willis describes as "a case-study at a motorbike club in the Birmingham area," the object of study is fundamentally that handed down by Hoggart and Williams—working-class culture as a "whole way of life." The framing discourse however has now shifted from literary criticism to cultural anthropology. The textual material to receive commentary now comes in the form of a transcript of tape-recorded interviews with members of the motorbike club. Facing the title page of Willis's essay is a full-page photograph of a young man on a motorcycle who either is, or strongly resembles, Peter Fonda in the film *Easy Rider*. The image however is uncaptioned, and the article makes no reference either to Fonda's film of 1969 or to Stanley Kramer's movie of 1954, starring Marlon Brando, *The Wild One*. There is no place for such representations in the logocentric fantasy that the essay enacts. In this fantasy the cultural anthropologist holds his microphone to the lips of the Sphinx-like proletariat, and the authentic voice of the subculture speaks its secret. There is no part in this play for that play of representations that may have produced not only the fantasmatic identifications of the bikers but also the sociologist's own identifications with *them*—the desire that may have led him to the club in the first place and sustained his research. Immediately following Willis's article is a long piece by Hall on "The Social Eye of *Picture Post*." *Picture*

Post was a British illustrated newsmagazine that derived its format from the highly successful photo newsmagazines first developed on the European continent during the 1920s and 1930s. (The US equivalents were *Life* and *Look*.) Hall describes the complex articulations of image and text through which *Picture Post* constructed the representations of social life in which the British were invited to recognize themselves *as* "British." Unlike Willis's article, Hall's essay contains no assumption that there is a self-possessed and "authentic" culture out there simply waiting to be "expressed"; on the contrary, one of the tasks the essay undertakes is a critique of the ideology of "transparency" that informs all "realisms," whether in cultural anthropology, in photojournalism, or in the cinema. Hall's long essay began as a book review of a published collection of materials from *Picture Post* compiled by one of its former editors. In a sense, then, the article might be seen as a regression to textual exegesis in the tradition of literary studies. Both object and discourse however are radically changed. The object is not a "great work" of literature but a product of the mass media, and to the analytical method of sociology there has been added that of semiology.

It had long been common for people to speak loosely of "the language of" this or that activity—including, of course, "the language of painting," "the language of photography," "the language of film." However, it was only in the late 1950s to mid-1960s that the supposed analogy between "natural language" (speech and writing) and signifying systems other than language began to be interrogated from the standpoint of modern linguistic science. The classic locus of this work is a long essay by Roland Barthes, "Elements of Semiology," which was first published in 1964 in the French journal *Communications*. This same issue of *Communications* contains another essay by Barthes, "Rhetoric of the Image," which applies some of the principles laid out in the longer essay to the analysis of an advertisement. (The first English translation of "Rhetoric of the Image" would appear seven years later in the first issue of *Working*

Papers in Cultural Studies.) The same issue of *Communications* also contains an important article by Christian Metz in which the Saussurian semiology outlined by Barthes is brought to bear on the cinema. This single issue of the journal *Communications*, then, provided the outline of a methodology—"Elements of Semiology"—together with two additional essays that show how the semiological method may be extended to the analysis of advertising and of cinema. However, although at this nascent state a semiotics of the still image and of the moving image were equally feasible, the subsequent development of these two projects was to be unequal, with film studies taking the lead. The semiological approach to the study of film, originating in France, was first introduced into an English-language context by Peter Wollen in his book of 1969, *Signs and Meaning in the Cinema*. The work was subsequently developed and disseminated mainly through the agency of *Screen* magazine.[6] The British journal *Screen*, published by the Society for Education in Film and Television, was relaunched as a quarterly magazine in 1971—the inaugural year of *Working Papers in Cultural Studies*. The earliest issues of the new *Screen* were concerned mainly with questions of cinematic realism. *Screen* began by opposing broadly "constructivist" accounts of realism, such as those of Bertolt Brecht, Walter Benjamin, and the early Soviet filmmakers, to the "naturalist" assumptions then prevailing in writings about cinema. It was in the line of this initiative that in 1973 a *Screen* special issue on the work of Metz brought semiology to bear on issues of representation. In 1971, five years after his groundbreaking essay in *Communications*, Metz had published a rigorously detailed book-length study of language and cinema. In 1975 Metz contributed two equally influential essays to a special issue of *Communications* on psychoanalysis and cinema. A *Screen* special issue on psychoanalysis followed almost immediately in the summer of 1975, and the autumn issue in that same year carried Laura Mulvey's influential essay "Visual Pleasure and Narrative Cinema," in which Mulvey joined psychoanalytic theory to feminist

politics.[7] The move by *Screen*, from 1975, to bring psychoanalytic theory to bear on questions of politics and representation was the continuation of an initiative begun in the late 1960s in the journal *New Left Review*. A 1968 issue of *New Left Review* contains a translation of Jacques Lacan's famous paper on the "mirror phase," lodged between a selection of texts by Antonio Gramsci on the Italian factory occupations of 1919–1920 and a defiant document by the Bolivian guerrilla fighter Inti Peredo, written following the death of Che Guevara.[8] The turn to psychoanalysis, especially to Lacan, was intended to provide Marxism with its missing account of the production of the subject in language. (As much as we speak language, so language "speaks" us. Social practices are structured like languages, and "growing up" is a growing into a complex of structures that produce, as much as they may be produced by, agents in the political process.) The move was nevertheless controversial. In 1976 four members of the *Screen* editorial board resigned in protest at the journal's newly psychoanalytic direction.[9] *Working Papers in Cultural Studies* maintained a suspiciously noncommittal distance from attempts to reconcile the disparate discourses of Marxism and psychoanalysis. In 1977, *Screen* published a closely argued attack on the humanist and empiricist epistemologies implicitly retained in the category "culture" as deployed in the work of the Birmingham Centre.[10] In retrospect—as I have noted with reference to the Willis and Hall articles juxtaposed in the second issue of the Centre's journal—we may see that the Centre embraced *contradictory* epistemological assumptions from its beginning. This implicit contradiction was to explode into explicit theoretical and cultural-political conflict in the 1980s, a conflict that is not yet resolved and marks the broader field of cultural studies, and of politically conscious art, to this day.

From Two Paradigms to New Ethnicities In 1976 the journal *Working Papers in Cultural Studies* ceased publication and gave way to a series of collectively produced books. The first of these, *Resistance Through Rituals*, was devoted to the description and analysis of working-class youth

subcultures. Subsequent volumes included *Women Take Issue* and *The Empire Strikes Back*. This sequence of titles marks an evolving attention—from class, to gender, to race—reflecting the increasing pluralism entering Left politics in this period. The "new" political constituencies—women, racial minorities, and gays—were emphasizing a new form of political struggle: a politics of *representations*. Louis Althusser's influential definition of ideology as "a system of representations" had undermined the traditional Marxist theory of ideology. No longer seen as "false consciousness" (a dependent epiphenomenon of the political economy), ideology was theorized as a "relatively autonomous" sphere of political struggle. "In truth," Althusser wrote, "ideology has very little to do with 'consciousness.' . . . It is profoundly unconscious."[11] The new emphasis on the agency of representations in political struggle led to a split in the ranks of British cultural studies. In an essay of 1980, Hall characterized the division in terms of "two paradigms": culturalism and structuralism. Most centrally, the "two paradigms" debate was over the nature and status of "experience." As Hall summarized the two positions:

> Whereas, in "culturalism," experience was the ground—the terrain of "the lived"—where consciousness and conditions intersected, structuralism insisted that "experience" could not, by definition, be the ground of anything, since one could only "live" and experience one's conditions *in and through* the categories, classifications and frameworks of culture. These categories, however, did not arise from or in experience: rather, experience was their "effect." The culturalists had defined the forms of consciousness and culture as collective. But they had stopped far short of the radical proposition that, in culture and in language, the subject was "spoken by" the categories of culture in which he/she thought, rather than "speaking them." These categories were, however, not merely collective rather than individual productions: they were for the structuralists, *unconscious* structures.[12]

The debate between "culturalists" and "structuralists" set the agenda for all-subsequent work in British cultural studies. Hall concludes his article on the "two paradigms" with the observation: "In their sustained and mutually reinforcing antagonisms they hold out no promise of an easy synthesis. But, between them, they define where, if at all, is the space, and what are the limits within which such a synthesis might be constituted."[13] Hall's own work represents an exemplary attempt to hold the contradictions of the culturalist and structuralist paradigms in a productive tension. If Hall kept "a foot in both camps," however, he seemed at first to put more weight on the foot he had in culturalism. For example, in 1980, he wrote:

> Culturalism . . . has insisted, correctly, on the affirmative moment of the development of conscious struggle and organization as a necessary element in the analysis of history, ideology and consciousness: against its persistent down-grading in the structuralist paradigm. . . . In this sense, culturalism properly restores the dialectic between the unconsciousness of cultural categories and the moment of conscious organization: even if, in its characteristic movement, it has tended to match structuralism's over-emphasis on "conditions" with an altogether too-inclusive emphasis on "consciousness."[14]

By 1988, however, Hall's balance began to shift. The problematic of Hall's essay of 1988, "New Ethnicities,"[15] is much the same as that of his earlier article on the "two paradigms." In "New Ethnicities" Hall posits two different cultural political positions: one based on a unifying notion of "The Black Experience" (Hall's capitalization), and the other posited on the rejection of any essentialism of experience or identity—as he put it, "the end of the innocent notion of the essential black subject." Clearly, the former of these positions may be assigned to the culturalist end of the spectrum, and the latter to the structuralist extremity. Hall now writes:

> What is at issue . . . is the recognition of the extraordinary diversity
> of subject positions, social experiences and cultural identities which
> compose the category "black"; that is, the recognition that "black"
> is essentially a politically and culturally *constructed* category, which
> cannot be grounded in a set of fixed trans-cultural or transcendental
> racial categories and which therefore has no guarantees in Nature.[16]

We may here discern an echo of earlier debates in cultural studies over
the category "working class." For example, some ten years previously,
Colin MacCabe had argued:

> To talk of a working class or popular memory may all too easily lead
> to talking of class as a collective subject. A class, however, is not a
> subject, an identity, but rather the ever-changing configuration pro-
> duced by the forces and relations of production. A set of economic,
> political and ideological forces constantly constitute classes in strug-
> gle and classes can find no definition outside those struggles.[17]

On the eve of the landslide electoral victories of Ronald Reagan and
Margaret Thatcher, an innocent category of "working class conscious-
ness" that had inspired cultural studies in Britain from its earliest be-
ginnings was now being called into question. Not dissimilarly, in his paper
on the "New Ethnicities," Hall concludes that "we are . . . approaching
. . . the end of a certain critical innocence in black cultural politics."[18]
Black politics is entering a "new phase." But, says Hall:

> We need to be absolutely clear what we mean by a new phase because,
> as soon as you talk of a new phase, people instantly imagine that what
> is entailed is the *substitution* of one kind of politics for another. . . .
> Politics does not necessarily proceed by way of a set of oppositions

and reversals of this kind, though some groups and individuals are anxious to stage the question this way.[19]

In the polarized binary terms of the "two paradigms" debate, Hall might stand accused of wanting to have it both ways. But psychoanalytic theory subverts such "either-orism." In his contribution to a panel discussion held at the Institute of Contemporary Arts, London, in the year following the publication of his paper "New Ethnicities," Hall was to explicitly acknowledge the necessity of a psychoanalytic critique of rationalism to the project of cultural studies. He spoke of the phenomenon of Thatcherism, but his remarks might equally well have been applied to Reaganism. He says that his experience of working on the phenomenon of Thatcherism, and on the appeal of Thatcher herself, had definitively pushed him away from the last vestige of any rationalist conception of ideology. If we are to understand the logic of Thatcherism, he says, then it is better to ask "what is the logic of a dream" rather than "what is the logic of a philosophical investigation." What had characterized Thatcherism, Hall remarks, was its ability to displace and condense apparently contradictory symbolizations in the same space. He therefore urges the necessity of not simply allocating a space within politics for sexual, psychic, and personal questions but of understanding the way in which the whole of politics is itself grounded in psychosexual processes. Only in this way, he says, can such questions as those of violence, aggression, and terror be addressed—questions not dealt with in a tradition of rationalist political discourse dominated by contractual notions, in which subjects are interpellated on the basis of, and in terms of, a rational calculus of interests. It is essential, then, to acknowledge that there is a domain of political thought and action which is always drawing on psychosexual processes, and therefore cannot be understood without reference to such processes. However, this is not the same as saying that politics can be

reduced to such processes. Political processes have to be understood in relation to unconscious processes, but this is not the same as saying that political processes are nothing other than the repetition in, and the projection into, the real, of already existing unconscious forms. Hall concludes with the (crucial) point that it is important to theorize the relation between the unconscious and political cultural processes without ever hoping to reconcile the two, to as it were "sum" them, or resolve the equation. It is impossible to simply translate one set of processes into the other. It is in fact precisely the recognition of the unconscious which puts an end to this rationalist ambition.[20]

In recent years, cultural studies in Britain has progressively moved into confluence with the work in psychoanalytic theory already under way in film, photography, and literary studies in general, and in feminist and gay studies in particular (which had first brought issues of sexuality into the political arena). Recollecting this British history now, in California, I am well aware of the argument that, as the United States has its own culture, then *for this reason* cultural studies in the United States is necessarily a different discipline from what it is in Britain. Paul Gilroy answers this argument in his book of 1993, *The Black Atlantic*.[21] Gilroy rejects "the unthinking assumption that cultures will always flow into patterns congruent with the borders of essentially homogeneous nation states," which may produce "a nationalistic focus that is antithetical to the rhizomorphic, fractal structure of the transcultural, international formation [that Gilroy calls] the black Atlantic."[22] My own experience of debates in and about cultural studies in the United States is that they have tended to become polarized in a way familiar to me from the "two paradigms" debate in Britain I have very schematically outlined above. This is not to stake a claim for British intellectual priority in the general field of cultural studies, it is simply to observe that there are fundamental problems for the theory and politics of culture—as difficult to avoid as they are to resolve—which are not confined within national borders. Resisting the breathless call to

interminable novelty, I have (re)turned to the history of the "two paradigms" debate as it evolved in Britain in a spirit of "remembering, repeating, and working-through." I hope that today, against the grain of prevailing binary logics, against the stultifying "either-orism" of hegemonic instrumental rationalism, we may learn to tolerate the unavoidable entanglement of divergent discourses. A way in which such a shift in reasoning might inflect the "working through" of the "two paradigms" debate today may be illustrated with reference to Gilroy's discussion of the work of Patricia Hill Collins.[23] In effect, Gilroy criticizes Hill Collins for the *partial* nature of her application of the "structuralist" paradigm. He writes: "The deconstructive zeal with which Hill Collins urges her readers to take traditional epistemological assumptions apart is exhausted after tackling 'woman' and 'intellectual.' It runs out long before she reaches the key words 'black' and 'Afrocentric,' which appear to be immune to this critical operation."[24] As a consequence:

> Another version of racial essentialism is smuggled in through the back door porch even as Hill Collins loudly banishes it from her front door. . . . an embeddedness in Enlightenment assumptions continues despite the ostentatious gestures of disaffiliation. Experience-centered knowledge claims . . . simply end up substituting the standpoint of black women for its forerunner rooted in the lives of white men. This may have some value as a short-term corrective, but it is less radical and less stimulating than the possibility that we might move beyond the desire to situate our claims about the world in the lives of these whole and stable subjects.[25]

But the value as a "short-term corrective" of an experience-centered knowledge claim might be precisely what justifies it *politically* (albeit such value cannot be specified in advance of a particular conjuncture). And the belief that the criterion of logical consistency in argument is universally

applicable might itself be faulted as embedded in Enlightenment assumptions. I agree with what Gilroy says about Hill Collins's theoretical argument. My point is simply that such criticism might become irrelevant if Hill Collins's rhetoric were to be transposed from the academy to the ground of constituency-building in black feminist politics. From a political standpoint, nothing is more appropriate than the application of radically deconstructive analyses to the imaginary identities of racism. It might be inappropriate, however, to apply a similarly rigorous deconstruction to the emergent subject of a minority "identity." The two cases are asymmetrical. In the latter, the historical momentum desired is from the imposed dis-integration of those who, in Homi Bhabha's words, "have suffered the sentence of history—subjugation, domination, diaspora, displacement"[26] toward increased coherence and agency. Certainly such coherence can only ever be imaginary. The essential subject is only ever a fiction, *but it is a fiction with real political effects.* In real politics, the pertinent question in the face of an "identity" is not "Is it coherent?" but "What does it achieve?"[27] As Slavoj Zizeck notes: "The condition of being active politically is precisely to *be* unilateral: the structure of the political act as such is 'essentialist.'"[28] Politics is as much an art of the imaginary as of the real. History is witness that appeals to an essential identity are successful in creating and mobilizing politically effective constituencies—for good or for ill.

It is irrelevant to criticize identity politics—*as politics*—because it rests on theoretically untenable assumptions about the subject. But nor should we reject theory because it may be ideologically inconvenient or (most devastating charge) "elitist." As an insult, "Elitist!" functions as a performative utterance (in the strictly Austinian sense), its meaning varying widely according to context. Etymologically, however, the meaning of the word is more limited. The feminine noun *élite* is derived from the past participle, *élit,* of the French verb *élire,* "to choose"—which in turn derives from the Latin *eligere,* "elect." Literally, then, in the

Western-style democracies largely coextensive with global capitalism[29] the word *elite* applies to any minority selected to govern a majority. In this literal sense, the members of a national government constitute an elite, as does the officer class of the military or the executive class of a corporation. Literally, "elitism," when used pejoratively, names any practice that serves to support the narrowly patrician interests of a select ruling class at the expense of the majority of those they purport to "represent." Much of the production of the so-called "popular" or "mass" media must therefore be considered "elitist," to the extent that it perpetuates and disseminates hegemonic corporate values and beliefs. The charge of "elitism," therefore, is applicable to much of the "popular culture" that cultural populists find most "accessible." When populists redefine the word *elitism* by *opposing* it to the term *accessible,* the word slips its etymological moorings and drifts across the political spectrum. For example, an article in the literally "elitist" newspaper *Le figaro* proclaims: "It is necessary to overturn the spirit of our teaching which suffers from the illness of elitism."[30] This "illness" (for which Fascist, Stalinist, and Maoist populisms offered their various cures) afflicts *language,* both in the literal and in the more broadly semiotic sense. Much like the cornea, language is considered to be naturally transparent when healthy; if it is not transparent then it must be diseased. Here, a clear-eyed democratic appeal on behalf of intelligibility and common sense implicitly pathologizes, stigmatizes, and discredits those who do not speak in a popular idiolect.

It is significant that the *Le figaro* article indicted *teaching.* Ironically, it is within the academy itself that there has most recently been a resurgence of cultural populism—closely aligned with "identity politics" and associated mainly with the growth of "cultural studies." Here we do well to note a distinction respected in the study of popular culture inaugurated by the Birmingham Centre. As Hall recalls, "The Centre did not say: 'All you have to do is to be a good activist and we will give you a degree for

it.'"[31] This is not to promote political quietism amongst academics. On the contrary, it is to urge a close attention to the specificity of differing forms of political praxis, to the disparate registers in which they operate, and to the mutable and indeterminate relations between them (as Gilroy puts it, in a different context, "negotiating the relationship between vernacular and non-vernacular forms").[32] It is beside the point to criticize essentialist identity politics for its theoretically naive assumptions about identity. It is no less beside the point to reject psychoanalytic theory because what it has to say about identity may be ideologically inconvenient and cannot be reduced to a slogan. Populists throughout modern history, and across the political spectrum, have found such theory offensive, but the only substantial offense of such "elitism" today is against the paternalistic common sense of the corporate-political establishment that *literally* constitutes the "elite"—and the only one worth contesting.

It has been argued that psychoanalytic theory cannot contest patriarchy because it is a product of patriarchy. In the Soviet Union, shortly after the October Revolution, there were those who argued that the existing railway system was bourgeois, that it should be torn up and new "proletarian" railways built. Early in the history of Russian Formalism it had been recognized that, as Tzvétan Todorov put it, "The form of a work is not its only formal element: its content may equally well be formal."[33] This insight entailed its own transformation as the idea that the form of a work has (ideological) content. The Russian railway theorists (to whom Stalin gave the name "troglodytes") made no concessions in their application of this undeniable wisdom, but it may be put to more nuanced use. When drawing on European intellectual traditions we must constantly examine, as Gilroy puts it, "the place which these cultural perspectives provide for the images of their racialised others as objects of knowledge, power, and cultural criticism."[34] But if it were invariably true that one "cannot dismantle the master's house with the master's tools" then we would have to reinvent *language itself*.[35] In the first chapter of

The Psychopathology of Everyday Life, Freud describes the part played in his thought processes by an anecdote told to him by a colleague. The anecdote concerns "the customs of the Turks living in Bosnia and Herzegovina," who "place a higher value on sexual enjoyment than on anything else." Does Freud, here, unreflectingly and insensitively perpetuate extant Western Orientalist attitudes? Yes, certainly he does. Does this have any consequence for his theory of the role of unconscious processes in forgetting? No, none whatsoever.

It is no longer plausible to separate culture into such distinct realms as "mass culture," "popular art," and "high art." At the levels of production and distribution, all cultural workers today actually or potentially rely on much the same technologies and institutions, and all cultural products are equally subject to commodification (albeit the specific forms of their relations to the market vary). At the level of reception, the meanings of all products of contemporary culture tend to be cut from much the same cloth: woven from intertextually interrelated but institutionally heterogeneous strands of sense, originating in disparate times and spaces. As there are no longer any definitively separate realms of cultural production, it follows that there can be no islands of counterhegemonic purity. Notwithstanding the claims of cultural populists or cultural conservatives, "mass" visual culture is to be neither celebrated nor condemned. It serves neither to simply express nor to repress popular aspirations and desires; it is rather complexly involved in their production and articulation. In addressing such complexity in his essay on *Picture Post*, and in a subsequent article on "The Determinations of Newsphotographs," Hall established an early direction for work in cultural studies which took as its object the general environment of mass-media imagery, and which would incorporate the new methods of visual analysis originating in France. Hall himself did not develop his own early work on images *as such*, and neither did the work of the Birmingham Centre as a whole. As Hall has more recently stated, the overall project of the Centre was "to

address the problems of what Gramsci called 'the national popular': how it was constructed; how it was being transformed; why it mattered in the play and negotiation of hegemonic practices."[36] Most broadly defined, the project calls for no *particular* attention to the agency of image production as a "hegemonic practice." Much like the "drive," in psychoanalytic theory, cultural studies is to be defined not in terms of its object but in terms of its *aim*. Hall stresses, "cultural studies is not one thing; it has never been one thing."[37] Cultural studies cannot be one discipline, it cannot have one object, it cannot have one mode of analysis. Only the aim of cultural studies allows it to be named: *"cultural studies" studies the relationship between culture and politics* (between culture, which is not one thing, and politics, which is not one thing). The early Cultural Studies movement in Britain treated the image in a desultory fashion. It was left almost exclusively to film and photography theory to develop the systematic study of contemporary visual culture, but within the separate confines of the supposed "specificity" of their objects. Metz said he began by loving the cinema but that his desire to analyze the object of his love ended by damaging or even destroying it. In Kleinian terms, we might see the preoccupation of film theory in the 1970s with the *specificity* of cinema as an act of "reparation," a product of the paradoxical desire that the same analytical gesture that rends the object should, in the same movement, guarantee its integrity. Academic "Film Studies," a loving discipline, may continue to constitute its object as it sees fit. The study of "contemporary visual culture" today must take its objects as it finds them, and it finds them in pieces.

No iconoclasm has befallen images; their shattering has left them stronger than when they were whole. Images are now as much a material force in and between societies as are economic and political forces. Contemporary visual culture—the combined product of "the media" and a variety of other spheres of image production—can no longer be seen as simply "reflecting" or "communicating" the world in which we live:

it contributes to the making of this world. Individuals and nations act in accordance with beliefs, values, and desires that increasingly are formed and informed, inflected and refracted, through images: from television, advertising, cinema, newspapers, magazines, videotapes, CD-ROM, the Internet, and so on. The impact of information technology on both "mass media" and more traditional media has considerably expanded the cultural and political importance of images. Most notably, the global proliferation of media networks brought about by the space-contracting technology of satellite television now gives images an unprecedented power to affect national and international opinion, not least through their impact on the mutual perceptions of differing national, ethnic, and racial groups. This is the field of *representations*, coextensive with politics, which first came under scrutiny in the semiotics of film and photography and in early cultural studies. The objects of visual culture first examined were such things as narrative films, advertisements, documentary photographs, and so on. Television, however, presented a special problem for existing modes of analysis, as it was more difficult to treat the products of television as discrete and bounded objects. This is one of the points where the following chapters intervene. Nevertheless, I hardly speak of television in the institutional sense. The particular object of my attention is not television, or cinema, or photography, or any other singular form of visual representation. It is rather, in an expression coined by Paul Virilio, the "teletopological puzzle" that is all of these *together*—"together" not as a totality but as a constantly shifting constellation of fragments.

Phenomenologically, the field of visual images in everyday contemporary "Western" cultures (and others, such as that of Japan) is heterogeneous and hybrid. The consumer of images "flips" through endless magazines, "channel surfs" on waves of TV shows. The integrity of the semantic object is rarely, if ever, respected. Moreover, the boundaries of the "object" itself are expanded, made permeable or otherwise transformed. For example, a "film" may be encountered through posters,

"blurbs," and other advertisements, such as trailers and television clips; it may be encountered through newspaper reviews, reference work synopses, and theoretical articles (with their "filmstrip" assemblages of still images); through production photographs, frame enlargements, memorabilia, and so on. Collecting such metonymic fragments in memory, we may come to feel familiar with a film we have not actually seen. Clearly this "film"—a heterogeneous psychical object, constructed from image scraps scattered in space and time, arbitrarily anchored in a contingent reality (a newspaper interview, a review)—is a very different object from that encountered in the context of "film studies." This "film" is a representative example of what I think of (albeit perversely) as "television." Such hybrid virtual objects take provisional form in a teletopological space-time largely indifferent to the physical bounds of TV screens and program times. The peculiarity of this space-time of visual representations, the shifting coordinates in which imaginary identities are "fixed," is the object of this book.

PART 2: FANTASIES OF POSTMODERN GEOGRAPHY

> Today everything that derives from history and from historical time must undergo a test. Neither "cultures" nor the "consciousness" of peoples, groups or even individuals can escape the loss of identity that is now added to all other besetting terrors. . . . nothing and no one can avoid trial by space.
> **Henri Lefebvre**[38]

In his book of 1989, *Postmodern Geographies*, Edward Soja recalled: "In 1984, [Frederic] Jameson, [Henri] Lefebvre, and I took a spiraling tour around the centre of Los Angeles, starting at the Bonaventure Hotel."[39] Soja describes their itinerary in his final chapter, "Taking Los Angeles Apart: Towards a Postmodern Geography." What Soja encounters on

the tour is a theme park of world space: Los Angeles is, as he puts it, *"une ville devenue monde."*[40] In his penultimate chapter, "It All Comes Together in Los Angeles," he writes: "There is a Boston in Los Angeles, a Lower Manhattan and a South Bronx, a São Paulo and a Singapore." Consequently, "What better place can there be to illustrate and synthesize the dynamics of capitalist spatialization?"[41] In his own social history of Los Angeles, Mike Davis praises Soja for brilliantly encapsulating the "image of Los Angeles as prism of different spatialities."[42] But he rejects what he sees as Soja's ungrounded assumption that these spatial formations represent the universal shape of things to come, "the paradigm of the future." Davis is similarly critical of Jameson for promoting the same idea, as in, for example, his "famous evocation (in his 'Cultural Logic of Late Capitalism') of Bunker Hill as a 'concrete totalization' of postmodernity."[43] Both Soja and Jameson, Davis complains, "in the very eloquence of their different 'postmodern mappings' of Los Angeles, become celebrants of the myth."[44] Davis's hostility to the idea that the future of the world may be traced in the lines of Los Angeles's freeways may appear self-contradictory, given that the subtitle of his own book about Los Angeles, *City of Quartz*, is *Excavating the Future in Los Angeles*. But more importantly, in dwelling on what Soja and Jameson may have in common, we risk losing sight of the substantive *difference* between what they say, and between what each made of his "spiraling tour" from the Bonaventure.

Speaking of the Bonaventure, in the widely discussed essay of 1984 to which Davis refers, Jameson comments:

> This latest mutation in space—postmodern hyperspace—has finally succeeded in transcending the capacities of the individual human body to locate itself, to organize its immediate surroundings, perceptually, and cognitively to map its position in a mappable external world. . . . this alarming disjunction point between the body and its

built environment . . . can itself stand as the symbol and analogue of that even sharper dilemma which is the incapacity of our minds, at least at present, to map the great global multinational and decentred communicational network in which we find ourselves caught as individual subjects.[45]

The great spatial network of late twentieth-century capitalism is the ultimate object of concern for both Soja and Jameson. But whereas Soja collapses the world into Los Angeles, Jameson collapses both into the Bonaventure. Both Soja and Jameson use the term *hyperspace* to speak of the object of their concern, but they are really speaking of quite different things. Soja refers to "the hyperspace of the city of Los Angeles,"[46] whereas Jameson uses the term to name the space of the Bonaventure Hotel—a building that, he finds, "does not wish to be part of the city, but rather its equivalent and its replacement or substitute."[47] Unlike the form of the city, the form of the hotel is (even allowing for the prism of external constraints that refract any architect's intention) the work of an auteur.[48] It is further significant that Soja speaks in terms of "illustration and synthesis," whereas Jameson speaks of "symbol and analogue." Los Angeles serves Soja as a field of empirically observable data, within which he discerns, as Davis puts it, "the outlines of a paradigmatic postfordism, an emergent twenty-first century urbanism." For Jameson, the Bonaventure offers not empirical data but allegorical form, which does not directly "illustrate" the shape of *future* urban life, but which indirectly "figures" *present* power as lived by those submitted to it. This distinction emerges most clearly in Jameson's book of 1992, *The Geopolitical Aesthetic: Cinema and Space in the World System*. He writes:

Bergson's warning about the temptations of spatializing thought remain current in . . . an era of urban dissolution and re-ghettoization, in which we might be tempted to think that the social can be mapped

that way, by following across a map insurance red lines and the electrified borders of private police and surveillance forces. Both images are, however, only caricatures of the mode of production itself (most often called late capitalism) whose mechanisms and dynamics are not visible in that sense, cannot be detected on the surfaces scanned by satellites, and therefore stand as a fundamental representational problem—indeed a problem of a historically new and original type.[49]

This passage implies sharp criticism of the approach to the urban environment taken by both Soja and Davis, writers who concern themselves with precisely such "caricatures." But we might more usefully accept that the types of spatial descriptions offered by Soja and Davis are simply incommensurable with those provided by Jameson. They are not really in conflict as they occupy different grounds, different registers of description: provisionally (in Derrida's expression, "under erasure") the "empirical" and the "psychological." The means to a more detailed understanding of the terms of the differences between Davis, Soja, and Jameson are provided by the work of the third member of the party on their "spiraling tour" around Los Angeles from the Bonaventure: Lefebvre.

Soja describes Lefebvre as "the incunabulum of post-modern critical human geography, the primary source for the assault against historicism and the reassertion of space in critical social theory."[50] Lefebvre's book *The Production of Space* first appeared, in French, in 1974, at which time it represented the culmination of an engagement with questions of space he had begun in 1968. The English translation was published in 1991, the year Lefebvre died. The most fundamental project of Lefebvre's book is to reject the conception of space as "a container without content," an abstract mathematical/geometrical continuum, independent of human

subjectivity and agency. As his homage to Lefebvre implies, Soja's work continues Lefebvre's project of theorizing space not as a Kantian a priori but as a product of human *practice*. Lefebvre defines what he calls "spatial practice" as "a projection 'onto the ground' [*sur le terrain*] of all aspects, elements and moments of social practice."[51] For Lefebvre, spatial practice is "observed, described and analysed on a wide range of levels: in architecture, in city planning . . . in the actual design of routes and localities . . . in the organization of everyday life, and, naturally, in urban reality."[52] Soja's project, as well as that of Davis, clearly accords with this concept of space as formed when social relations "hit the ground." For Lefebvre, however, spatial practice—that which is "empirically observable"—is only one of "the three moments of social space," which he names "the perceived, the conceived, and the lived." Lefebvre uses the expression "spatial practice" to refer to the register of "the perceived"; he uses "representations of space" to refer to "the conceived," and "representational space" to refer to "the lived." Summarized in bare outline: *spatial practice*, as already observed, is the material expression of social relations in space: a marketplace, a bedroom, a lecture theater, a ghetto. *Representations of space* are those conceptual abstractions that may inform the actual configuration of such spatial practices, for example, Cartesian geometry, linear perspective, Le Corbusier's "modular" or the Quattrocento painter's *braccio*. *Representational space* is space as appropriated by the imagination; Lefebvre writes that it "overlays physical space, making symbolic use of its objects"[53] and is predominantly nonverbal in nature. For all the difficulties in sustaining any absolute distinctions between Lefebvre's three categories, they nevertheless help us to see the projects of Soja and Jameson as addressing different aspects of an overall, complex problematic of space. In Lefebvre's terms, then, Soja's work may be seen as privileging "spatial practice": the empirical, the perceivable; whereas Jameson's attention is rather to "representations of space": the "symbolic use" of the empirical world. It should be

emphasized however that, for Lefebvre, there can be no question of choosing one form of attention to the exclusion of the other. It is precisely in his attempt to account for the simultaneous imbrication of the physical and the psychological that the ambition, and difficulty, of Lefebvre's work lies. Soja's book, replete with graphs and tables, is constrained by a social science framework. His basic thesis, "spatiality is . . . a social product," is in agreement with Lefebvre. Unlike Lefebvre, however, Soja shows little interest in the problem of the imbrication of social space and mental space. More precisely, he sees mental space as a dangerously threatening supplement to his statical-statistical space. He complains: "Social space folds into mental space, into diaphanous concepts of spatiality which all too often take us away from materialized social realities."[54] However, for all that bar graphs and pie charts keep quiet about it, mental space and social realities are *in reality* inseparable.

In a misrecognition that is the mirror reversal of the one made by Soja, the sociologist author of a book about "images of the city in the detective story," writes that his analysis takes as its object "not some supposed real city, situated somewhere in the world and which the crime novel shows in the manner of a touristic or geographic description, but rather the city of paper which the novel drafts: written, unreal, symbolic, *coded*."[55] But what this author calls the "real city" can never be perceived as totally distinct from the "paper city." The city in our actual experience is *at the same time* an actually existing physical environment, *and* a city in a novel, a film, a photograph, a city seen on television, a city in a comic strip, a city in a pie chart, and so on. For example, a photograph on the cover of a special issue of the French weekly newsmagazine *Le nouvel obser-vateur*[56] shows a graffiti painting rendered on a bleak concrete city wall. Figures with guns and clubs appear in the foreground of the painting. Behind them rises a painted silhouette skyline of high-rise buildings— evoking *at the same time* the HLM (low-rent housing projects) of French cities *and* the iconical downtown skyscraper skyline familiar from the

Hollywood film noir. The magazine's cover story is about violent (mixed race) youth uprisings in the French "projects." Interviewed about her adolescent students, a young schoolteacher from the troubled Paris suburb of Bobigny observes: "They make no distinction between the world of the street, of television and the school." Soja has no access to this hybrid space, at once material and psychical, in which these young people (together with the rest of us) *actually live and act*. He resists, as he puts it, "an ideational process in which the 'image' of reality takes epistemological precedence over the tangible substance and appearance of the real world."[57]

Soja argues from basic common sense. There is a fundamental objection in common sense to considering fantasy in the context of the social and the political. In *Roget's Thesaurus* the word "fantasy" is flanked by "poetry" on one side and "visual fallacy" on the other. The distribution of these terms is in agreement with the broad everyday use of the word. On the one hand, the term *poetry* invokes a more or less intentional act of imagination; on the other hand, *visual fallacy* signals the unintentional, the hallucinatory. Whatever the case, whether the particular sense of "fantasy" in question is nuanced toward the voluntary caprice or the involuntary delusion, in popular understanding "fantasy" is always opposed to "reality." In this definition fantasy is the *negative* of reality. Here "reality" is conceived as that which is "external" to our "inner" lives. In this commonsense view we simultaneously inhabit two distinct and separate worlds. One is mental, private, "internal." The other is physical, public, "external." Political and social considerations are seen as belonging to the latter arena of common empirical realities. The British philosopher Gilbert Ryle noted a lacuna in this widespread notion: "The transactions between the episodes of the private history and the public history remain mysterious, since by definition they can only belong to neither series."[58] It is to this "mysterious" area of transaction that psychoanalysis allows us access through the theory of the *unconscious*.

This theory posits, precisely, "the idea of another locality, another space, another scene, *the between perception and consciousness*."[59] Psychoanalysis is founded on the recognition that what Soja calls "materialized social realities" are not all that are real for us: conscious and unconscious fantasies are as immutable a force in our lives as any material circumstances. The agency of the unconscious has no place in Soja's common-sense worldview, and the word *unconscious* is not to be found in his writing. The same is true of Davis's work. Jameson uses the term quite frequently, but in an idiosyncratic sense that has little to do with the psychoanalytic sense of the word. (I discuss this in my final chapter, "Brecciated Time.") In seeking a way out of the "spiraling orbit," become a vicious circle around a city reductively conceived as nothing other than a literally *concrete* entity, in seeking access to that *other space* of the concrete reality of dreams, to which psychoanalysis is attentive, we may again turn to the work of Lefebvre.

Lefebvre was a veteran Marxist theoretician and militant who at times criticized psychoanalysis for privileging subjective interiority at the expense of lived social relations. Nevertheless, there are key moments in *The Production of Space* when he opens doors onto the objects and methods of psychoanalysis. Lefebvre sees the "problematic" of space as "composed of questions about mental and social space, about their interconnections."[60] Most simply put, he sets out to demonstrate the unity of these "two" realms. In a passage that strikingly evokes Lacan's formulation of the "mirror stage," Lefebvre writes:

> [Space] is first of all *my* body, and then it is my body counterpart or "other," its mirror-image or shadow: it is the shifting intersection between that which touches, penetrates, threatens or benefits my body on the one hand, and all other bodies on the other.[61]

In a psychoanalytic perspective, Lefebvre's insistence on the centrality of the body subverts the distinction he makes between "representations of

space" and "representational space." If, as he insists, and as psychoanalysis would agree, "The whole of (social) space proceeds from the body,"[62] then how is he able to see such "representations of space" as geometry as exempt from the same bodily determinations as "representational space"? (see Chapter 1, "Geometry and Abjection"). The answer to this question probably lies in Lefebvre's division of the laboring body from the perceiving body, in which perceptual processes are seen as essentially passive. For example, he speaks of "the passive body (the senses) and the active body (labour)."[63] That Lefebvre may nevertheless be unconsciously aware of a contradiction is intimated in a passing tribute, in *The Production of Space*, to the surrealists—those who celebrated the triumph of imagination over brute perception. During the immediate postwar period, Lefebvre had attacked surrealism's "substitution of poetry for politics." In his book of 1947, *Critique of Everyday Life*, the book in which he is most critical of surrealism, Lefebvre remarks: "Man must be everyday, or he will not be at all." By conscious irony, or unconscious homage (most likely both) the aphoristic form of his sentence echoes the closing line of André Breton's novel of 1928, *Nadja:* "La beauté sera CONVULSIVE ou ne sera pas."[64] According to Lefebvre's biographer, Rémi Hess, Lefebvre was first introduced to Marxism by Breton, and had associated with the surrealists during the 1930s. In 1974, in *The Production of Space*, Lefebvre concedes:

> The leading surrealists sought to decode inner space and illuminate the nature of the transition from this subjective space to the material realm of the body and the outside world, and thence to social life. Consequently, surrealism has a theoretical import which was not originally recognized.[65]

This "theoretical import" of surrealism, as the surrealists themselves acknowledged, is best worked out in psychoanalytic terms. Lefebvre and Lacan were born in the same year, 1901. Both lived through much the

same continuum of French history.[66] Like Lefebvre, Lacan also had early relations with the surrealists. It was within the historical matrix of the moment of surrealism (see Chapter 4, "Chance Encounters," and Chapter 5, "Seiburealism") that he formed the ideas that would lead to his now famous (and often reductively understood) notion of the "mirror stage" in the formation of identity (see Chapter 6, "Paranoiac Space").

Lefebvre is a *discriminating* thinker. *The Production of Space* contains criticism of semiotics and poststructuralism, of Derrida and Foucault. Yet, as the *afterword* to the English translation notes, "Lefebvre never rejects such formulations outright. He always engages with them in order to appropriate and transform the insights to be gained from them in new and creative ways."[67] Lefebvre's dense and complex arguments do not develop in an orderly linear succession. The book appropriately invites a "spatial," rather than a "temporal," reading—analogous to the way in which the Situationist International (also no strangers to Lefebvre) recommended that urban space be navigated, "*à la dérive.*" In his article of 1958, "Theory of the Dérive," Guy Debord writes:

> The lessons drawn from the dérive permit the drawing up of the first surveys of the psychogeographical articulations of a modern city. Beyond the discovery of unities of ambiance, of their main components and their spatial localization, one comes to perceive their principal axes of passage, their exits and their defenses. One arrives at the central hypothesis of the existence of psychogeographical pivotal points.[68]

The modern city provides the common site of the observations in the chapters that follow ("follow," as I have already observed, more *à la dérive* than in the manner of a thesis). The "city" here, however, is not to be understood in the established terms of urbanists and city planners, nor in the sociometric terms of the new geographers. It is rather to be

considered as a neuralgic node in what Jameson calls "the great global multinational and decentred communicational network in which we find ourselves caught as individual subjects,"[69] and as a hybrid and heterogeneous site of (self/other) representations (see Chapter 4, "Chance Encounters," and Chapter 7, "The City in Pieces").

In 1984, Jameson discussed the capacity of certain "postmodernist texts" to evoke, "a whole new postmodern space in emergence around us." He concluded: "Architecture . . . remains in this sense the privileged aesthetic language."[70] Almost a decade later, however, in the book in which he seems most closely to return to the questions of global space he first addressed in 1984, Jameson chose to write about cinema. Such a sliding of attention from architecture to cinema was prefigured by Benjamin. In his essay "The Work of Art in the Age of Mechanical Reproduction," Benjamin writes:

> Architecture has always represented the prototype of a work of art the reception of which is consummated by a collectivity in a state of distraction. . . . Today . . . [r]eception in a state of distraction, which . . . is symptomatic of profound changes in apperception, finds in the film its true means of exercise.[71]

It is precisely "profound changes in apperception" that preoccupy Jameson. More precisely, as already noted, it is the failure of apperception which concerns him—what he sees as our physical and intellectual incapacity to comprehend the "new hyperspace" of postmodernism, the vehicle and form of the new global capitalism. In *The Geopolitical Aesthetic*, in a passage that may recall his concluding remarks about the Bonaventure, Jameson writes:

> In our time the referent—the world system—is a being of such enormous complexity that it can only be mapped and modeled

indirectly, by way of a simpler object that stands as its allegorical interpretant, that object being most often in postmodernism a media phenomenon.[72]

The "media phenomenon" he chooses to talk about is cinema. Unavoidably, however, we can today only position this cinema in relation to that of which he does not speak, the "structuring absence" of his book: television. On the one hand, in everyday language, *cinema* means "narrative cinema." Phenomenologically, the film is localized in space and time: in the finite unreeling of a narrative in a particular theater, at a particular time, and on a particular day. The word *television*, on the other hand, means television programs of all kinds: news, current affairs, and documentaries; sports events, rock concerts, opera, and ballet; serialized soap operas, "quality" dramatic productions, and episodic situation comedies; police, Western, and science fiction adventures; science, cooking, gardening, and other educational and "special interest" programs; "telefilms" and, of course, the broadcasting of films originally made for the cinema. Television presents itself as if it "covers" life itself. The urban dweller who turns away from the image on her or his television screen, to look out of the window, may see the same program playing on other screens, behind other windows, or, more likely, will be aware of a simultaneity of different programs. Returning from this casual act of voyeurism they may "zap" through channels, or "flip" through magazines. Just as Benjamin refers to architecture as appreciated "in a state of distraction," so television and photography are received in much the same way. The cinematic experience is temporally linear. For all that narrative codes may shuffle the pack of events, the spatial modulations that occur in the diagesis are nevertheless *successively* ordered and experienced as a *passage* through space and time. The global space-time of television, however, is fractured and kaleidoscopic. In this, it is closer to the ubiq-

uitous environment of photography than to cinema. On the first page of his book of 1980, *La chambre claire*, Barthes writes: "I declared that I liked Photography against the cinema—from which, however, I never managed to separate it."[73] In his essay of 1971, "For a Metahistory of Film," Hollis Frampton observes:

> Cinema is a Greek word that means "movie." . . . There is nothing in the structural logic of the filmstrip that can justify such an assumption. Therefore we reject it. From now on we will call our art simply: film.
>
> The infinite film contains an infinity of endless passages wherein no frame resembles any other in the slightest degree, and a further infinity of passages wherein successive frames are as nearly identical as intelligence can make them.[74]

Barthes's difficulty in definitively separating the still from the moving image is given a pragmatic grounding in Frampton's observation that there is no intrinsic reason why "cinema" should show movement—as the individual frames of a film need not *necessarily* differ from each other. Such observations help deconstruct the strict binarism of the conventional opposition between moving and still image, and prepare the ground for a consideration of the mediatic environment as a whole—which demands a revised understanding of the space and time of the general field of representations. Here again, psychoanalytic theory is indispensable. Shoshana Felman has remarked that psychoanalysis is "a unique and original mode of learning," with:

> a very different temporality from the conventional linear—cumulative and progressive—temporality of learning, as it has traditionally been conceived by pedagogical theory and practice. Proceeding not through linear progression but through breakthroughs, leaps,

discontinuities, regressions, and deferred action, the analytic learning process puts in question the traditional pedagogical belief in intellectual perfectibility, the progressist view of learning as a simple one-way road from ignorance to knowledge.[75]

"Leaps, discontinuities, regressions, and deferred action"—I can think of no more appropriate description of the way we receive the contemporary image environment. The meanings that govern us are not arrived at by "a simple one-way road." The metaphor is familiar: the road of history, the road of life. Entering the shadow of the declining phase of the twentieth century, Lefebvre identified the "trial by space" to which "everything that derives from history" would submit. Lefebvre was a Marxist who joined others, notably Michel Foucault, in rejecting all historicist teleologies—all one-way roads—as woodenly implausible. The problem of history nevertheless remained, albeit in pieces, its fragments now swept to the margins of the newly spatial critical paradigms. Lefebvre was perhaps the first to identify "loss of identity" as a "besetting terror" of the trial by space. In our present fin-de-siècle increasing displacements of populations between nations, changing distributions of racial and ethnic populations *within* nations, and the mutating geographies of post–cold war global politics are redrawing old maps of identity— national, cultural, and individual. An identity implies not only a location but a duration, a history. A lost identity is lost not only in space, but in time. We might better say, in "space-time." Lefebvre, and the postmodern geographers who followed him, sought to emphasize the time of lived social space over timelessly abstract "mental" space. The chapters that follow were written with no respect for this distinction between the social and the psychical, as the distinction is itself an abstraction, a fantasy. I begin, "degro zero," with the supposedly subjectless abstract space of geometry.

Simple geometrical opposition becomes
tinged with aggressivity.

Gaston Bachelard[1]

Although it makes no direct reference to Louis Althusser's essay of 1970, "Ideology and Ideological State Apparatuses,"[2] Roland Barthes's essay of 1973, "Diderot, Brecht, Eisenstein," has the effect of spatializing the Althusserian concept of ideology as representation: "There will still be representation for so long as a subject (author, reader, spectator or voyeur) casts his gaze towards a horizon on which he cuts out the base of a triangle, his eye (or his mind) forming the apex."[3] Laura Mulvey's essay of 1975, "Visual Pleasure and Narrative Cinema,"[4] subsequently theorizes the voyeuristic subject of Barthes's theatrical space in terms of Freudian psychoanalysis. The change across this five-year period is profound. Instead of a contingent set of ideas that might be dissipated by reason, "ideology" was now conceived of in terms of a space of representations that the subject inhabits, a limitless space that the desiring subject negotiates by predominantly unconscious transactions.

For all these innovations, however, there remained significant ties with tradition. Barthes's optical triangle is, after all, one-half of the diagram of the camera obscura—a metaphor not unfamiliar to students of Marx. Furthermore, 1975 was also the year of publication, in French, of Michel Foucault's *Discipline and Punish*.[5] Barthes's "eye at the apex" was therefore easily conflated with that of the jailor, actual or virtual, in the tower at the center of the panopticon. For all that Foucault himself would have opposed it, this further contributed to the survival of that strand of theory according to which ideology is an instrument of

domination wielded by one section of a society and imposed upon another—"the dominant ideas are the ideas of those who dominate." In this context, then—and given the urgent exigencies of a feminist *real-politik*—it is not so surprising that one effect of Mulvey's essay was that all man-made images of women were henceforth viewed, without discrimination, as instruments of sadistic objectification, and were therefore proscribed.

I believe that the metaphor of the "cone of vision," predominant in theories of representation since the mid-1970s, is itself responsible for a reductive and simplistic equation of looking with objectification. In so far as this metaphor is drawn from physiological optics, it is inappropriate to the description of psychological functions. In so far as it is drawn from Euclidean geometry, it is inadequate to describe the changed apprehension of space which is an attribute of so-called "postmodern" culture.

I

Space has a history. In the cosmology of classical Greece, as F. M. Cornford writes, "the universe of being was finite and spherical, with no endless stretch of emptiness beyond. Space had the form of . . . a sphere with centre and circumference."[6] This classical space essentially survived the biblically derived "flat earth" of early Christian doctrine to re-emerge in the late Middle Ages. In medieval cosmology, supercelestial and celestial spheres encompassed, but did not touch, a terrestrial sphere—the scene of human action—in which every being, and each thing, had a place preordained by God and was subject to his omnivoyant gaze. Foucault has termed this medieval space the "space of emplacement," this space, he observes, was effectively destroyed by Galileo:

> For the real scandal of Galileo's work lay not so much in his discovery, or rediscovery, that the earth revolved around the sun, but

in his constitution of an infinite, and infinitely open space. In such a space the place of the Middle Ages turned out to be dissolved . . . starting with Galileo and the seventeenth century, extension was substituted for localisation.[7]

The vehicle of this changed cosmology was Euclidean geometry. Euclid wrote the *Elements of Geometry* around 300 B.C. Edmund Husserl, in *The Origin of Geometry*, supposes that this system arose out of practical activities, such as building. However, the classical conception of space seems to have been based upon visual evidence rather than technique— the horizon appears to encircle us, and the heavens appear to be vaulted above us.[8] In the Renaissance this conflict between observation and intellection, between hyperbolic and Euclidean space, was played out during the early stages of the invention of perspective. The absence of a necessary connection between knowledge of Euclidean geometry and the development of perspective is evident from the example of the Islamic world. In the West, the primacy of geometry over perception was stressed by St. Augustine, who wrote: "Reason advanced to the province of the eyes. . . . It found . . . that nothing which the eyes beheld, could in any way be compared with what the mind discerned. These distinct and separate realities it also reduced to a branch of learning, and called it geometry."[9]

Although dependent upon Euclid's *Elements of Geometry*, Renaissance perspective took its most fundamental concept from Euclid's *Optics*. The concept is that of the "cone of vision." Some two thousand years after Euclid, Filippo Brunelleschi conceives of this same cone as intersected by a plane surface—the picture plane. By means of this model, something of the premodern worldview passes into the Copernican universe—a universe that is no longer geocentric but is nevertheless homocentric and egocentric. A basic principle of Euclidean geometry is that space extends

infinitely in three dimensions. The effect of monocular perspective, how-
ever, is to maintain the idea that this space does nevertheless have a
center—the observer. By degrees the sovereign gaze is transferred from
God to Man. With the "emplacement" of the medieval world now
dissolved, this ocular subject of perspective, and of mercantile capitalism,
is free to pursue its entrepreneurial ambitions wherever trade winds blow.

Entrepreneurial humanism first took liberties with, then eventually
replaced, theocentric determinism according to a model that is implicitly
Aristotelian, and in a manner that exemplifies the way in which spatial
conceptions are projected into the representation of political relationships.
In Aristotle's cosmological physics it was assumed that the preponderance
of one or other of the four elements first posited by Empedocles (earth,
water, air, and fire) would determine the place of that body within a
continuum from the centre to the periphery of the universe. This con-
tinuum of actual and potential "places" constituted space. Analogously,
the idea that a human being will find his or her "natural" resting place
within the social space of differential privileges according to his or her
"inherent" qualities has remained a cornerstone of humanist-derived
political philosophies. Newton disengaged space per se from Aristotelian
"place,"[10] and Newtonian physics was in turn overtaken by the physics
of Einstein, in which, in the words of Hermann Minkowski, "space by
itself, and time by itself, are doomed to fade away into mere shadows,
and only a kind of union of the two will preserve an independent
reality."[11] More recently, the precepts of general relativity have them-
selves come into question in "quantum theory."[12] The cosmology of
modern physics has nevertheless had little impact on the commonly held
worldview in the West, which is still predominantly an amalgam of
Newton and Aristotle—"places in space," a system of centers of human
affairs (homes, workplaces, cities) deployed within a uniformly regular
and vaguely endless "space in itself."

In the modernist avant-garde in art, references to a mutation in the
apprehension of space and time brought about by modern physics and

mathematics are not unusual. Thus, for example, in 1925 El Lissitsky wrote: "Perspective bounded and enclosed space, but science has since brought about a fundamental revision. The rigidity of Euclidean space has been annihilated by Lobachevsky, Gauss, and Riemann."[13] Nevertheless, modernists more commonly ascribed a changed apprehension of space not to scientific concepts per se but rather to technology. Thus Dziga Vertov wrote: "I am the cinema-eye. I am a mechanical eye. I, a machine, can show you the world as only I can see it. . . . I ascend with aeroplanes, I fall and rise together with falling and rising bodies."[14] Constrained by mechanical metaphors, Russian futurism, like cubism, ultimately failed— notwithstanding El Lissitsky's pronouncement—to abandon Euclidian geometry. The mirror of perspectival representation was broken only in order that its fragments, each representing a distinct point of view, be reassembled according to classical geometric principles—to be returned, finally, to the frame and the proscenium arch.[15]

In the modern period, space was predominantly space traversed (by this token we judge that the prisoner has little of it). In the "postmodern" period, the speed with which space is traversed is no longer governed by the mechanical speed of machines such as airplanes, but rather by the electronic speed of machines such as computers and video links, which operate at nearly the speed of light. A mutation in technology therefore has, arguably, brought the technolog*ism* inherited from the spatial perceptions of modernist aesthetics into line with the perceptions of modern physics. Thus, for example, Paul Virilio writes that "technological space . . . is not a geographical space, but a space of time."[16] In this space-time of electronic communications, operating at the speed of light, we see things, he observes, "in a different light"—the "light of speed."[17] Moreover, this space seems to be moving, once again, toward self-enclosure. For example, David Bolter, a classics professor writing about computer programming, concludes, "In sum, electronic space has the feel of ancient geometric space."[18] One of the phenomenological effects of the public applications of new electronic technologies is to

cause space to be apprehended as "folding back" upon itself. Spaces once conceived of as separated, segregated, now overlap: live pictures from Voyager II, as it passes through the rings of Saturn, may appear on television sandwiched between equally "live" pictures of internal organs, transmitted by surgical probes, and footage from Soweto. A counterpart in the political sphere of the fold-over spaces of information technologies is terrorism. In the economic sphere it is the tendency of multinational capitalism to produce First World irruptions in Third World countries, while creating Second World pockets in the developed nations. To contemplate such phenomena is no longer to inhabit an imaginary space ordered by the subject-object "standoff" of Euclidean perspective. The analogies that fit best are now to be found in non-Euclidean geometries—the topologist's Möbius strip, for example, where the apparently opposing sides prove to be formed from a single continuous surface.

Space, then, has a history. It is not, as Kant would have it, the product of a priori, inherently Euclidean categories of mind. It is a product of representations. Premodern space is bounded; things within it are assigned a place along a predominantly vertical axis—"heaven-earth-hell," or the "chain of being" extending from God down to stones. Modern space (inaugurated in the Renaissance) is Euclidean, horizontal, infinitely extensible, and therefore, in principle, boundless. In the early modern period it is the space of the humanist subject in its mercantile entrepreneurial incarnation. In the late modern period it is the space of industrial capitalism, the space of an exponentially increased pace of dispersal, displacement and dissemination, of people and things. In the "postmodern" period it is the space of financial capitalism—the former space in the process of imploding, or "infolding"—to appropriate a Derridean term, it is a space in the process of "intravagination." Twenty years ago Guy Debord wrote about the unified space of capitalist production, "which is no longer bounded by external societies," the abstract space of the market which "had to destroy the autonomy and quality of places," and he

comments: "This society which eliminates geographical distance reproduces distance internally as spectacular separation."[19] Such "internal distance" is that of psychical space. Nevertheless, as I have already remarked, psychoanalytically inspired theories of representation have tended in recent years to remain faithful to the Euclidean geometrical-*optical* metaphors of the modern period.

II

At the head of her 1975 exposition of Jacques Lacan's concept of "The Imaginary,"[20] Jacqueline Rose places a quotation from Lacan's first seminar (1953–1954): "I cannot urge you too strongly to meditate on the science of optics . . . peculiar in that it attempts by means of instruments to produce that strange phenomenon known as images."[21] As already observed, 1975 was also the year of publication of Mulvey's essay "Visual Pleasure and Narrative Cinema," with its own emphasis on, in Mulvey's words, "the voyeuristic-scopophilic look that is a crucial part of traditional filmic pleasure." If we reread these two papers today we should read them in tandem, as the one is an essential, albeit somewhat contradictory, complement of the other. In terms of theories of visual representation (at least, in Britain and the United States) Mulvey's essay is, arguably, the single most influential article of the 1970s, and it is worth remembering the context in which it first appeared.[22] The observation that there is a fundamental difference between "classic" semiology, which reached its apogee in the mid-1960s, and semiotics since about 1970 has become a commonplace. The difference, which in principle affects not only semiotics but all theoretical disciplines, is that the classical subject-object dichotomy has been "deconstructed"—the interpreter is no longer outside the act of interpretation; the subject is now part of the object. As I have remarked, the metaphor of the "cone of vision," inherited from classical perspective, has been used to clarify this insight. If the theme of

"the look" dominated anglophone theories of film and photography during the 1970s, and entered theories of painting in the 1980s, it is perhaps because, apart from the urgent sexual-political questions it could address, the cone of vision metaphor also functioned as an aide-mémoire in a crucial epistemological break with Western tradition.

In the 1970s the cone of vision model was often conjoined with Lacan's concept of the "mirror stage." In Mulvey's essay, for example, Lacan's early geometric perspective version of "the imaginary" provides a model of cinematic "identification" in opposition to identification's own "mirror image"—scopophilic objectification. However, as Rose's article on "the imaginary" is at pains to point out, "It is precisely at the moment when those drives most relevant to the cinematic experience as such start to take precedence in the Lacanian schema [she refers to the scopic and invocatory drives] that the notion of an imaginary plenitude, or of an identification with a demand sufficient to its object, begins to be undermined."[23] On the one hand, the model of the cone of vision was valuable in reinstating the ideologically elided presence of the observer in the space of representation. On the other hand, it was complicit in preserving what was most central to the ideology it sought to subvert—that punctual ego that Lacan identifies, in his later extended critique of the geometric perspective model of vision, as assuming that it can "see itself seeing itself." That much of the point of the Lacanian critique of vision had been lost is nowhere better indicated than in the debates that followed Mulvey's influential paper, which so often revolved around the objection that Mulvey had said nothing about the position of the women in the audience.

We see here precisely what Rose identifies as the "confusion at the basis of an 'ego psychology,'" which is "to emphasise the relationship of the ego to *the perception-consciousness system* over and against its role as fabricator and fabrication, designed to preserve the subject's precarious pleasure from an impossible and non-compliant real" (my emphasis).[24] This confusion is supported and compounded by the cone of vision model.

Certainly, as already noted, the model incorporates the subject as an intrinsic part of the system of representation, insofar as the image projects its sightlines to an ideal point where that subject is supposed to be; nevertheless, the object in this case is quite clearly maintained as external to the subject, existing in a relation of "outside" to the subject's "inside." The object of psychoanalysis, the lost object, may thus easily be confused with some real object. As Rose indicates, it is precisely for this reason that Lacan subsequently abandons the geometric perspective model.

"The idea of another locality," writes Freud, in a famous phrase. "The idea of another space," adds Lacan, "another scene, the *between perception and consciousness*" (my emphasis).[25] Psychoanalysis reveals unconscious wishes—and the fantasies they engender—to be as immutable a force in our lives as any material circumstance. They do not, however, belong to material reality, but to what Freud termed "psychical reality." The space where they "take place"—"between perception and consciousness"—is not a material space. Insofar, therefore, as Freud speaks of "psychical reality," we are perhaps justified in speaking of "psychical space."[26] In the passage I have quoted, Barthes speaks of representation as taking place whenever the subject "cuts out the base of a triangle, his eye (or his mind) forming the apex." "His eye or his mind . . ."—clearly, Barthes conflates psychical space with the space of visual perception, which in turn is modeled on Euclid. But why should we suppose that the condensations and displacements of desire show any more regard for Euclidean geometry than they do for Aristotelian logic? Some of the peculiar spatial properties of the theater of desire are indicated by Freud in his paper "A Child Is Being Beaten."[27] Here the subject is positioned in the audience *and* on stage—where it is both aggressor *and* aggressed. The spatial qualities of the psychical mise-en-scène are clearly non-Euclidean: different objects may occupy the same space at the same (non)instant, as in condensation in dreams; or subject and object may collapse into each other. As Rose observes, what this paper most fundamentally reveals is "the splitting of

subjectivity in the process of being held to a sexual representation (male or female)."[28]

"Author, reader, spectator or voyeur," writes Barthes, identifying his subject of representation. All of these subjects desire, but none more *visibly* than the voyeur. In the chapter of *Being and Nothingness* which bears the title "The Look," and to which Lacan refers in his own extended discussion of the look as conceived in terms of geometric perspective, Sartre chooses to describe his "being-as-object for the Other" from the position of the voyeur: "Here I am, bent over the keyhole; suddenly I hear a footstep. I shudder as a wave of shame sweeps over me. Somebody has seen me. I straighten up. My eyes run over the deserted corridor. It was a false alarm. I breathe a sigh of relief." But, Sartre continues, if he now persists in his voyeuristic enterprise, "I shall feel my heart beat fast, and I shall detect the slightest noise, the slightest creaking of the stairs. Far from disappearing with my first alarm, the Other is present everywhere, below me, above me, in the neighboring rooms, and I continue to feel profoundly my being-for-others."[29] As Lacan puts it, "I am a picture" (just as "I" was God's picture in the medieval space of emplacement).

If Sartre had been less hostile to the concept of the unconscious he might not have excluded the condition of "being-for-others" from his relation to the object of his scopophilic interest. Maurice Merleau-Ponty's phenomenology moved toward a rapprochement with psychoanalysis (in a preface he contributed in 1960 to a book on Freud he spoke of a "consonance" between the two disciplines). Chapter 4 of Merleau-Ponty's final, unfinished work, *The Visible and the Invisible*, is titled "The Intertwining—The Chiasm." (*Chiasm*, an anatomical term for the crossing over of two physiological structures, is derived from a Greek root that means "to mark with a cross." A cross usually consists of one line placed "across" another, but it might also be perceived as two right angles—each the reflection of its inverse other, and only barely touching each other.

Appropriately, then, the same Greek root has also given us *chiasmus*—the rhetorical term for the trope of "mirroring.") The emphasis upon the alienation of subject and object, so often found in readings of Lacan's paper of 1936 on the mirror stage,[30] is absent from this essay by a man whose work so impressed Lacan (an essay in which we rediscover the "chiasm" in *chiasmus*). Merleau-Ponty writes:

> Since the seer is caught up in what he sees, it is still himself he sees: there is a fundamental narcissism of all vision. And thus, for the same reason, the vision he exercises, he also undergoes from the things, such that, as many painters have said, I feel myself looked at by the things, my activity is equally passivity—which is the second and more profound sense of the narcissism: not to see in the outside, as the others see it, the contour of a body one inhabits, but especially to be seen by the outside, to exist within it, to emigrate into it, to be seduced, captivated, alienated by the phantom, so that the seer and the visible reciprocate one another and we no longer know which sees and which is seen.[31]

Otto Fenichel begins his paper of 1935, "The Scoptophilic Instinct and Identification," by remarking on the ubiquity of references to the incorporative aspects of looking—for example folktales in which "the eye plays a double part. It is not only actively sadistic (the person gazing puts a spell on his victim) but also passively receptive (the person who looks is fascinated by that which he sees)."[32] He adds to this observation a reference to a book by Géza Róheim on "looking-glass magic"; the mirror, Fenichel observes, by confronting the subject with its own ego in external bodily form, obliterates "the dividing-line between ego and non-ego." We should remember that Lacan's paper on the mirror stage concerns a *dialectic* between alienation and identification, an identification not only with the self but also, by extension, with other beings of whom

the reflected image is a simulacrum—as in the early phenomenon of transitivism. Fenichel writes: "One looks at an object in order to *share in* its experience. . . . Anyone who desires to witness the sexual activities of a man and woman really always desires to share their experience by a process of empathy, generally in a homosexual sense, i.e. *by empathy in the experience of the partner of the opposite sex*" (my emphasis).[33]

As I have remarked, as far as is known, it never occurred to Euclid to intersect his cone of vision with a plane surface. This idea, which gave birth to perspective, is attributed to Brunelleschi, who gave a famous practical demonstration of his invention. Using his perspective system, Brunelleschi painted a picture of a church upon a panel. In order that the viewer see the image from the correct position—the true apex of the cone of vision—Brunelleschi made a small hole in the panel. The viewer, from a position behind the panel, looked through the hole into a mirror. What the viewer then saw was not himself or herself, nor the reversed image of the screen behind which he or she was concealed. What they saw was the church of Santo Giovanni de Firenze and the Piazza del Duomo.[34] In the description of a contemporary:

> He had made a hole in the panel on which there was this painting . . . which hole was as small as a lentil on the side of the painting, and on the back it opened out pyramidally, like a woman's straw hat, to the size of a ducat or a little more. And he wished the eye to be placed at the back, where it was large, by whoever had it to see . . . it seemed as if the real thing was seen: and I have had it in my hand, and I can give testimony.[35]

To my knowledge, and surprise, Lacan never spoke of Brunelleschi's experiment. But this hole in the panel, "like a woman's straw hat," is the same hole through which Norman Bates peers in Hitchcock's *Psycho*. Had we been able, there and then, to arrest this eye in the name of a moral certainty, we might have saved Janet Leigh. In reality there would have

been no choice. We should not, however, confuse police work with psychoanalysis, or with art criticism, or with art. It is a mistake to believe that the truth of psychological states may be derived from observable behavior. The cone of vision model, however, encourages precisely such misrecognitions. As Sarah Kofman writes in her book on the model of the camera obscura, "All these specular metaphors imply the same postulate: the existence of an originary sense . . . the 'real' and the 'true' pre-exist our knowledge of them."[36]

The model of the cone of vision in 1970s theory has both a positive and a negative aspect. On the positive side, it reinstates the subject in the space of representation; on the negative side, it maintains a subject-object dichotomy as a relation of inside/outside, underwriting that familiar confusion in which the psychical becomes a mere annex to the space of the social. Thanks to such positivism, certain critics pay lip service to psychoanalytic theory while speaking of scopophilia as if there were nothing more to say about it than that it is a morally reprehensible form of behavior of men.

Catherine Clément describes Lacan's "era of models" as falling into two distinct periods. The first was a time of points, lines, arrows, and symbols—two-dimensional representations. The second "began when he realised that two dimensions were not enough to make his audience understand the theory of the unconscious as he conceived of it: specifically, he wanted to show that the unconscious is a structure with neither an outside nor an inside."[37] To this second period belong the topological models—the torus, the Möbius strip, the Klein bottle—which "gave him the means to represent forms without insides or outsides, forms without boundaries or simple separations, forms of which a hole is a constitutive part."[38] Clément concludes that such geometrical models "merely complicated the exposition of his ideas." However, in the special case of the application of psychoanalytic theory to "visual" art, I believe this metamorphosis of models provides a necessary corrective to a too-easy confluence of psychoanalytic concepts with some familiar prejudices of

positivist-intuitionist art theory and criticism—a discourse too ready to collapse sexuality into gender, psychology into sociology, and too ready to take for granted precisely that sexual *difference* that psychoanalysis puts into question.

III

No space of representation without a subject, and no subject without a space it is not. No subject, therefore, without a boundary. This, of course, is precisely the import of the mirror stage: the founding Gestalt, the matrix within which the ego will take place. For Julia Kristeva, however, there is a necessary gesture anterior to this first formation of an uncertain frontier in the mirror stage, a prior demarcation of space. Insofar as geometry is a science of boundaries, and in a certain interpretation of Kristeva, we might say that the origin of geometry is in *abjection*.[39]

As a concept, the "abject" might fall into the gap between "subject" and "object." The abject, however, is in the history of the subject, prior to this dichotomy; it is the means by which the subject is first impelled toward the possibility of constituting itself as such—in an act of revulsion, of expulsion of that which can no longer be contained. Significantly, the first object of abjection is the pre-Oedipal mother—prefiguring that positioning of the woman in society which Kristeva locates, in the patriarchal scheme, as perpetually at the boundary, the borderline, the edge, the "outer limit"—the place where order shades into chaos, light into darkness. This peripheral and ambivalent position allocated to woman, says Kristeva, has led to that familiar division of the field of representations in which women are viewed as either saintly or demonic—according to whether they are seen as bringing the darkness, or as keeping it out. Certainly, in Kristeva's work, the "feminine"—in the wider sense she has given this term—is seen as marginalized by the symbolic, patriarchal order; but it is biological woman—the procreative body—that this order abjects. In *The Revolution of Poetic Language*, Kristeva writes:

"It is not the 'woman' in general who is refused all symbolic activity and all social representativity. . . . That which is . . . under the sign of interdiction is the reproductive woman, through whom the species does not stop at the 'imaginative producer' and his mother, but continues beyond, according to a natural and social law."[40] The woman's body, that is to say, reminds men of their own mortality. When Narcissus looks into this abjected pool, of milk and blood, he sees the pale form at the feet of Holbein's ambassadors. Thus in *Powers of Horror* Kristeva reiterates: "Fear of the archaic mother proves essentially to be a fear of her generative power. It is this power, dreaded, that patrilineal filiation is charged with subduing."[41] Thus, in the rites with which certain tribal peoples surround menstruation, Kristeva identifies a fear of what she calls the "power of pollution."[42]

There is an extraordinary passage in Plotinus in which this particular apparition of the abject is allowed to reveal itself in a discourse created precisely to conceal it.[43] Plotinus has been speaking of beauty, and he continues:

> But let us leave the arts and consider those works produced by Nature and admitted to be naturally beautiful which the creations of art are charged with imitating, all reasoning life and unreasoning things alike, but especially the consummate among them, where the moulder and maker has subdued the material and given the form he desired. Now what is the beauty here? *It has nothing to do with the blood or the menstrual process:* either there is also a colour and form apart from all this or there is nothing unless sheer ugliness or (at best) a bare recipient, as it were the mere Matter of beauty. . . . Whence shone forth the beauty of Helen, battle-sought; or of all those women like in loveliness to Aphrodite; or of Aphrodite herself; or of any human being that has been perfect in beauty; or of any of these gods manifest to sight, or unseen but carrying what would be beauty if we saw? [my emphasis].[44]

Plotinus's Platonic answer to his own question is, of course, the "Idea." What is abjected here—distanced by that trope of *accumulation*, that wave of perfect beings which carries the speaker away—is the body itself, as the mere "matter" of beauty. The abjected matter of which Kristeva speaks, from fingernail clippings to feces—all that which we must shed, and from which we must distance ourselves, in order to be (in order, as we say, to "clear a space for ourselves"). "It has nothing to do with . . . ," writes Plotinus, using a device similar to that which classical rhetoric named "preterition," but which must wait another fifteen hundred years for Freud to conceptualize as "negation"—for, of course, it has everything to do with Plotinus's desire. We have only to view the abject from a certain angle to see a category that might have been known to Plotinus, from a text by Longinus—the "sublime." Thus, in its eighteenth-century incarnation, at the edge of Romanticism, in Anthony Shaftesbury: "the rude rocks, the mossy caverns, the irregular unwrought grottos and broken falls of waters, with all the horrid graces of the wilderness itself . . . these solitary places . . . beauties which strike a sort of melancholy."[45] For all the discussions recently devoted to the sublime, I still see in it a simple displacement, a banal metaphorical transference of affect from the woman's body to these caverns and chasms, falls and oceans, which inspire such fervant ambivalence, such a swooning of identity, in these Romantic men.

"Beauties which strike a sort of melancholy"—in *Soleil Noir,* Julia Kristeva shows me the path that leads from beauty to an object I have lost, or which has abandoned me;[46] I also know that depression may be the mask that anger wears—the concept of the sublime may be the sublimation of a more violent fear. Adopting the voice of the facism he describes, here is Klaus Theweleit in *Male Fantasies:*

> If that stream reaches me, touches me, spills over me, then I will dissolve, sink, explode with nausea, disintegrate in fear, turn horrified into slime that will suffocate me, a pulp that will swallow me like

quicksand. *I'll be in a state where everything is the same, inextricably mixed together* [my emphasis].[47]

It proves, finally, to be not woman *as such* who is abjected, but rather woman as privileged signifier of that which man both fears and desires: the extinction of identity itself. In the terms of the thermodynamic model that informs Freud's concept of the death drive, what is feared is the "entropy" at work at the heart of all organization, all differentiation. In religious terms, it is the indifferent "dust" to which we must all return. The transient matter of the woman's body however is doubly abjected, in that it is chronically organized to remind us of our common condition as brief events in the life of the species. By this same token, however, the woman also signifies precisely that desired "state where everything is the same": the pre-Oedipal bliss of the fusion of bodies in which infant and mother are "inextricably mixed"; that absence of the pain of differing, condition of identity and meaning, whose extinction is deferred until death.

IV

Apropos of looking, Sartre writes: "It appears that the world has a sort of drain hole in the middle of its being and that it is perpetually flowing off through this hole."[48] It is perhaps this same intimation of loss in the register of the visual which the quattrocento defended itself against by fetishistically turning the intuition into a system: "perspective"—built not only upon a founding subject, the "point of view," but also upon the disappearance of all things in the "vanishing point." Previously, there was no *sign* of absence—the *horror vacui* was central to Aristotelianism. In classical cosmologies, space was a plenum. Similarly, in the medieval world, God's creation was a fullness without gap. In quattrocento perspective the subject first confronts an absence in the field of vision, but

an absence disavowed: the vanishing point is not an integral part of the space of representation; situated on the horizon, it is perpetually pushed ahead as the subject expands its own boundary. The void remains abjected. In later, non-Euclidean geometry we find the spherical plenum of classical cosmologies collapsed upon itself to enfold a central void. For Lacan, this figure, the "torus," can represent a psychical space in which the subject repetitively comes into being, in a procession that circumscribes a central void—locus of the lost object, and of the subject's death.

Much has been made of the insecurity of the "postmodern condition" and of its attendant "crisis of representation." There is nothing new in insecurity; it is the very condition of subjectivity, just as it is the condition of representation to be in crisis. This is not to say, however, that nothing changes. I have argued that our space has changed, and that our optical models for negotiating it are now out of their time. In "Women's Time" Kristeva describes a mutation of space, a new "generation" of "corporeal and desiring mental space," in which "the very dichotomy man/woman as an opposition between two rival entities may be understood as belonging to metaphysics." She asks, "What can 'identity,' even 'sexual identity,' mean in a new theoretical and scientific space where the very notion of identity is challenged?"[49]

In this changed space, this new geometry, the abject can no longer be banished beyond some charmed, perfectly Euclidean circle. The postmodern space of our "changing places" can now barely accommodate the old ghettos, which are going the way of the walled city-state. Perhaps we are again at a moment in history when we need to define the changing geometries of our changing places. I do not believe that it is a time when an art/theory that thinks of itself as "political" should admonish, or exhort, or proffer "solutions." I believe it is a time when it should simply describe. Perhaps it is again, in this time of postindustrial revolution, the moment for a realist project. It cannot, of course, be what it was at the time of Gustave Courbet, or even of Bertolt Brecht. Attention to psychical reality calls for a *psychical realism*—impossible, but nevertheless . . .

Fifteen years ago, in her groundbreaking essay "Visual Pleasure and Narrative Cinema,"[1] Laura Mulvey used Freud's paper on "Fetishism" to analyze "the voyeuristic-scopophilic look that is a crucial part of traditional filmic pleasure." Today the influence of Mulvey's essay on the critical theory of the image has not diminished, but in the realm of photography theory it has not evolved.[2] Idealized, preserved in the form in which it first emerged, Mulvey's argument has itself been fetishized. Fetishized, which is to say *reduced*. Mulvey broke the ground for a psychoanalytically informed theory of a certain type of image. Many of Mulvey's followers have since shifted the ground from psychoanalysis to sociology, while nevertheless retaining a psychoanalytic terminology. In the resulting confusion, sexuality has been equated with gender, and gender has been collapsed into class. It has now become familiar to hear the authority of Mulvey's essay invoked to equate a putative "masculine gaze" with "objectification." Here, in a caricature of the psychoanalytic theory on which Mulvey based her argument, "scopophilia" is defined as a relation of domination-subordination between unproblematically constituted male and female subjects, and "objectification" is named only in order to be denounced. In his preface to the 1970 edition of *Mythologies*, Roland Barthes wrote of "the necessary conjunction of these two enterprises: no denunciation without an appropriate method of detailed analysis, no semiology which cannot, in the last analysis, be acknowledged as *semioclasm*." Mulvey's essay is exemplary in the way it holds these "two enterprises" in balance. If I "depart" from

Mulvey's essay now it is not in order to criticize it, I learned much from it and still agree with most of what she says; it is rather to travel further in the direction it first indicated, toward a psychoanalytic consideration of unconscious investments in looking. The route I have chosen is by way of a photograph by Helmut Newton, as Newton is a photographer whose work so conspicuously attracts denunciation, and so clearly lends itself to Mulvey's analysis.

NEWTON'S PHOTOGRAPH

We know that Newton's photograph *Self-Portrait with Wife June and Models*, Vogue studio, Paris 1981,[3] had its immediate origin in a chance encounter. In an interview with Newton, Carol Squiers asks: "One of your self-portraits shows you wearing a trench coat with a nude model, and your wife sitting off to one side. Does your wife sit in on photo sessions?" Newton replies: "Never. Ever. She had just come by for lunch that day."[4] In describing Newton's picture I shall recapitulate a certain history of semiology, that most closely associated with Barthes, which sets the stage for the introduction of the subject of representation into critical theory of the image in the early 1970s. That is to say I shall reconstruct the prehistory of Mulvey's introduction of psychoanalytic theory into a field of analysis dominated by linguistic models: models whose implicit spaces are classical, ordered according to binary logics—from the level of the phoneme to that of rhetoric—along the Cartesian coordinates of syntagm and paradigm. I shall begin with what we can actually see in this image. We see at the left the model's back and, in the center of the frame, her frontal reflection in a mirror. Newton's reflection, similarly full length, fits the space beneath the model's reflected elbow. The photographer is wearing a raincoat, and his face is hidden as he bends over the viewfinder of his Rolleiflex camera. The photographer's wife, June, sits just to the right of the mirror, cross-legged in a director's chair. Her left elbow is

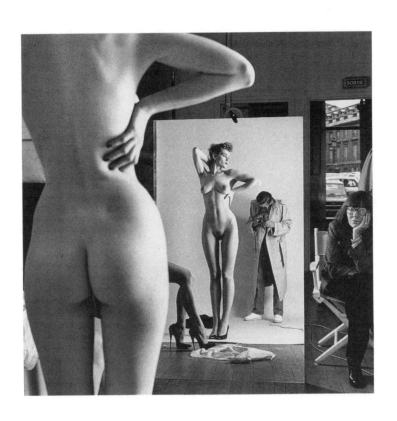

propped on her left knee, her chin is propped on her left hand, her right hand makes a fist. These are the elements of the picture which are most likely to come immediately to our attention. In addition, reflected in the mirror, we can see a pair of legs with very high-heeled shoes, whose otherwise invisible owner we assume to be seated. We also see, behind the figure of June, an open door through which we glimpse an exterior space—a city street, or square, with automobiles. Finally, we may notice a number of subsidiary elements: at the center, what appear to be items of clothing discarded on the floor; at the extreme right, other items of clothing on hangers; above the open door, the sign *"sortie"*; and so on.[5] This initial description concerns what is least likely to be contested about this image, what classic semiotics would call its "denotations."

We may now consider what this same early semiotics called the "connotations" of the image, meanings that we may also take in "at a glance" but which are more obviously derived from a broader cultural context beyond the frame of the image.[6] We may additionally consider the rhetorical forms in which the "signifiers of connotation" are organized. The image of the model reflected in the mirror is the very iconogram of "full frontal nudity": an expression, and an indeterminate mental image, which entered popular memory in the 1960s from discussions in the media about "sexual freedom" in cinema and the theater. The model's pose is drawn from an equally familiar, and even older, paradigm of "pinup" photographs. The cliché position of the model's arms serves the anatomical function of lifting and leveling her breasts, satisfying the otherwise contradictory demand of the "pinup" that the woman's breasts should be both large and high. The lower part of the model's body is similarly braced for display by means of the black and shiny high-heeled shoes. These shoes exceed their anatomical function of producing muscular tension in the model; they are drawn from a conventional repertoire of "erotic" items of dress. This reference is emphasized by "repetition" in the shoes on the disembodied legs that appear to the left of the main

figure, where the evenly spaced "side-elevation" depiction of the excessively elevated heels (another repetition) diagrams the primacy of erotic meaning over function (these shoes were not made for walking). The shoes encourage an understanding of the model as "naked" rather than "nude," which is to say they gesture toward scenarios of sexuality rather than of "sublimation" (for example, the high-minded artist's "disinterested" aesthetic contemplation of the female form). The sexual connotation is further anchored[7] by the apparently "hastily discarded" garments at her feet.[8]

The figures of repetition in this photograph, and there are others, are articulated as subsidiary tropes within an overall structure of antithesis. The antithesis "naked"/"clothed" divides the picture plane along its vertical axis. By contrast with the model, who thereby appears all the more naked, Newton is absurdly overdressed. The model's nakedness is moreover already amplified by being monumentally doubled and presented from both front and back. Newton's pole of the "naked"/"clothed" antithesis is itself augmented by repetition in the jacketed and booted figure of June. There are further such rhetorical structures to be identified in this image; to enumerate them all would be tedious, it is enough to note that the apparent strength of many images derives from our "intuitive" recognition of such structures. Perhaps one more is worthy of comment, if only in passing. The discarded garments in the mirror set up a subsidiary "combined figure" of chiasmus ("mirroring") and antithesis about the axis established where the background paper meets the studio floor: a dark garment on a light ground, a light garment on a dark ground (the areas and shapes involved being roughly analogous). This reinforces my tendency, otherwise not strong, to read the two pairs of models' legs in terms of the opposition "light"/"dark"; it encourages the idea that the woman I can only partially see may be Black. Here, clearly, I am at the periphery of the range of meanings in respect of which I may reasonably expect to meet a consensus agreement. To return to things on which we are more

likely to agree I shall close my list of connotations and the forms of their organization by commenting on the raincoat that Newton wears. In a sexual context, and this image is indisputably sexual, the raincoat connotes those "men in dirty raincoats" who in the popular imagination frequent the back rooms of "sex shops." In this same context the raincoat is also the favored dress of the male exhibitionist, the "flasher."

It is not normal for the photographer to exhibit himself, as Newton does here. The mirror is there so the model can see *herself*, and thus have some idea of the form in which her appearance will register on the film. Normally, the photographer would have his back to the mirror, remaining outside the space of the image. Here, however, Newton has colonized the desert island of backdrop paper that is usually the model's sovereign possession in the space of the studio. He has invaded the model's territory, the domain of the visible. From this position, he now receives the same look he gives. The raincoat is Newton's joke at his own expense, he exhibits himself to his wife, and to us, as a voyeur. In his interview with Squiers, Newton says, "I am a voyeur! . . . If a photographer says he is not a voyeur, he is an idiot!" In *Three Essays on the Theory of Sexuality*, Freud remarks, "Every active perversion is . . . accompanied by its passive counterpart: anyone who is an exhibitionist in his unconscious is at the same time a *voyeur*."[9] The photographer—a flasher, making an exposure—is here explicitly both voyeur *and* exhibitionist. His raincoat opens at the front to form a dark delta from which has sprung this tensely erect and gleamingly naked form. The photographer has flashed his prick, and it turns out to be a woman. Where am I in all this? In the same place as Newton—caught looking. At this point in my description I have caught myself out in precisely the position of culpability to which Mulvey's paper allocates me—that of the voyeur certainly, but also that of the *fetishist*. The provision of a substitute penis for the one the woman "lacks" is what motivates fetishism. The fetish allays the castration anxiety that results from the little boy's discovery that his mother, believed to lack nothing,

has no penis. Mulvey writes, "The male unconscious has two avenues of escape from this castration anxiety: preoccupation with the re-enactment of the original trauma (investigating the woman, demystifying her mystery) . . . or else complete disavowal of castration by the substitution of a fetish object or turning the represented figure itself into a fetish. . . . This second avenue, fetishistic scopophilia, builds up the physical beauty of the object, transforming it into something satisfying in itself."[10] If it is clearly the "second avenue" we are looking down in this picture we must nevertheless acknowledge that it runs parallel with the "first." For who else wears a raincoat? A detective—like the one who, in all those old B-movies, investigates the dangerously mysterious young woman. Following her, watching her until, inevitably, the *femme* proves *fatale*.

Caught looking, I (male spectator) must now suspect that I am only talking about this picture at such length in order to be allowed to *continue* looking. I remember one such instance of invested prevarication from my childhood. I was perhaps seven years old and accompanying my mother on one of her periodic trips to visit my grandmother. The tramcar we rode stopped outside a music hall; it was here that we dismounted to continue on foot. On this occasion, the only one I remember, the theater was advertising its two main current attractions. One was a strong-man and escape artist. The heavy chains and manacles of his trade were on public exhibition in front of the theater, in a glass-topped display case. On the wall behind this manly apparatus, and also under glass, were photographs of the theater's other main attraction—a striptease artist. I remember assuming an intense interest in the chains, regaling my mother with a barrage of questions and observations designed to keep her from moving on, while all the time sneaking furtive and guilty glances at the pictures of the half-naked woman. I could tell from my mother's terse replies that she knew what I was up to and I allowed myself to be tugged away, the sudden inexplicable excitement of the moment giving way to a terrible shame. The structure of that recollected space now maps itself onto the

space of Newton's picture. I become the diminutive figure of Helmut, myself as child. June's lips, which I now interpret as tense with disapproval, are about to speak the words that will drag me away . . . but from what? If I was seven years old then the year was 1948, the same year Robert Doisneau made his photograph *Un regard oblique*, which shows a middle-aged couple looking into the window of a picture dealer, the man's slyly insistent gaze on a painting of a semi-naked young woman. Whatever we may suppose to have been on the mind of Doisneau's "dirty old man" it is unlikely to have been within the repertoire of my own childish imaginings. For psychoanalysis however *consciousness* is not at issue. There would be no objection in psychoanalytic theory to seeing this "innocent" child of the latency period as caught on the same hook as Doisneau's adult; but neither is there any justification in psychoanalysis to reducing what is at stake here to a simple formula, whether it be the structure of fetishism or whatever else. We cannot tell what is going on in the look simply by looking at it.

Newton has made an indiscernible movement of the tip of one finger. The shutter has opened and paused. In this pause the strobe has fired, sounding as if someone had clapped their hands together, once, very loud. The light has struck a square of emulsion. Out in the street a driver in a stationary car has perhaps glimpsed, illuminated in this flash of interior lightning, the figure of a naked woman. Perhaps not. In his book *Nadja*, André Breton confesses, "I have always, beyond belief, hoped to meet, at night and in a woods, a beautiful naked woman or rather, since such a wish once expressed means nothing, I regret, beyond belief, not having met her." He then recalls the occasion when, "in the side aisles of the 'Electric Palace,' a naked woman . . . strolled, dead white, from row to row"—an occurrence, however, he admits was quite unextraordinary, "since this section of the 'Electric' was the most commonplace sort of illicit sexual rendezvous."[11] The final issue of *La révolution surréaliste* contains the well-known image in which passport-type photographs of the sur-

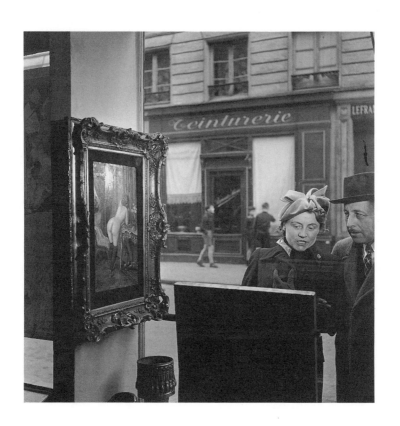

realist group, each with his eyes closed, frame a painting by Magritte. The painting shows a full-length nude female figure in the place of the "missing word" in the painted sentence, *'je ne vois pas la . . . cachée dans la forêt.'*[12] In looking there is always something that is not seen, not because it is perceived as missing—as is the case in fetishism—but because it does not belong to the visible.

OPTICAL SPACE, PSYCHICAL SPACE

Ironically, the reduction of looking to the visible, and to the register "objectification-exploitation," was inadvertently encouraged by the very "return to Freud," initiated by Jacques Lacan, to which Mulvey's paper contributed. In his first seminar, Lacan had urged that we "meditate on the science of optics."[13] In an essay of 1987 I commented that it was precisely the model of the "cone of vision," derived from Euclidean optics, which had provided the common metaphor through which emerging psychoanalytic theories of representation could be conflated with extant Marxian theories of ideology, eventually leading to the "Foucauldianization" of psychoanalytic theory in much recent work on the image. In 1973 Barthes had written, "There will still be representation for so long as a subject (author, reader, spectator or voyeur) casts his gaze towards a horizon on which he cuts out the base of a triangle, his eye (or his mind) forming the apex."[14] As I noted in my article: "Barthes's optical triangle is . . . one-half of the diagram of the camera obscura—a metaphor not unfamiliar to students of Marx." Furthermore, Mulvey's essay was published in 1975, the same year as Michel Foucault's book *Discipline and Punish*.[15] As I further noted, "Barthes's 'eye at the apex' [the eye of Mulvey's male spectator] was therefore easily conflated with that of the jailor, actual or virtual, in the tower at the centre of the panopticon [which] contributed to the survival of that strand of theory according to which ideology is an instrument of domination wielded by one section of a

society and imposed upon another."[16] I especially noted that what Barthes situates, indifferently, at the apex of his representational triangle is the subject's "eye or his mind." Here, I commented, "Barthes conflates psychical space with the space of visual perception, which in turn is modelled on Euclid. But why should we suppose that the condensations and displacements of desire show any more regard for Euclidean geometry than they do for Aristotelian logic?"[17] The attraction of the cone of vision model for a critical theory of visual representations is the explicit place it allocates to the subject as an inherent part of the system of representation. The major disadvantage of the model is that it maintains the object as external to the subject, existing in an untroubled relation of "outside" to the subject's "inside." As I observed, the predominance of the optical model has encouraged the confusion of real space with psychical space, the confusion of the psychoanalytic object with the real object.

I have noted that Mulvey's use of Freud's 1927 paper on "Fetishism" has in turn been used to put a psychoanalytic frame around a nonpsychoanalytic notion of "objectification," one derived from a Marxian idea of commodification—the woman packaged as object for sale. What has been repressed in the resulting version of "scopophilia" is that which is most central to psychoanalysis: the unconscious, and therefore any acknowledgment of the active-passive duality of the drives to which Freud refers in his remark on the unconscious counterpart of exhibitionism. There is no objectification without identification. Otto Fenichel begins his paper of 1935, "The Scoptophilic Instinct and Identification," by remarking on the ubiquity of references to the incorporative aspects of looking— for example folktales in which "the eye plays a double part. It is not only actively sadistic (the person gazing puts a spell on his victim) but also passively receptive (the person who looks is fascinated by that which he sees)."[18] He adds to this observation a reference to a book by Géza Róheim on "looking-glass magic"; the mirror, Fenichel observes, by confronting the subject with its own ego in external bodily form,

obliterates "the dividing-line between ego and non-ego." We should remember that Lacan's paper on the mirror stage, also invoked in Mulvey's paper, concerns a *dialectic* between alienation and identification, an identification not only with the ideal self but also, by extension, with other beings of whom the reflected image is a simulacrum—as in the early phenomenon of transitivism. Fenichel writes: "One looks at an object in order to *share in* its experience. . . . Anyone who desires to witness the sexual activities of a man and woman really always desires to share their experience by a process of empathy, generally in a homosexual sense, i.e. *by empathy in the experience of the partner of the opposite sex*" (my emphasis).[19]

THE OBJECT OF "OBJECTIFICATION"

The concept of "empathy" which Fenichel invokes here is not yet, in itself, psychoanalytic. To make psychoanalytic sense of the dialectic of objectification-identification to which he refers we need a psychoanalytic definition of the object. In Freud's description, the "object" is first the object of the *drive*—a drive whose "source" is in a bodily excitation, whose "aim" is to eliminate the consequent state of tension and whose "object" is the more or less contingent agency by which the reduction of tension is achieved. In Freud's succinct definition: "The object of an instinct is the thing in regard to which or through which the instinct is able to achieve its aim."[20] The original object is not sexual, it is an object of the self-preservative instinct alone. The neonate must suckle in order to live. The source of the self-preservative drive here is hunger, the object is the milk, and the aim is ingestion. However, ingestion of milk and excitation of the sensitive mucus membranes of the mouth are inseparable events. Fed to somatic satisfaction, and after the breast has been removed, the infant may nevertheless continue to suck. Here the act of sucking, functionally associated with the ingestion of food, becomes enjoyed as

"sensual sucking," a pleasure in its own right. In this description, sexuality emerges in a "peeling away" from the self-preservative drive in the process known as "anaclisis" or "propping."[21] Insofar as the somatic experience of satisfaction survives, it does so as a constellation of visual, tactile, kinaesthetic, auditory, and olfactory memory-traces. This complex of mnemic elements now comes to play the part, in respect of the sexual drive, which the milk played in regard to the self-preservative drive. This is to say there has been a metonymical displacement from "milk" to "breast" and a metaphorical shift from "ingestion" to "incorporation." The object termed "breast" here does not correspond to the anatomical organ but is fantasmatic in nature and internal to the subject; this is in no way to reduce its material significance. In his book, *The First Year of Life*, René Spitz describes the primacy of the oral phase in human development. He writes, "all perception begins in the oral cavity, which serves as the primeval bridge from inner reception to external perception."[22] In this context, Jean Laplanche stresses that:

> The *object* . . . this breast is not only a symbol. There is a sort of coalescence of the breast and the erogenous zone . . . the breast inhabits the lips or the buccal cavity . . . Similarly the aim . . . undergoes a radical change. With the passage to incorporation, suddenly something new emerges: the permutability of the aim; we pass from "ingest" not to "incorporate" but to the couple "incorporate/be-incorporated" . . . in this movement of metaphorisation of the aim, the subject (the carrier of the action) suddenly (I do not say "disappears," but) loses its place: is it on the side this time of that which eats, or the side of that which is eaten?[23]

This ambivalence, then, marks sexuality from the very moment it emerges *as such*, "the moment when sexuality, disengaged from any natural object, moves into the field of fantasy *and by that very fact becomes sexuality*" (my

emphasis).[24] We cannot therefore posit a simple parallelism: on the one hand need, directed toward an object; on the other hand desire, directed toward a fantasy object. As Laplanche and Jean-Bertrand Pontalis put it, fantasy "is not the object of desire but its setting. In fantasy the subject does not pursue the object or its sign: he appears caught up himself in the sequence of images."[25] Thus Laplanche writes:

> The signs accompanying satisfaction (the breast accompanying the offering of nursing milk) will henceforth take on the value of a fixed arrangement, and it is that arrangement, a fantasy as yet limited to several barely elaborated elements, that will be repeated on the occasion of a subsequent appearance of need . . . with the appearance of an internal excitation, the fantastic arrangement—of several representative elements linked together in a short scene, an extremely rudimentary scene, ultimately composed of partial (or "component") objects and not whole objects: for example, a breast, a mouth, a movement of a mouth seizing a breast—will be revived.[26]

Thus, "at the level of sexuality . . . the object cannot be grasped separately from the fantasy within which it is inserted, the breast cannot be grasped outside of the process of incorporation-projection where it functions."[27]

I have been speaking of infantile autoerotism, in which polymorphous "component instincts" (oral, anal, phallic) seek satisfaction on sites ("erotogenic zones") of a neonate body experienced only as a fragmentary constellation of such sites. In Freud's account of the subsequent development of sexuality, the passage from infantile autoerotism to adult object-choice is described as routed by way of narcissism. The phase of "narcissism," as the term suggests, coincides with the emergence of a sense of a coherent ego (a "body-ego") through the agency of an internalized self-representation: the newly unified drive now takes as its object the child's own body *as a totality*. In adult "object-choice" an

analogously whole *other* person is taken as particular love-object, within the parameters of a general *type* of object-choice (heterosexual, homosexual; anaclitic, narcissistic). By this point, Freud seems to have offered contradictory descriptions of the object: on the one hand, initially, the object is that which is most contingent to the drive; on the other, later, it is that which "exerts the sexual attraction." As Laplanche comments: "If the object is at the origin of sexual attraction, there is no place for thinking of it as contingent, but on the contrary that it is narrowly determined, even determining, for each of us." In response, Laplanche proposes the notion of the *source-object* of the drive: "The source being defined here as a point of excitation implanted in the organism as would be a foreign body."[28] He sees the example of the internal breast as the prototype of such a source-object. By way of illustration, he suggests the analogy of the scientific experiment in which an electrode, implanted in the brain of an animal, is capable of being stimulated by a radio signal.[29]

I have not yet mentioned the place of vision in all this. In Freud's thought a wide range of distinct forms of behavior are seen as deriving from a small number of component drives. The sexually invested drive to *see* however is not reduced to any such component instinct, it rather takes its own independent place alongside them. The physiological activity of seeing clearly presents itself as self-preservative in function. The sexualization of vision therefore comes about in the same process of "propping" of the libido on function as has already been described. Freud refers to looking as analogous to *touching*, Laplanche writes:

> Imagine . . . the horns of a snail which would be moving with a sort of going-out and coming-in motion; in fact, precisely, the horns of the snail carry eyes. There we have the image of what Freud means in relating vision to exploratory groping [*tâtonnement*], and in comparing it to a collecting of samples [*prise d'échantillons*] in the exterior world. Thus the non-sexual activity of looking, in the movement of

propping, becomes the drive to see in the moment when it becomes *representative*, that is to say the interiorization of a scene. I recall the primacy of vision in the theory of the dream, but equally in the theory of the unconscious, for that which Freud calls thing-presentations, the very substance of the unconscious, are for a large part conceived of on the model of visual representation.[30]

It has been observed that the scopic drive is the only drive that must keep its objects at a distance. This observation implies a definition of the object that is more bound to physical reality than psychoanalysis can ever afford to be. Certainly the look puts out its exploratory, or aggressive "shoots" (in Lacan's expression) but it equally clearly also takes in objects, from physical space into psychical space—just as surely as it projects unconscious objects into the real.

ENIGMATIC SIGNIFIERS, PERVERSE SPACE

Freud describes infantile sexuality, the common basis of the sexuality of us all, as "polymorphously perverse." Formed in the paths of the vicissitudes of the drives all human sexuality is deviant. Nothing about it belongs to anything that could be described as a "natural" instinctual process. In the natural world instinctual behavior is hereditary, predictable and invariant in any member of a given species. In the human animal what might once have been instinct now lives only in shifting networks of symbolic forms, from social laws to image systems: those we inhabit in our increasingly "media-intensive" environment, and those that inhabit us—in our memories, fantasies, and unconscious formations. Human sexuality is not natural, it is cultural. Freud inherited comprehensive data on "sexual perversions" from nineteenth-century sexologists, such as Richard von Krafft-Ebing and Havelock Ellis, who view

the behaviors they cataloged as deviations from "normal" sexuality. Freud however was struck by the ubiquity of such "deviations"— whether in dramatically pronounced form or in the most subdued of ordinary "foreplay." It was Freud who remarked that that mingling of entrances to the digestive tract we call "kissing" is hardly the most direct route to reproductive genital union. In his *Three Essays on the Theory of Sexuality* of 1905 he observes, "The disposition to perversions is itself of no great rarity but must form a part of what passes as the normal constitution."[31] In opposition to the sexologists, who took socially accepted "normal" sexuality as inherent to human nature, Freud states that "from the point of view of psychoanalysis the exclusive sexual interest felt by men for women is also a problem that needs elucidating and is not a self-evident fact."[32] Sexuality in psychoanalysis is not to be reduced to the biological function of perpetuation of the species; as Laplanche emphasizes, "The currency of physical reality is not in use in psychoanalysis which is simply not concerned with the domain of adaptation or biological life."[33] If the word *perversion* still has an air of disapprobation about it today this is not the fault of psychoanalytic theory; it is due to the sense it takes in relation to social law, written or not. Considered in its relation to social law we might ask whether fetishism should really be considered a perversion, at least in that most ubiquitous nonclinical form accurately described by Mulvey: that idealization of the woman in the phallocratic Imaginary that is precisely the inverted image of her denigration in the Symbolic.[34] The Symbolic however is not seamless. For the Symbolic to be seamless, repression would have to be totally effective. If repression were totally effective we would have no return of the repressed, no symptom, and no psychoanalytic theory. As an expression of the overvaluation of the phallic metaphor in patriarchy, the fetishistic component of Newton's photograph is perfectly normal—but only when we fetishize it, only when we isolate it from the space within which it is situated.

The space of Newton's photograph is not normal. The only clear thing about this picture is the familiar "pinup" pose of the model. According to the conventions of the genre we would expect to see *only* the model— isolated against the seamless background paper, cut off from any context by the frame of the image. Such a familiar space is alluded to in the rectangle of the mirror, which approximates the familiar 2:3 ratio of a 35mm shot. But the isolating function of the framing edge has failed here, and it is precisely *this* function that a fetishistic relation to the image would demand. Elements that are normally excluded, including the photographer himself, have tumbled into the space framed by the mirror. This space is in turn set within a larger context of other elements that would normally be considered out of place. The resulting jumble is counterproductive to fetishism. Where fetishism demands coherence, for this is its very founding principle, this image has a different productivity; it functions as a mise-en-scène, a staging, of the fundamental incoherence of sexuality: its heterogeneity, its lack of singularity, its lack of focus. Commenting on Freud's *Three Essays on the Theory of Sexuality*, Laplanche writes:

> The whole point is to show that human beings have lost their instincts, especially their sexual instinct and, more specifically still, their instinct to reproduce. . . . With its descriptions of the sexual aberrations or perversions . . . the text is an eloquent argument in favour of the view that drives and forms of behaviour are plastic, mobile and interchangeable. Above all, it foregrounds their . . . vicariousness, the ability of one drive to take the place of another, and the possibility of a perverse drive taking the place of a non-perverse drive, or vice versa.[35]

In this photograph, as with the drives, there is much mobility: Helmut Newton stands in the model's space; June Newton occupies Helmut's place. Things are started—like the pair of disembodied legs—which are

brought to no particular conclusion and are of indeterminate significance. The looks that are given by the protagonists neither meet nor converge, and they add up to nothing in particular. June is positioned as voyeur at a piece of sexual theater. Helmut is both voyeur and exhibitionist; a familiar form of denunciation of this image would simply assume that the model is the victim of a sadistic attack, a casualty of an economy to which "sexploitation" is central, but we might equally suspect a perverse component of exhibitionism in her being there to be looked at—an exhibitionism likely to provoke a mixture of desire, envy, and hostility in male and female viewers alike. At first glance it might seem that the viewer of this image is invited to focus unswervingly on this central figure of the model, reduced to a visual cliché with no more ambiguity than a target in a shooting gallery. But the very banality of this central motif encourages the displacement of our attention elsewhere, but where? Nowhere in particular. In the space of events in which this vignette is situated nothing is fixed, everything is mobile, there is no particular aim; it is a perverse space.

For the human animal, sexuality is not an urge to be obeyed so much as it is an enigma to unravel. Laplanche has identified the early and inescapable encounter of the subject with "primal seduction," the term he gives to "that fundamental situation where the adult presents the infant with signifiers, non-verbal as well as verbal, and even behavioural, impregnated with unconscious sexual significations."[36] It is these that Laplanche calls "enigmatic signifiers": the child senses that such signifiers are addressed to it, and yet has no means of understanding their meaning; its attempts at mastery of the enigma, at symbolization, provoke anxiety and leave unconscious residues. Such estrangement in the libidinal relation with the object is an inescapable condition of entry into the adult world, and we may expect to find its trace in any subsequent relation with the object, even the most "normal." It is this trace of the encounter with the enigma of sexuality that is inscribed in Newton's picture. Reference to

fetishism alone cannot explain why this picture looks the way it does. The concept of fetishism makes the whole question a purely genital matter. In a book on the erotic imagery of classical Greece and Rome, Catherine Johns remarks: "The vulva is rarely seen: its situation makes it invisible in any normal position even to its owner."[37] It is in this purely relative "nothing to see" that the male fetishist sees the woman's sex only in terms of an absence, a "lack." All men are fetishists to some degree, but few of them are full-blown clinical fetishists. Most men appreciate the existential fact of feminine sexuality *as* a fact, albeit one that is not to be grasped quite as simply as their own. The surrealists could not see what was "hidden in the forest" until they closed their eyes in order to imagine it; even then they could not be sure, for there are other forests to negotiate, not least amongst these the "forest of signs" which is the unconscious. Sooner or later, as in Newton's image, we open our eyes, come back to a tangible reality: here, that of the woman's body. That which is physical, that which reflects light—which has here left its trace on the photosensitive emulsion. But what the man behind the camera will never know is what her sexuality means to her, although a lifetime may be devoted to the inquiry. Perhaps this is the reason why, finally, Newton chooses to stage his perverse display under the gaze of his wife.

Sex is deadly serious.

Helmut Newton[1]

I have a friend in New York. An Australian. A photographer. We're in his loft and he pulls a print from down under a pile on a metal shelf. Hands it to me with a crazy giggle he has when he's enjoying himself but a bit embarrassed about it. I have to assume that the self-conscious looking kid in the photograph is him. Dolled up by his parents for some high-street photographer. Long ago. Far away. "Look on the back," he says. I turn the print over. There's the name of the studio: *Helmut Newton*.

HELMUT NEWTON PORTRAITS, PANTHEON BOOKS, NEW YORK, 1987

Plates 1–22: Helmut; June; doctors; models . . . 1934–1986:

June on the *métro* in 1957, alongside a much older woman; June in Paris twenty-five years later, looking down at a fresh postoperative scar that starts well above her navel and ends just above her pubis. June in Melbourne in 1947. June in Monte Carlo thirty-five years later.

Helmut adolescent, sprawled on a Berlin beach, a girl in each arm and one between his knees. Helmut fifty-two years later, on his back for the doctors—Paris, San Francisco. *Self-Portrait in Yva's Studio*, Berlin 1936: all hat and overcoat and gloves and camera case. *Self-Portrait during an Electrocardiogram*, Lenox Hill Hospital, New York 1973: all naked and wired up, with dangling leads and penis; arms akimbo, elbows

bent, raised away from his body; one behind his head; a newly taken prisoner.

All naked (except for high-heeled shoes), arms akimbo, elbows bent, raised away from her body; one behind her head, alongside an older woman; the woman is June; Helmut appears between them, reflected in the mirror that reflects the model—*Self-Portrait with Wife June and Models*, Vogue studio, Paris 1981.

We see both the model's back and her reflection in the mirror. The rectangle of the mirror, in which her image appears full length, fits the space beneath her right elbow. Helmut's reflection, also full length, fits the space beneath her reflected elbow. June, just to the right of the mirror, sits cross-legged in a director's chair. Her left elbow on her left knee, chin propped on her left hand, mouth tense. Her right hand makes a fist. Helmut is wearing a raincoat, his face hidden as he bends over his Rolleiflex.

CAUGHT LOOKING

CS: One of your self-portraits shows you wearing a trench coat with a nude model, and your wife sitting off to one side. Does your wife sit in on photo sessions?

HN: Never. Ever. She had just come by for lunch that day.

Newton talking to Carol Squiers, *Portraits*[2]

Here I am, bent over the keyhole; suddenly I hear a footstep. I shudder as a wave of shame sweeps over me. Somebody has seen me.

Sartre, *Being and Nothingness*[3]

I am a voyeur! . . . If a photographer says he is not a voyeur, he is an idiot!

Newton, *Portraits*[4]

Every active perversion is . . . accompanied by its passive counterpart: anyone who is an exhibitionist in his unconscious is at the same time a *voyeur*.

Freud, *Three Essays on the Theory of Sexuality*[5]

There are certain clubs here and in Paris where people just watch other people fuck.

Newton, *Portraits*[6]

Anyone who desires to witness the sexual activities of a man and woman really always desires to share their experience by a process of empathy, generally in a homosexual sense, i.e. by empathy in the experience of the partner of the opposite sex.

Otto Fenichel, *Collected Papers*[7]

The mirror is there so the model can see herself; the photographer would normally have his back to the mirror; a correct distance would divide their supposedly incommensurable roles: exhibitionist, voyeur. But Newton has invaded her space, planted his feet on her paper desert island—that Light Continent inhabited by Big Nudes. From this position, he now receives the look he gives. By entering the model's space he has, in a sense, taken her place—identified himself with her. June, his wife, has taken his place. Newton reveals himself to her, and to us, as a voyeur—the raincoat is his joke at his own expense. A voyeur in a raincoat? The photographer is here both a voyeur *and* an exhibitionist: a flasher, making an exposure. The raincoat opens at the front to form a shadowy delta, from which has sprung this tensely erect and gleamingly naked woman, this coquette. The photographer has flashed his prick, and it turns out to be a woman. Who else wears a raincoat? A detective—like the one who, in all those old B-movies, investigates all those old dangerously mysterious young women. Following her, watching her until,

inevitably, the *femme* proves *fatale*. Where am I in all this? In the same place as Newton—caught looking.

KEEP LOOKING

Newton has made an indiscernible movement of the tip of one finger. The shutter has opened and paused. In this pause the strobe has fired, sounding as if someone had clapped their hands together, once, very loud. The light has struck a square of emulsion. Out in the street a driver in a stationary car has perhaps glimpsed, illuminated in this flash of interior lightning, the figure of a naked woman. Perhaps not. In the future (now past) the shutter will close. Newton will put down the camera. Helmut and June will go to lunch. The models will put on their clothes, perhaps they will go to lunch together. Perhaps not. I know nothing of this woman who is now "showing everything"; nor of the other woman whose stiletto-heeled legs project from the left into the mirrored space. It is difficult to decide where, precisely, these legs are to be located (with the result that the space of the mirror seems curiously apart from the real space of the room, almost as if the disembodied legs, and Newton, existed *only* in the mirror). Ridiculously, the legs can be "read" as an awkward appendage to the out-of-focus foreground figure—bringing to my mind (more ridiculously) an old woodcut in which the Devil is depicted with a forked penis. Such provision of a substitute penis for the one the woman "lacks" is what motivates fetishism. The fetish allays the castration anxiety that results from the little boy's discovery that his mother, believed to lack nothing, has no penis. The contradictory function of the fetish is to deny the perception it commemorates. It is a particular example of a general form of defense against disquieting knowledge of the world which Freud termed "disavowal"— which takes the form "I know very well, but nevertheless . . ." Other defensive moves are possible. If the penis is not here then it clearly must

be elsewhere, in space or in time. One has only to keep looking. (*All* of this, of course, is ridiculous; but the unconscious is far less sensible about such things than we are.)

> Whatever uneasiness he may have felt was calmed by the reflection that what was missing would yet make its appearance: she would grow one (a penis) later.
>
> **Freud,** "Splitting of the Ego in the Process of Defence"[8]

That form of masculine behavior we call "Don Juanism" is popularly understood as motivated by an insatiable thirst for conquest. As I wrote some years ago, "we can interpret Don Juan's behavior another way: the most poignant moment for Don Juan takes place . . . between the bedroom door and the bed—it's the moment of undressing."

> CS: When you photographed yourself nude in 1976, your clothes were very neatly folded on a chair in the picture. But when you photograph women who are nude, their clothes are scattered everywhere . . .
>
> HN: I'm quite a tidy person. I would hate to live in disorder. . . . But this is interesting—I create that disorder—I want the model to take all her clothes off and just dump them.
>
> **Newton** talking to Carol Squiers, *Portraits*[9]

WASTE OF TIME

> If I say to a person, I want to see you naked, and in my head I say, Well I would like to fuck her but the reason I don't is because I'm scared to get AIDS or something.
>
> **Newton,** *Portraits*[10]

The little boy thought he knew women, now he knows better. In this moment he has also learned that what exists can also *not* exist. The only find of comparable magnitude to the discovery of the reality of sexual difference is the discovery of the reality of death. Small children have a problem with death; the fact of death tends to disappear over their conceptual horizon. "Dead" to the child initially means "not here," which in turn implies "elsewhere." Again, one only has to "keep looking" to restore what was lost. What was lost *can* be found, but every move repeats the discovery of loss. Observing a universal compulsion to repeat painful experiences, Freud was led to posit a "death drive" alongside the libidinal drive. Much confusion surrounds this concept. I prefer the recent formulations of Jean Laplanche. There is only one drive, and it is sexual, but it has two aspects: one seeks to conserve the self and its object, the other seeks to destroy one or the other (or both, for in reality they are the same—read Freud on Narcissism)—hence sexual aggression and sadomasochism. Newton's joke at his own expense is self-destructive (the raincoat on this hunched figure, miniaturized by the object of his fascination, reminds me of the phrase—*King Lear*, I think—"a giant's robe on a dwarfish thief"). June's appearing in this picture in public is self-destructive, for she has now changed seats with the woman on the *métro*. The same "joke" of aging is being played on the shining woman at the center of this image, but only in reality, not in this photograph. Everything pivots around this naked figure (appropriately, we see her from both front and back). There to be admired simply because she exists she need do nothing more than *be*. She is a statue in marble, like the *Venus Victrix* in Villiers de L'Isle-Adam's *L'Eve future* who is imagined to utter, "Moi, je suis seulement la Beauté même. Je ne pense que par l'esprit de qui me contemple" (I, I am simply beauty itself. I think only through the mind of the one who contemplates me). Yes, I know. The model is a *real* woman, caught up in an economy in which her identity is reduced to that of a figment of a man's imagination. I

understand why you think that that's the most important thing about this picture; but economies are not only monetary, they are psychical, and the psychical is worth more than a penny in our exchanges. This statue in marble, like so many of the women in Newton's photographs, is on a marble slab; the photograph, like so many photographs—which annihilate color, movement, and sound—leaves the detective an exquisite corpse. Back in the days of silent movies, Jean Cocteau remarked that the camera "filmed death at work." Portraits are a byproduct, a waste product, of time at work—the waste of time.

> All these young photographers who are at work in the world, determined upon the capture of actuality, do not know that they are the agents of Death. This is the way in which our time assumes Death: with the denying alibi of the distractedly 'alive,' of which the Photographer is in a sense the professional. . . . For Death must be somewhere in a society; if it is no longer (or less intensely) in religion, it must be elsewhere; perhaps in this image which produces Death while trying to preserve life . . . Life/Death: the paradigm is reduced to a simple click, the one separating the initial pose from the final print.
>
> **Roland Barthes**, *Camera Lucida*[11]

> I'm not at all interested in death. I'm not preoccupied by death. My wife, June, once said, Helmut, don't you want to discuss this subject? And I said, It doesn't interest me. I don't want to discuss it, it's a waste of time. . . . I don't care about it.
>
> **Newton**, *Portraits*[12]

PERVERSE LOVE

This is a photograph, not a movie; but nevertheless, this is a moral tale. I think of those allegorical paintings that show *Time ordering Old Age to*

destroy Beauty. Why is there so often a *trio* of principal protagonists in these allegories of the human condition? If I had more time I might write about this. I immediately think of two images in relation to Newton's *Self-Portrait with Wife June and Models*: Doisneau's 1948 photograph *Un regard oblique*, which shows a middle-aged couple looking into the window of a picture dealer, the man's slyly insistent gaze on a painting of a semi-naked young woman; and Balthus's 1933 painting, *La toilette de Cathy*, in which a young man, seated in an attitude that reminds me of June's posture in Newton's picture, seems to take an anxious lack of interest in the semi-naked young woman who is having her hair combed by a much older woman. ("It doesn't interest me. . . . I don't care about it.")

In an essay on "The Perverse Couple," Jean Clavreul describes a complex system of relations that "nest" one inside the other, like "Russian dolls." First there is the relation of the fetishist to his object; but the fetishist of whom Clavreul speaks can value this object only to the extent that *someone else* values it. Secondly, then, there is the relation of this second person to his object. Where this person is his wife, as it very often is, then there also exists the relation of this woman to her husband, in his relation to his (become "their") fetish object—as well as, of course, to her. A third person is now called upon as *witness*, as the "perverse couple" thus formed seek the recognition of an "external" other. Perverse? All human sexuality is deviant. Nothing about our sexuality belongs to anything that could be described as a "natural" instinctual process. In the natural world instinctual behavior is hereditary, predictable, and invariant in any member of a given species. In the human animal what might once have been instinct now lives only in shifting networks of symbolic forms—from social laws to image systems. Human sexuality is not natural, it is cultural. The same movement that produces culture, in the broadest sense of the word, also produces the unconscious—psychoanalysis is the theory of this unconscious, and

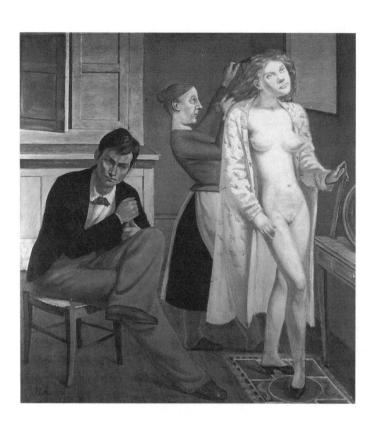

it was in the discovery of the unconscious that Freud first dismantled the barrier between "normal" reproductive heterosexuality and "perversions." At the end of the nineteenth century Freud inherited comprehensive data on sexual perversions from the sexologists. For researchers such as Richard von Krafft-Ebing and Havelock Ellis the behaviors they cataloged were viewed as deviations from "normal" sexuality. Freud however was struck by the ubiquity of such "deviations"—whether in dramatically pronounced form, or in the most subdued of ordinary "foreplay." (It was Freud who remarked that that mingling of entrances to the digestive tract we call "kissing" is hardly the most direct route to reproductive genital union.) In his 1905 *Three Essays on the Theory of Sexuality* he observes, "The disposition to perversions is itself of no great rarity but must form a part of what passes as the normal constitution." In opposition to the sexologists, who took socially accepted "normal" sexuality as inherent to human nature, Freud states that "from the point of view of psychoanalysis the exclusive sexual interest felt by men for women is also a problem that needs elucidating and is not a self-evident fact." If the word *perversion* still has an air of disapprobation about it today this is not the fault of psychoanalysis. Perversion is defined *only* in relation to social law, written or not. Robert Mapplethorpe could exhibit his most "perverse" pictures at the Whitney Museum of American Art only in exchange for the redeeming promise of his own impending death. Clavreul recognizes that the pervert within the perverse couple may receive public acknowledgment, even acceptance, of his perversion because it may be recognized as situated within the redeeming field of *love*.

ALICE SPRINGS: PORTRAITS, TWELVETREES PRESS, PASADENA, 1986

Why is a young girl so pretty, and why does this state last such a short time? I could become quite melancholy over this thought, and

yet, after all, it is no concern of mine. Enjoy, do not talk. The people who make a profession of such reflections generally do not enjoy. However, it can do no harm to harbor this thought, for the sadness it evokes, a sadness not for one's self but for others, generally makes one a little more handsome in a masculine way.

Søren Kierkegaard, *Diary of a Seducer* [13]

All men of my generation are concerned with *this* under their chins. I say I look like an old crocodile!

Newton, *Portraits* [14]

His mouth tired, tense—*Helmut Newton*, Paris 1976. Sitting for June; between his legs, his camera, exhausted. Sprawled on the bed behind him a woman's naked form, in one of those positions that in painting would imply lascivious exhaustion (the "little death"). One of her arms hides her face, in a gesture reminiscent of Masaccio's shameful Eve being cast from Eden. At the same time, by one of those often absurd spatial collapses produced in the camera, she seems to be whispering in Newton's ear—the profound and dreadful secret of her body, a secret told to no man. In *Une femme est une femme*, Angéla, twenty-four, wants a baby. If Angéla had had that baby in 1961, the year the film was made, the year Anna Karina (Angéla) got the best new actress award at Cannes, Angéla's child would now be twenty-eight. Anna must now be fifty-two. Angéla works as a stripper. As she strips she sings, "Je ne suis pas sage, je suis trop cruelle"; but (she sings) all the men forgive her because (final line of the chorus) "Je suis *très* belle!" In Jean-Luc Godard's written outline, Angéla is called "Josette." Godard says, "Josette believes in her art and practices conscientiously in front of a mirror." But the only such scene I remember is when Josette/Angéla/Anna stuffs a pillow up under her jumper to see how she will look pregnant. When her frown of

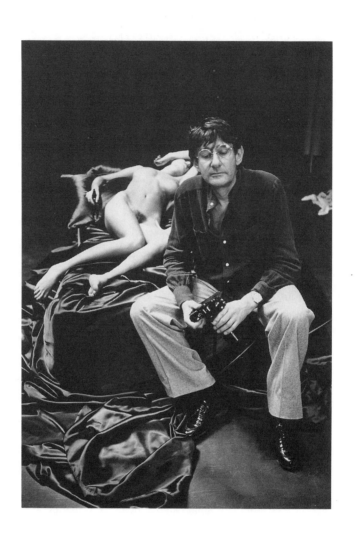

concentration departs her child's face it will leave no more trace than does her perfect smile. My own reflection now always seems too tired, too tense. I look away. Newton looks down, into the mirror of his Rolleiflex. I see the words *Peau Saine* on one of those pots that show that a woman shares this bathroom. "Peau Saint," I think, and the image of the woman in Newton's mirror returns to me as a Sainte Sebastienne, waiting to receive time's arrows. June's (Alice's) book lies open on the floor of my office, alongside Helmut Newton's *Portraits*. Helmut is still receiving the young woman's confession. It is the anticipation of this confession—hoped for each time the shutter is withdrawn, exposing the tiny dark room to that which is hopelessly beyond it—that gives Newton's picture its gravity.

We are all more or less cured psychotics.

Octave Mannoni [1]

 About two-thirds of the way through his book *Nadja*, André Breton describes meeting Nadja in a restaurant. The clumsy behavior of a waiter prompts her to tell an anecdote about an exchange she had, earlier in the day, with a ticket collector in a *métro* station. Clutching a new ten-franc piece in her hand, Nadja asks the man who punches her ticket: "Head or tails?" To which the man replies "Tails" and adds, indicating perhaps a vocation as a psychoanalyst: "You were wondering, Mademoiselle, if you would be seeing your friend just now." No one would suppose that Nadja is going down the *métro* for nothing, but, as the ticket collector discerned, she is not necessarily aware of what she hopes to find there. There is more to our wanderings in the city than urban planners take account of.

Freud said that when he put on his hat and went into the street he stopped being a psychoanalyst. On at least one occasion he demonstrated that analysts may be no better than the rest of us at knowing their own motives while out in the city; he writes:

> As I was walking, one hot summer afternoon, through the deserted streets of a provincial town in Italy which was unknown to me, I found myself in a quarter of whose character I could not remain long in doubt. Nothing but painted women were to be seen at the windows of the small houses, and I hastened to leave the narrow street at the next turning. But after having wandered about for a time without enquiring my way, I suddenly found myself back in the same street,

where my presence was now beginning to excite attention. I hurried away once more, only to arrive by another *détour* at the same place yet a third time. Now, however, a feeling overcame me which I can only describe as uncanny, and I was glad enough to find myself back at the piazza I had left a short while before, without any further voyages of discovery.[2]

By his own account Freud's ignorance of his most apparent motives for returning to that street, motives that for him were "blindingly obvious," was not shared by the street's inhabitants. Freud fails to see what is "under his nose" because his nose is buried in his *plan*, his conscious goal, and the diagram that will lead him there. He has temporarily forgotten what he himself taught us: there is always another side to this map, "another place" in this topography.

In his book *The Practice of Everyday Life*, in the chapter titled "Walking in the City," Michel de Certeau inaugurates a dual mapping of urban space. There is first what he calls the "concept city," "founded by utopian and urbanistic discourse," whose first operation must be "the production of its *own* space [*un espace propre*]." Certeau comments, "Rational organization must thus repress all the physical, mental and political pollutions that would compromise it."[3] However: "Beneath the discourses that ideologise the city, the ruses and combinations of powers that have no readable identity proliferate; without points where one can take hold of them, without rational transparency, they are impossible to administer." "No readable identity," writes Certeau, but he nevertheless goes on to inaugurate a reading of walking in the city, moreover, one conducted in terms of linguistics. After a discussion of pedestrian displacements in terms of classical rhetoric, Certeau remarks—in agreement with such writers as Emile Benveniste and Jacques Lacan—that such tropes characterize a "symbolic order of the unconscious." He observes, "From this point of view, after having compared pedestrian processes to linguistic

formations, we can bring them back down in the direction of oneiric figuration."[4] Certeau goes on to identify "three distinct (but connected) functions of the relations between spatial and signifying practices . . . the *believable*, the *memorable*, and the *primitive*. They designate what 'authorizes' (or makes possible or credible) spatial appropriations, what is repeated in them (or is recalled in them) from a silent and withdrawn memory, and what is structured in them and continues to be signed by an in-fantile (*in-fans*) origin."[5] I understand the word *believable* here to designate those material-factual conditions that furnish the occasion, pretext, alibi, or disguise for what would otherwise be illegitimate, "merely subjective" constructions of reality. As for the "memorable," Freud's discussion of the uncanny is only a special case of his more general observation that what appears to come to us from the outside is often the return of that which we ourselves have placed there—something drawn from a repository of suppressed or repressed memories or fantasies. All this is familiar enough. It is the final term in Certeau's trilogy of "relations between spatial and signifying practices"—the "primitive," that which is "signed by an in-fantile [*in-fans*] origin"—which calls for a clarification that Certeau does not provide. Certeau concludes his essay on "walking in the city" with these words: "The childhood experience that determines spatial practices later develops its effects, proliferates, floods private and public spaces, undoes their readable surfaces, and creates within the planned city a 'metaphorical' or mobile city, like the one Kandinsky dreamed of: 'a great city built according to all the rules of architecture and then suddenly shaken by a force that defies all calculation.'"[6] He says no more on the subject, but what *are* these "infantile determinants" of our experiences and practices in and of the city?

Writing of certain instances of the experience of the uncanny, Freud remarks: "They are a harking-back to particular phases in the evolution of the self-regarding feeling, a regression to a time when the ego had not yet marked itself off sharply from the external world and from other

people."[7] The space of this time, "primitive" to us all, was later mapped in some detail by Melanie Klein, of whom Lacan has written: "Through her we know the function of the imaginary primordial enclosure formed by the *imago* of the mother's body; through her we have the cartography, drawn by the children's own hands, of the mother's internal empire, the historical atlas of the intestinal divisions in which the *imagos* of the father and brothers (real or virtual), in which the voracious aggression of the subject himself, dispute their deleterious dominance over her sacred regions."[8] It is often observed that much as Freud discovered the child in the adult, so Klein found the infant in the child; as is well known, her "royal road" to this discovery was the analysis of play. Klein wrote that she approached the play of the child "in a way similar to Freud's interpretation of dreams." In her therapeutic technique the child's play takes on the function served by the verbal associations of the adult patient; consistently with Freud she cautions that "we have to consider each child's use of symbols . . . in relation to the whole situation which is presented in the analysis; mere generalized translations of symbols are meaningless."[9] Klein's interpretations were not based simply on the child's manipulations of its toys, they concerned the totality of the field of the child's play—the consulting room, and its furniture, within which the child displaced its body just as it deployed its toys. Klein came to view the spatialization of this theater of play as the exteriorization, "projection," of an internal world, a world of relations between "objects." Much of Klein's work is concerned with the description of internal objects, bound up with the somatic origins of fantasy.[10] We are familiar with such expressions as "a lump in the throat," or "butterflies in the stomach"; we are also accustomed to hear that hunger "gnaws" at the stomach, or fear "grips" the heart. In these examples from ordinary language, bodily sensations are identified with actual entities, endowed with an agency of their own, either benevolent or malevolent. There may also be times when we feel "empty inside." As adults we employ such metaphors without abandoning our knowledge

of actual physiology. The infant has no such knowledge. The infant's primitive understanding of its own bodily feeling is its only reality. What we call "milk" the infant (what we call "the" infant) may experience, after feeding, as a benevolent object that emanates bliss. This object is destined to fade. Hunger will take its place—a malevolent agency, bringing destruction of the "good object," and pain. At this primitive level, the "object" is the fantasmatic representation of the phenomenological form of the infant's earliest experience. In the Kleinian description, the infant's reality is a battleground of and for such objects.

The subsequent formation of a bounding body-ego, to which the much discussed "mirror stage" contributes, does not put an end to the movements of projection, introjection, and identification described by Klein; they are rather transposed into different registers and extensively subjected to repression. Upon a world understood in terms of the fantasmatic mother's body there is imposed a world whose salient features are projected from the corporeal envelope of the newly formed subject. Sándor Ferenczi observed:

> The derisive remark was once made against psycho-analysis that, according to this doctrine, the unconscious sees a penis in every convex object and a vagina or anus in every concave one. I find that this sentence well characterises the facts. The child's mind (and the tendency of the unconscious in adults that survives from it) is at first concerned exclusively with its own body, and later on chiefly with the satisfying of his instincts, with the pleasurable satisfactions that sucking, eating, contact with the genital regions, and the functions of excretion procure for him; what wonder, then, if also his attention is arrested above all by those objects and processes of the outer world that on the ground of ever so distant a resemblance remind him of his dearest experiences. . . . Thus arise those intimate connections, which remain throughout life, between the human body and the

objective world that we call *symbolic*. On the one hand the child in this stage sees in the world nothing but images of his corporeality, on the other he learns to represent by means of his body the whole multifariousness of the outer world.[11]

For example, when "Little Hans" saw some water being let out of a railway engine he responded with, "Oh look, the engine's widdling. Where's it got its widdler?" Freud completes the anecdote: "After a little while he added in reflective tones: 'A dog and a horse have widdlers; a table and a chair haven't.' He had thus got hold of an essential characteristic for differentiating between animate and inanimate objects."[12] Such distinctions, founding the real world—the "normal"—are learned, which is to say they may fail to be learned, or may be learned badly. Prior to such distinctions, spacing, there are only identifications, fusion. Spatial metaphors necessarily accompany the "object" metaphors that abound in everyday language: for example, we may feel "one" with someone, be "on their side" in a dispute, and worry when, even though physically close to us, they appear "distant." Paul Schilder has given a schematic description of the continuum between normal and pathological space:

> There is the space as a phylogenetic inheritance which is comparatively stabilized, which is the basis of our actions and orientations. It is the space of the perception ego. We live our personal lives in relation to love objects, in our personal conflicts, and this is the space which is less systematized, in which the relations change, in which the emotions pull objects nearer and push them further away. When the emotional life regresses very far the perception ego-space loses more and more of its importance. In this regressive space identifications and projections change the space and its value continually. This is the Id space which finds a very far-going expression in schizophrenic experiences. It is the space of magic.[13]

The space of magic: it is supposed that in the infant's early experience it is as if it summons the breast into being; unconscious survivals of this state into adult life may contribute to obsessional neurosis. Freud writes:

> I have adopted the term "omnipotence of thoughts" from a highly intelligent man who suffered from obsessional ideas. . . . He had coined the phrase as an explanation of all the strange and uncanny events by which he, like others afflicted with the same illness, seemed to be pursued. If he thought of someone, he would be sure to meet that very person immediately afterwards, as though by magic.[14]

Obsessively, a distraught Breton is tormented by thoughts of Nadja. He desperately feels the need to see her, but has no rendezvous with her until the following day. He goes out in a taxi, and, "Suddenly, while I am paying no attention whatever to the people on the street, some sudden vividness on the left-hand sidewalk, at the corner of Saint-Georges, makes me almost mechanically knock on the window. It is as if Nadja had just passed by. I run, completely at random, in one of the three directions she might have taken. And as a matter of fact it is Nadja. . . . This is the second consecutive day that I have met her: it is apparent that she is at my mercy."[15]

The normal infantile space of magic recedes ("once upon a time, long ago and far away . . .") as the ego forms out of the nucleus of early object relations—a precarious process. In her paper of 1946, "Notes on Some Schizoid Mechanisms," Klein remarks, "The early ego largely lacks cohesion, and a tendency towards integration alternates with a tendency towards disintegration, a falling to bits."[16] The "cracks in the structure" which may result may lead to subsequent crises of delimitation of ego/object boundaries, to "psychosis." Early object identifications are, as Edith Jacobson expresses it: "founded on primitive mechanisms of introjection or projection corresponding to fusions of self and object images

which disregard the realistic differences between the self and the object. They will find expression in illusory fantasies of the child that he is part of the object or can become the object by pretending to be or behaving as if he were it. Temporary and reversible in small children, such ideas in psychotics may turn into fixated, delusional convictions."[17] Jean Laplanche and Jean-Bertrand Pontalis write: "Fundamentally, psychoanalysis sees the common denominator of the psychoses as lying in a primary disturbance of the libidinal relation to reality; the majority of manifest symptoms, and particularly delusional constructions, are accordingly treated as secondary attempts to restore links with objects."[18] In psychosis, the internal and external world are poorly differentiated, or not differentiated at all; for example, whereas, in "normal" life we may encounter a person A who "reminds us of" another person B, the schizophrenic patient may simply substitute the latter for the former; or, again, he or she may experience the internal representations of "fantasy" as actual representations of external reality.[19] We should remember that psychoanalysis systematically insists that there are no fixed boundaries between "normal" and pathological realities. The precondition of the pathological is in early "normal" experience; it is in this sense that we may understand Mannoni's remark that "we are all more or less healed psychotics"[20]—to which we may add that there is never anything more than this "more or less."

To the "psychoses" belong those forms of mental disturbance which everyday language names "madness." Toward the end of *Nadja*, Breton writes: "I was told, several months ago, that Nadja was mad. . . . she had had to be committed to the Vaucluse sanitarium."[21] The first published fragment from Breton's *Nadja* appeared in the penultimate issue of *La révolution surréaliste*. In this same issue, in an article illustrated with Paul Régnard's photographs of "Augustine" from the *Iconographie photographique de la Salpêtrière*,[22] Breton and Louis Aragon celebrate 'The Fiftieth Anniversary of Hysteria,' which they find to be "the greatest

poetic discovery of the end of the nineteenth century" and "in every respect . . . a supreme means of expression."[23] The intentionally ironic indifference of these two psychiatrically trained poets to the diagnostic niceties of their former profession is evident. Nevertheless they might more consistently have reserved their approbation for the psychoses rather than the neuroses.[24] According to Lacan, writing in another surrealist journal, *Minotaure*, paranoic deliriums "need no interpretation whatsoever to express by their themes alone, and marvellously well, these instinctive and social complexes which psychoanalysis has the greatest difficulty in bringing to light in neurotics. It is no less remarkable that the murderous reactions of these patients very frequently emerge at a neuralgic point of the social tensions with which they are historically contemporary."[25] History was very shortly to provide Lacan with an exemplary case of such violence, his subsequent study of paranoia to appear in *Minotaure* was dedicated to "The Crime of the Papin Sisters." Léa and Christine Papin were domestic servants who for six years, in the words of Paul Eluard and Benjamin Péret, "endured, with the most perfect submission, commands, demands, insults," until the day they "literally massacred their employers, tearing out their eyes and crushing their heads."[26] About the same time that the awed comments of Eluard and Péret appeared in *le surréalisme au service de la révolution*, the surrealists had published a pamphlet in support of the patricide Violette Nozière. Much earlier, the inaugural issue of *La révolution surréaliste* had featured a "mug shot" photograph of the anarchist Germaine Berton surrounded by portrait photographs of all the surrealist group (a guard of honor to which a picture of Freud has, for the occasion, been conscripted). Berton had assassinated the royalist Marius Plateau, editor of the extreme right-wing journal *L'action française*. The assembled photographs are accompanied by a fragment from Baudelaire: "Woman is the being who throws the greatest shadow or the greatest light on our dreams." The dream is of violent revolution. Eluard and Péret had spoken of the Papin sisters'

hatred, "this very sweet alcohol which consoles in secret for it promises, sooner or later, to add physical force to its violence."[27] These particular women—clinically paranoiac or not—were seen as exemplifying the production of legitimate violence at three key "neuralgic points" of social tension: in the case of Nozière, the family; in the case of the Papin sisters, the workplace; and in the case of Berton, politics.

Breton's description of his first, pedestrian, encounter with Nadja indicates precisely what he was out looking for:

> Last October fourth, toward the end of one of those idle, gloomy afternoons I know so well how to spend, I happened to be in the Rue Lafayette: after stopping a few minutes at the stall outside the *Humanité* bookstore and buying Trotsky's latest work, I continued aimlessly in the direction of the Opéra. The offices and workshops were beginning to empty out from top to bottom of the buildings, doors were closing, people on the sidewalk were shaking hands, and already there were more people in the street now. I unconsciously watched their faces, their clothes, their way of walking. No, it was not yet these who would be ready to create the Revolution. I had just crossed an intersection whose name I don't know, in front of a church. Suddenly, perhaps still ten feet away, I saw a young, poorly dressed woman walking toward me.[28]

Nadja, for Breton—for a time—is to be the locus of the transformation of everyday life, as if the social revolution absent from the France of 1928 could be acted out on the stage of sexuality. Breton is out looking for an explosive, Nadja is looking for a container. Breton celebrates the affirmative "being in the world" of the Nadja who "enjoyed being nowhere but in the streets, the only region of valid experience for her."[29] But Nadja seems to have little sense of her own independent existence *without* the streets, and the encounters they offered. Breton writes, "She uses a new

image to make me understand how she lives: it's like the morning when she bathes and her body withdraws while she stares at the surface of the bath water. 'I am the thought on the bath in the room without mirrors.' "[30] Schilder reports some of the utterances of his patients: "I am not sure whether this room is one or more"; "You can't go out of this house, there is no other world"; "I do not know where I am. I feel that I am in the space between. That frightens me."[31] It is as if Nadja is in the street to find those scattered objects she cannot contain when alone—an anxious search. Breton writes: "Here on the right, is a low window that overlooks the moat, and she cannot take her eyes off it. It is in front of this window which looks so forlorn that we must wait, she knows that much. It is from here that everything can come. It is here that everything begins. She holds onto the railing with both hands so that I will not pull her away"[32]; or again, "Nadja cannot endure the sight of a mosaic strip extending from the counter across the floor, and we must leave the bar only a moment after we have come in."[33] Lacan observes, "The perceptual field [of the paranoid subject] is imprinted with an immanent and imminent 'personal signification.' "[34] Breton muses, "Perhaps life needs to be deciphered like a cryptogram." Aragon, in his own book about the city streets, *Le paysan de Paris*, writes:

> Where the most ambiguous activities of the living are pursued, the inanimate may sometimes catch a reflection of their most secret motives: our cities are thus peopled with unrecognised sphinxes, which will not stop the musing passer-by and ask him mortal questions. But if in his wisdom he can guess them, then let him question them, and it will still be his own depths which, thanks to these faceless monsters, he will once again plumb.[35]

What is most familiar in that to which Aragon alludes is discussed by Freud in such papers as "The Uncanny" or his paper on *fausse reconnaissance*.

Fundamentally, "What is involved is an actual repression of some content of thought and a return of this repressed content,"[36] which may additionally involve "the identity being displaced from the really common element on to the locality."[37] Breton misrecognizes Nadja's illness because it is centered perfectly upon that which surrealism was in the process of celebrating—the encounter with the enigmatic in the everyday. However, the accompanying affect in Nadja's encounter with the enigmatic is qualitatively and quantitatively different from that in the encounter with the "uncanny" (which the French equivalent of "uncanny" spells out as *l'inquiétante étrangeté*). Nadja's experience is of a world in which the two terms of Breton's simile are collapsed into an identity—for her, life *is* a cryptogram. It is precisely in *this* that her relation to the streets is "infantile."

Laplanche has identified the early and inescapable encounter of the subject with "primal seduction," the term he gives to "that fundamental situation where the adult presents the infant with signifiers, non-verbal as well as verbal, and even behavioural, impregnated with unconscious sexual significations."[38] It is these that Laplanche calls "enigmatic signifiers": the child senses that such signifiers are addressed to it, and yet has no means of understanding their meaning; its attempts at mastery of the enigma, at symbolization, provoke anxiety and leave unconscious residues. Such estrangement in the libidinal relation with the object is an inescapable condition of entry into the adult world, and we may expect to find its trace in any subsequent relation with the object, even the most "normal." About a quarter of the way into *Nadja* Breton devotes some ten pages, and four photographs, to a description of his desultory visits to the theater: to the *Théâtre moderne*, with its bar like "a living room at the bottom of a lake"; and to the *Théâtre des deux masques*, where he witnesses a "Grand Guignol" drama, *Les détraquées*, "which remains . . . the only dramatic work that I choose to recall." The plot of *Les détraquées*, in Breton's four-page summary, seems to concern the encounter

of a child with perverse (here, female) adult sexuality. I say "seems to concern" as we are made to share Breton's own uncertainty: "The lack of adequate indications as to what happens after the balloon falls and the ambiguity about precisely what Solange and her partner are a prey to . . . is still what puzzles me *par excellence*."[39] Breton immediately follows his account of *Les détraquées* with a partial description of a dream that "includes a reference to certain episodes of *Les détraquées*" and which Breton found "remarkable" in that it "emphasized only the painful, repugnant, not to say cruel aspect of the considerations I had embarked upon" (included in the dream is an insectlike creature that attempts to choke Breton, who experiences "an inexpressible disgust"). It is also within the space of these pages about his visits to the theater that Breton confesses, "I have always, beyond belief, hoped to meet, at night and in a woods, a beautiful naked woman or rather, since such a wish once expressed means nothing, I regret, beyond belief, not having met her." He then recalls the occasion when, "in the side aisles of the 'Electric Palace,' a naked woman . . . strolled, dead white, from row to row"—an occurrence he admits was unextraordinary, "since this section of the 'Electric' was the most commonplace sort of illicit sexual rendezvous."[40] I suspect that these scenes refigure, transcribe, symbolize each other, contain each other—just as the *Théâtre Moderne* is contained as a scene within the theatrical space of *Nadja*, which is a maze of façades. For *Nadja*, Breton commissioned photographers to take pictures of that which he might otherwise have felt obliged to describe. Images of places and things, including the drawings that Nadja made for Breton, are deployed throughout the book like so many decorated curtains, rising and falling between scenes with the turn of a page—or like so many theatrical "flats." We may recall that one of the origins of perspective is in the art of scenography. Breton's city is a stage for the encounter with the marvelous in the everyday. Breton is actor-director and general manager. Brilliant illusions are conjured on this stage, but they are imposed on a space whose

coordinates are fundamentally Cartesian, whose geometries are Euclidean. In this, Breton's space is different from that of Nadja's, and there is a sense in which, throughout the book, they are never in the same place, and never meet.

Accompanying the celebration of the "anniversary of hysteria," and the fragment of *Nadja*, in the penultimate issue of *La révolution surréaliste* is the transcript of an extended discussion (amongst the surrealists themselves) of sexuality. Intervening in the exchange, in response to his own question, "Does love necessarily have to be reciprocal?," Breton states: "It is necessarily reciprocal. For a long time I thought the contrary, but I have recently changed my mind." Breton was elsewhere to voice his regret that he had not been able to love Nadja as she had loved him, which is to say that he was not fully able to participate in a world that the surrealists had so far eulogized only from a safe distance—that of the *détraquée*. Toward the close of the book Breton reflects that Nadja was "born to serve human emancipation . . . in its simplest revolutionary form," which includes "thrusting one's head, then an arm, out of the jail—thus shattered—of logic, that is, out of the most hateful of prisons." He concedes that this is "dangerous," adding, "It is from this last enterprise, perhaps, that I should have restrained her."[41] Breton did however exercise *self*-restraint, placing his own boundaries on *l'amour fou* and hence, implicitly, on surrealist revolution.[42] To speak more accurately, Nadja *introduced* Breton to his own limits and limitations. Breton reports that while speeding back from Versaille by car, at night, Nadja had "pressed her foot down on mine on the accelerator, tried to cover my eyes with her hands in the oblivion of an interminable kiss, desiring to extinguish us, doubtless forever, save to each other, so that we should collide at full speed with the splendid trees along the road. What a test of life indeed! Unnecessary to add that I did not yield to this desire."[43] Speaking of the Papin sisters, Lacan remarks: "One has heard in the course of the debates the astonishing affirmation that it was impossible

that two beings should both be struck, together, by the same madness. . . . This is a completely false affirmation. Joint deliriums (*les délires à deux*) are amongst the most ancient of known forms of psychosis."[44] Breton regrets, "Whatever desire or even illusion I may have had to the contrary, perhaps I have not been adequate to what she offered me." But what was offered was that dark side of the drive whose only objects are fragments, and whose aims are destructive. Laplanche observes that pride of place amongst the "enigmatic signifiers" is reserved for what Freud called the "primal scene," where (the scene now dramatically lit by Klein) "the parents are united in an eternal coitus which combines *jouissance* with death, excluding the baby from all capacity to participate, and therefore to symbolize."[45] Breton returns from his walk only to pose the question of the city again in its most unanswerable terms:

> It is not for me to ponder what is happening to the "shape of a city," even of the true city distracted and abstracted from the one I live in by the force of an element which is to my mind what air is supposed to be to life. Without regret, at this moment I see it change and even disappear. It slides, it burns, it sinks into the shudder of weeds along its barricades, into the dream of curtains in its bedrooms, where a man and woman indifferently continue making love.[46]

The department store is [the flâneur's] last
haunt.

Walter Benjamin[1]

 April in Tokyo. In Ueno Park, picnics are laid under low-lying clouds of cherry blossom. Pools of beer spatter tarpaulin rafts bearing cargoes of revelers down avenues of trees (each barque with its fringe of neatly parked shoes). The banks of these asphalt rivers teem with sightseers, entranced as much by the spectacle of the picnickers as by the blossoms whose brief flowering—momento mori—provides the moral pretext for the party. The blossoms are piped into the Shibuya branch of the Seibu department store in the form of ambient video. Via monitors on all twelve floors, on the interlacing escalators, in the elevators, the images blossom in every corner of the store; as do images of Mount Fuji (flowers dissolving to mountain to the sound of John Lennon's "Imagine"); and living resemblances of passersby, sucked at random from the streets, momentarily turning the monitors into a thousand windows onto the outside. (From outside, glancing up to the exterior digitized video displays whose screens span several floors, the pedestrian might have observed only giant rays, languorously undulating in the depths of an ocean before dissolving into animated pixelated news of the latest hostage crisis.)

Benjamin saw the nineteenth-century shopping arcade as an intermediate stage in the transition from street to department store. The arcade—an interior street—was lit by day by means of skylights, whose transparent expanses became possible only when iron was used to support the glass. Glancing up, one might see clouds; or by night, stars. In Seibu these glazed iron rectangles have burst from their grids; I imagine

them lazily tumbling in computer animation as they metamorphose into these ubiquitous video monitors. Bathed in an even fluorescence indifferent to the actual time of day, these screens may show us clouds, or the surface of Mars, or any other thing whose appearance can be specified in binary digits. Tokyo is a hundred kilometers east of Mount Fuji. From the beginning of the Edo period (1600) to the end of the Meiji era (1912) the mountain was intermittently but clearly visible from the city—providing a fixed spatio-spiritual reference point (a place within Tokyo from which Mount Fuji could be glimpsed was a *meisho*—"famed scenic spot"). Today, construction and atmospheric pollution have erased the mountain, at least to the naked eye. New reference points, new mountains, have arisen within the city itself in the form of these department stores from which alone, today, may one see Mount Fuji. Nevertheless some of the phenomenology of its viewing has been retained in that it is glimpsed in passing—as it might appear intermittently in the gaps between buildings—as one travels from monitor to monitor through the store.

The Japanese have given the word *tachiyomi* to the act of reading—opportunistically, fragmentarily—while on the move: this desultory flipping through the pages of comic books and magazines, picked up in passing, with no real intention to buy; that reading of a newspaper picked up from an adjacent seat while traveling on the subway. Recalling his days with Jacques Vaché, in Nantes during the war, André Breton spoke of their habit of "dropping into the cinema when whatever was playing was playing, at any point in the show, and leaving at the first hint of boredom—of surfeit—to rush off to another cinema where we behaved in the same way, and so on." Today we switch TV channels. (For a period, in some New York restaurants, it became fashionable to "browse" the menu—a taste of this, a portion of that.) Tourists take "package holiday" bites at one culture, then at another: a couple of days in this city, a few more days in that (here am I, dropping in on this

district, wandering around that quarter). And haven't the Japanese accumulated a reputation for browsing Western culture for whatever they please to "indigenize"? If cultures are indeed to be considered as complex texts, then they have become texts that the more affluent and leisured "flip" through, without commitment, while on the move.

In the book department of this Seibu store (400,000 volumes, amongst which I find two dissertations on surrealism from UMI Research Press, Ann Arbor), a wall has become a projection screen for clips from classic Hollywood movies—ordered by categories, one of which is "War." Over waves of US bombers taking off for a night raid (Tokyo was destroyed by saturation firebombing) a voice resolves to "seek out the enemy, wherever he might be." To the right of the screen, where the bombers disappear out of frame, is a large display case containing the burned-out model tower whose summit explodes in the closing scenes of *Ghostbusters*. (Breton first met Vaché, in 1916, in a military psychiatric hospital where Breton was an intern and Vaché a patient. Amongst the other patients was a young man who believed that the "war" was a simulacrum; that the "shells" were dummies, the "wounds" merely makeup. He believed that the dead were brought from the dissecting tables of medical schools, and distributed around the fake "battlefields" under cover of darkness.) The American bombers are taking off from left to right, the way the West reads. Browsing the books I come across a comic strip, the first frames of which show Japanese bombers taking off from right to left. First they destroy Pearl Harbor, then they bomb the US mainland. Now Japanese soldiers are kicking down the doors of American homes. A young family—a man, woman, and small child—huddle in their living room as soldiers fall upon them. The man is killed. The soldiers start to tear the clothing from the woman. The child cries. A Japanese officer swings it by the ankles, in an arc which fills a double page, to smash it into a wall. The child's face, torn from its skull, cannons across the spread, trailing an inky stroke recalling Zen

calligraphy. The soldiers variously rape the woman for half a page (her cries rendered in English) before the assault force regroup to pose for their photo, perched on the extended arm of a toppled Statue of Liberty. On the following page, the final one, we see the Emperor Hirohito mounted on a horse. The streets of Tokyo are safe, some say, because all the violence is contained within such comics. In the second surrealist manifesto, Breton had declared, "The most simple surrealist act is, revolvers in hands, to go down into the street and to fire at random, as much as one is able, into the crowd." It has become commonplace to observe that such acts are today a regular, albeit infrequent, feature of everyday life; it is observed that surrealism faltered with the onset of the Second World War, when the real world exploded with a violence that art could not have anticipated. (Back in France for the Allied invasion the surrealist photographer Lee Miller roamed shattered streets whose doorways were windows onto appalling and fantastic landscapes. Inadvertently stepping on a human hand she picked it up, and in anger and disgust hurled it across the street.) But this is to forget that surrealism *began* with the First World War, and that at least one of its ambitions between the wars was that of the sublimation of the terror and loss latent in everyday life by means of its *representation*, its transformation into fantasy (particularly within the horizons of sexual love).

In the street, the crowd may momentarily open to allow a glimpse of a figure, a face, which is lost as quickly as it touches the erotic nerve. "Love at last sight," Benjamin called it. The department store offers its own perverse variation on this phenomenon by means of those fragile curtained spaces wherein women are invited to leave the throng of spectators in order themselves to become spectacle. Spectacle for themselves, and for those strangers of their sex who may join them to undress, but spectacle also for the illicit gaze enticed by a gaping curtain. (Roland Barthes asks, "Is not the most erotic part of the body where the clothing gapes?") I hastily look away; some light, ricocheting around the mir-

rored interior to decay on my retina, has left a confusion (more cubist than surrealist) from which memory alone may extract the already familiar fragment of a loved body. In his essay on surrealism, Benjamin wrote, "The lady, in esoteric love, matters least. So, too, for Breton. He is closer to the things that Nadja is close to than to her." We may give this "esoteric love" a clinical name—"fetishism." The department store, shrine of commodity fetishism, also solicits that fetishism of which Freud speaks. To negotiate a route to some legitimate destination, the male flâneur must cross seas of dresses, and deserts heavy with the scent of perfume and makeup. He has no other choice but to enter these zones of the taboo. His alibi is as perfect as his sense of illicit pleasure is inescapable. Absentmindedly browsing through a rail of garments he may believe he is thinking of a gift for his lover, but he is also blindly feeling his way across the mother's body. Suddenly thirsty in Seibu, I find a drinking fountain in whose transparent upper section water runs over a bed of gravel—a section cut from a stream and displayed on a plinth, a natural part-object.

At street level there is a bar in the form of a ruin ("postapocalyptic architecture") through whose facade projects an aircraft wing, its underslung engine pod metonymically recalling the B-52s that razed Vietnam. In Nigel Coates's *Café Bongo*, "interior" ruptures the fragile membrane between it and "exterior." Hajime Yatsuka, architect of a store for the fashion designer Angelo Tarlazzi in this same Roppazao district, said he conceived of his entire building as an "interior" to the city.

Benjamin remarked: "The street becomes a dwelling for the flâneur; he is as much at home among the façades of houses as the citizen is in his four walls." The *departo* is a common dwelling for the affluent refugees from "four-mat" rooms who sleep on the subways. Everywhere, the sight of people sleeping. Men sleep in the expansive couches seemingly provided for this purpose (for what else?) at the edges of those spaces where, on successive floors of Seibu, the escalators change

direction. On the subway station beneath this store (Yarakucho), young women office workers sleep. They sleep commuting to and from the confines of the outer suburbs. At the weekend they return—to Shibuya, Ginza, Ikebukuro, or some other branch of Seibu. They buy clothes by Isse Miyake, *Comme des Garçons*, or some other designer hopelessly beyond the means of their European or US counterparts. Some ninety minutes by train from their tiny rooms they pass the day in *flâneurie*, drifting through the hopelessly luxurious spaces of Seibu—spaces that open onto all space through the ubiquitous ambient video. A displaced person from the northern English working class, I remember the "front-room" kept by a more affluent aunt. A room smelling of wax polish, opened only for cleaning and for visitors. These latter were allowed to look but not touch, to view the room through the open door but not to enter (no one sat in this "sitting room," or spoke in this "parlor"). It might have been a holographic simulacrum of a room, switched on to provide the psychological relief of additional living space—the same relief offered in Seibu. In Seibu, as in its western counterparts (at least in this detail), the furniture department is arranged like so many front-rooms of the rich; as if extracted from their real contexts and "beamed down" onto this floor, this city, made up of nothing but front-rooms; bereft of walls, but separated by interior streets whose main use is *flâneurie*.

Godard said something to the effect that, as anything could be put into a film, then everything should be. Much more than the film, the Seibu department store is an assemblage of contributions from a heterogeneous collective—buyers, tenant boutique owners, resident video artists, librarians, travel agents, and so on. Here, there is no equivalent of authorial control, or of narrative closure (therefore no need for the evasions of Breton and Vaché, the principles of organization are already nonholistic, pragmatic, and opportunistic). To the extent that this assemblage constitutes a totality, it emerges from a process equivalent to

the collective writing practices of the surrealists. The Seibu *departo* is a work of surrealism in its postmodern phase, a work whose inexhaustible permutations are written "automatically" by the flâneur, whose interest in the goods on sale is expected to be no more or less than his or her interest in the environment that contains them. (Benjamin's aphorism: "Architecture is appreciated in a state of distraction.")

In Japan, you are as likely to see a significant art exhibition in a department store as in a museum. While Seibu is showing Jean Dubuffet, the Tokyo Metropolitan Art Museum (in Ueno Park) has this April, 1988, opened *The 1920s in Japan.* Here I learn that the 1923 Great Kanto Earthquake, which destroyed Tokyo, is considered the landmark event ushering in Japan's "Machine Age" in the arts. Breton's *Manifeste du surréalisme* and the first issue of *La révolution surréaliste* were published in Paris in 1924. I find plenty of evidence in the Tokyo Metropolitan Art Museum of the influence of the machine aesthetic in general, and the Bauhaus in particular, upon the visual arts—photography, painting, architecture, industrial design, cinema, theater design, and fashion—on display. There is also ample indication of the widespread influence of German Expressionism, particularly in the theater and the cinema; as the 1920s draw to a close there is an increasing preponderance of politically inspired "realist" initiatives. I find almost no indication whatsoever of any interest in surrealism. There seems no reason to suppose that knowledge of surrealism was any more or less available in Japan in the 1920s than knowledge of other European aesthetic movements. Writing in 1970, Shûzô Takiguchi—cited in the Breton and Eluard *Dictionnaire abrégé du surréalisme* as a "surrealist writer"—states that "in Japan, there has never existed any surrealist group as in France." I am not qualified to guess what surrealism might have meant, or failed to mean, to the Japanese between the wars, or today. I am sure it is other than what it means to me. Many historians of surrealism choose to end their chronology with the "Events of May" of 1968. In that same year, a French

television crew was sent to interview Yukio Mishima. They found this advocate of traditional values (who two years later would represent his defense of them in an impeccably executed seppuku), in the suburbs of Tokyo, in a house that resembled a villa on the Côte d'Azur. The ground floor was furnished in the eighteenth-century French style, while the upper floor was International Style modern. Mishima explained, "Here, only what you cannot see is Japanese."

At the beginning of his essay "Reflections on Exile," Edward Said tells anecdotes about friends, mainly writers, who testify to their pain in being separated from their homeland and their mother tongue. He is quick to acknowledge not only that exile is suffered by a comparatively small number of writers and artists, but that it has "torn millions of people from the nourishment of tradition, family and geography." He speaks of the "hopelessly large numbers, the compounded misery of 'undocumented' people suddenly lost, without a tellable history." Here, he says, we must "leave the modest refuge provided by subjectivity and resort instead to the abstractions of mass politics."[1] But this early interruption to his text, this irruption of a public voice, soon gives way to the privacy of another anecdote about a friend. The clash of private and public voices in Said's essay represents the difficulty of placing the exile. Said's anecdotes show the experience of exile as lived in irreducibly subjective isolation; at the same time, he observes, the exile exists only in relation to nationalism, the "assertion of belonging in and to a place, a people, a heritage."[2] But here Said asks, "What is there worth saving and holding on to between the extremes of exile on the one hand, and the often bloody-minded affirmations of nationalism on the other? . . . Are they simply two conflicting varieties of paranoia?"[3] Said does not answer this question, but to ask it suggests that between the anecdotal expression of "personal feelings" and the abstractions of political discourse we must interpellate the discursive space of that "other locality" of which Freud spoke—that place, as Jacques Lacan put it,

"between perception and consciousness." The term *paranoia* has of course passed from psychoanalysis into everyday use, but the "ordinary language" sense of the word generates little of interest in answer to Said's question. In everyday use, "paranoia" means "a feeling of persecution unjustified in reality." Insofar as the exile has, in Said's own words, been "torn . . . from the nourishment of tradition, family and geography" then the feeling of persecution is surely justified. As for nationalism, it depends on the case, but there are instances where such a feeling would be equally justified. For example, the discourses of both Israeli and Palestinian nationalisms express feelings of persecution, for which both may legitimately argue a basis in reality. Some might judge one of these realities to be now past, while the other remains present. But at this point we encounter precisely the necessity of understanding the term *paranoia* in its psychoanalytic setting. There is no "past reality" in the *psychical reality* that is the object of psychoanalysis. Freud puts it simply: "There is no time in the unconscious": the past event, whether actual or fictional, produces real effects in the present.[4] Said recognizes this when he defines exile as a "condition of terminal loss," which also acknowledges that the space of exile is a psychical space as much as it is physical. Before considering this space in its unconscious dimensions, however, we should first fix its coordinates in the space of instrumental reason.

The opposition "exile"/"nation" rests on a logic of exclusion/inclusion. According to this logic "exile" is not the only term that may appear opposite "nation." Said, for example, distinguishes between "exiles," "refugees," "expatriates," and "émigrés." The origin of exile, he observes, is in the ancient practice of banishment, which stigmatizes the exile as rejected. Refugees, he finds, are a byproduct of the modern state, political innocents united in bewilderment. Expatriates share the condition of the exile in all respects but one: having chosen to leave their homeland they are therefore free to return. The status of the émigré,

Said says, is "ambiguous": the émigré may once have been an exile but, like the European settler in Africa, Asia, or Australia, may have constructed a new national identity away from national origins. As one category of displaced subject tumbles on the heels of another in Said's text the term *exile*, no longer connoting fixity, comes to indicate a contingent resting place in a world in which today's exile may be yesterday's tourist. The subject positions Said mentions are in differing relations to their homeland but in the same relation to their host country: they are all "foreigners." One of Julia Kristeva's more recent books, *Etrangers à nous-mêmes*, is a book about the foreigner. She writes:

> To live with the other, with the foreigner, confronts us with the possibility . . . of *being an other*. It is not simply a matter—humanistically—of our aptitude for accepting the other, but of *being in his or her place*, which amounts to thinking of oneself and making oneself other than oneself. Rimbaud's "I is an other" was not only the avowal of the psychotic phantom that haunts poetry. The word announced exile, the possibility or the necessity of being foreign [*être étranger*] and of living in the foreigner's country [*vivre à étranger*], thus prefiguring the art of living in a modern era, the cosmopolitanism of the excoriated [*écorchés*].[5]

Kristeva here makes a mirror of the foreigner: to encounter the other in one's own space is to confront one's own alterity to that other's space. The phrase by Rimbaud she invokes, "I is an other," moreover perfectly describes the alienated identification that the infant makes in the "mirror stage," as described by Lacan. In further presenting Rimbaud's phrase as haunted by psychosis, as announcing exile and as "prefiguring the art of living in a modern era," Kristeva echoes Said's assimilation of exile to paranoia, makes this the common condition of us all, and associates the condition with a changed global space.

It is now a familiar observation that our subjective sense of the spatial relations ordering our world has undergone a historical mutation. The unprecedented speed of the locomotives and airplanes of modernity had the effect on the popular imagination of causing geographical space to shrink; extensive contact with other cultures nevertheless still entailed actual bodily displacement and was available to comparatively few. The space engendered by the communication technologies of postmodernity however, as Paul Virilio puts it, "is not a geographical space, but a space of time."[6] Historical events no longer simply "take place" in their immediate locality, but may be broadcast at the speed of light to simultaneously appear in a myriad other places. Jean Baudrillard has described the consequent tendency of historical reality to "disappear behind the mediating hyperreality" of the "simulacrum." In the classical mimetic theories of representation which dominated Western thought before modernism, the image was a mirror of reality—not of any contingent reality but an ordered reality, the anticipation of a perfected reality. Today that mirror has shattered. Its fragments, perpetually in motion, reflect nothing reassuring. The psychoanalytic concept of the mirror stage, which I have already mentioned and to which I shall return, has alerted us to the importance of our relation to the image in the formation of a coherent identity out of pre-Oedipal fragmentation and disorganization. From a Western world in which images were once limited in number, circumscribed in meaning, and contemplated at length, we have today arrived at a society inundated with images consumed "on the fly"—from glossy magazines, from photomats, video rental stores, broadcast and cable TV, communication satellites, and increasingly realistic computer simulations. Flipping and "zapping" through avalanches of books and journals, TV channels and CD-ROM, we are in turn bombarded by pictures not only of hopelessly unattainable images of idealized identities but also images of past and present suffering, images of destruction, of bodies quite literally in pieces. We are ourselves "torn" in the process, not only emotionally

and morally but in the fragmentary structure of the act of looking itself. In an image-saturated environment that increasingly resembles the interior space of subjective fantasy turned inside out, the very subject-object distinction begins to break down, and the subject comes apart in the space of its own making. As Terry Eagleton has written, the postmodern subject is one "whose body has been scattered to the winds, as so many bits and pieces of reified technique, appetite, mechanical operation or reflex of desire." Such fragmentation, decentering, and loss of subject-object boundaries, is characteristic of paranoia.

The term *paranoia* is derived from the Greek words for "changed reason" (*para*, *nous*) and originated in the Hippocratic school in the fifth century B.C. when the word was used to denote all manifestations of severe mental disorganization. There then intervened that period of Western history in which religious explanations of such mental states prevailed: for example, in the idea of demonic possession. The word *paranoia* returned to the medical literature in 1863 when the German psychiatrist Karl Ludwig Kahlbaum used it to speak of persecutory and megalomaniac delusions. Said may very well have had this picture in mind—persecution and megalomania—when he spoke of exile and nationalism as "two conflicting varieties of paranoia." By the end of the nineteenth century then the term *paranoia* was used in a restricted sense, the function of denoting the more general field of severe mental illness having passed to the word *psychosis*.[7] In his introduction to a recent collection of "Essential Papers on Psychosis" the editor remarks that although psychotic states have come to be "roughly grouped into two major categories, the affective psychoses and the schizophrenias," nevertheless their "aetiology and pathogenesis remain unknown." He remarks, for example, that the term *schizophrenia* has come to be used as if it signified a singular "disease" whereas in fact, "all that the term represents is a description of a cluster of symptoms which have no clear prognosis or definitional implications by themselves."[8] The psychoses are defined and classified therefore only

according to the symptomological pictures they present, to their "phe-nomenology." Patients who present symptoms that lie in the area of overlap between extant nosological categories have traditionally been termed "borderline cases." The clinically psychotic person, in everyday language, is "raving mad"; in extreme cases of paranoia the paranoiac is clearly and completely out of touch with reality. Psychoanalysis however recognizes only differences of degree between normal and abnormal psychology. Unconscious processes are the same in all of us, and we all experience psychotic states when we dream. Just as the neurotic who enters analysis may be only a step away from the neurotic who would never think of such a thing, at the other end of the spectrum the borderline case in analysis may be only a step away from institutionalization. In a recent paper the American psychoanalyst John Frosch has proposed that the comparatively vague term *borderline* be replaced by the expression "psychotic character." Frosch derives his diagnostic category from the presence of "ill-defined psychotic-like features" in patients who are "not clinically psychotic." The idea acknowledges the often intermittent and short-lived nature of psychotic episodes in otherwise normal, or normally neurotic, people. In looking at the paranoid process in more detail then we should bear in mind that to whatever extreme it may appear to take the subject, it is never far from "normal" psychology.

Freud's first substantial discussion of paranoia is in his long paper of 1911, "Psychoanalytic Notes on an Autobiographical Account of a Case of Paranoia (Dementia Paranoides)." The case is that of the German jurist Daniel Paul Schreber, who had the delusion that he had been chosen by God to restore the world to a lost state of bliss, and that in order to do this it was necessary that he be transformed into a woman in order that God might inseminate him. Schreber also believed that his doctor was conspiring against him to commit "soul-murder."[9] In an 1895 commu-nication to Wilhelm Fliess, Freud had proposed that paranoia is one of the "neuroses of defense" and that its mechanism is projection. In letters

to Sándor Ferenczi and Jung written thirteen years later (1908) Freud further hypothesized that the root of paranoia is in repressed passive homosexuality, a finding that both of his correspondents confirmed from their own case studies.[10] Freud finds that paranoia is to be defined in the *form* of the defense against the admission of homosexual desire. He writes: "It is a remarkable fact that the familiar principal forms of paranoia can all be represented as contradictions of the single proposition: '*I* (a man) *love him* (a man),' and indeed that they exhaust all the possible ways in which such contradictions could be formulated."[11] The "principal forms of paranoia" of which Freud speaks are: delusions of *persecution, erotomania*, delusional *jealousy*, and *megalomania*. All are derived from the different ways in which the proposition "*I love him*" may be denied. In the case of persecutory paranoia it is the verb that is contradicted; that is to say the proposition "I love him" is denied in the form "I *hate* him." However, Freud writes:

> The mechanism of symptom-formation in paranoia requires that internal perceptions—feelings—shall be replaced by external perceptions. Consequently the proposition "I hate him" becomes transformed by *projection* into another one: "*He hates* (persecutes) *me,* which will justify me in hating him." And thus the impelling unconscious feeling makes its appearance as though it were the consequence of an external perception.[12]

In the case of erotomania, it is the object of the sentence which is contradicted: "I love him" becomes "I love *her*"; this in turn, through projection, becomes "*She* loves me," and "she" in return is loved with a vengeance. Delusional jealousy contradicts the subject: "I love him" becomes "*She* loves him." Here, Freud comments, "distortion by means of projection is necessarily absent . . . since, with the change of the subject who loves, the whole process is in any case thrown outside the self."[13]

Finally, in megalomania, the basic proposition is denied in its entirety and becomes, "I do not love anyone," but, "since, after all, one's libido must go somewhere, this proposition seems to be the psychological equivalent of the proposition: 'I love only myself.'"[14]

After Freud the next substantive contribution to the psychoanalytic description of psychosis came from the work of Melanie Klein. It is often observed that much as Freud discovered the child in the adult, so Klein found the infant in the child. Klein's primary innovation, apart from her therapeutic technique, was her description of the infant's internal "object" world.[15] We are familiar with such expressions as "a lump in the throat," or "butterflies in the stomach"; we are also accustomed to hear that hunger "gnaws" at the stomach, or fear "grips" the heart. In these examples from ordinary language, bodily sensations are identified with actual entities, endowed with an agency of their own, either benevolent or malevolent. As adults we employ such metaphors without abandoning our knowledge of actual physiology. The infant however has no such knowledge, its primitive understanding of its own bodily feelings is its only reality. What we call "milk" the infant may experience, after feeding, as a benevolent object that emanates bliss. This object is destined to fade. Hunger will take its place—a malevolent agency bringing destruction of the "good object" and pain. What Klein calls the "object," then, is the fantasmatic representation of the phenomenological form of the infant's earliest bodily experience, experience centered upon orality. In his book *The First Year of Life*, René Spitz emphasizes the primacy of the oral phase in human development. He writes, "All perception begins in the oral cavity, which serves as the primeval bridge from inner reception to external perception."[16] Jean Laplanche observes that in these earliest months of life, "There is a sort of coalescence of the breast and the erogenous zone . . . the breast inhabits the lips or the buccal cavity." In Klein's description, this primitive oral world splits in the experience of loss of the breast. The "breast" here does not correspond to the anatomical organ but is the name

given to that constellation of visual, tactile, kinaesthetic, auditory, and olfactory memory-traces that serve as the psychical representatives of the experience of somatic satisfaction. From the physiological ingestion of the milk, then, we pass to the psychological incorporation of an "object." More specifically, as Laplanche emphasizes: "We pass from 'ingest' not to 'incorporate' but to the couple 'incorporate/be-incorporated' [for] . . . in this movement of metaphorisation of the aim, the subject . . . loses its place: is it on the side this time of that which eats, or the side of that which is eaten?"[17] Devouring, being devoured: the violent poles of infantile experience often represented in the fantasies and play of small children and in adult horror films. In her paper of 1935, "A Contribution to the Genesis of Manic-Depressive States," Klein writes: "Quite little children pass through anxiety situations (and react to them with defence mechanisms), the content of which is comparable to that of the psychoses of adults."[18] In 1946, in "Notes on Some Schizoid Mechanisms," Klein names this stage of infantile development, belonging to the earliest months of life, the "paranoid-schizoid position." Klein's use of the term *position*, as Juliet Mitchell notes, "facilitates the making of a connection between adult psychosis and infant development—a 'position' is an always available state, not something one passes through."[19]

Klein's work forms the essential backdrop to Lacan's paper on the "mirror stage." The concept is well known to those familiar with critical theory. The mirror is not essential—any source of a simulacrum will do—but the infant at the mirror makes the most engaging picture. Somewhere between the age of six and eighteen months it gets the idea that the image is of itself. It is as if the infant (*infans*, without speech) has found the means to acknowledge, "Yes, that's me, over there," and, says Lacan, it "jubilates" in its own reflection. Catherine Clément gives the most succinct definition of the mirror stage: "the moment when one becomes oneself because one is no longer the same as one's mother."[20] The imago of a unitary ego, Freud's "body-ego," has coalesced out of

the primitive flux of the "body in pieces" in which, as Clément puts it: "[The infant's] body does not exist. It is a mere pile of parts. A piece of the mother's breast, a bit of skin, a fragment of shoulder, a part of a lip. It has no body of its own. At this early stage the child is a fragmented body, a violent body."[21] The mirror stage unifies these warring organic cantons and encloses them within a frontier: the psychocorporeal equivalent of the nation state. The bounded identity assumed in the mirror stage however is an *identification*, an alienation in the image of the other: "That's me, *over there*." Moreover the infant's self-image is a self-idealization; as Lacan writes, it "anticipates on the mental plane the conquest of the functional unity of [its] own body, which, at that stage, is still incomplete on the plane of voluntary motility."[22] The image of the mirror stage is a sort of prosthesis. It is incorporated by the infant to compensate for the disparity between its disunified experience of its own body and the apparent coherence and motor superiority of adults and older children. There is a sense, then, in which the infant is in competition with the introjected sense of its self. In his paper of 1948, "Aggressivity in Psychoanalysis," Lacan speaks therefore of the "primary identification that structures the subject as a rival with himself."[23] Lacan's concept of the mirror stage was extensively informed by his early studies of adult psychotics. Lacan trained as a psychiatrist; his thesis, written while he was a resident in a psychiatric clinic and published in 1932, is titled "On Paranoid Psychosis in Relation to the Personality." The subject of the thesis is a woman Lacan refers to as "Aimée," who had attempted to stab a celebrated Parisian actress. Aimée's ambition was to be a famous writer; for Aimée, the actress she attacked represented herself in the ideal form to which she aspired. Aimée had never quite drawn the line between herself and her mother, whom she never ceased to idealize. After the mother's death, Aimée displaced her feelings toward her onto a series of substitute female figures. The actress, the last in line of these, finally received the aggression that Aimée had never allowed herself to feel

toward her ideal ego, that composite figure in which her narcissism fused with her identification with her mother. More accurately: she had felt hostility but had refused to symbolize it. Refused access to the word, the aggression returned in the deed, in what psychoanalysis calls "acting out." In his thesis Lacan wrote: "In the form of her victim Aimée struck the exteriorisation of her ideal, as the perpetrator of a crime of jealous passion strikes the unique object of her hatred and her love."[24] In the year following the publication of his thesis Lacan contributed an essay to the surrealist journal *Minotaure* called, "Motifs of the Paranoid Crime (The Crime of the Papin Sisters)."[25] Léa and Christine Papin were domestic servants who for six years, in the words of the surrealists Paul Eluard and Benjamin Péret, "endured, with the most perfect submission, commands, demands, insults," until the day they "literally massacred their employers, tearing out their eyes and crushing their heads."[26] Léa and Christine were twins who had never really come to distinguish themselves from each other. The only other inhabitants of the house in which they lived were the mother and daughter couple they served as maids. As Clément comments, "Christine had been so close to Léa that she could only project her hatred along with Léa onto another female couple. Aimée, on the other hand, would take some time to work out the amorous hatred that she secretly bore toward her alter ego, and the forms taken by the fantasies derived from this hatred became increasingly remote from their original object."[27]

Aimée was inseparable from her mother. Christine and Léa were similarly inseparable. Clément reports that one of the women to whom Aimée subsequently became attached had the opinion that Aimée was "masculine." Christine said she was certain that in another life she was intended to be Léa's husband. We will recall that Freud found the cause of paranoia in repressed homosexuality. According to his own findings however all heterosexuals necessarily harbor a repressed homosexual component of their sexuality—but not all of them become paranoid as a

result. There is another problem in Freud's account. He says that the characteristic mechanism of paranoia is projection, but the case of Schreber leads him to explicitly question his previous ideas about the functioning of this mechanism. He writes: "It was incorrect to say that the perception which was suppressed internally is projected outwards; the truth is rather, as we now see, that what was abolished internally returns from without."[28] As Lacan is later to express it, in his own terms, "what has been foreclosed from the Symbolic reappears in the Real." The concept of foreclosure represents Lacan's summary of Freud's attempts to describe a defense mechanism specific to psychosis. The foreclosed element has never gained access to the discourse of the subject, it can therefore be neither repressed nor projected. When the foreclosed element "returns" it returns not to the symbolic but to the real, in the form of a delusion or hallucination. Freud found paranoiacs to be "people who have not freed themselves completely from the stage of narcissism." In Lacan's account the paranoiac is fixated at the narcissistic mirror stage, the pre-Oedipal stage of the ideal ego. This fixation will entail the foreclosure of sexual difference. Freud's use of the term *homosexuality* presupposes a subject who has knowledge of sexual difference and is therefore certain of his or her sexual identity. In the paranoid episode however the subject regresses to a stage where there is no such certainty. The apparently homosexual object choice in paranoia therefore is an epiphenomenon of the autoerotism of this stage. In 1953 Schreber's translators, Ida Macalpine and Richard Hunter, published a paper in which they explicitly rejected the idea that the repression of homosexuality is at the origin of paranoia.[29] Lacan writes of Macalpine, "Her critique of the cliché . . . is masterly. . . . Homosexuality, supposedly a determinant of paranoiac psychosis, is really a symptom articulated in its process."[30]

Paranoiacs do not clearly differentiate themselves from other people and things. Their speech does not coincide with their identity; they speak as if they were an other, or simply an object in a world of objects. They

have lost the illusory but necessary sense of transcendence that would allow them to position themselves at the center of their own space. In her essay "Space, Time, and Bodies," Elizabeth Grosz writes: "It is our positioning within space, both as the point of perspectival access to space, but also as an object for others in space, that gives the subject any coherent identity." The matrix of space is the body. Grosz continues: "The subject's relation to its own body provides it with basic spatial concepts and terms by which it can reflect on its own position. Form and size, direction, centredness (centricity), location, dimension and orientation are derived from the perceptual relation the subject has to and in space."[31] Subjectivity "takes place" in corporeal space. "The ego," says Freud, is "a mental projection of the surface of the body." The psychical representations of the body and the space it inhabits first form under the anarchic hegemony of the drives. The unitary body does not yet exist, there is only the borderless space of the body in fragments described by Klein. If we want a picture of this space, Lacan suggests: "We must turn to the works of Hieronymous Bosch for an atlas of all the aggressive images that torment mankind."[32] In the mirror stage the child anticipates its future coherence in an act of identification. However, as Edith Jacobson expresses it, such early identifications are founded on

> fusions of self and object images which disregard the realistic differences between the self and the object. They will find expression in illusory fantasies of the child that he is part of the object or can become the object by pretending to be or behaving as if he were it. Temporary and reversible in small children, such ideas in psychotics may turn into fixated, delusional convictions.[33]

In psychosis boundaries fail, frontiers are breached. In psychotic space an external object—a whole, a part, or an attribute of a person or thing—may be experienced as if it had invaded the subject. In his *Memoirs of My*

Nervous Illness, Schreber writes: "From the first beginnings of my contact with God . . . hardly a single limb or organ in my body escaped being temporarily damaged by miracles . . . my *lungs* were for a long time the object of violent and very threatening attacks . . . the *gullet* and the *intestines* . . . were torn or vanished repeatedly."[34] The sense of being invaded may be projected onto some larger screen than that of the psychotic's own body; the threat may be seen as directed against some greater body with which the psychotic identifies: for example, the "body-politic" of nation, or race. Psychosis, moreover, may be infectious. Speaking of the trial of the Papin sisters, Lacan remarks: "One has heard in the course of the debates the astonishing affirmation that it was impossible that two beings should both be struck, together, by the same madness. . . . This is a completely false affirmation. Joint deliriums [*les délires à deux*] are amongst the most ancient of known forms of psychosis."[35] In the age of the intimate address of the national imago to its counterpart before a television screen, the *folie à deux* may take on national proportions.

The same logic that generates the opposition "exile"/"nation" across national frontiers may oppose one racial group to another within national borders. History has familiarized us with the insidious movement in which "nation" is confused with "race." Institutionalized racism may ensure that racial minorities live in a condition of internal exile within the nation of which they are citizens—an exile that, if it is not legal, cannot be named. Roland Barthes once defined the bourgeoisie as "the social class which does not want to be named." He writes, "Politically, the haemorrhage of the name 'bourgeois' is effected through the idea of *nation* . . . today the bourgeoisie merges into the nation."[36] By refusing to be named, the bourgeois class represents itself and its interests as a universal norm, from which anything else is a deviation. In the West the Caucasian race has in effect "exnominated" itself in the word *White.* Whether or not there is any scientific justification for Johann Friedrich Blumenbach's term

Caucasian, it does at least have the advantage of simply naming one racial category amongst others. *White* however has the strange property of directing our attention to color while in the very same movement it exnominates itself *as* a color. For evidence of this we need look no further than to the expression "people of color," for we know very well that this means "not White." We know equally well that the color white is the higher power to which all colors of the spectrum are subsumed when equally combined: white is the sum totality of light, while black is the total absence of light. In this way elementary optical physics is recruited to the psychotic metaphysics of racism, in which White is "all" to Black's "nothing"—as in the attitude of those white colonialists Hélène Cixous speaks of, who live in a country they have stolen "as if the eyes of their souls had been put out."[37] To speak of the color of skin is to speak of a body. "People of color" are embodied people. To have no color is to have no body. The body denied here however is a very particular body, it is the abject body: the body that defecates, vomits, and bleeds; the entropic body that dies. In Kristeva's account, infantile abjection of the maternal body is the irreducible imperative that impels any subject whatsoever toward its necessary identity. Abjection, establishing the first line of demarcation, is the zero degree of identity; as inevitable as it is beyond reason, it cannot be explained. The paranoid racist subject, seeking to take its place on the "clean and proper" side of abjection, has refused to symbolize the abject within itself. It has foreclosed its abject body only to have this body return to it in the form of the "dirty Jew," the "dirty Italian," and "people of colour"—or as an American colleague once said to me about the English, "They're a people who think their shit doesn't smell."

I have noted the tendency for "nation" to be confused with "race." Nazism is the most horrific example, but there are many others. At the end of the First World War, the armies of each of the allied nations marched in a victory parade in the Champs Elysées. The Harlem

Hellfighters were a battalion of Black American soldiers. Highly decorated, they served longer than any other American unit and were the first allied unit to reach the Rhine. They were not allowed to march in the victory parade.[38] Clearly it was felt that there would be something wrong with the picture of America that this would present. In *The Four Fundamental Concepts of Psycho-Analysis*, Lacan tells an anecdote about a day when he, "a young intellectual," was out in a small boat with "a few people from a family of fishermen." As they were waiting for the moment to pull in the nets, one of the fishermen pointed out to Lacan something floating toward them on the waves. It was a sardine can, glittering in the sun. "You see that can?," said the fisherman, "Well, it doesn't see you!" The fisherman found the incident highly amusing, Lacan "less so." Searching for the reason for his discomfort, it occurred to Lacan that "in a sense" the can *was* looking at him, and that from the can's point of view—that is to say, from the position represented by the reflected point of light—Lacan "looked like nothing on earth . . . rather out of place in the picture."[39] A young bourgeois among workers, we might say, "his face didn't fit." On an afternoon in November of 1988, Karen Wood, a White woman from Binghamton, New York, was killed by a rifle bullet as she stood in the backyard of her new home in Bangor, Maine. The man who shot her was a local hunter, who said he believed he had seen a deer. According to an article in the *New York Times*[40] the man was obviously criminally negligent, in clear contravention of Maine laws governing hunting, and liable in Maine law to prosecution for manslaughter. However, he was not prosecuted. The *Bangor Daily News*, referring to the shooting as "a double-tragedy," reflected overwhelming local sympathy for the man. The newspaper criticized the victim for wearing white gloves in her garden, as these may have made the man think he saw a white-tailed deer. Another local journalist wrote that if Karen Wood "had been wearing one piece of blaze-orange clothing, she'd be alive today." The consensus expressed in readers' letters to local newspapers was that

"out-of-staters ought to learn a thing or two about Maine's traditional way of life." On a night in August of 1989, Yusuf K. Hawkins, a Black teenager, was shot to death by White teenagers as he was on his way to look at a secondhand car in the Bensonhurst section of Brooklyn. Hawkins was from a mainly Black neighborhood of the East New York section of Brooklyn; Bensonhurst is predominantly White. *New York Times* journalists noted that many Bensonhurst residents expressed sympathy for the killers, reporting a White teenage girl on the scene as telling them, "The black people don't belong here. This is our neighborhood."[41] A racist decision by the military; an unkind joke; a tragic accident; a vicious murder. Certainly, it makes no sense in common sense to juxtapose these incidents. Nevertheless each incident may be seen as exemplifying the more or less aggressive defense of a space perceived as violated by an invader. Common sense, reason, is not at issue. What a situation may be in reality is quite simply disregarded by unconscious processes. Speaking of Aimée, Clément remarked, "The forms taken by the fantasies derived from [her] hatred became increasingly remote from their original object." Psychical space may have much the same relation to real space that the dream has. In another *New York Times* story I read of two communities in the town of Malverne, New York: one mostly Black, the other mainly White. The reporter writes, "The two are divided by Ocean Avenue, and residents on both sides refer to the other as 'over the ocean.'"[42] In this example, and in the extreme case, the clinically paranoid person would quite simply *see* an ocean, in a less marked paranoid attitude the subject would behave exactly *as if* there were an ocean—with all the absolute territorial imperatives, all the patriotic moral fervor attached to the defense of the motherland, that this could invoke.

Moral fervor is frequently a characteristic of racism, and the morality is generally sexual. There has been no more strident call to White racist arms than that of the "defense" of White women. The mobilizing fantasy image of this particular racist discourse is that of the sexual

penetration of a body. The image seems to be one of invasion, the fantasy seems to be paranoid. We should however distinguish between two forms of the perceived threat: rape and seduction. One is invasive, the other is not. Even in the former case the structure seems neurotic rather than psychotic, seems more likely to involve repression rather than foreclosure. The White male racist who fantasizes a White woman's rape by a Black man might be seen as defending himself against his own aggressive sexual impulses. He represses the fantasy in which he himself is a rapist; the emotional investment in the unconscious fantasy forces it back into consciousness but now in an acceptable disguise: the rapist is identified as Black, absolving the subject of the fantasy of any culpability in the imaginary crime. Moreover the violence of the fantasy, as it may now lay claim to moral justification, can be unleashed in its full force ("projection" here may take on a deadly physical materiality). The racist's fear that the White woman may be seduced by the Black man however suggests delusional jealousy—a paranoid, rather than neurotic, symptom. It is the inverted form of his fear that the woman will actively seduce the man—which in turn is derived from the White's jealous envy of the Black, an unconscious envy untouched by statistics on unemployment or death rates. As a small child at school, in the late 1940s in the industrial North of England, I was told that there were three types of people in the world: those who lived in very cold climates, those who lived in very hot climates, and those like ourselves who lived in temperate climates. The people in cold climates had to work so hard just to stay alive that they never had time to create things, as a consequence they had no civilization. Those who lived in hot climates on the other hand were so well provided for by nature that they never had to work at all, they ate the fruits that fell into their laps and enjoyed their leisure. Needless to say, they had no civilization either. People in temperate climates however, people like us, had to work hard to feed themselves, but not so hard that they never had time to work at other things. That

was why people like us had created civilization. I distinctly remember the envy I felt toward the people of the hot climates. It was a guilty feeling, as I knew I was supposed to feel proud to be a temperate and civilized person. Today I see that my teacher had communicated his own unconscious envy and guilt to me; it cannot have been much fun being a schoolteacher in a working class neighborhood of a bomb-ruined steel town in austere postwar Britain. The Garden of Eden my teacher created for the people of the hot climates, the people "over the ocean," was a Garden of Earthly Delights: a paradise where pleasure came as easily as the fruit on the trees, and one never lost one's appetite. Jealous envy is an unavoidable component of our relation to the other, the one who is different, who knows something we do not, who experiences things we shall never know. There is always something we want, and it is easy to believe that the other has it. In Spike Lee's film, *Do the Right Thing*, Mookie, the Black employee of "Sal's Famous Pizzeria," has the following exchange with Pino, Sal's White racist son:

Mookie: Who's your favorite basketball player?

Pino: Magic Johnson.

Mookie: And not Larry Bird? Who's your favorite movie star?

Pino: Eddie Murphy.

Mookie: Last question: Who's your favorite rock star?

(*Pino doesn't answer.*)

Mookie: Barry Manilow?

(*Pino's brother Vito supplies the answer.*)

Vito: It's Prince. He's a Prince freak.

Mookie: Sounds funny to me. As much as you say nigger this and nigger that, all your favorite people are "niggers."

Pino: It's different. Magic, Eddie, Prince are not niggers, I mean, are not Black. I mean they're Black but not really Black. They're more than Black. It's different.

Mookie: Pino, I think secretly that you wish you were Black. That's
 what I think.[43]

Mookie has spotted Pino's envy. The exchange might have taken place
in an analysis, albeit Mookie's technique would probably be judged overly
interventionist. But if Pino has now accepted his admiration of Black
achievements why is it that his racism remains intact? As already noted,
from infancy onward the formation of an identity takes place through a
series of identifications with others, alienated ideal models "to which the
subject attempts to conform."[44] The mirror stage shows us the primacy
of the visual image in this process. Our media-saturated environment
provides an almost limitless choice of images that may serve to represent
the ideal. Just as Aimée identified with a series of women celebrities, Pino
identifies with a chain of literally spectacular Black men—"magic" and
"princely" men who would not be found sweeping the sidewalk in front
of a pizzeria (one of the unheroic tasks assigned to Pino by his father).
As passive spectator to his Black heroes' media-amplified activity, Pino
has adopted a "feminine" attitude. In order to fully assimilate his self-
image to the model of his ideals, and to regain the aggressively "mas-
culine" identity required of a young man of his class and ethnic back-
ground, he must foreclose their difference from him, of which Blackness
is the privileged signifier. Blackness, foreclosed in the symbolic, returns
in the real as the defining attribute of his persecutory bad object, the
"nigger." Pino's racism then, far from being expunged by his love for
Black entertainers will only intensify, for his hostility draws its strength
from his jealous admiration.[45]

 This is not to "psychoanalyze" Pino—that would be preposterous (not
least because he is a fictional character). By definition, a psychoanalysis
entails a proper clinical setting in which an adequately experienced analyst
gains access to a wide range of detailed materials over a long period of

time. This is rather an instrumental use of psychoanalytic theory. I began with a now familiar situation in which someone writing in the area of critical theory of culture—"cultural studies"—uses psychoanalytic terminology in a text from which psychoanalytic theory is, in any substantive sense, absent. The recourse to such terms is nevertheless meaningful. In Said's text I saw the use of the term *paranoia* as marking the place of a caesura between personal anecdote and political discourse. Taking Said at his word, I have begun to look at nationalism, at racism, *as if* they might indeed be paranoid structures. Psychoanalytic theory here functions as a heuristic device, a means to reinscribe a *space between* positions that have become frozen in opposition.[46] There are good reasons why debates over nationalism and racism are emotive, consequently they often generate more heat than light. We cannot afford to dispense with any source of illumination by which we may examine the images—real and fantasmatic—across which we construct our conflict-ridden identities. The conflict that flares into violence in Spike Lee's film is precisely over images, identities. On the walls of Sal's Famous Pizzeria are photographs of Italian American celebrities. Buggin' Out wants to see some Black faces on this wall of fame. Sal defends his own sovereign space. In this territorial dispute however neither party may claim original rights. When the sons of émigré Italians confront the descendants of abducted Africans in Sal's Pizzeria they do so in a Black and Hispanic district with a Dutch name, which was stolen from Native Americans. Most of us know the melancholy tension of separation from our origins. Said defines exile as a "condition of terminal loss." Kristeva chooses a more painful image to express this loss: she sees exile as the "cosmopolitanism of the excoriated." Excoriation, the loss of one's skin: violent image of the destruction of that first and last barrier between the ego and paranoiac space.

In her book about Walter Benjamin's Paris arcades project, Susan Buck-Morss tells the story of how, in 1924, . Benjamin traveled to Italy "in order to bring to paper his [thesis] *The Origin of German Tragic Drama*, with which he hoped to secure an academic position at the University of Frankfurt."[1] This was the year of Lenin's death, and the year of the first surrealist manifesto. An eventful year in politics and art, it was no less eventful for Benjamin's personal life. In Italy he met, and fell in love with, Asja Lacis, "a Bolshevik from Latvia, active in post revolutionary Soviet culture as an actress and director, and a member of the Communist Party since the Duma revolution."[2] In 1928, having failed to win the approval of the university, *The Origin of German Tragic Drama* was nevertheless published.[3] Benjamin dedicated it to his wife, from whom he separated that same year. In this same year Benjamin also published *One Way Street*,[4] a montage of textual fragments in which he juxtaposes observations on everyday life with descriptions of his dreams. One of the longer fragments is titled: "Teaching Aid—Principles of the Weighty Tome, or, How to Write Fat Books."[5] *One Way Street* is not a Weighty Tome. No academic monument, it has more the appearance of a city plan: avenues of open space cross its pages, between compact and irregular blocks of text. Benjamin's dedication to *One Way Street* reads:

This street is named

Asja Lacis Street

after she who

like an engineer

cut it through the author

I

When, in 1924, Benjamin first told Lacis about the academic thesis he was
working on, her horrified response was: "Why bury oneself with dead
literature?"[6] In Benjamin's subsequent production, funerary construction
gives way to a lighter and more open textual architecture. When, in 1925,
he and Lacis wrote an essay together about the city of Naples, the central
image (which Susan Buck-Morss tells us was "suggested by Lacis") is that
of "porosity." Naples rises where sea meets cliff. Lacis and Benjamin
write:

> At the base of the cliff itself, where it touches the shore, caves have
> been hewn. . . . As porous as this stone is the architecture. Building
> and action interpenetrate in the courtyards, arcades, and stair-ways.
> In everything they preserve the scope to become a theater of new,
> unforeseen, constellations. The stamp of the definitive is avoided. No
> situation appears intended forever, no figure asserts its "thus and not
> otherwise." This is how architecture, the most binding part of the
> communal rhythm, comes into being here.[7]

Benjamin and Lacis find that: "Buildings are used as a popular stage. They
are all divided into innumerable, simultaneously animated theaters. Bal-
cony, courtyard, window, gateway, staircase, roof are at the same time
stage and boxes."[8] Or, again: "Housekeeping utensils hang from balco-
nies like potted plants. . . . Just as the living room reappears on the street,
with chairs, hearth, and altar, so . . . the street migrates into the living
room."[9] The permeability that Lacis and Benjamin saw in the streets of
Naples is also to be found in *One Way Street,* a street that will eventually
lead to the *Passagen-Werk.* We will remember that Benjamin named this
street *Asja Lacis Street,* "after she who, like an engineer, cut it through
the author." Just as Benjamin recounts his dreams in *One Way Street,* so

his laconic dedication to the book is itself a dream image: the image of a book that is a city street, cut through the body of the author by his lover. Benjamin's written body is penetrated by Lacis, just as the body of what might have been *his* text on Naples became porous, translucent, permeable to *her* voice. The lapidary inscription commemorates an erotic event in which the categorical distinctions that separate body, city, and text dissolve.

The (con)fusion of representations of body and city has a history. In the third book of Vitruvius, dedicated to the design and construction of temples, the Roman architect describes how the outstretched limbs of a "well-formed man" subtend the circle and the square. The purpose of the description—the basis of a widely known drawing by Leonardo da Vinci—is to urge that buildings should display the same harmonious relation of parts to whole as Vitruvius found in the human form.[10] The body is not simply that which is to be contained by a building, the body *contains* the very generating principle of the building. In an article of 1974,[11] Françoise Choay describes how, in the work of Alberti and other architect-theorists of the Italian Renaissance, the Vitruvian doctrine was woven into a mythology of origins. For example, Humanist authorities wrote that the first men derived their units of measurement from the palms of their hands, their arms, and their feet. Or again, that Adam, driven from the Garden of Eden, protected himself from the rain by joining his hands above his head—a gesture that subsequently led him to construct the first roof. That the human body is seen as the origin not only of the building, but of the entire built environment, is apparent from the descriptions and drawings of anthropomorphized cities that appear in illustrated books during the Renaissance. Choay describes an image from a book by Francesco di Giorgio Martini as showing:

> a personage whose head is adorned with a fortress which he supports with his arms. His body is inscribed in a rectangle marked *città*. His

legs are spread, and his feet and elbows are figured by towers. His navel marks the center of a circular public place, on the periphery of which is situated the principal church.[12]

Such fantasy constructions were already implied in the writings of Alberti, who had found that "the city is like a large house and the house like a small city,"[13] but that ultimately, "every edifice is a body."[14]

If, in Renaissance Italy, the city could be conceived of as a body, it was because the city had recently coalesced from a condition in which it was virtually undifferentiated from the countryside. In a book of 1974, translated in 1991 as *The Production of Space*, Henri Lefebvre observes:

> The city in Vitruvius is conspicuous by its absence/presence; though he is speaking of nothing else, he never addresses it directly. It is as though it were merely an aggregation of 'public' monuments and 'private' houses. . . . Only in the sixteenth century, after the rise of the medieval town (founded on commerce, and no longer agrarian in character), and after the establishment of 'urban systems' in Italy, Flanders, England, France, Spanish America, and elsewhere, did the town emerge as a unified entity—and as a *subject*.[15]

The text in which Alberti inaugurates the concept of the corporeal city[16] postdates, by about fifteen years, his treatise on painting, *De Pictura*, which contains the first written description of a method of drawing in linear perspective. Perspective provided, quite literally, the "common ground" on which the identification of architectural space with corporeal space could "take place." In the Renaissance, the inaugural act in constructing a painting was to lay out the horizontal plane that united the illusory space of the image with the real space of the viewer. This is the familiar grid of receding squares, accelerating toward a vanishing point,

which in many paintings rises to the finished surface thinly disguised as a tiled floor. The side of each square in the underlying perspective grid represented a common unit of measurement, the *braccio*, equivalent to one-third of the height of a standing man. By this means, the correct stature of a depicted figure could be determined relative to any point in the illusory depth of the represented space. The size of all other objects — not least the built environment — could then be determined by reference to this common corporeal measure. Man, here, is literally "the measure of all things." For all that the erect male body may have been at the origin of this space, however, it quickly ceded its place to its disembodied metonymic representative, the eye — in what Lefebvre calls "the spiriting-away or scotomization of the body."[17] As a consequence, as Luce Irigaray remarks, "Man no longer even remembers that his body is the threshold, the porch of the construction of his universe(s)."[18]

At the dawn of modernity, disembodied geometric and mathematical principles came to dominate all visual representational practices. The same abstract order that informed painting and architecture was brought to enhance the instrumentality of such things as navigational charts, maps, and city plans. In conformity to the exigencies of a militant and expansive mercantile capitalism, the image of the convergence of parallel lines toward a vanishing point on the horizon became the very figure of Western European global economic and political ambitions. This optical-geometric spatial regime — the panoptical-instrumental space of colonialist capitalist modernity — would govern Western European representations for the ensuing three centuries. It has been widely remarked that this representational space, inaugurated in the Renaissance, entered into crisis in the early part of the twentieth century. We have become familiar with the arguments from industrialization, urbanization, and technology: Fordism and Taylorism, factory town and garden city, steam train and airplane, telephone and radio, all were implicated in a changed "common sense" of space. On the basis of the "artistic" evidence, also, few would disagree

that the early twentieth century was a time of major change in Western representations of space, and space of representations. Exhibits presented in evidence here typically include such things as analytical cubism, the twelve-tone scale, jazz, and Bauhaus design. It is in terms of such arguments that I understand Lefebvre when he writes: "Around 1910 a certain space was shattered. It was the space of common sense, of knowledge [savoir], of social practice, of political power . . . the space, too, of classical perspective and geometry . . . bodied forth in Western art and philosophy, as in the form of the city and town."[19] Lefebvre also observes, however, that "'common sense' space, Euclidean space and perspectivist space did not disappear in a puff of smoke without leaving any trace in our consciousness, knowledge or educational methods."[20] A certain space was shattered, but nevertheless it did not disappear. The "nevertheless" does not signal that disjunction between knowledge and belief to which Freud gave the term *Verleugnung*, "disavowal." For our terminology here, we might better turn to Mao Tse-Tung: the relation between the existing instrumental space of political modernity and the emergent space of aesthetic modernism is one of "nonantagonistic contradiction."

II

Benjamin and Lacis, themselves out of place in Naples, found all things in Naples to be dis-located, as when "the living room reappears on the street." This particular image, retrospectively determined by a short history of surrealism, returns in Benjamin's long essay of 1938 about Paris at the time of Baudelaire. Here, Benjamin remarks on the tendency of the *flâneur* to "turn the boulevard into an *intérieur*." He writes: "The street becomes a dwelling for the *flâneur;* he is as much at home among the façades of houses as the citizen is in his four walls. To him the shiny, enameled signs of business are at least as good a wall ornament as an oil painting is to a bourgeois in his salon."[21] This passage, in retrospect, helps to reveal

a fundamental ambiguity both in Lacis and Benjamin's essay about Naples and in Benjamin's dedication to *One Way Street*. The *flâneur* who turns the street into a living room commits an act of transgression which reverses an established distinction between public and private spaces. Benjamin and Lacis, however, saw the porosity of urban life in Naples as the survival of precapitalist social forms that had not yet succumbed to the modern segregation of life into public and private zones. Again, Benjamin's terse dedication to *One Way Street* pictures a fusion of spaces in the same instant that—through the image of penetration—it asserts the individual integrity of those spaces. Like an arrested filmic lap-dissolve, which refuses to decide either origin or destination, the image forms through condensation. It also forms through displacement to, or from, the image of Baron Georges-Eugène Haussmann's infamous *percements* that ripped through working-class districts of Paris like the cannon fire they were designed to facilitate.[22] An ambivalence inhabits this textual fragment: as if two different spaces—one sealed, the other permeable—compete to occupy the same moment in time. In both the essay on Naples and the dedication to *One Way Street*, the metaphor of porosity competes with a dialectic of interior and exterior which belongs to a different register. This ambivalence marks the representational space of modernism in general.

One of the most visible images of the modern dialectic of interior and exterior is the wall of steel and glass, of which the glass and iron structures of the Paris arcades are a prototype. We may take the specific example of the administrative office, for a model factory complex, built by Walter Gropius and Adolf Meyer for the Werkbund exhibition in Cologne in 1914. As Richard Sennett has described it:

> In this building you are simultaneously inside and outside. . . . From the outside you can see people moving up and down between floors. . . . You can see through walls, your eyes move inside to outside, outside to inside. The confines of the interior have lost their

meaning. . . . Gropius and Meyer have used glass in and around the doors so that you can literally look through the building to people entering from the other side. . . . Inner and outer become apparent at once, like the front and side of a cubist portrait.[23]

It is no doubt this sort of "image of the modern"[24] that Benjamin has in mind when he celebrates "the twentieth century, with its porosity, transparency, light and free air."[25] The modernist architect to whom he pays explicit hommage, however, is not Gropius but Le Corbusier, the designer of the "radiant city."[26] Le Corbusier's project of 1930 for the Ville Radieuse is the source of the now cliché perspectivist vision of urban modernity as made up of evenly spaced towers rising from a limitless expanse of park land. The project evolved from Le Corbusier's plan for the Ville Contemporaine, to contain three million people, which was exhibited in Paris in 1922. Kenneth Frampton describes the Ville Contemporaine as "an elite capitalist city of administration and control with garden cities for the workers being sited, along with industry, beyond the 'security zone' of the green belt encompassing the city."[27] We may remember, then, that as much as modernity is the locus of transparency in architecture, it is also at the origin of the social isolation in and between high-rise apartment houses, the death of the street as a site of social interaction, and the practice of "zoning," which establishes absolute lines of demarcation between work and residential areas, and between cultural and commercial activities. The transparent wall, used by such socialist modernists as Gropius to unite interior with exterior, was destined to become the very index of capitalist corporate exclusivity.

III

Lefebvre finds both that, around 1910, "a certain space was shattered" and that "it did not disappear." The phallocentric abstract space of capitalist

modernity survived to inhabit the representational space of aesthetic modernism. Indeed, it survives into the present day. It is not that one spatial formation was replaced by another. It is rather as if a superior "layer" of spatial representations itself became permeable, "porous," and allowed an inferior layer to show through. Lefebvre himself supplies the appropriate analogy. He notes that early in the genesis of a biological organism, "an indentation forms in the cellular mass. A cavity gradually takes place. . . . The cells adjacent to the cavity form a screen or membrane which serves as a boundary. . . . A closure thus comes to separate within from without, so establishing the living being as a 'distinct body.'" This "closure," however, is only ever relative: "The membranes in question remain permeable, punctured by pores and orifices. Traffic back and forth, so far from stopping, tends to increase and become more differentiated, embracing both energy exchange (alimentation, respiration, excretion) and information exchange (the sensory apparatus)." Closure, then, rather than belonging to the natural order, is a creation of the social order. Thus Lefebvre writes: "A defining characteristic of (private) property, as of the position in space of a town, nation or nation state, is a closed frontier. This limiting case aside, however, we may say that every spatial envelope implies a barrier between inside and out, but that this barrier is always relative and, in the case of membranes, always permeable."[28] The transgressional magic of the *flâneur* is to make the interior appear on the "wrong side" of its bounding wall, the wrong side of the façade. Certainly, the transformation is an illusion, but then the interior itself is an illusion—in a double sense. First, Benjamin points out that the bourgeois interior emerges into history, in the nineteenth century, as a reified fantasy:

> For the private person, living space becomes, for the first time, antithetical to the place of work. . . . The private person who squares his accounts with reality in his office demands that the interior be

maintained in his illusions. . . . From this springs the phantasmagorias of the interior. For the private individual the private environment represents the universe. In it he gathers remote places and the past. His drawing room is a box in the world theatre.[29]

In an essay about the domestic architecture of Adolf Loos, Beatriz Colomina writes:

> In Loos's interiors the sense of security is not achieved by simply turning one's back on the exterior and becoming immersed in a private world—"a box in the world theatre," to use Benjamin's metaphor. It is no longer the house that is a theater box; there is a theater box inside the house, overlooking the internal social spaces, so that the inhabitants become both actors in and spectators of family life—involved in, yet detached from their own space. The classical distinctions between inside and outside, private and public, object and subject, are no longer valid.[30]

To develop Colomina's insight, I would say that it is not that these distinctions are no longer valid, but rather that they have been displaced—as in the Paris arcades, which pierce the façade only to reproduce the façade in the form of glass entrails within the body of the building.[31] Further, Lefebvre's example of the biological organism would indicate that, in any real sense, the absolute distinction between interior and exterior can never be valid. It will always belong to "reality," never to the order of the Real. Here, then, is the second sense in which the interior is an illusion. Extending the analogy of the biological organism to the social space of the built environment, Lefebvre reminds us that an apparently solid house is "permeated from every direction by streams of energy which run in and out of it by every imaginable route: water, gas,

electricity, telephone lines, radio and television signals, and so on," and that similar observations apply in respect of the entire city. Thus, he writes: "As exact a picture as possible of this space would differ considerably from the one embodied in the representational space which its inhabitants have in their minds, and which for all its inaccuracy plays an integral role in social practice."[32] If the built environment is conceived of in terms of the body, then a different body is at issue here.

An Arnold Newman photograph from 1949 shows the components of a prefabricated house laid out on what appears to be the concrete runway of an airfield. Every shape in the intricate pattern of this carpet of components is equally visible. No hierarchy, formal or functional, governs the relations between the parts. Contiguity alone links wood, metal, and glass; frames, planks, and pipes. This is nothing like a house, yet nothing but a house. If the houses destined to be its neighbors had been laid out alongside, it would have been impossible to tell where one ended and the other began. At the beginning of his book of 1974, *Économie libidinale*, Jean-François Lyotard similarly lays out the surfaces of the body. In a long and violent passage, glistening with mucus and blood, he unfolds not only that which is seen, "the skin with each of its creases, lines, scars . . . the nipples, the nails, the hard transparent skin under the heel," but also the most intimate and deep interior linings of the body. Moreover, as nothing but proximity links one surface to another, we pass indiscriminately to other contiguous bodies. We pass, for example, from these lips to other lips, and to the lips of others. We pass from the palm of the hand, "creased like a yellowed sheet of paper," to the surface of an automobile steering wheel. Even further, Lyotard reminds us, we must not forget to add colors to the retina, or to add to the tongue "all the sounds of which it is capable," including "all the selective reserve of sounds which is a phonological system." All of this, and more, belongs to the libidinal body. This "body" bears no allegiance to what Lyotard terms the "political economy" of the organic. The "political body" is a hierarchically

organized assembly of constituent organs—jointly ruled by mind and heart—which seeks to resist death and to reproduce itself. It is a body clearly differentiated from other bodies, and from the world of objects. It is this body under the Law which may become the site of "transgression"—illustrated, for Lyotard, by a Hans Bellmer drawing in which a fold in a girl's arm stands in place of the crease of the vulva. It is not such transgressive metaphor that is at issue but a more corrosive metonymy. Lyotard writes: "We must not begin with transgression, we must immediately go to the very end of cruelty, construct the anatomy of polymorphous perversion, unfold the immense membrane of the libidinal 'body,' which is quite the inverse of a system of parts." Lyotard sees this "membrane" as composed of the most heterogeneous items: human bone and writing paper, steel and glass, syntax and the skin on the inside of the thigh. In the libidinal economy, writes Lyotard: "All of these zones are butted end to end . . . on a Moebius strip . . . a moebian skin [an] interminable band of variable geometry (a concavity is necessarily a convexity at the next turn) [with but] a single face, and therefore neither exterior nor interior."[33]

Gropius and Meyers's design for the 1914 Werkbund Exhibition may render interior and exterior mutually visible, but it does not thereby abolish the hierarchical distinction between the two: it is, after all, an administration building. The glass walls of the corporate towers that follow may be transparent, but they are no more porous than are their "glass ceilings." Such façades retain their classical function[34] of both leading the eye toward a vanishing point, or point of interest, and of marking a *boundary*. Lefebvre seems to leave the transparent wall out of account when he notes: "A façade admits certain acts to the realm of what is visible, whether they occur on the façade itself (on balconies, window ledges, etc.) or are to be seen *from* the façade (processions in the street, for example). Many other acts, by contrast, it condemns to obscenity: these occur *behind* the façade. All of which seems to suggest a 'psychoanalysis

of space.'"[35] The façade of which Lefebvre speaks here is opaque. By his account, if nothing is concealed then there is no need for psychoanalytic theory. This would be to reduce psychoanalysis to a theory of repression, but modern psychoanalysis is no more *necessarily* concerned with repression than the modern façade is necessarily opaque. Lefebvre's observation about the façade is the only passage where he suggests the possibility of a psychoanalysis of space. There are nevertheless many points in Lefebvre's complex and densely argued book where his ideas invite development in terms of psychoanalytic theory. Most fundamentally, he writes that space is "first of all *my* body, and then it is my body counterpart or 'other,' its mirror-image or shadow: it is the shifting intersection between that which touches, penetrates, threatens or benefits my body on the one hand, and all other bodies on the other."[36] The full psychoanalytic implications of such a remark—most obviously, in relation to Lacan's idea of the "mirror stage"—remain to be developed. Indeed, insofar as they apply to considerations of space, they are as yet little developed within the field of psychoanalysis itself.

IV

The problematic of space is encountered from the beginning of Freud's therapeutic practice and metapsychological theory: both in real terms, as in the question of the therapeutic setting, and in metaphorical terms, as in his topographical models of mental processes. It is perhaps because of this early ubiquity that the topic of space as such came to receive little, and late, direct consideration in psychoanalysis. To my knowledge, Paul Schilder's essay of 1935, "Psycho-Analysis of Space,"[37] is the first to address the topic explicitly and exclusively. Schilder finds that "space is not an independent entity (as Kant has wrongly stated) but is in close relation to instincts, drives, emotions and actions."[38] His remarks here anticipate an isolated work-note made by Freud in 1938: "Space may be

the projection of the extension of the psychical apparatus. No other derivation is probable. Instead of Kant's *a priori* determinants of our psychical apparatus. Psyche is extended; knows nothing about it."[39] Schilder's findings in respect of psychical space emerge from his work on, in the words of the title of his book of 1935 (a book that is one of the sources of Lacan's idea of the mirror stage), "the image and appearance of the human body."[40] In "Psycho-Analysis of Space" Schilder writes:

> There is at first an undifferentiated relation between an incompletely developed body-image and the outside space. Clearer differentiations take place around the openings of the body. There is a zone of indifference between body and outside world which makes distortions of body-space and outside-space by projection and appersonization possible.[41]

"Appersonization" is the process in which "we may take parts of the bodies of others and incorporate them in our own body-image."[42] In a pathological setting, such interchange of body parts is a characteristic of the "psychoses." Amongst what Freud calls the "defense psychoses," autism and schizophrenia bear most directly on the corporeal relation to external reality. In her book of 1972 on *Autism and Childhood Psychosis*, the British psychoanalyst Frances Tustin notes: "The common psychiatric division of psychotic children [is] into those suffering from Early Infantile Autism and those suffering from childhood Schizophrenia."[43] Tustin finds this distinction "too rigid." For expository clarity however, outside of a clinical setting, it is convenient to retain the distinction. Schematically, the terms *autism* and *schizophrenia* name the opposing extremities of a continuum of modes of psychocorporeal relation to external reality. The middle range of this schematic continuum would encompass "normal" socially acceptable ways of relating to the world. At one extreme limit, autism represents a total closing down of that relation: the autistic subject

may appear "dead to the world." At the opposite extreme, schizophrenia represents a total opening of the relation: to the extent that the schizophrenic body is scattered in pieces throughout its world. Both autism and schizophrenia are normal states of very early infancy, the time when there is as yet little substantive distinction between an outer world of "real" objects, and the inner world of those "objects" that are the psychical representations of sensations from, primarily, bodily organs and the mother's body. Pathological autism and schizophrenia represent a fixation at, or regression to, such early object relations. We should however remember that, as Freud remarks: "The frontier between the so-called normal states of mind and the pathological ones is to a great extent conventional, and . . . is so fluid that each one of us probably crosses it many times in the course of a day." As Octave Mannoni succinctly puts it: "We are all more or less healed psychotics."[44]

A book of drawings by Antonin Artaud, published in France in 1986,[45] is accompanied by an essay by Jacques Derrida which is, in effect, an extended reflection upon the rarely used French word *subjectile*—a word that appears, appropriately rarely, in Artaud's writings. The 1978 edition of the *Petit Robert* dictionary defines *subjectile* as "surface serving as support (wall, panel, canvas) for a painting." This is not how the term functions for Artaud. Rather, as Derrida notes, the *subjectile* is that which lies "between the surfaces of the subject and the object."[46] It is the place where may be traced "the trajectories of the *objective*, the *subjective*, the *projectile*, of the *introjection*, the *interjection*, the *objection*, of *dejection* and *abjection*, etc."[47] Derrida describes a graphic work by Artaud in which:

> with the aid of a match, Artaud opens holes in the paper, and the traces of burning perforation are part of a work in which it is impossible to distinguish between the subject of the representation and the support of this subject, in the *layers* of the material, between that

which is above and that which is below, and thus between the subject and its outside, the representation and its other.[48]

Reading this, I was reminded of a recurrent television news image: the image of a house, or apartment, whose walls have been pierced by rocket fire, or shells. For all its repetitions, the image never fails to "pierce" me. This has nothing to do with Barthes's *punctum*, nor the *studium*. This is neither a private nor an ethical reaction. Something quite different is at issue. Discussing the child's anxiety at being separated from its mother, Freud notes that at the origin of the distress is the child's perception of the mother as the one who will satisfy its needs. Thus, rather than being reducible simply to object loss, "The situation . . . which [the child] regards as a 'danger' and against which it wants to be safeguarded is that of a . . . *growing tension due to need*, against which it is helpless" (italics in the original). Even more fundamentally, regardless of need, anxiety derives from "the economic disturbance caused by an accumulation of amounts of stimulation which require to be disposed of. It is this factor . . . which is the real essence of the 'danger.'"[49] In the contemporary environment of mass media, particularly television, we are all of us subject to anxiety arising from, amongst other things, exposure to pain we are helpless to alleviate. The helpless distress we may feel— comparable to infantile "transitivism"—bears witness to the congenital instability of psychocorporeal boundaries which is at the source of both empathy and jealousy, compassion and aggression. It indicates the fragility and permeability, the porosity of the layers between one embodied subject and another. In the physical encounter, the porosity is of the boundary of skin which contains the body ego, the "skin ego."[50] In the mediatic encounter, there is permeability between "layers," such that interior and exterior, here and there, are simultaneously affirmed and confused. I am thinking of the corneal and retinal layers that both

receive and transmit the image; the phosphor-coated layer of glass that—in receiving the bombardment of electrons that encode the image—effectively pierces the layer, the screen that is the wall of my living room; the pierced layer of the wall *in* the image within or behind the television screen—within that building, behind that wall, where someone in their living room perhaps once watched television.

V

The Paris arcades of which Benjamin spoke, and the modernist buildings that they presaged, did not mark the emergence of a historically unprecedented space. Such examples rather represent the imperfect partial development of an image of space latent in all of us: the pre-Oedipal, maternal, space: the space, perhaps, that Benjamin and Lacis momentarily refound in Naples. In this space it is not simply that the boundaries are "porous," but that the subject itself is *soluble*. This space is the source of bliss and of terror, of the "oceanic" feeling, and of the feeling of coming apart; just as it is at the origin of feelings of being invaded, overwhelmed, suffocated. The generation of Europeans to which I belong grew up in a world of fixed borders, of glacial boundaries: frozen, it seemed for eternity, by the cold war. Now, in the time of thaw, borders everywhere are melting, sliding, submerging, reemerging. Identities—national, cultural, individual—are experiencing the exultant anxieties that accompany the threat of dissolution. Benjamin's Europe was one of strong borders, a fact that was to prove tragically fatal to Benjamin himself. Today's national borders are largely inconvenient to world capitalism—they have long been routinely ignored by transnational corporations and by a money market become a global computer network, operating at the speed of light. As weak and emergent nations struggle to maintain their faltering identities by drawing their borders more tightly around them, stronger established nations are losing the political will to effectively police their

uncertain limits. The boundaries of today's Europe are increasingly porous. The recent history of Germany is an example. A space in transition, it represents the economic and political equivalent of "osmosis"—the movement of a fluid through a semipermeable membrane, from the weaker to the stronger solution. However, as "The Wall" crumbled inside Germany, osmosis at Germany's borders—fluid transmissions from the weaker to the stronger economy—revived a pathological horror of mixing, the modern history of which has been so effectively cataloged by Klaus Theweleit.[51] The rhetoric of neofascism, by no means unique to Germany, sounds familiar—but it now resounds in a different space. Rhetoric, we may remember, was originally an art of space—of gesture and of staging—as well as an art of speech. The space of the stage, the antique source of perspectival space, has changed.

In explaining the principle of drawing in perspective, Leonardo asked his reader to imagine he were looking through a window and tracing the outline of what he saw upon the surface of the glass. Paul Virilio describes the television screen as "an introverted window, one which no longer opens onto adjoining space."[52] Today, the perspectivist's "window on the world," and proscenium arch, remain the habitual frames of our representations—even in television. But such means of circumscribing the mise-en-scène appear out of their time; dislocated remnants from another time, a sort of nostalgia. The truth of this is nowhere better seen than in the images of computer-generated "virtual" realities with which we have recently become familiar. Their impeccably Euclidean "wire-frame" spaces invoke nothing so much as illustrations from seventeenth-century treatises on perspective, creating much the same uncannily nostalgic effect as a polystyrene bowl that has been molded to bear the impression left in wet clay by a potter's fingers. Benjamin remarked that the arrival of photography in the nineteenth century "gave the moment a posthumous shock." Much of this shock was the shock of the uncanny: the strangeness of the automaton, the android, the replicant; the shock of the unfamiliar

familiarity of this new old representational space. The photograph, we are now accustomed to observe, lends itself easily to fetishism: that psychical structure that is the preferred commodity form of capitalism, the most favored psychoaesthetic currency in which modernity and "postmodernity" alike are traded. Photographs, therefore, are most amenable to "disavowal" as the mechanism by which we may defend ourselves against their more distressing (un)realities. As Mannoni expresses the form of disavowal, "I know very well, but nevertheless."[53] "I know very well that this (unpleasurable) reality exists/existed, *but nevertheless* here there is only the beauty of the print."[54] Since Laura Mulvey's influential essay "Visual Pleasure and Narrative Cinema,"[55] we have also become accustomed to the idea that fetishism is a predominant psychosexual structure of cinematic representation. The television image is rarely "beautiful" in the way of a photograph, or a cinematic shot,[56] nor does its evanescent mobility allow the petrification necessary for fetishistic investment. The regressive unconscious defense mechanisms invoked by television, as it funnels suffering and excitation into our box in the world theater, as it pours all the world's broken cities into our *interior*, are different from those invoked by photography and cinema photography. They produce a different space.

For all its "thick skinned" stupidity, television is also a fragile permeable membrane of near-global extension. Its web of instant mutable satellite links, indiscriminately crossing fixed meridians and old frontiers, has turned global space from a graph paper into a palimpsest. Virilio has remarked that both Benjamin and René Clair compared architecture to cinema, in that both address what Benjamin termed "simultaneous collective reception."[57] What Virilio finds of particular interest in this comparison is the implicit recognition of a historical transition from the representational priority of "surface" to that of "interface." Benjamin notes that Baudelaire described the inhabitant of the modern city as "a *kaleidoscope* equipped with consciousness," and that with the coming of

film, "perception in the form of shocks was established as a formal principle."[58] The subsequent arrival of television—also, like architecture, a technique of "simultaneous collective reception"—has massively consolidated this principle. In his essay of 1936, "The Work of Art in the Age of Mechanical Reproduction," Benjamin writes: "Our taverns and our metropolitan streets and offices and furnished rooms, our railroad stations and our factories appeared to have us locked up hopelessly. Then came the film and burst this prison-world asunder by the dynamite of the tenth of a second, so that now, in the midst of its far-flung ruins and debris, we calmly and adventurously go traveling."[59] Today, for more anxious, less adventurous, armchair travelers, the "far-flung ruins and debris" of exploded towns are routinely projected into our living rooms through the aperture of television. Television, "the box," is today's "box in the world theater"—so often a theater of war. For Virilio, it is television that has definitively marked the end of perspectival space, the orderly concatenation of façades. He writes: "The blind alley disappears into the superimposed vision of a . . . television that never turns off, that always gives and receives . . . all surfaces and all the pieces of a tele-topological puzzle."[60] All the surfaces and all the pieces of the body form a complex puzzle we were once required to solve in order to become human. Like the elements of a building, the completed puzzle-picture holds together more or less provisionally: here, cracks may run wild under a calm façade; there, they may shatter a transparent carapace; and other structures may endure only in mute and fearful isolation. Today, the autistic response of total withdrawal, and the schizophrenic anxiety of the body in pieces, belong to our psychocorporeal forms of identification with the teleto-pological puzzle of the city in pieces.

Film has finally attracted its own Muse. Her
name is Insomnia.

Hollis Frampton[1]

That which love worst endures, *discretion.*

John Donne[2]

In *La paresse*, Jean-Luc Godard's fifteen-minute contribution to the film *Sept péchés capitaux*,[3] Eddie Constantine plays an actor in B-movies who turns down an offer of sex from an ambitious young starlet. The reason he refuses, he tells her, is that he cannot bear the thought of—afterward—having to get dressed all over again. In a note on this short film, Alain Bergala observes:

> Eddie Constantine marvelously embodies that very special state given by an immense lassitude, an apparent inertia which is in fact a state of great porosity to the strangeness of the world, a mixture of torpor, of loss of reality and of a somewhat hallucinatory vivacity of sensations. . . . Godard speaks to us of this very special way of being in the world, on the edge of sleep.[4]

That such a somnolently receptive attitude might be the basic condition of all cinematic spectatorship was first suggested in a special issue of the journal *Communications* devoted to psychoanalysis and cinema. Published in 1975, the issue has five photograms on its cover—arranged vertically, in the manner of a filmstrip. The top and bottom frames are both from the same film, *The Cabinet of Dr. Caligari*. They show the face of the somnambulist Cesare—first with eyes staring open, then with eyes closed. To look quickly from one frame to the other produces a rudimentary animation—Cesare appears to blink. The image of the cinema audience as waking somnambulists, blinking as they emerge from the auditorium

into the light, may be found in more than one of the essays in this issue of *Communications*. Christian Metz, for example, writes that "spectators, on leaving, brutally expelled from the black interior of the cinema into the vivid and unkind light of the lobby, sometimes have the bewildered face . . . of people just waking up. Leaving the cinema is a bit like getting out of bed: not always easy."[5] Metz notes that the subject who has fallen prey to the "filmic state," feels "as if numb" (*engourdi*). Roland Barthes describes his own feelings on leaving the cinema in much the same terms.[6] He feels "a little numb [*engourdi*], a little awkward, chilly, in brief sleepy: *he is sleepy*, that's what he thinks; his body has become something soporific, soft, peaceful: limp as a sleeping cat."[7]

Barthes's short essay of 1975, "En sortant du cinéma," may be read as a reprise of his essay of 1973, "Diderot, Brecht, Eisenstein."[8] The theme of "representation"—defined as a structure that guarantees the imaginary capture of a subject by an object—is central to both essays but is developed differently in each. The earlier essay points to an irresolvable problem in any politically inspired attempt to free the spectator from the grasp of the spectacle *from within the spectacle itself.* Barthes acknowledges that the "tableau," the "epic scene," the "shot"—all work against narrative mimesis and identification. Framing the mutely eloquent "social gest," the tableau may produce the effect of "distanciation" (*Verfremdung*). The spell is broken, the spectator's eyes are opened—but onto what? "In the long run," Barthes observes, "it is the Law of the Party which cuts out the epic scene, the filmic shot; it is this Law which looks, frames, enunciates."[9] It takes a "fetishist subject," Barthes writes, to "cut out the tableau" from the diagesis. He cites a lengthy passage from Diderot's defense of the tableau, which concludes: "a painting made up of a large number of figures thrown at random on to the canvas . . . no more deserves to be called a *true composition* than scattered studies of legs, nose and eyes . . . deserve to be called a *portrait* or even a *human figure*." Barthes comments that it is this transcendental *figure*

"which receives the full fetishistic load."[10] But Diderot's unification of a "body in pieces" within the bounds of a "figure" might as well be assimilated to Jacques Lacan's account of the mirror stage as to Freud's account of fetishism. In his later paper, Barthes writes: "I stick my nose, to the point of squashing it, to the mirror of the screen, to this imaginary "other" with whom I narcissistically identify myself."[11] To pass from Barthes's earlier paper to the later one is to watch a scene of fetishistic fascination cede prominence to one of narcissistic identification—but as if in a filmic cross-dissolve, where neither scene may yet be clearly distinguished from the other. What remains in focus, in both the 1973 and the 1975 essays, is the question of the autonomy of the subject of civil society in modern, media-saturated democracies. But whereas Barthes's essay "Diderot, Brecht, Eisenstein" explicitly takes up the question of how to awaken the hypnotized subject of this society of the spectacle, "En sortant du cinéma" implicitly raises the question of whether somnolence itself may not be the spectator's best defense before the spectacle of the Law.

As much as he may go to the cinema to see this or that movie, Barthes confesses, he also goes for the darkness of the auditorium. The necessary precondition for the projection of a film is also "the color of a diffuse eroticism." Barthes remarks on the postures of the spectators in the darkness, often with their coats or legs draped over the seat in front of them, their bodies sliding down into their seats as if they were in bed. For Barthes, such attitudes of idle "availability" represent what he calls the "modern eroticism" peculiar to the big city. He notes how the light from the projector, in piercing the darkness, not only provides a keyhole for the spectator's eye but also turns that same spectator into an *object* of specular fascination, as the beam "illuminates—from the back, from an angle—a head of hair, a face." Just as Metz speaks of *"l'état filmique"* of the spectator, so Barthes posits a fundamental *"situation de cinéma."* But whereas Metz speaks of this torpidly receptive state as produced by

a visit to the cinema, for Barthes it is a precondition of the visit. He writes:

> The darkness of the movie theater is prefigured by the "twilight reverie" (preliminary to hypnosis, according to Breuer-Freud) which precedes this darkness and leads the subject, from street to street, from poster to poster, finally to engulf him in a dark cube, anonymous, indifferent, where must be produced this festival of affects we call a film.[12]

While watching the film, he writes:

> It is necessary for me to be in the story (the *vraisemblable* requires it), but it is also necessary for me to be *elsewhere:* an imaginary slightly unstuck [*décollé*], that is what, as a scrupulous fetishist. . . . I require of the film and of the situation where I go to look for it.[13]

Barthes unsticks himself from the screen by allowing his attention to peel away, to "take off," to "get high."[14] His act of ideological resistance—for all that it proceeds from an ethical attitude—takes the route of pleasure, rather than denial. He responds to the fetishistic and ideologically suspect visual pleasure of narrative cinema not by resisting the perversion, but by doubling it. Barthes suggests a culturally dissident way of going to the cinema other than "armed by the discourse of counter-ideology"; it is:

> in allowing oneself to be fascinated *two times:* by the image and by what surrounds it, as if I had two bodies at the same time: a narcissistic body which looks, lost in the close mirror, and a perverse body, ready to fetishise, not the image, but precisely that which exceeds it: the grain of the sound, the theater itself, the darkness, the obscure mass of other bodies, the rays of light, the entrance, the exit:

in brief, to distance myself, "unstick," I complicate a "relation" by a "situation."[15]

We leave the movie theater, Barthes suggests, only to reenter an *other* cinema, that of civil society. He writes: "The historical subject, like the spectator in the cinema I am imagining, is also *stuck* to ideological discourse. . . . the Ideological would be at bottom the Imaginary of a time, the Cinema of a society . . . it even has its photograms: the stereotypes with which it articulates its discourse."[16] These remarks suggest the question, "What relation, if any, have the means by which Barthes 'unsticks' himself from the Imaginary in the movie theater to the situation of the historical subject glued to the Ideological in society?" It might appear that Barthes "distracts" himself from the film by behaving in the cinema much as he might when in the street. In its early history, cinema was more often integrated into everyday urban *flânerie* than it is today. For example, in a chapter appropriately entitled "Streetwalking around Plato's Cave," Giuliana Bruno has described the peripatetic forms of spectatorship—and their attendant erotics—that accompanied the introduction of cinema to Italy in the closing years of the nineteenth century, most explicit in the practice of projecting films in the open air of Naples's main shopping arcade.[17] Or again, we may recall the later practice of André Breton and Jacques Vaché, who would visit as many cinemas in Nantes as they could within the space of a single afternoon—entering and leaving with no regard for any narrative development other than that of their own *dérive*. Today, our everyday passage through the "cinema" outside the movie theater takes us through television, advertising, and glossy magazines. These are the arts that are today appreciated—like architecture, in Benjamin's description—"in a state of distraction." However, the distraction that typically accompanies an evening's television viewing—answering telephone calls, fixing drinks, chatting, "zapping,"

flipping through newspapers and magazines, and so on—has nothing to do with the distance Barthes finds in the movie theater. When watching television, Barthes remarks, anonymity is lost, the surrounding bodies are too few. Worst of all, "the darkness is erased," and we are *condemned to the Family.*" As a consequence of all this, "the *eroticism* of the place is foreclosed."[18] In an essay about a Paris dance-hall, Barthes writes: "I admit to being incapable of interesting myself in the beauty of a place, if there are no people in it . . . and reciprocally, to discover the interest of a face, a silhouette, an item of dress, to savor an encounter, I need the place of this discovery, also, to have its interest and its savor."[19] This simultaneity of fascination by both people and place, he remarks later, amounts to "that which one calls Festival, and which is quite different from Distraction."[20] We may recall that Barthes refers to the film, as a "Festival of affects." He goes to the cinema, he says, only in the evening. The city at night is a form of organization of general darkness, and Barthes sees the darkness of the cinema as a particular form of organization of the darkness of the city at large. The movie auditorium, he says, condenses the "modern eroticism" of the big city. It is as if what Barthes calls "the eroticism of the place" were a modern equivalent of the eighteenth-century *genius loci,* the "genius of the place." Like the attendant Spirit, the erotic effect may be unpredictably fleeting in its appearances. In *Le plaisir du texte,* Barthes writes: "It is intermittence, as psychoanalysis has so well stated, which is erotic: . . . the staging of an appearance-disappearance."[21] The eroticism that may accompany what Barthes calls "the Cinema of a society," like the "dancing ray of the projector" of which he speaks, *flickers.* Baudelaire chose precisely this term to describe the pleasures of the crowded city street, speaking of "the flickering grace of all the elements of life."[22] The photograms of Barthes's biphasic Cinema—his festival for two bodies, narcissistic and perverse—appear abruptly, detaching themselves from the phenomenal flux in the manner of the *fragment* of which he speaks in *Roland Barthes par Roland Bar-*

thes—in "a yawning [*bâillement*] of desire."[23] If desire "yawns" it may have more than a little to do with the alert torpidity of the somnambulist, or of someone on their way home to bed.

In a passage in *Soirées de Paris,* Barthes recounts flickering chance encounters during his walk home at the end of an evening spent in cafés—as if reversing the itinerary, "from street to street, from poster to poster," he describes as leading him to the cinema. On the rue Vavin he crosses the path of a beautiful and elegant young woman, who trails behind her "a delicate scent of muguet." On a column in the rue Guynemer he comes across a film poster, with the names of two actresses—Jane Birkin and Catherine Spaak—printed in huge letters (as if, Barthes remarks, the names alone were "incontestable bait"). In front of a house on the rue de Vaugirard there appears "an attractive silhouette of a boy."[24] The film poster clearly may represent what Barthes calls a "photogram" of the Ideological. Along with other forms of publicity, film posters mainly show stereotypical individuals and objects, in stereotypical relations and situations. In *Mythologies,* and subsequent texts, Barthes gave us the means to demystify and dismantle such "rhetoric of the image" in terms of counterideological analyses—Marxism, semiology. In "En sortant du cinéma," Barthes uses a Lacanian vocabulary. In these terms, what constitutes the Imaginary exceeds what an ordinary taxonomy of objects of daily use may classify as "images." The "beautiful woman" and the "attractive boy" not only have their counterparts in actual film posters, they may serve as living photograms—ideologemes—in Barthes's Cinema of society. In "En sortant du cinéma," Barthes asks, in passing: "Do we not have a dual relation to the common place [*lieu commun*][25]: narcissistic and maternal?" The woman trails behind her "a scent of muguet." In France, by long tradition, sprigs of muguet—a small, white, bell-shaped flower—are sold on the streets on the first day of May. Small children—raised in their mother's shadow—learn the division of common time through such traditions. This woman who casts the shadow

of time itself might be assimilated to the maternal side of that "dual relation" that Barthes invokes. The "attractive silhouette" of the boy— whose fugitive character elicits what Benjamin called "love at last sight" (prompted by Baudelaire's verses *À une passante*)—might be assimilated to the other, narcissistic side.

Another evening in Paris, Barthes follows a route that will eventually lead to the "dark cube" of a movie theater. He first visits a gay bathhouse, then moves on to what seems to be some sort of brothel. Here, Barthes notes, "About to leave is a beautiful Moroccan who would really like to hook me [*m'accrocher*], and gives me a long look; he will wait in the dining room until I come down again, seems disappointed that I don't take him right away (vague rendezvous for the following day). I leave feeling light, physically good."[26] The image of Barthes on the stair, exchanging glances with the "beautiful Moroccan," reminds me of another image. Bergala's note on *La paresse* is part of a Godard filmography in a special issue of *Cahiers du cinéma*. A band of photograms runs horizontally along the bottom of each page of the filmography—less like a filmstrip than a comic strip, or *photo roman*. One of the images is from *La paresse*. Eddie Constantine appears to have just descended a carpeted staircase, which winds up and out of frame behind him. He is immaculately dressed in suit and tie and is wearing a hat. He is looking at the starlet—who is standing close by him, dressed only in her underwear. Barthes traces Brecht's idea of the "social gest" to Diderot's concept of tableau. The tableau has a history prior to Diderot. In the mid-sixteenth century, Humanist scholars gave advice to painters in which two ideas were essential: first, the painter should depict human action in its morally most exemplary forms; secondly, as the "history painter" could show only a single moment from a moral fable, then that moment should be the *peripateia*—the "decisive moment" when all hangs in the balance.[27] The images of, respectively, Barthes and Constantine on the stair, both have something about them of a motif that appears throughout the history of Western European

painting: "Hercules at the Crossroads." I ask to be excused comment on what, to a "counterideological discourse," is most obvious in both of these modern mises-en-scènes of choice—the inequitable distribution of material authority across the lines of, respectively, race and gender. My particular interest here is in what this image condenses of Bergala's description of Godard's film, and what, in turn, this description condenses of all of what Barthes has to say about "*la situation de cinéma.*" The woman in the diagesis is making a spectacle of herself; in French, one might say, "*elle fait son cinéma.*" Constantine on the stair, much like Barthes on the stair, responds with, to repeat Bergala's words: "an apparent inertia which is in fact a state of great porosity to the strangeness of the world, a mixture of torpor, of loss of reality and a somewhat hallucinatory vivacity of sensation."

The expression "hallucinatory vivacity" may remind us of Barthes's description of the photograph. The photograph, he says, represents "an anthropologically new object," in that it constitutes "a new form of hallucination: false at the level of perception, true at the level of time."[28] The film, however, is "always the precise opposite of an hallucination; it is simply an illusion."[29] The film "can present the cultural signs of madness, [but] is never mad by nature."[30] To the contrary, the photograph is an authentically "mad image, rubbed by the real."[31] Nevertheless, the abrasion of image against real, which Barthes finds and values in photography, is at least structurally similar to his readiness, when in the cinema, "to be fascinated *two times:* by the image and by what surrounds it." In *Roland Barthes par Roland Barthes*, he writes: "The dream displeases me because one is entirely absorbed by it: the dream is *monological;* and the fantasy pleases me because it remains concomitant to the consciousness of reality (that of the place where I am); thus is created a double space, dislocated, spaced out."[32] These men on the stair are not sleepwalkers, but they are "spaced out." In "En sortant du cinéma" it is as if Barthes is urging a practice of spectatorship that will

pull the filmic experience toward the side of fantasy and away from the shore of the dream. Barthes's inclination to phenomenology leads him to seek mutually exclusive "essences" of film and photography. But such oppositions fade as he steers closer to semiology and psychoanalysis. Barthes himself admits as much, even in one of his more "phenomenological" texts. On the first page of *La chambre claire*, he writes: "I declared that I liked Photography *against* the cinema—from which, however, I never managed to separate it."[33] Here then, is another site of abrasion: where photography touches cinema. Barthes's well-known interest in the film still is often mentioned to exemplify his preference for the photograph over the film. The "photogram," however, is strictly *neither* photograph *nor* film. It is the material trace of that moment of arrest which establishes a space *between* the photograph *and* the film. In terms of Lacan's discussion of the gaze, to which Barthes explicitly gestures in "En sortant du cinéma," this time of arrest is that of the "lure."

The filmic image, says Barthes, is "a *lure*." He adds: "This word must be understood in the analytical sense."[34] Lacan uses the word *leurre* with the full range of meanings it takes in French: "lure," "bait," and "decoy"; "allurement" and "enticement"; "trap," "delusion," and "deceit." The analytical sense that Lacan brings to it comes most specifically from what he makes of Roger Caillois's remarks on the "three functions of mimicry."[35] Lacan says that in the animal and insect behaviors named by Caillois as *travesty, camouflage,* and *intimidation,* "the being gives of itself, or it receives from the other, something which is mask, double, envelope, detached skin, detached to cover the frame of a shield."[36] The frame from *La paresse* depicts just such a meeting of masks—as beautiful as the chance encounter, on a staircase, of some undergarments with a business suit. "Without any doubt," Lacan remarks, "it is by the intermediary of masks that the masculine, the feminine, meet in the most pointed, the most ardent, way."[37] However,

Lacan notes a difference between human behavior and the behaviors described by Caillois:

> Only the subject—the human subject, the subject of desire . . . is not, unlike the animal, entirely held by this imaginary capture. He takes his bearings in it [*Il s'y repère*]. How? To the extent that he isolates the function of the screen, and plays with it. Man, in effect, knows how to play with the mask, as being that beyond which there is the gaze. The screen is here the place of mediation.[38]

Christian Vincent's film *La discrète* is a story of seduction and betrayal set in modern-day Paris.[39] It takes its title, however, from a practice of the seventeenth century. Fashionable women of that period would wear a "beauty spot"—usually a dot of black taffeta—on their face. When worn on the forehead it was called a *majestueuse,* placed by the eye it was a *passionnée,* by the lips a *galante,* and on the chin a *discrète.* In eighteenth-century Venice, the *moretta* was one of only two masks worn at carnival time, and it was worn only by women. The *moretta* was held in position by means of a button gripped between the teeth—in order to speak, the woman had to unmask, to quite literally "reveal herself." Both practices exemplify (in one case, quite literally) a play with the mask in the field of the gaze. As in all play—productive of spacing, difference—meaning is created. A fascination beyond words is at the same time a potentially garrulous semiotic system. For the human animal, the lure is a place of passage between Imaginary and Symbolic, between the drive and the contractual regulation of sexuality. What flickers on the screen of the lure is the dance of Desire and the Law. Barthes emphasizes that the filmic image, which so often stages the scene of lure, is itself a lure. However, so, potentially, is any other image in the "Cinema of society." Barthes himself recognizes this in the very terms of his exasperation at the film poster he comes across in the rue Guynemer, the actresses' names printed

large, "as if they were incontestable bait" (*appâts*). The look given by the actresses emerges from within an image-product of a visual cultural institution—here, the cinema—of the Cinema of society. That is to say, the look emerges from within the *gaῖe*. Amongst the various functions of the gaze is the *subjection* of what Barthes calls the "historical subject." Lacan gives the example of the mural paintings that adorn the great hall of the Palace of the Doges, in Venice: "Who comes to these places? Those who form that which Retz calls *the people*. And what do the people see in these vast compositions? The gaze of those persons who—when they are not there, they the people—deliberate in this hall. Behind the painting, it is their gaze which is there."[40] Today, the environment of images from what we call "the media" has taken the place and the function of those murals in the Palace of the Doges. Lacan does not mention it, but the paintings—like the products of the media today—would also have been an object of wonder and delight, of fascination, for those subjected to the authority of those who commissioned the images. The long history of the multiple forms of decoration and pageant in society demonstrates the inseparability of power from visible display: the element of hypnotic fascination in voluntary submission. However, such means of control are unstable, and the history of authority is also one of struggle for mastery of the "twilight reverie."

Lassitude, inertia, torpor; a body become soporific, soft, limp; a loss of reality, a porosity to the strangeness of the world, a hallucinatory vivacity of sensations. A "very special way of being in the world," known for centuries of Western Christianity as the condition of acedia—a state of mortal sin. In his book on the concept of acedia in medieval thought and literature,[41] Siegfried Wenzel traces the notion of the "sin of sloth" to the fourth Christian century and the milieu of Egyptian desert monks who lived near Alexandria. For these monks, acedia was the name of a demon with whom they frequently fought. A stealthy drowsiness would announce the arrival of the demon. There would then follow an assault

of impressions, thoughts, and feelings that could overwhelm devotional duty. Monks became melancholy, they found it difficult to remain in their cells and would wander out in search of the secular world they had renounced. By the twelfth century, acedia—"sloth"—was firmly established as one of the "seven deadly sins." Its most "modern" description, however, was given at the inception of the concept. Wenzel writes that, in the early Christian moral theology of Clement of Alexandria, acedia was judged to be the product of "affections of the irrational part of man's soul, which originate in sense impressions or in memory and are often accompanied by pleasure." In the soporific state of acedia, "reason is . . . subjected to the ebb and flow of affections, which tyrannize it and keep it in a state of turmoil—the master has become a slave."[42] Acedia, then, threatens the hierarchical order of things: the theocentric order of Christianity, certainly, but also the secular world order of Western capitalism which would succeed it. The religious education of the industrial proletariat continued to stress that "the devil finds work for idle hands." Common soldiers in imperialist armies, when neither fighting nor training, were put to such work as whitewashing lumps of coal. Fundamental to the instrumental logic of slave ownership was the category of the "lazy slave"; in the logic of the colonialist it was the "lazy native." Clearly, the threat of lassitude was less to production than to authority—whether that of God or Mammon. Lassitude can in fact be highly productive, but what it produces is insubordination and syndicalism, mutinies and revolutions. At this point, however, we may no longer distinguish between the corrosive consequences of lassitude and the products of a counterideological reason honed through leisure.

Until about the twelfth century, acedia was considered to be mainly a monastic vice, one that attacked those devoted to the contemplative life.[43] In *Soirées de Paris*, Barthes confesses to his difficulty in remaining in his cell: "Always this difficulty in working in the afternoon," Barthes writes, "I went out around six-thirty, looking for adventure."[44] It would not have

surprised a desert monk to learn that Barthes wound up soliciting a male prostitute on the rue de Rennes, giving him money on the promise of a rendezvous an hour later. "Naturally," Barthes writes, "he wasn't there." Barthes acknowledges how barely credible his action must seem, in exchanging money for such a promise. But he also recognizes that, whether or not he had gone to bed with this man, "at eight o'clock I would have found myself again at the same point in my life; and, as the simple contact of the eyes, of the promise, eroticises me, it is for this *jouissance* that I had paid."[45] In this particular sector of the libidinal economy, sexual tension is perversely spent in the exchange not only of promises but of temporal location—here coined in a grammatical tense, the future anterior: "I shall have had." Constantine, spaced out, refuses sex with the starlet because he speaks to her from a different time: from the aftermath of the afterglow. Acedia is a complex vice. The fourth-century treatises on spiritual life which established the concept of acedia also inaugurated the practice, followed in medieval handbooks, of identifying the "daughters" to whom this or that of the seven capital sins had given birth. Disobedience was only one of the daughters of acedia, amongst the many others was Deferment.

Metz refers to the "novelistic film," as "a mill of images and sounds which overfeed our zones of shadow and irresponsibility."[46] Barthes defers feeding—like a recalcitrant infant who turns from the breast in search of adjacent pleasures; even, or especially, those "not good for it." He asks: "Could there be, in the cinema itself (and in taking the word in its etymological profile), a possible *jouissance of discretion?*"[47] In exercising his discretion, Barthes is at the same time *at* the discretion of something else. His presence in the cinema is *impulsive*. In *Le plaisir du texte*, he speaks of "that moment when my body goes to follow its own ideas—for my body does not have the same ideas as I do."[48] The pressures of a "twilight reverie" impel Barthes "from street to street, from poster to poster," to immerse himself in darkness. Freud spoke of "som-

nambulistic certainty" to characterize the unerring confidence with which, under certain circumstances, a long-lost object is found.[49] All that is certain in our compulsion to repeat, however, is that the object will elude us. ("Naturally," Barthes writes, having kept the rendezvous, "he wasn't there.") As to the source of our need to *keep* keeping, in Lacan's words, "an appointment . . . with a real that escapes us,"[50] we are all in the dark. Clement of Alexandria found acedia to be the product of "affections of the irrational part of man's soul, which originate in sense impressions or in memory . . . often accompanied by pleasure." This psychoanalytic judgment *avant la lettre* suggests that "this special way of being in the world, on the edge of sleep" steers us closer to the shores of that "other locality" where Freud first took his bearings: "another space, another scene, *the between perception and consciousness*."[51] Between the spectator totally enthralled by the narrative, and the critic who sits analyzing shots, there is a continuum of degrees of alertness. Barthes, however, sliding down into his seat, adopts a posture toward the film which cannot be assigned to a simple position on a scale between enthrallment and vigilance. "I am hypnotized by a distance," he writes, "and this distance is not critical (intellectual); it is, if one can say this, an amorous distance." A *jouissance* of discretion. A pleasure in differences, distances. A tactful delight in heterogeneity: the "flickering grace of all the elements of life" that Baudelaire found on the streets of Paris, now revealed by the flickering light of the projector in the auditorium. The café-frequenting spectator's glass of Kir and dish of olives have given way to Coca-Cola and buttered popcorn, but the society is no less utopian for that. In American cities, where "street life" so often gives way to "street death," the citizen is almost certainly safer in the movie theater than at home, at work, or in prison. In a world riven by violent factional and fractional conflict, the cinema is peaceful. The cinema audience—a totally aleatory conglomeration of alterities—sleeps together in a space of finely judged proximities, a *touching* space.

On leaving the cinema, the Cinema of society we reenter today is a *global* cinema, where cultural and ideological differences come together in intimate electronic proximity. In this cinema, also, the image is a lure. Flickering on the hook is the alternative the mirror relation presents: narcissistic identification or aggressive rivalry. Here also, Barthes seems to suggest, we may defer taking the bait—but not in order to calculate a fine scale of "correct distances" between fusion and abjection. The distance that hypnotizes him, Barthes says, is not intellectual but "amorous." The territory of this distance is claimed in the name of Lassitude. Exercising a somnolent discretion, from within a state of great porosity to the strangeness of the world, Barthes embraces that daughter of acedia whom we can only name—in the full sense of the word—*Dissipation*.

In general one must avoid seeking to explain one part of the manifest dream by another, as though the dream had been coherently conceived and was a logically arranged narrative. On the contrary, it is as a rule like a piece of breccia, composed of various fragments of rock held together by a binding medium, so that the designs that appear on it do not belong to the original rocks imbedded in it.

Sigmund Freud[1]

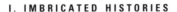

I. IMBRICATED HISTORIES

Le paysage enfant de la terreur moderne.

Louis Aragon[2]

At an award ceremony in San Francisco, held in 1993 at the Kabuki movie theater, the Senegalese novelist and filmmaker Ousmane Sembène was presented with the Akira Kurosawa Award for lifetime achievement in film directing.[3] The evening began with traditional Senegalese drumming. There then followed a screening of Sembène's film *Guelwaar* (1992), which deals with religious and political conflict between Muslims and Catholic Christians in present-day Senegal. The dialogue was in Wolof and French, with English subtitles. After the film, Sembène—in traditional dress—came on stage to receive the applause of the audience and his award. He was accompanied by a young African, in Western dress, who translated his French into English. The European American presenter of the award, in paying tribute to Sembène, thanked him for reminding us that the United States is not the center of the world. The presenter then went on to recall Sembène's first full-length film, *La noire de . . .* (1966). This film, the first African feature film to be made by an African, tells the story of the exploitation of an illiterate young African woman by a French couple who have brought her to Antibes to work as their maid. *La noire de . . .* , the presenter remarked, showed the prescience of Ousmane Sembène in anticipating—almost thirty years ago—the Zoe Baird affair.[4] The remark reminded me of an intervention at another appearance Sembène had made, earlier in the week, to answer questions after the screening of his film *Ceddo*. This film, made in 1977, is set in seventeenth-century

Senegal. In it, African slaves are shown rising against their African masters. In the question period that followed, a man asked, with pain and anger in his voice, how Sembène could have made a film that showed African history in such a light. Did Sembène not know that African Americans looked to African history as the alternative to the US history of slavery?[5] In the presenter's analogy between Sembène's film *La noire de . . .* and the Zoe Baird affair, and in the objection from the man in the audience to the representation of African history in *Ceddo*, we can see—from very different positions within US society—a common disavowal of the very fact that the presenter had, symptomatically, felt obliged to acknowledge. The disavowal takes the form: "I know very well that the United States is not the center of the world, but nevertheless US history and world history are the same." Such everyday disavowals evade, in Kadiatu Kanneh's words, "a radical questioning of History's status as the one story of Western progress and culture."[6] They reveal the difficulty of escaping, as Homi Bhabha puts it, the "assumed hierarchical forms of rationality and universality" of the West. However, we do not escape such forms of rationality simply by recognizing that Africa has its own history. We must also allow that Africa has its own *time*.

In concluding his remarks at the award ceremony, Sembène said that although the cinema was now a hundred years old, for Africa it was newly born. Nevertheless, he said, Africa would celebrate the hundred-year anniversary of cinema, for Africa has inherited its accumulated wisdom. Sembène's apparently paradoxical image of a cinema that is both "newly born," and "a hundred years old," his seemingly contradictory readiness both to assume the mantle of Western film history and to cast it off, exemplifies not only what W. E. B. Du Bois identified as "double consciousness,"[7] but also what Homi Bhabha has called "a repetition that is *initiatory*." Speaking of Franz Fanon, Bhabha writes:

> It is Fanon's temporality of emergence—his sense of the *belatedness of the Black man*—that does not simply make the question of "on-

tology" inappropriate for Black identity, but somehow *impossible* for the very understanding of humanity in the world of modernity: *You come too late, much too late, there will always be a world—a white world between you and us.*

Bhabha continues:

> It is the opposition to the ontology of that white world—to its assumed hierarchical forms of rationality and universality—that Fanon turns in a *performance* that is iterative and interrogative—a repetition that is *initiatory*, instating a differential history that will not return to the power of the Same. Between *you and us* Fanon opens up an enunciative space.[8]

Ontology, the search for essence, tends toward autochthony, a quest for origin—in the tracing of a history: personal, racial, ethnic, or national. But, to invoke Michel Foucault: "What is found at the historical beginning of things is not the inviolable identity of their origin; it is the dissension of other things. It is disparity."[9] What Bhabha calls "a differential history" cannot originate in a punctual origin—to which the Black Theseus, lost in the maze of Western history, is connected with an Ariadne's thread. Its lines can be traced only across the spaces of present conflicts, weaving in and out of their conflicting times. Sembène's film *Guelwaar* is an acerbic comedy of manners between Senegalese Christians and Senegalese Muslims, in which the two groups are brought into near murderous confrontation over a mistaken and disputed identity: that of a Catholic corpse erroneously laid to rest in a Muslim burial ground. The body is finally disinterred, but only after violence, and under the supervision of armed police and local politicians. But no physical means has yet been provided of bearing the corpse from the freshly opened grave to the dusty cross-wielding throng that awaits it—singing hymns, beyond the desiccated

thorn hedge that marks the limit of the scorched patch of Islamic earth upon which their infidel feet may not tread. One of the grave-diggers wrests free of the hedge, where it had rested discarded and previously invisible, a hand-hewn bench of traditional design. It is by means of this fragment of an Africa from before either Islam or Christianity that the deceased crosses to the other side of the divide between the two religious factions. We know that the fragment will return to the hedge once its purpose has been served. Sembène's apposite image (the very origin of the word *metaphor* is in the Greek word for "transport") may remind us that what we call "the present" is not a perpetually fleeting point on a line "through time," but a collage of *disparate* times, an imbrication of shifting and contested spaces.

Lest we lapse, once more, into romanticizing Africa as the eternal and exotic other—a land where compasses and clocks behave differently from in the West—we need only look about us on leaving the movie theater where Sembène received his award. The Kabuki theater is on the edge of San Francisco's Japantown, which is separated from the mainly African American neighborhood to the South by Geary Boulevard—a thickly flowing eight-lane river of automobiles. Jack's Bar, alongside the Kabuki, is a fragment of African American cultural history now stranded amongst sushi bars and Oriental gift shops. On the walls are large photographs from the 1940s of Joe Louis, surrounded by admirers at the bar, and of John Lee Hooker, performing on Jack's small stage. In my psychotaxonomy of San Francisco, Jack's Bar is classed together with other such intimately individual out-of-place fragments. For example, to the west of Japantown, in Golden Gate Park—stranded between John F. Kennedy Drive and Martin Luther King Jr. Drive—is the Japanese Tea Garden. Apart from the Hollywood-Orientalist typography that disfigures some of its signs, the garden is still, a hundred years after it was created, almost completely Japanese in design. On leaving the garden, it would be easy to miss the modest bronze plaque set back amongst foliage by the exit.

It reads: "To honor Makato Hagiwara and his family, who nurtured and shared this garden from 1895 to 1942." It says nothing more, and the historical silence that follows has only recently been broken. The year 1942 was the year in which the US government introduced the "Civilian Exclusion Orders" that dispossessed over 110,000 Japanese Americans and confined them to concentration camps on some of the most barren lands in America. In a recent book about one of these camps—the one at Manzanar, a day's drive from San Francisco—I read:

> Manzanar, which means "apple orchard," was named by the Spanish. . . . At one time it was a fertile place, but in 1919 the farms of the area were bought up by the government. The water they depended upon was diverted into the massive Los Angeles Aqueduct to serve that growing city, and as a result, the Owens valley degenerated into a man-made desert.[10]

Whether correctly or not—psychohistory being no more attentive to empirical truth than psychogeography—I imagine the Hagiwara family cultivating the desert at Manzanar. Sembène's film *Guelwaar* concludes with a scene in which Senegalese poor destroy a truckload of UN relief supplies (freedom from neocolonialism requiring that "independence" be observed to the letter); the camera leaves them grinding the grain into the arid road.

One of the overdetermined lines of division traced in *Guelwaar* is between *city* Christians and *rural* Muslims. In a recent study of Arab and African cinema, Lizbeth Malkmus and Roy Armes identify the contrast of town and village as "one of the key organizing concepts of all African filmic space and narrative." They note a general tendency within African films "to allow specific geographical divisions . . . to represent the social and economic divisions of Africa as a whole." In Sembène's films, in particular, they find that "the dialectical form of spatial organization is

extended to such extra-spatial oppositions as "wealthy/poor," "pregnant woman/dead baby."[11] Further: "Another way of formulating the basic binary scheme is to set physical and mental space in opposition."[12] So, for example, in *La noire de* . . . the maid Diouana's mobile and expansive memories of Dakar are contrasted with her actual life in Antibes, which the camera shows almost entirely in terms of the confines of the apartment where she is imprisoned in repetitive domestic labor. Here, Malkmus and Armes observe, "what might, in another system of film narration, be seen as a problem of time (the lack of a future) is conveyed . . . in spatial terms."[13] With reference to a film by another Senegalese, Djibril Diop-Mambety, Malkmus and Armes note that it may serve as a perfect example of "that type of modern fiction which Alain Robbe-Grillet describes as being characterized by a present tense: 'which is continually inventing itself . . . which repeats itself, bisects itself, contradicts itself, without ever accumulating enough bulk to constitute a past.'"[14] Again, in Sembène's film *Ceddo*, "set in a very vaguely defined seventeenth century," we see "aspects of colonization which occurred separately in time . . . telescoped together to form elements of a filmic conflict that is worked out spatially." Moreover, "Sembène includes a modern sunshade . . . and allows the missionary a vision of a modern Catholic ceremony in Dakar."[15] What Malkmus and Armes note overall, in their review of a diverse range of African films, is a "comparative lack of concern with time." We may, however, disagree: a concern with time is paramount, but it is represented *differently*. That Malkmus and Armes know this, but do not know they know it, is indicated when they write: "The African system of . . . organizing spatial representation can be seen as in many ways akin to a [photographic] collage."[16] There could be no more apt analogy for the representation of time in the films they discuss, as an assembly of si-multaneously present events, but whose separate origins and durations are out of phase, historically overlapping. This is the imbricated time of our global lived space.

In an image apposite to Sembène's enunciatory position—in transport between an already aged Western cinema and its youthful African counterpart—Paul Virilio, "returning from San Francisco to Europe," passes over the glaciers of Greenland and observes: "Behind us glow the red fires of dusk and, in the same instant, ahead of us glimmer the green lights of dawn." He continues: "Seeing that which had previously been invisible becomes an activity that renews the exoticism of territorial conquests of the past. But seeing that which is *not really* seen becomes an activity that exists for itself. This activity is not exotic but *endotic*, because it renews the very conditions of perception."[17] Virilio forms his neologism, "endotic," by replacing the Greek prefix *exo-*, "without," by its opposite: *endo-*, "within." The experience that prompted this, however—seeing dawn and dusk *at the same time*—was of being neither within nor without; it was an experience of being between the two, a "between" formed only in the simultaneous presence of the two. "Between *you and us*," Bhabha writes, "Fanon opens up an enunciative space." For D. W. Winnicott, this space is precisely the location of cultural experience. He writes that it is: "*the potential space between the subjective object and the object objectively perceived.* . . . This potential space is at the interplay between there being nothing but me and their being objects and phenomena outside omnipotent control."[18] Modern Western history is the history precisely of the urge to "omnipotent control," to mastery. It is the history of an untiring quest to renew "the exoticism of territorial conquests of the past," a history of perpetual aggression. Jacques Lacan identifies aggressivity as "one of the intentional coordinates of the human ego, especially relative to the category of space [which] allows us to conceive of its role in modern neurosis and in the 'discontents' of civilization."[19] Our teleimagistic global collage, forever in movement, is composed of fragments ripped from their contexts, their serrated boundaries advancing and receding in an unending deadly dance with their neighbors, their imbricated times violently clashing, diverging—only to collide again.

On the island of Tobago, I pull my rented car off a potholed road in the steep hills of the northern coast. I have seen something startlingly familiar in this beautiful and unknown landscape. Rusted red above the track, half-buried in a tangle of thick green creepers and purple flowers, is a huge iron waterwheel. It resembles similarly eroding relics of manufacturing prosperity in the northern industrial landscapes of my English childhood. I climb up to it, picking my way over fallen stone walls all but hidden under the tropical vegetation. From here, the eye commands a splendid sweep of bay, with palms leaning over a winding strip of beach. A bay, I imagine, where African slaves once loaded boats with sugar from the now ruined plantation factory. Written on the crumbling iron of this Ozymandius, I read: *A & W Smith & Co Glasgow 1871*. Even in Arcadia, I have found a monument to what Lacan has called "the barbarism of the Darwinian century."[20] Those in the West are all lost amongst such debris, the accumulation of rubble left behind in the accumulation of capital. Abandoned lives spent alongside the idly rusting machinery of former steel-towns, ruined lives passed in the ruined landscapes formed in the liquid wake and barren spoil-heaps of chemical industries and strip mines, lives displaced from fertile farmlands prematurely buried under the empty real-estate "developments" of the Reagan and Thatcher years. Those still with jobs are lost amongst the debris of the finest products of capitalism, left wandering in the mall. Writing in 1985, William Kowinski noted: "The shopping mall completed the link between the highway and television; once the department stores and the national chains and franchises were inside, just about anything advertised on the tube could be found at the mall."[21] Today "the tube" has extended the shopping street into the upper atmosphere. I am on a flight into Los Angeles. Video projectors have just transmitted live news broadcasts onto screens in the aircraft cabin; I leaf through a shopping catalog provided in the seat pocket in front of me. Above this pocket, inset in the seat back, is a telephone handset. I may use a credit card as a key to release the telephone and call

anywhere in the world; I may also use it to order goods from the catalog, which will be wrapped and waiting for me on my deplaning at LAX. Back on the ground, as I head for the baggage claim area, the "terminal" is itself an agglomeration of video terminals informing me of times and places I may make further connections to other places and other times. In the bars where other travelers kill time, other video screens may be transmitting live images of distant wars, or of urban insurrections not far beyond the tinted glass of this aptly named "terminal building." Punctually, the televised news is shattered by "commercial breaks." In the uniquely abrupt manner of American television, totally without warning, the image of an armored car, rounding the shell-pocked corner of a broken street, will cut to the latest GM pickup truck, hurtling over the rise of a potholed dirt road—the same palm-covered hills behind. Mary Ann Doane writes: "According to Susan Sontag, 'we live under continual threat of two equally fearful, but seemingly opposed, destinies: unremitting banality and inconceivable terror.' Television produces both as the two poles structuring the contemporary imagination."[22]

Among the films shown in the 1993 San Francisco International Film Festival is one that was shot using a toy video camera.[23] In a succession of pixelized and gloomy black-and-white scenes, the short film records ennui and banter between young people in a cramped New York apartment. They spend a lot of time watching television. One of them, reflecting on a train of professional and emotional setbacks, speaks of an uncomfortably dawning awareness that his life exists independently of his desires and fantasies. He says he fears that his life will never amount to more than a random accumulation of the debris of events. In his "Theses on the Philosophy of History," Walter Benjamin writes about a painting by Paul Klee, *Angelus Novus*. The painting:

> shows an angel looking as though he is about to move away from
> something he is fixedly contemplating. His eyes are staring, his mouth

is open, his wings are spread. This is how one pictures the angel of history. His face is turned towards the past. Where we perceive a chain of events, he sees one single catastrophe which keeps piling wreckage upon wreckage and hurls it in front of his feet.[24]

Architecture has been described as "frozen time." National monuments are the accretion of national history. Where they are absent, national identity is fragile. An Albanian, in the mainly ethnically Albanian south of Serbia, anguishes: "I know we've been here the whole time, fine. I know that. But you can see the Roman baths, the Turkish mosques, the Serbian monasteries. Where are our buildings?"[25] Where national monuments exist, their destruction may erase national identity, at least this is what nationalists believe. The destruction of historic mosques in Bosnian towns has been an intrinsic part of the Bosnian Serb program of "ethnic cleansing." In a depressingly familiar report in the *New York Times*, I read: "The ornately decorated Ferhad-Pasha Mosque, one of those destroyed, dated from 1583 and was considered one of the most beautiful in the Balkans."[26] Some months later, another article in the *New York Times* tells of a bridge in the town of Mostar. Bombarded by Croatian gunners for several weeks, it has now collapsed, four centuries after being built. A masterpiece of sixteenth-century Ottoman architecture, the bridge at Mostar was also a metaphor for the common life of Muslims, Croats, and Serbs prior to the start, in mid-1991, of the violent disintegration of Yugoslavia into ethnic statelets. According to a Belgrade architect, quoted in the article, "The bridge was a piece of metaphysical architecture that linked cultures and peoples." He concludes: "I ask myself how the people of Mostar will live without that bridge. They have now lost a part of their being. With a loss like this, people lose their place in time."[27]

The award ceremony with which I began, the eruption of Africa in the Japantown of a North American city, celebrated hybridity—in terms of

aesthetic protocols now called "postmodern." Robert Young celebrates "the urban centers of the West where local culture has become hybridized by once migrant groups, and where assimilation, still often assumed to be a one-way process, has developed a form of diasporic internationalism, undoing the ideology of race and nation."[28] But the prefix *post-* must always alert us to the fact that nothing is really over—ideologies are not so simply undone. "Post-colonial," we know, means "*neo*-colonial." As Young writes: "We are talking, with neocolonialism, about the legacies of history, not as a textual archive, but as the continued productivity of history in the present."[29] Such living legacies project the diachronic into the synchronic, not only across the lines between the West and its "others" but also across periodic divisions internal to the West. A friend told me of his visit to a photography exhibition, in a Polish museum, dedicated to Polish history. History was divided into significant periods and each period allocated a room of its own. One was expected to move from room to room in strict chronological order. However, as each room opened onto more than one adjacent room, chronologically distant periods often stumbled into abrupt and violent spatial collision. The ferocity of the Serbian assault on Croatia, in the early days of the conflict in what used to be Yugoslavia, may be seen—at least in part—as a consequence of entering a room of mental images from the early 1940s, when Croatia supported Germany and Croatian facist militia massacred tens of thousands of Serbs. Both real and mental images mingle in this mnemotechnic habitat.[30] Writing in the *New York Times*, John Kifner reports: "The pictures hang in home after Serb home—Balkan equivalents of 'Washington Crossing the Delaware,' and keys to the mind-set of the Serbs. . . . 'The Maiden of Kosovo' [painted by Uros Predic, in 1917] shows a young woman giving a drink from a jug to a wounded Serbian warrior (with slain Turks nearby) who has fallen on the battlefield at Kosovo in 1389."[31] The ethnic Slavs slaughtered by other ethnic Slavs, in the euphemistic insanity of "ethnic cleansing," are the descendants of those Slavs who

converted to Islam during the Turkish occupation after the Battle of Kosovo. In an interview published earlier in the same newspaper, the mayor of a Serbian town defended Serbian actions by referring to the centuries of Ottoman domination of Bosnia and Herzegovina. He told the *New York Times* reporter: "We've always been here and the Muslims have only been here since the 15th [sic.] century."[32] Kifner reports: "Maps in Serbian, Bosnian and Croatian offices seek to justify borders on the basis of old kingdoms identified by medieval shields." Marx had already described it:

> The tradition of all the dead generations weighs like a nightmare on the brain of the living. And just when they seem engaged in revolutionising themselves and things, in creating something entirely new, precisely in such epochs of revolutionary crisis they anxiously conjure up the spirits of the past to their service and borrow from them names, battle slogans and costumes in order to present the new scene of world history in this time-honoured disguise and this borrowed language.[33]

The Bosnian prime minister, Haris Silajdzic, a Muslim, tells the *New York Times:* "This medieval siege, slaughter, genocide is happening to a country that deserves to be protected. If nothing else, like a museum."[34] For the majority of people in the West, outside of ex-Yugoslavia, such bombardments as that which destroyed the bridge at Mostar are known only via the media—particularly satellite television. In front of the television screen, as Jean Baudrillard remarks in respect to a previous conflict, "We are, day by day, virtually bombarded."[35] To be bombarded by images poses no immediate mortal danger. Nevertheless it is possible that, in this everyday environment, we too may, as the Belgrade architect put it, "lose our place in time." The fabric of self-identity—individual, ethnic, or national—is woven in time and space, history and geography, memory and place. In mediatic space-time, however, neither monument

nor moment survives beyond the immediate, and there are no permanently stable points of orientation. It is not only the links between images which have been shattered. In this present fin-de-siècle, the aggressive history of the West has exploded nothing less than the image itself.

Saint Augustine begins a chapter of his text on *The Trinity* with a passage from Corinthians: "As long as we are in the body, we are absent from the Lord; for we walk by faith, not by sight."[36] For the early Christian church, the journey of faith was to end in the end of history, and in the end of faith itself, which would dissolve in the luminous *certainty of vision* of the eternal trinity. It is in this light that we may understand the otherwise cryptic citation from Augustine which Julia Kristeva places at the head of her short essay of 1975 about the cinematic image: "Although man is disquieted in vain, yet he walks in an image."[37] Kristeva comments:

> Saint Augustine, once again, speaks and consolidates the truth of the symbolic and fantasmatic order for two thousand years of Christianity. . . . Specular fascination captures terror and restores it to the symbolic order. Christian art, in the penumbra of churches, more than anywhere else, understands, multiplies and exploits this fascination. Calm reigns before a vision of hell framed in an image.[38]

Reading this brings to my mind a memory of the Arena Chapel in Padua. One of its famous frescoes by Giotto, covering an entire wall, is a scene of the Last Judgment. The other walls collectively display the unfolding path of human existence which would lead to this Judgment Day, a narrative of hope for the redemption of man through the exemplary lives of the Virgin and Christ. In 1944, allied bombs partially destroyed the Church of the Eremitani, only yards away from the Arena, the Chapel of the Scrovegni. In my fantasy, however, it is the Arena that

explodes, raining its fragments on the city of Padua like the scattered contents of a huge Giotto jigsaw puzzle.³⁹ The "grand narrative"⁴⁰ of human existence, the source of inspiration and legitimation of all social institutions and individual actions in fourteenth-century Europe, is not destroyed but it is now encountered in a very different way—the way in which, today, we characteristically encounter all the narratives of our existence. Today's puzzle pieces, however, could never be reunited in a coherent picture, and no calm reigns before their disjoined visions of hell.

From a world in which images were once limited in number, circumscribed in meaning, and contemplated at length, we have today arrived at a society inundated with images consumed "on the fly." Images from magazines, newspapers, snapshots, videos, films, broadcast and cable television, and so on. The image as object of contemplation has been blasted into so many synecdochic representatives: "bites" and "clips." The fragmented universe of images today is the expanding consequence of an explosion that took place at the inception of metropolitan modernity, when Baudelaire characterized the inhabitant of the newly emerged metropolis as "a *kaleidoscope* equipped with consciousness." Baudelaire's analogy registers that spatial confusion of subject and object to which Lacan was subsequently to bring so much insight. In his essay on aggression, Lacan writes:

> The notion of the role of spatial symmetry in man's narcissistic structure is essential in the establishment of the bases of a psychological analysis of space . . . animal psychology has shown us that the individual's relation to a particular spatial field is, in certain species, mapped socially, in a way that raises it to the category of subjective membership. I would say that it is the subjective possibility of the mirror projection of such a field into the field of the other that gives human space its originally "geometrical" structure, a structure that I would be happy to call *kaleidoscopic*.⁴¹

The waking dreams of a luminously engineered modernity with which Western reason began this century have since engendered nightmares. Scientific socialism has foundered, and the only rationalism to succeed in its own terms has been the ruthless logic of the market, production, and profit. The enormous wealth accumulating in the newly "global" economy, however, has yet to "trickle down" to the unemployed, the deranged, and the diseased who accumulate not only at its spatial margins but also at its centers—on the streets of the world's richest cities. However, although the economic gap between wealthy and poor has increased in this last quarter of the century, the rights most conspicuously claimed today are more likely to be the civil rights of a social minority than the material rights of a broader economic class. Toward the close of the twentieth century, various forms of "identity politics" have largely superseded the economic-class politics that was the privileged form of social contestation at the beginning of the century. The ground of history as class struggle, with which we entered the century, has fractured along such fault lines of distinction and division as those between nationality, gender, sexuality, race, ethnicity, and religion. As this list already indicates, a paradox of "identity politics" is that it may impose barely tolerable strains on the very identities it would interpellate—as actual individuals come into being across, as well as within, such boundaries. Boundaries, nevertheless, are inevitable. The very category of identity implies the line of that necessary difference that distinguishes self from other. The infant that fails to develop the knowledge that it is separate from its mother's body cannot become a "child," cannot enter society. Just as such spatialization is a necessary condition of identity, so is temporalization. There is no identity—national, cultural, or individual—which does not imply both a place *and* a time. There is no identity that is not both mise-en-scène and narrative—in personal memory, and common history. We are now undergoing, as Kanneh puts it, "a post-imperialist crisis of identity around the politics of time and place."[42] The formal teaching of history, in schools and universities, is in turmoil. There is no longer a single narrative,

"History," in which we may all inscribe our own lives. There is a dislocation between "official" history, written by professional historians, and the lived histories of a multiplicity of minority groups—"subaltern" histories.[43] A "subaltern history," in the words of Ranajit Guha, of the Subaltern Studies group, "seeks to describe the contribution made by the people *on their own*, that is, *independently of the élite*."[44] Those engaged in the construction of such "subaltern" histories, however, are themselves a small minority in society. Identity requires a history in which to "take place." If official history—and other "grand legitimating narratives"—is in disarray and subaltern histories are not widely encountered, we are left with the question of where the tales by which most people live come from. For the majority, they no longer come from the Arena Chapel and its counterparts. By default, increasingly, they must come from the violently kaleidoscopic environment we have sedately named "contemporary visual culture."

II. GLOBAL IMAGINARIES

The Ideological would be at bottom the Imaginary of a time, the Cinema of a society . . . it even has its photograms: the stereotypes with which it articulates its discourse.

Roland Barthes[45]

It is precisely the kaleidoscopically "schizophrenic" character of the mediatic environment that Frederic Jameson remarks on in his widely discussed essay of 1984, "Postmodernism, or The Cultural Logic of Late Capitalism." He finds that history, as it entered the last quarter of the twentieth century, the era of "a remarkable . . . intensification of an addiction to the photographic image,"[46] had crumbled into "a rubble of distinct and unrelated signifier."[47] In this environment, he writes, "The retrospective dimension indispensable to any vital reorientation of our

collective future [has] become a vast collection of images . . . a series of pure and unrelated presents in time."[48] Moreover, in that personal identity, as much as collective identity, is "the effect of a certain temporal unification of past and future with the present before me,"[49] identity also is equally at risk. Jameson concludes: "The crisis in historicity now dictates a return, in a new way, to the question of temporal organization in general in the postmodern force field, and indeed to the problem of the form that time, temporality and the syntagmatic will be able to take in a culture increasingly dominated by space and spatial logic."[50] In the discussions that followed Jameson's essay, however, the "question of temporal organization" was swept away in a flood of publications about *space*. The preoccupation of cultural theorists with questions of space had begun before Jameson's article, to the extent that his remarks about time seemed *at the time* to be "behind their time"—a futile last shot fired in a battle, already lost, on behalf of Marxist historicism. Seventeen years earlier, Foucault observes: "The great obsession of the nineteenth century was, as we know, history. . . . The present epoch will perhaps be above all the epoch of space. We are in an epoch of simultaneity: we are in the epoch of juxtaposition, the epoch of the near and far, of the side-by-side, of the dispersed."[51] Such renewed interest in space was at least in part the consequence of a more general reorientation in thought in the second half of the twentieth century. In the course of the remarks to which I have referred, Foucault speaks of structuralism. He characterizes it as "the effort to establish, between elements that could have been connected on a temporal axis, an ensemble of relations that makes them appear as juxtaposed, set off against one another, implicated by each other." This "spatialization" of signifying elements was fundamental to the reorientation of the study of language brought about by Ferdinand de Saussure. Here, the "diachronic" orientation of philology gave way to the "synchronic" orientation of modern structural linguistics, in which signified is disjoined from signifier, and the notion of

(inherent) "signification" gives way to that of (contingent) "value." One of the earliest criticisms of structuralist thought came from those—often Marxists—who claimed that structuralism left *history* out of account. Writing in 1967, Foucault countered, "Structuralism does not entail a denial of time; it does involve a certain manner of dealing with what we call time and what we call history." Subsequent "poststructuralist" and "deconstructionist" critiques of structuralism have not revoked this fundamental reorientation and recasting of "what we call time and what we call history."[52] Jameson's anxiety over the "crisis in historicity," however, remains widely shared.[53] I mention this debate, but it is not one that will directly concern me here. I am neither qualified nor inclined to intervene in discussions between historians and historiographers. As I have already stated, my concern is rather with how the sense of history which underwrites an identity *occurs* as it were "by default" across everyday encounters with the contemporary field of images.[54] It is with *this* interest that I refer to the work of Jameson. Jameson is almost alone in having considered the "contemporary field of images" as a *global* fact—not only in the widely read essay I have mentioned, but in a more recent, and less commented, book about cinema.

Jameson's book of 1992, *The Geopolitical Aesthetic: Cinema and Space in the World System*, is organized in two parts. Part 1 consists of a discussion of a number of American films, mainly from the 1970s and 1980s,[55] which Jameson takes as examples of what he calls the "conspiratorial text." He argues that conspiracy narratives in recent Hollywood cinema may be understood as the attempt to represent in "allegorical" form the totality of a "world system" become "so vast" that it can no longer be "encompassed by the natural and historically developed categories of perception with which human beings normally orient themselves."[56] He writes: "On the global scale, allegory allows the most random, minute, or isolated landscapes to function as a figurative machinery . . . a host of partial subjects, fragmentary or schizoid constel-

lations often now stand in allegorically for trends and forces in the world system."[57] Hollywood conspiracy narratives, he claims, may be taken to constitute "an unconscious, collective effort at trying to figure out where we are and what landscapes and forces confront us in a late twentieth century whose abominations are heightened by their concealment and their bureaucratic impersonality."[58] In terms of what Jameson here and elsewhere calls "cognitive mapping,"[59] the conspiratorial text represents "the cartography of the absolute." In his preface to Jameson's book, Colin MacCabe writes: "Cognitive mapping is the least articulated but also the most crucial of the Jamesonian categories. Crucial *because it is the missing psychology of the political unconscious*" (my emphasis).[60] Part 2 of *The Geopolitical Aesthetic* consists of four chapters, each centered on the analysis of an individual film in which Jameson finds a less global, more national form of cognitive mapping: "a kind of allegorical thinking which is less ultimate than the cartography of the absolute . . . although of a piece with it and sharing common mental operations."[61] Here he discusses the Soviet filmmaker Alexander Sokurov's *Days of the Eclipse* (1988), the Taiwanese director Edward Yang's *Terrorizer* (1986), Jean-Luc Godard's *Passion* (1981), and two works by the Filipino filmmaker Kidlat Tahimik—*The Perfumed Nightmare* (1977) and *Turumba* (1983). Jameson finds that, in their different ways, these films represent the operation of what he calls a "geopolitical unconscious," that which "attempts to refashion national allegory into a conceptual instrument for grasping our new being-in-the-world."[62] Throughout Jameson's book, the expressions "political unconscious," "cognitive mapping," and "allegory" are used interchangeably to name a single set of what he calls "common mental operations." McCabe claims that Jameson's notion of "cognitive mapping" offers to provide the "missing psychology of the political unconscious." The question that concerns me here is precisely the relation of Jameson's "common mental operations" to the psychoanalytic concept of the unconscious. The question is more than merely academic; it concerns

the way we derive a sense of historical processes from the environment of the media.

In his introduction to *The Geopolitical Aesthetic*, Jameson refers to the films he will discuss as a "set of exhibits."[63] The word *exhibits* may evoke the institutional space of an art gallery, or cinema; or it might suggest the context of a court of law, where select items—"exhibit A," "exhibit B," and so on—are presented as evidence in support of an argument. In fact, the discursive space of Jameson's book about "cinema and space" is somewhere between the two: between the places where images and narratives are enjoyed and the places where ideas are tried.[64] This interim space is that of practical criticism, and the theses illustrated by Jameson's cinematic examples are implied rather than systematically articulated. There are nevertheless points at which the buried mass of his previously assembled theoretical apparatus breaks the surface. Perhaps the most telling of these is in Jameson's introduction to the book, where he mentions in passing "what I have called cognitive mapping—and what Althusser described in his classical model of the three fundamental terms of ideology (the individual subject, the real, and the Imaginary projection by the subject of the former's relationship to the latter)."[65] The terse references compacted into these few lines[66] indicate the theoretical foundations on which the rest of the book is constructed.[67] In terms of Jameson's Marxist intellectual culture, the history of the basic ideas that inform *The Geopolitical Aesthetic* may be traced, beyond Louis Althusser, to Engels. Fundamentally, the ideas are about two interrelated issues: the relation of the author to the text, and the relation of the text to the real world. In a much-commented letter of 1888 to Margaret Harkness,[68] Engels distinguishes between the "realism" of the socialist *Tendenzroman* and the realism he finds exemplified in the work of Balzac—a realism that "may creep out in spite of the author's own views."[69] Engels defines realism as "the truthful reproduction of typical characters under typical circumstances." The word *typical* here indicates his requirement that the

characters and relations described in the narrative represent, beyond mere local anecdote, subject positions and relations that may be generalized in terms of the social order as a whole. To take an example from a text by Balzac which Jameson himself discusses, Balzac states in his novel *La vieille fille* that one of his two protagonists, Du Bousquier, "abrupt, energetic, with loud and demonstrative manners . . . might quite adequately be said to represent the Republic," while the other, the Chevalier de Valois, "mild and polished, elegant . . . and upholding good taste to the end, offered the very image of the old court aristocracy."[70] In Balzac's novel, it is the former who gains the upper hand, just as the newly rich bourgeoisie he represents was to triumph over the aristocracy in actual history. The fact that Balzac's own Legitimist political sympathies were with the declining aristocracy was of no substantive consequence to Engels, who writes: "That Balzac was thus compelled to go against his own class sympathies and political prejudices, that he *saw* the necessity of the downfall of his favorite nobles . . . that he saw the real men of the future [is] one of the greatest triumphs of Realism."[71] Engels's estimation of the progressive nature of the work of the politically conservative Balzac has a counterpart in Jameson's judgment of the literary work of the Fascist sympathizer Wyndham Lewis. In his book on Lewis, published in 1979, Jameson writes: "In Lewis . . . artistic integrity is to be conceived, not as something distinct from his regrettable ideological lapses (as when we admire his art, *in spite of* his opinions), but rather in the very intransigence with which he makes himself the impersonal registering apparatus for forces which he means to record."[72] Jameson brings this same idea to the discussion of a film in his essay of 1979 about Sidney Lumet's *Dog Day Afternoon* (1975).[73] The notion that the political significance of a text may run contrary to the political allegiances of its author here serves Jameson in defense of his decision to write about a *commercial* film. He anticipates protests from "critics who object *a priori* that the immense costs of commercial films, which inevitably place their production under the

control of multinational corporations, make any genuinely political content in them unlikely, and on the contrary insure commercial film's vocation as a vehicle for ideological manipulation." To this hypothetical objection, Jameson replies:

> No doubt this is so, if we remain on the level of the intention of the individual film-maker, who is bound to be limited consciously or unconsciously by his or her objective situation. But it is to fail to reckon with the political content of daily life, with the political logic which is already inherent in the raw material with which the film-maker must work: such political logic will then not manifest itself as an overt political message. . . . But it will certainly make for the emergence of profound formal contradictions to which the public cannot but be sensitive, whether or not it yet possesses the conceptual instruments to understand what those contradictions mean.[74]

The view of the relation of author to text in Jameson's criticism is clearly that approved by Engels. So far as the relation of the text to the real world is concerned, Jameson's views are no less clear. In his book on Lewis, Jameson remarks that Lewis's work provides "an exemplary manifestation of Althusser's account of the way in which art uses and transcends its ideological raw materials."[75] Replying to a critic, Althusser writes: "The peculiarity of art is to 'make us see' [*nous donner à voir*] . . . 'make us feel' something which *alludes* to reality . . . Balzac or Solzhenitsyn, as you refer to them, they make us *see*, *perceive* (but not *know*) something which *alludes* to reality." He continues: "What art makes us *see* . . . is the *ideology* from which it is born, in which it bathes, from which it detaches itself as art, and to which it alludes."[76] Similarly, in a review of the work of the painter Leonardo Cremonini,[77] he asserts: "The specific function of the work of art is to make *visible* [*donner à voir*], by establishing a distance from it, the reality of the existing ideology."[78] In a nutshell

(typographically represented by the translator's brackets) it is Althusser's "*donner à voir*" that for Jameson is the kernel of the artistic process. In Jameson's words, it is: "the process by which the work of art can be said to 'produce' the ideological as an object for our aesthetic contemplation and our political judgment."[79] All of this is clear. What is not clear, however, is how the view implicitly derived from Engels may be merged with the one explicitly derived from Althusser.[80] Engels's Realist epistemology is unambiguously empiricist. Althusser unambiguously rejects the empiricist account of the way the individual acquires knowledge—in *experience*, the world simply presenting itself, via the senses, "as it is." For Althusser, both the subject and its experiences are *constituted* in representations. Realist art, according to Engels, is art that shows reality—the real world—"as it *really* is." According to Althusser, art can only show "the reality of the existing ideology."[81] What this ideology represents is (in what is perhaps Althusser's best known statement) "not the system of the real relations which govern the existence of individuals, but the imaginary relation of those individuals to the real relations in which they live."[82] Jameson's whole thesis, however, is that the films he talks about give us access to something—"trends and forces in the world system"—which has somehow the status of an objectively existing fact, rather than a theoretical construction, or a fantasy. This access Jameson sees as guaranteed by: "the political logic which is *already inherent in the raw material* with which the film-maker must work" (my emphasis). At times he speaks as if the access were achieved directly, and at other times as if it were achieved indirectly. To take the former instance first: In Engels's epistemology, the "triumph of Realism" is achieved when the text *conforms* to the world it depicts, shows the working of historical forces *directly*. Such a Realist text is, in Jameson's expression, an "impersonal registering apparatus." In *The Geopolitical Aesthetic*, Jameson describes a film by Tahimik in which the late twentieth-century Philippines is shown submitting to much the same historical process that Balzac had depicted

at work in nineteenth-century France. Jameson observes that Tahimik's film *Turumba* "offers a virtual textbook demonstration of the penetration of capital into a traditional village, and the transformation of collective relations by the market and money relationships."[83] But if asked to sum up the expository mode of the textbook "in a word," we would be unlikely to suggest "allegory." The example from *Turumba* is not one of "allusion," nor is what we are given to see "ideology." Rather, in this film, we see the reality—in practices—of historically mutating social and economic relations in a seemingly direct and unmediated way, a way of which Engels might well have approved. The image is *illustration*, rather than allusion. To speak in terms of Western art history, this example is closer to nineteenth-century Realist painting than to the allegorical paintings of the sixteenth century: more Courbet than Bronzino; more *Burial at Ornans* than *Venus, Cupid, Folly, and Time*.

Turning now to the second instance: In his essay about *Dog Day Afternoon*, Jameson gives an example of what he there calls *figuration*, but which in his later work he calls "allegory." He identifies the most politically significant opposition in the film as being that between "the FBI agent and the local police chief, whose impotent rages and passionate incompetences . . . set off the cool and technocratic expertise of his rival."[84] Jameson observes of the FBI agent that "his anonymous features mark a chilling and unexpected insertion of the real into the otherwise relatively predictable framework of the fiction film"[85] (echo of Engels). In addition, however, the agent "comes to occupy the place of that immense and decentralized power network which marks the present multinational stage of monopoly capitalism. The very absence of his features becomes a sign and an expression of the presence/absence of corporate power in our daily lives."[86] This passage from Jameson's essay of 1979 prefigures the thesis, thirteen years later, of *The Geopolitical Aesthetic*. In this particular example, the *personification* of "immense multinational power" takes the *attribute* "faceless." Certainly such "sign

and expression" constitutes allegory in the form most familiar to historians of Western art. (For example, in the sixteenth and seventeenth centuries the "personification" of "Truth" typically took the form of a woman, identifiable by such "attributes" as a mirror, which cannot lie, and a laurel crown, as victory is ultimately hers.) It was Erwin Panofsky who first remarked on the appearance of allegory in the cinema. In his essay of 1934, "Style and Medium in the Motion Pictures," Panofsky notes the personifications and attributes most prevalent in the cinema of his day: "the Vamp and the Straight Girl (perhaps the most convincing modern equivalents of the medieval personifications of the Vices and Virtues), the Family Man and the Villain, the latter marked by a black moustache and walking stick."[87] Inanimate objects also may serve an allegorical function. Panofsky notes that, in the films of his day, "A checkered tablecloth meant, once for all, a 'poor but happy' milieu." The recurring image of a small bridge in Tahimik's film, *The Perfumed Nightmare*, prompts Jameson to write:

> "Mediation" . . . is here symbolically designated by the picture of a bridge, and specifically of the little hump-backed stone bridges of the village, over which real and toy vehicles laboriously pass. As a "concept," it has something to do with the relationship between cultural stages (Third and First Worlds); between the "levels" of social life itself . . . between the past and the future . . . between confinement and freedom.[88]

But if we may see an example here of what Jameson claims, in his essay on *Dog Day Afternoon*, to be that which is *already inherent* in "the raw material with which the film-maker must work," it is only by looking through a particular lens. I do not disagree with Jameson's interpretation; in the context of this film there can be no doubt that he is right. Nevertheless, albeit pedantically, I ask that we observe the letter of what

Jameson no doubt knows full well. There are no "contradictions" in the Real, and if the bridge framed by Tahimik's camera "figures" the relation of First to Third World, it is only because it is "given to us to see" (*nous donner à voir*) in a particular political perspective. The "ideology" thereby revealed is none other than that of the interpreter. This far, such interpretive schemas are the modern counterpart of the knowledge of classical and Christian mythological texts required of the "learned painter" of allegories. But whereas the humanists applied their scholarship in both the encoding and decoding of images, today's scholars are more likely to deploy their knowledge only in interpreting images—with an attendant danger. As MacCabe remarks, in his preface to *The Geopolitical Aesthetic*, the "practical difficulty" besetting a classic Marxist analysis of culture is that "all cultural forms end up with the same content. One must resign oneself to endlessly analyzing the same messages—in the end, there is simply the endless recoding of property relations."[89] MacCabe finds, "It is to this practical difficulty that Jameson's theory of the political unconscious responds."[90]

There is reason to be wary when the theory of the unconscious is invoked, like some deus ex machina, to respond to a "practical difficulty." Perhaps we should take time out to remind ourselves of some basics. What is at issue is *interpretation*. Freudian psychoanalysis is founded on a theory of the unconscious and of infantile sexuality. It began with the treatment of hysteria. The hysterical symptom is caused by the "repressed" memory of something too disturbing (painful, shameful, exciting, frightening, it is all the same) to be allowed into consciousness. First by means of hypnosis, and later by free association, Freud and Josef Breuer aimed to recover the lost event and restore it to conscious memory—thereby liquidating the symptom that had usurped its place. Interpretation, then, played little part in earliest psychoanalytic practice. As psychoanalysis evolved, however, the memory of the real event came to be replaced in prominence by the fantasy of the forbidden wish, and the element of

interpretation in psychoanalysis came to the foreground. Interpretation in psychoanalysis begins with the interpretation of dreams. A dream is the hallucinatory fulfillment of a wish, but a wish that is unacceptable to the conscious mind of the subject who wishes. Where the wish gains access to consciousness it does so only in a "compromise formation" that is the outcome of a conflict. The manifest dream, therefore, is a transformation of the latent content in the service of the defense. This same insight is applied to the analysis of symptoms, parapraxes, and other manifestations of speech and behavior which bear evidence of defensive conflict—the result not only of "repression" but of such other defensive mechanisms as "negation," "projection," "disavowal," "foreclosure," and so on. In all cases, interpretation is the means by which latent meanings are derived from manifest content. There are two methods of interpretation described in Freud's book, *The Interpretation of Dreams*. His original technique of interpreting dream elements, which he first applied to the analysis of his own dreams, consists in following the chains of associations of the dreamer. In a sense, therefore, the dreamer interprets his or her own dream. In this interpretative method, the latent meaning of a manifest element is arrived at only indirectly, via webs of associations governed by the "primary processes" of unconscious formation: "condensation," "displacement," and "considerations of representability." In the 1909 edition of *The Interpretation of Dreams*, however (the first edition was published in 1899), Freud adds another means of interpretation of the manifest contents of dreams, one in which certain symbols are translated by the analyst *directly*, on the basis of a knowledge of typical symbols. Freud notes that these invariant symbols may be found not only in dreams but in folktales, myths, religion, and other cultural spheres. The existence of symbols with transindividual meanings was a fact Freud could not ignore, but the interpretation of such symbols is not in itself psychoanalytic. As Freud himself notes, in the opening chapters of *The Interpretation of Dreams*, such a "dream-book" approach to the interpretation of

invariant symbols dates from early classical and Oriental history. As it supposes a fixed relation to exist between symbol and meaning—a meaning given "once and for all"—then the dream-book approach might better be described as one of "decoding" rather than "interpretation." This, in fact, is the approach closest to classical procedures for deciphering allegories, with its apparatus of such code books as Andrea Alciati's *Emblematum liber* of 1531 and Cesare Ripa's *Iconologia* of 1593. Although the significance of a dream element *might* be found by reference to a general "shorthand" of common symbols, it is more likely that it would emerge only when situated in a specific individual context. Freud, finally, was interested only in what the "symbol" meant to the individual in analysis—a meaning arrived at only over time, in the wider context of all the other materials produced in the analysis. When Melanie Klein subsequently came to approach the play of the child, as she put it, "in a way similar to Freud's interpretation of dreams," she emphatically cautioned: "We have to consider each child's use of symbols in connection with his particular emotions and anxieties and in relation to the whole situation which is presented in the analysis; *mere generalized translations of symbols are meaningless*" (my emphasis).[91]

We may now return to the bridge in Tahimik's film, *The Perfumed Nightmare*. Jameson's initial attribution of the meaning "mediation" to this image is unproblematic. In everyday English, the word *bridge* is commonly used to metaphorically express such otherwise abstract notions as "communication" between two parties and "transition" from one state to another. Obviously we would not call these meanings unconscious. In a certain psychoanalytic literature, the image of the bridge is seen as the "unconscious" representation of the penis that joins the parents in sexual intercourse, and the transitions of birth and death.[92] But this dream-book type of "Freudian" reading differs from its "Marxist" counterpart (in this example, Jameson's signified "relationship between cultural stages") only in that it exchanges "the endless recoding of property relations" for a

no less interminable recoding of Oedipal relations. The fact is, in the dream of a particular individual, a bridge can represent anything at all. For example, there is no reason why the image of a bridge—by the intermediary of the homonymically named card game—should not allude to the idea of a "gamble." (This would be an example of what Freud calls a "verbal bridge.") Certainly, there is nothing to *stop* the image representing the penis that joins the parents in intercourse, or the fragile connection an immigrant from the Third World may feel to the materially rich "First World." Or even, albeit improbably, all of the above (in what Freud called "overdetermination"). Nor, in a dream, is there anything to stop the image of a bridge representing anything other than a *bridge*. None of these meanings, or any other meaning, is guaranteed in advance of the specific context—the specific history—of the analysis. (All of this is what it *means* to speak of "the disjunction of signifier from signified," and, "the sliding of the signified under the signifier.") In brief, then, the type of "allegorical" interpretation employed by Jameson, although it may occasionally be *used* in psychoanalysis, is not in itself psychoanalytic. As a model of semiotic analysis it is closer to Panofsky's secular iconography than it is to Freud's psychoanalysis.

There is another image from Tahimik's film which might better serve to illustrate the operation, and necessity, of a *psychoanalytically* informed semiotics. The image occurs no less often than the image of the bridge. At seemingly regular intervals throughout the film, the camera lingers on a white water buffalo. The water buffalo is found throughout Southeast Asia, but this animal—a carabao—is a species indigenous to the Philippines. Moreover, the carabao is normally black, or at least a very dark brown. An albino carabao is as exceptional as a white cow—which, by consequence, is sacred in India. The Filipinos do not worship the carabao. Its signification in Tahimik's film is not religious but satirical, lampooning that attempt to "bridge" difference which is mimicry ("passing"). Whenever the carabao appears in *The Perfumed Nightmare*, it appears twice: as

anecdote and as allegory, as a factual element of the landscape and as a serious joke. The image is at once seen by all, and *legible* only to some. A similarly motivated, and similarly constructed, satirical gesture has more recently produced a Filipino version of the logo on a well-known "designer" Polo shirt. The Filipino shirt is called "Bolo"—the Tagalog word for "machete." The logo shows a man wielding a machete—astride a carabao.[93] Tahimik's film contains "textbook examples" of the mechanism that Freud called "condensation." Far from directing us to global universals, the examples given here illustrate the importance of attention to specific context—here defined at the level of national culture. To be quite clear: although "condensation" is a privileged mechanism of the unconscious, I assume that Tahimik's use of it here is conscious.[94] I further assume that the meanings *he* may reasonably suppose the carabao to animate are *preconscious*—such oppositions as White/Black, indigenous/foreign, rural/metropolitan are amongst the psychical contents likely to be held in common by those sufficiently knowledgeable of Filipino culture to get Tahimik's joke. Certainly, as Freud pointed out, jokes are favored vehicles for unconscious meanings, but if we were to turn our attention to these *individual* items we would quickly lose the carabao's trail. Psychoanalytic theory is indispensable to cultural studies in its attention to the semantic structuring of the "national popular." Psychoanalytic therapy, on the other hand, is most emphatically none of its business.

We should be cautious in distinguishing between *processes* and *contents* when we export psychoanalytic theory to the realm of cultural analysis. Freud gave the name "primary processes" to those combinatory logics (primarily, *displacement* and *condensation*) which entirely govern the construction of unconscious productions. But such structuring logics are not confined to the unconscious, and it is easy to demonstrate their operation in many aspects of everyday life: in jokes (for example, above, the "Bolo" shirt), poetry, many advertising images, certain forms of photography and filmmaking, and so on. Attention to the perpetual *movement* of meaning—

from a word to an image, from one image to another, and so on—is absolutely essential if we are to avoid the stultifying literal mindedness of so much cultural criticism. Freudian psychoanalysis is indispensable to understanding this process. However, we should exercise great caution in identifying the contents that comprise the chains that displace literal meaning toward some other meaning, and even greater care in proposing where the chains may be leading. Jameson sees evidence of a global "political unconscious" in the presence of universal allegory in cinema. To the contrary, Freudian psychoanalysis is witness to the fact that "mere generalized translations of symbols are meaningless." Freud scrupulously distinguishes between the *descriptive* and the *topological* sense of the term *unconscious*. The former, more general use covers all instances of representations not present to consciousness and therefore includes "preconscious" representations (thus Freud speaks of the "conscious-preconscious system"). The latter, more restricted sense of the term covers only those representations that are barred to consciousness by the mechanisms of defense. It is only in this latter sense that the term acquires its specifically *psychoanalytic* significance.[95] Jameson, however, allocates no place to defensive conflict in his account of the political "unconscious." Whatever Jameson's notion of the "political unconscious" may be it is not Freudian. Jameson himself candidly writes, in *The Geopolitical Aesthetic*, "'unconscious,' if you follow my loose, figural use of that otherwise individual term."[96] Just as Barthes once wrote of his own relation to psychoanalysis that it was "undecided," we might justifiably say the same of Jameson's relation to psychoanalytic theory. Certainly Jameson "knows" the work; his essay of 1977 on the "Imaginary and Symbolic in Lacan" alone is sufficient to demonstrate the close attention he has given to psychoanalytic theory. It is rather as if, in the structure of "disavowal" first named by Freud, he is saying: "I know very well, but *nevertheless*."[97] With Jameson, the "nevertheless" derives most obviously from his Marxism. Uncompromisingly committed to the thesis of the

primacy of the economic, Jameson does not flinch from the edge of self-parody—in what may appear as an inverted form of that vulgar Freudianism that is all too ready to see the sexed body hidden within even the most apparently nonsexual image. Speaking of David Cronenberg's film *Videodrome* (1983), Jameson observes: "Physiological anxieties are . . . tapped by the grotesquely sexual nightmare images, in which males are feminized by the insertion of organic cassettes (if not revolvers) into a newly opened dripping slot below the breast bone." *Nevertheless,* he comments: "Corporeal revulsion of this kind probably has the primary function of expressing fears about activity and passivity in the complexities of late capitalism, and is only secondarily invested with the level of gender itself."[98] Interpretation in psychoanalytic treatment is a complex technical topic. What is at issue here is not clinical practice but the interpretation of "visual" texts. In traditional "applied psychoanalysis"— for example, Freud's study of Leonardo da Vinci, or Marie Bonaparte's study of Edgar Allan Poe—the text was interpreted as a symptom of its author's pathology. Such a traditional approach, when recast within the study of contemporary visual culture, might interpret the text as symptomatic of the political cultural formations that produce authors and readers alike. Basically, it seems to me, this is the direction that Jameson takes in *The Geopolitical Aesthetic.* This might appear as a radical shift in the application of psychoanalytic theory, from the individual to the social. But it may equally be seen as a simple displacement of the fantasy of a punctual origin, and a fixed signification, from the individual to "society," or, in Jameson's particular case, "the world system." Such a logocentric approach further implies that the purpose of interpretation (cultural criticism) is to provide *answers* by means of a *knowledge* brought to the text from *outside.* The word *critic,* here, derives its sense from its opposition to *public.* It is the critic who, to invoke Jameson's words, "possesses the conceptual instruments to understand what those [profound] contradictions mean." Psychoanalysis however puts all such self-

possessed mastery, including that of the analyst, into question. The goal of an interpretation attentive to the unconscious can only be to pose questions and create knowledge in the process of reading itself: a knowledge *of the reader*, as much as of the text. As Shoshana Felman writes, the analytic meaning is "essentially the reading of a difference that inhabits language, a kind of mapping in the subject's discourse of its points of disagreement with, or difference from, itself." And she continues:

> The unconscious . . . is not simply *that which must be read* but also, and perhaps primarily, that which reads. The unconscious is a reader. What this implies most radically is that whoever reads, interprets out of his unconscious, is an analysand, even when the interpretation is done from the position of the analyst.[99]

It is only by owning up to the inevitably "individual" dimension of reading, then, that a hypothesis about general, unconsciously generated meaning may be arrived at—precisely because *the subject of individual biography is not socially unique*. This is no more than to restate the insight expressed in the feminist slogan, "The personal is political." That this maxim was so widely misunderstood—as a call for a turning away from the "public" to the benefit of the "private"—is testimony to the narcissistic fervor with which humanist ideology defends the "individual." Contrary to the binarism of such thought, what psychoanalysis has to offer is, in Bhabha's words, "a way of questioning what is the private in the public, and what is the public in the private."[100] It is only through attention to what occurs in this space and time *between* that we may make sense of the question: "How, *unconsciously*, is a sense of history and identity derived from the environment of media images?" To this point I have spoken mainly about how space figures in psychoanalytic theory; I should now turn to what psychoanalytic theory has had to say about time and memory.

> To think of history objectively is the silent work of the dramatist.
>
> **Friedrich Nietzsche**[101]

In everyday speech, nothing is more obvious, or less clear, than what we mean by "time." As Saint Augustine expressed the dilemma: "If nobody asks me, I know: but if I were desirous to explain it to one who should ask me, plainly I know not."[102] We use the word in speaking of such different notions as "simultaneity," "succession," "duration," "past," "present," and "future." We say that time "passes quickly" if we enjoy what we are doing, or "passes slowly" if we do not. We habitually distinguish between time as it is "in reality," and time as it appears to us—few would dispute that "clock time" and subjective time are different things. Two philosophical traditions correspond to these different aspects of prevailing commonsense notions of time. In the former, deriving mainly from Newton, time is an objective fact. Uninfluenced by objects and events, time—together with space—forms the "container" in which objects and events take place. Characterized by uniform and unidirectional flow, time is an absolute and irreducible condition of the physical universe. It is quite simply part of the way things are. The alternative tradition derives mainly from Kant. In this view, Newtonian mechanics describes not the way things are but rather the only way in which we may have knowledge of them. For Kant, time—again, like space—is an inescapably a priori form of our innate intuition of "things in themselves," which by themselves have neither spatial nor temporal properties. Other philosophical theories of time may generally be situated in relation to the polar positions schematically represented by Newton and Kant.[103] Modern physics has, of course, been much concerned with the nature of time, most famously in Einstein's theory of relativity. Such a concern with "cosmological" time extends, beyond Newton, to classical antiquity. The theoretical concern with subjective time, however, is essentially modern.

It dates mainly from Kant, but becomes a radically distinct form of inquiry with Freud.

In a paper of 1940, Bonaparte observes:

> It is impossible to suppose . . . that men have derived those forms of their intuition or perception which we call space and time from any conceivable source other than the environment in which they have evolved for thousands of years. . . . If Kant thought otherwise, it must have been because, not withstanding the aversion which he professed for the old school of metaphysics, he had not really been able to renounce the dualistic belief in a soul independent of the body.[104]

Analogously, in his book of 1974, *The Production of Space*, Henri Lefebvre writes: "It is necessary for space to be *occupied*. What, then, occupies space? A body—not bodies in general, not corporeality, but a specific body, a body capable of indicating direction by a gesture, of defining rotation by turning round, of demarcating and orienting space."[105] In an essay of 1977, the psychoanalyst Arnaud Lévy invokes the child's astonishment when, in the process of learning the notion of right and left, it recognizes that, by the simple act of turning around, it can make left pass to right, and right to left. The child learns that such spatial coordinates are relative to the body, rather than objective properties of the physical environment. Like Lefebvre, Lévy asserts: "Subjective space surrounds us like an envelope, like a second skin. The notions of in front and behind, of right and left are attached to it."[106] But further to such spatial concepts, Lévy argues, the body is also at the origin of our basic notions of temporality. We habitually situate the future "ahead" of ourselves, place the past "behind" ourselves, and assume the present to be exactly where we currently are: thereby implying an anterior-posterior temporal axis. Thus, Lévy observes, "Subjective space functions as metaphor of time."[107] Lévy develops and illustrates this basic observation with reference to material

from his analytic practice. Amongst his clinical anecdotes is an account of the fantasy of one of his patients: The man sees his body before him, as if floating in space. He has the impression that this body is in forward movement, like the figurehead of a sailing ship. He feels himself traversed by space-time as, mouth open, his fantasmatic body swallows the future ahead of it, and ejects it behind in the form of the past. He himself nevertheless remains as if apart from this corporeal process, as if simply observing it. Lévy remarks that his patient's fantasy image might well be captioned with the words of an old saying: "Man digs his grave with his teeth." Here, he notes, we again encounter "the usual temporal structure of subjective space . . . with the future situated ahead, the past behind. But, further to this, the future is linked to the mouth, the past to the anal orifice. The anterior-posterior axis of subjective space is the axis of the digestive tube. Time is, at the same time, food and excrement, oral object and anal object: it is, in fact, the *digestive object*."[108] Lévy supposes that the acquisition of knowledge of the anatomical structure and function of the digestive tract must necessarily represent a revolutionary event in the history of the human subject, overthrowing the former governing schemas of self-representation. He writes:

> Before this moment, the corporeal image is that of a sack of skin pierced by orifices; space is subdivided into two areas, external space and internal space, communicating with each other by these orifices. To this corporeal schema there corresponds a *syndrome of imperviousness*, easily spotted in the clinical setting in the structures called *borderline* or psychotic: the exterior would have the possibility of irrupting into the interior, the interior would be susceptible to escaping and flowing to the outside.[109]

With knowledge of the digestive tract, however, the basic spatial structure of the corporeal schema—the psychical images that represent

the body for the subject—passes from bipartite to tripartite. Lévy continues:

> Space is sub-divided into three areas by the appearance of an interior space, delimited by the digestive tube, open at the two extremities onto exterior space. . . . This "transitional space" is an internalized exterior, not really exterior and not really interior. The object in this space is mid-way between the external object, escaping from power, and the internal object, submitted to omnipotence.[110]

As the analysand's fantasy of his *detached* observation of his body may illustrate, the tertiary corporeal schema:

> promotes the arrival of a veritable interior space, clean [*propre*] and inviolable, of a veritable autonomous self, divided and differentiated from the other but in relation with the other in this space. Because the body is the reference point of meaning [*référence de sens*], the digestive space is at the basis of the notion of a neutral field of relation between an autonomous self and a differentiated other.[111]

Lévy's formulations are on that side of psychoanalysis which merges almost imperceptibly with developmental psychology. What begins as a necessary taking into account of the body ends in a more or less unproblematical reduction of temporal categories to corporeal functions.[112] The abstraction *time* in psychoanalysis is not yet recognized in a specifically *psychoanalytic* form.

As time is the very medium of psychoanalytic therapy (the time of the session, the time of personal history) it is unsurprising that the category has largely escaped objective consideration in psychoanalytic theory. In the most recent of the very few psychoanalytic studies devoted explicitly to time, Jean Laplanche distinguishes between four distinct "levels" at

which time may be considered.[113] Introducing his remarks as "a psychoanalytic philosophy of time," Laplanche begins by noting the historical transition, already mentioned, in which the philosophy of time was "disengaged from the problem of cosmological order to which it had been bound since Aristotle." As a consequence: "Temporality becomes independent of time. . . . Freed from the physical world in the largest sense of the word 'physical' temporality could only be ascribed to a subjectivity."[114] In forming a theory of subjective time, Laplanche urges, we should "distinguish the time of the living being and the time of the human subject."[115] The "time of the living being," on the one hand, is the time of the organism; it concerns the register of *perception* and is of the same order in the human and other animals alike. The "time of the human subject," on the other hand, refers us to "the capacity which the human being has of creating, of secreting [her or his] own time."[116] In addition to the three levels of consideration so far mentioned—cosmological time, the time of the living being, and the time of the human being—there remains a fourth: "history," the time of human societies. In Freud's own founding work, cosmological time receives little attention—by default, it is relinquished to what Laplanche judges to be "a debased, ready made Kantianism such as was in currency towards the end of the 19th century."[117] The time of the organism, on the other hand, receives some detailed consideration by Freud—especially in his article of 1924, "A Note upon the Mystic Writing Pad."[118] Cultural history is very extensively considered throughout Freud's writings—for example, in his books, *Totem and Taboo, Civilization and Its Discontents,* and *Moses and Monotheism.*[119] For my purposes here, however, what most concerns me is that which is most specific to Freud's work and to psychoanalytic investigation in general: that "secreted" time that is *memory and fantasy.*[120]

From its earliest beginnings, psychoanalysis confronts the *problem* of memory. It is in the first pages of the *Studies on Hysteria,* in the "Preliminary Communication" of Breuer and Freud, that we encounter their

famous formula: *"Hysterics suffer mainly from reminiscences."*[121] By the time of *The Interpretation of Dreams*, however, Freud had found that memory and fantasy could no longer be definitively dissociated, and his technique had moved beyond the "cathartic method" of the time of his association with Breuer. One characteristic of the shift was the tendency to "spatialize" time. As Octave Mannoni puts it: "[Freud] let the patient choose the subject of each daily session instead of trying to liquidate symptoms one by one. Thus, what related to the same symptoms could appear in several parts, in different contexts, and at moments more or less separated by time."[122] Early in *The Interpretation of Dreams*, Freud writes: "The way in which memory behaves in dreams is undoubtedly of the greatest importance for any theory of memory in general. It teaches us . . . as Delbœuf . . . puts it, 'que toute impression, même la plus insignifiante, laisse une trace inaltérable, indéfiniment susceptible de reparaître au jour.'"[123] Twenty-five years later, Freud returns to the idea that "even the most insignificant sensory impression leaves an unalterable trace, ever available for resurrection" in his essay "A Note upon the Mystic Writing Pad." The purpose of the essay is to allocate a place for memory in the schema of the "first topography"—conscious, preconscious, unconscious. More precisely, the analogy of the "mystic writing pad" serves to establish differences of topographical location *within* memory. Memory itself cannot be a conscious phenomenon; if it were then the system perception-consciousness would be overwhelmed with the sheer number of fresh impressions. All memory, then, is unconscious in the "descriptive" sense. In the "topological" sense, what in everyday speech is called "memory" is located in the preconscious. In speaking of topographically *unconscious* memories, however, Freud is not seeking to distinguish them as totally individual entities. He is rather distinguishing between differing registers of inscription of the "same" memory—such that a "memory-trace" may be available in one associative context but unavailable in another. Laplanche and Jean-Bertrand Pontalis observe

that this idea is in fact present as early as the *Studies on Hysteria*, where Freud "compares the organization of memory to complicated archives in which the individual memories are arranged according to different methods of classification: according to chronological order, according to the links in chains of associations, and according to their degree of accessibility to consciousness."[124] This view of memory differs significantly from the commonsense view in that there is no question of memory ever being a matter of the simple recovery of things and events "as they really happened." Laplanche and Pontalis write: "Generally speaking, all memories are recorded as a matter of course, but their evocation depends on the way in which they are cathected, decathected and counter-cathected."[125] The "memory-trace" is nothing more or less than a signifier amongst others, in complex and mobile relations with other signifiers. What Freud's work allows us to grasp is the ways in which such traces are combined to produce the "successes" and "failures" of memory alike.

In his seminar of 1964, Lacan observes: "Impediment, failure, split. In a spoken or written sentence something stumbles. Freud is attracted by these phenomena, and it is there that he seeks the unconscious. There, something other demands to be realized—which appears as intentional, of course, but of a strange temporality."[126] A failure of memory is the subject of Freud's first published analysis of a parapraxis. He writes:

> I was driving in the company of a stranger . . . to a place in Herzegovina: our conversation turned to the subject of travel in Italy, and I asked my companion whether he had ever been to Orvieto and looked at the famous frescoes there, painted by. . . .[127]

Freud first gives an account of his momentary inability to remember the name of the Italian painter Luca Signorelli in his essay of 1898, "The Psychical Mechanism of Forgetfulness," and returns to it in the inaugural

chapter of his book of 1901, *The Psychopathology of Everyday Life.* The incident occurred in September of 1898 while Freud was on holiday on the Adriatic coast, in what were then provinces of the Austro-Hungarian empire—Bosnia and Herzegovina. On a carriage ride from the town of Ragusa, he found himself in the company of a Berlin lawyer. The two of them first fell into conversation about the country through which they were traveling.[128] The discussion then turned to the subject of Italy and Italian painting. It was then that Freud found he could not remember the name *Signorelli.* In place of the painter's name he recalled the paintings themselves, with extraordinary clarity—particularly the artist's self-portrait that appears in a corner of one of the pictures. Freud's continued efforts to remember the name resulted only in his producing the names of two other painters—Botticelli and Boltraffio—both of which he immediately rejected as incorrect. Several days later, during which time he suffered the "inner torment" of continually failing to recapture the elusive name, it was mercifully provided by an Italian he happened to meet. The technique Freud subsequently used to analyze his inability to remember the name is the same technique of association he had developed for the analysis of dreams. Freud recalls that before the conversation in the carriage had turned to painting, he had told his traveling companion something he had heard from a colleague who had once practiced medicine in the region they were visiting. The Muslim population of the province showed a high regard for doctors and an attitude of great resignation toward death. As Freud recounts: "If the doctor has to inform the father of a family that one of his relatives is about to die, his reply is: '*Herr* [Sir], what is there to be said? If he could be saved, I know you would help him.' "[129] There was more to this anecdote about the Muslims of the region. But although it came to Freud's mind, he did not tell it to his companion. Freud's colleague had also told him that if a doctor ever had to inform one of these resigned and fatalistic people that their sexual life would be impaired, they would vehemently protest: "*Herr,* you must

know, if *that* comes to an end then life is of no value."[130] As he spoke, Freud's thoughts had become invaded by another memory in which death and sexuality were joined. Some weeks earlier he had been upset to hear of the suicide of one of his patients, a young man, on account of an incurable sexual disorder. The news of the death had reached Freud while he was staying in the Tyrolean town of Traffoi. In producing the first substitute name—Botticelli—it is as if Freud had remembered the -*elli* part of *Signor-elli*, but had substituted something else in place of *Signor-*. The missing *Signor-* of Signorelli's name is of course an independent word in Italian. Translated into German, Signor becomes Herr—the initial word of each of the two anecdotes that Freud heard from his colleague, and also the first sound of the word *Herzegovina*. Moreover, the first syllable of the substitute name *Botticelli* is *Bo*, which is the first sound of *Bosnia*. The second of the substitute names Freud would subsequently produce, *Boltraffio*, not only also begins in this same way, it terminates in a close approximation of *Traffoi*—the name of the town where he had heard of the death of his own patient. Lacan comments: "The substitute names are the terminal points of a chain of signifiers, they are the metonymic ruins of the repressed (the idea of death)."[131] The trope most at work here is synecdoche, the figure in which a part stands for the whole. The *Bo-* of *Botticelli* and *Boltraffio* is a part of the whole word *Bosnia*, which in turn is a part of the whole story told by Freud's colleague, which is part of the totality of Freud's thoughts about sexuality in relation to death—the ultimate authority figure, the "Herr" to whom we must all eventually pay our respects.

Freud speaks, precisely, of the psychopathology of *everyday* life. As Laplanche remarks: "We always make 'slips of the tongue' in the broadest sense of these words; our conscious messages are infiltrated by unconscious ones which remain unconscious because there is conflict."[132] An unbidden and unwelcome train of thought had come to Freud's mind, and he had tried to disregard it. As a result, Lacan writes: "What stayed with him, in the rest of his intercourse with this interlocutor, was the debris,

the pieces, the scraps of this speech. . . . That is the phenomenon of forgetting, literally made manifest by the degradation of speech in its relation to the other."[133] The two names Freud substitutes for the temporarily forgotten name *Signorelli* are the result of a play of purely phonic associations between repressed and recollected signifiers. The chains of associations are governed by metonymy, the substitutions themselves are governed by metaphor: sounds are treated as if they were images.[134] In commenting on this example, Freud writes: "Thus the names have been treated in this process like the pictograms in a sentence which has had to be converted into a picture-puzzle (or rebus)."[135] The rebus is Freud's most favored analogy for the dream; he uses it to oppose the tendency to conceive of the dream as a narrative. The mechanisms of the primary processes that interfere with our "normal" everyday psychology are the same mechanisms that govern our noctural dreaming—that state of normal psychosis. Freud notes: "The same mechanism which causes the substitute names 'Botticelli' and 'Boltraffio' to emerge from 'Signorelli' (a substitution by means of intermediate or compromise ideas) also governs the formation of obsessional thoughts and paranoiac paramnesias."[136] Again, Freud emphasizes that the distinction that separates "normal" from "abnormal" psychology is more a matter of social definition than of modes of mental operation.

Freud expresses his concern "to emphasize the similarity between the forgetting of proper names . . . and the formation of screen memories."[137] The essay in which Freud introduces the concept of "Screen Memories" appeared in 1899, the year following his publication of "The Psychical Mechanism of Forgetfulness," and he returns to the topic in the fourth chapter of *The Psychopathology of Everyday Life*. A screen memory is one that comes to mind in the place of, and in order to conceal, an associated but repressed memory. In the type of screen memory discussed by Freud in the first of the publications I have mentioned, it is an earlier memory that screens a later event. As Freud puts it, there is a "retroactive" chronological relation between the screen memory and the repressed

content. In the second of these publications, however, Freud notes that it is more usual to encounter the opposite relation: "an indifferent impression of recent date establishes itself in the memory as a screen memory,"[138] and it is the earlier memory that disappears behind it. In this same chapter, Freud also remarks on a third type "in which the screen memory is connected with the impression that it screens not only by its content but also by contiguity in time: these are *contemporary* or *contiguous* screen memories."[139] It is a characteristic of our memory, Freud observes, that the reproduction of our lives as a "connected chain of events" begins "only from the sixth or seventh year onwards—in many cases only after the tenth year."[140] On the one hand, memories of occurrences before these years tend to be fragmentary and unrelated to each other. Moreover, they rarely seem to concern events of any real importance; for example, "one woman reports that she remembers a number of accidents that occurred to her dolls when she was two years old but has no recollection of the serious and tragic events she might have observed at the same period."[141] On the other hand, the earliest memories we have often possess a vivid sensory intensity that more recent memories usually lack. It is just such a striking visual impression that characterizes the memory that serves Freud as his first published example of a screen memory. He presents the memory as if it were that of an interlocutor with whom he is conversing, but it is in fact one of his own. He is two or three years old and playing with two other children of similar age—a boy and a girl. They have been picking yellow flowers in a field. Seeing that the girl has the biggest bunch of flowers, the two boys snatch it from her. She runs in tears to a woman who stands outside a cottage, who consoles the girl by giving her a piece of freshly baked bread. Seeing *this,* the boys abandon the flowers and run to demand bread for themselves. This they receive. It tastes delicious. Freud remarks, "There seems to me something not quite right about this scene. The yellow of the flowers is a disproportionately prominent element in the situation as a whole."[142] He is eventually led to a recollection from his early adult life: He is seventeen years old, and on holiday

in the house of a family with whom his parents were old friends. He falls intensely and secretly in love with the fifteen-year-old daughter, who leaves for her school after only a few days. He then takes to solitary walks in the woods, dreaming of how his life could have been different—if only his own family had not moved away from hers after the ruin of his father's business, if only his father had not been ruined but had prospered, if only he had entered his successful father's profession and was now in a position to marry the girl. He writes: "I can remember quite well for what a long time afterwards I was affected by the yellow colour of the dress she was wearing when we first met, whenever I saw the same colour anywhere else."[143] There is more to Freud's ten-page discussion of this memory than I have recounted. Somewhat reductively, I have hurried to the point that serves my purpose here. It is this: Freud writes, "You think to yourself 'If I had married so-and-so,' and behind the thought there is an impulse to form a picture of what the 'being married' really is."[144] Here then is the origin of the "deflowering" of the girl in the earlier memory, the "disproportionately prominent" color of the flowers reveals her identity. Three things are illustrated here: the agency of sexuality in the formation of screen memories, the role of language—"verbal bridges"[145]—in the construction of mental images, and the role of fantasy in the (re)construction of our memories. The "impulse to form a picture"—a "dirty picture," inappropriate to an idealistic youth's first dream of love—is repressed. The instinctual energy that is the *impulse* is displaced onto a memory, something that "actually happened." Thus cathected, the now distorted memory becomes the reality kernel of a fantasy, serving the repressed wish. Those inclined to doubt that the idea of the marriage bed should so disturb even the most idealistic of young men might reflect on the fact that the little boy who "deflowered" the girl in the yellow dress did so by force, and with the assistance of another man (behind this scenario, in a Freudian perspective, we may discern the fantasy of the primal scene).[146] In the achievement of its discontented civilization, the human animal has indeed, as Laplanche put it, "lost its instinct." Where

instincts were, there the *drive* is—very well defined, in a Lacanian formula, as "the instinct alienated in a signifier."[147]

In the essay "Screen Memories" Freud writes:

> It may indeed be questioned whether we have any memories at all *from* our childhood: memories *relating* to our childhood may be all that we possess. Our childhood memories show us our earliest years not as they were but as they appeared at the later periods when the memories were aroused. In these periods of arousal, the childhood memories did not, as people are accustomed to say, *emerge;* they were *formed* at that time. And a number of motives, with no concern for historical accuracy, had a part in forming them, as well as in the selection of the memories themselves.[148]

Motives "with no concern for historical accuracy." The editor provides the following note made by Freud: "Dr. B—showed very neatly . . . that fairy tales can be made use of as screen memories in the same kind of way that empty shells are used as a home by the hermit crab. These fairy tales then become favourites, without the reason being known."[149] Lacan speaks of the small child's "prodigious porosity to everything in myth, legend, fairy tales, history, the ease with which he lets himself be invaded by these stories."[150] Freud's essay of 1908, "Family Romances," is about the childhood fantasy that one's family is not one's real family. "The commonest of these imaginative romances," he writes, is "the replacement of both parents or of the father alone by grander people." The family romance however is almost infinitely various: "Its many-sidedness and its great range of applicability enable it to meet every sort of requirement."[151] A nostalgia for the relational world of earliest childhood is at the root of family romances. In the eyes of the child its parents are all powerful. The "grander people" apparently substituted for the father or mother in later fantasies are merely these same parents as they originally appeared to the child. Maturity brings the knowledge that one's parents are not omnip-

otent. Their idealized images however are not abandoned but displaced. National leaders and other figures in positions of authority or caring may be unconsciously identified with the ideal parents. As such expressions as "motherland" and "fatherland" imply, nationalism itself is a beneficiary of feelings originally directed toward the parents. As Freud had written in his earlier essays on screen memories: "The 'childhood memories' of individuals come in general to acquire the significance of 'screen memories' and in doing so offer a remarkable analogy with the childhood memories that a nation preserves in its store of legends and myths."[152] Bhabha observes: "Nations, like narratives, lose their origins in the myths of time and only fully realize their horizons in the mind's eye."[153] In his article "Through the Serbian Mind's Eye," Kifner describes another picture he encountered "in home after Serb home"; the original was painted by Paja Jovanovic in 1896, two years before Freud's visit to the Adriatic coast. Kifner writes: " 'The Moving of the Serbs' portrays the Serbian Orthodox Patriarch Arsenije III Carnojevic, surrounded by mounted soldiers, flocks of sheep and women with babies, leading some 36,000 families from his seat near Kosovo to what is now Vojvodina in 1690, after Serbian revolts failed." A Serbian historian, Dejan Medakovic, tells Kifner: "Our morals, ethics, mythology were created at that moment, when we were overrun by Turks. The Kosovo cycle, the Kosovo myth is something that has permeated the Serbian people."[154] Again, in the name of a peculiar historical truth, the living are tortured for love of painted ghosts.

IV. MEMORY'S TRUTH

Truth is undoubtedly the sort of error that cannot be refuted because it was hardened into an unalterable form in the long baking process of history.

Michel Foucault [155]

"I told you the Truth," I say yet again, "Memory's truth, because memory has its own special kind. It selects, eliminates, alters,

exaggerates, minimizes, glorifies, and vilifies also; but in the end it creates its own reality, its heterogeneous but usually coherent version of events; and no sane person ever trusts anyone else's version more than his own."

Salman Rushdie[156]

In the memory of the teletopologically fashioned subject, actual events mingle indiscriminately not only with fantasies but with memories of events in photographs, films, and television broadcasts. In an essay of 1991,[157] the sociologist Marie-Claude Taranger gives a summary account of an oral history project inaugurated in 1977 and continued over a period of ten years. During this period, Taranger and her collaborators at the Université de Provence conducted more than four hundred recorded interviews with residents of the Marseille/Aix-en-Provence area. In each instance, the interviewee was invited to recount her or his personal memories of the years 1930–1945. Taranger's essay speaks of an almost universal tendency for personal history to be mixed with recollections of films and other productions of the media. She finds that, in all of the narratives, "the function of the film is clear: it completes life, it fills the holes [*manques*] in life. It allowed the narrators to see—it allows them today to recount—events which they did not personally encounter, fragments [*pans*] of History which are not part of their own history."[158] Here is one of the narrators speaking of her memories of the year 1940. At that time she was ten years old and living in Marseille, where she had spent all of her childhood in an orphanage:

> There were children amongst us who had been orphaned by the war/ by the exodus of people from the North who came down/ when you see these things/ who came down carrying everything on bicycles/ on their backs/ When there was no more petrol/ who left their automobiles on the side of the roads and who fled/ And we had a lot of children from there [Taranger's underlining].[159]

The narrator, here, had mixed with refugee children but had not herself shared their experience of the exodus. In telling what she remembers of this time, she shifts almost imperceptibly from her own direct experience to what she can only have *seen* later, and indirectly—in the cinema, or on television. "I saw at the cinema" has become quite simply, "I saw." Here is another woman speaking, who really *was* one of the refugee children who made the hazardous journey from the North down to Marseille:

> On the way/ we were strafed several times/ There were aircraft which flew over us/ You haven't seen that film/ with Brigitte Fossey/ *Jeux interdits*/ But it's true that her parents saved her so that/ In the exodus you saw those lines of people/ She went/ she is/ Overhead there was firing by the German aircraft/ They tried to stop us going on/ Well/ They cover you behind/ It's the parents who are killed/ It's like that that she got away to that farm with the little boy/ And it was true/ Well then/ When I was/ they called me after madame Goudron/ because I fell in the tar [Taranger's underlining].[160]

As Taranger comments: "The coming and going between the first and the third person shows it: at the high point of the action, the narrator is in the film. She tells a version of *Jeux interdits* which puts her at the side of Brigitte Fossey, living the same adventure." Moreover, Taranger notes:

> The narrator, when she tells of the death of Brigitte Fossey's parents, says nothing about her own mother, who was with her in the exodus. . . . But the rest of the story teaches us that she had herself at that moment (literally) lost her parents: who were not dead, but who she found again only later, after many days without news of them. It is reasonable to think that the death of the parents in the film figured the possible death of her real mother.[161]

Taranger's analysis is consistent with a psychoanalytic perspective, in terms of which (along the lines of the "hermit crab" analogy made by "Dr. B," above) we might say that a scene in the film—in which the parents of the young heroine are killed when they place their bodies between her and the German guns—has come to serve the narrator as a *screen memory*, representing the repressed fantasy of the death of her own parents. In another example given by Taranger, the narrator's speech demonstrates the consequences for memory of identification with a "significant other":

> *I saw* my husband go in a café/ and then on the table of the café/ there were corpses laid out from the house at the side.[162]

In this case, it is as if the "I saw" of personal witness has appropriated to itself the contents of what the other has seen. In another example, the narrator gives a detailed account of conditions in the concentration camps. The narrator herself, however, had not been imprisoned. It was her brother who had been deported to a camp in Poland. He survived, but on his return he refused to say anything to his sister on the subject of the camps. Moreover, after the death of their father, he severed all relations with her. In an insight derived from a sensibility rare amongst anglophone sociologists, Taranger observes: "The borrowed speech and images have clearly come to fill this absence [*manque*] of brotherly speech, and of the brother himself."[163]

What the Université de Provence investigators encountered throughout all the interviews were, as Taranger puts it: "Memories of facts [mixed] with memories of images, or of words, and even with memories of memories."[164] From such heterogeneous psychical materials, the individual narrator would reconstruct her or his hybrid personal history—imposing a coherent narrative order on the discontinuous fragments. (Those familiar with Freud's description of the "dream work" will note

the similarity of this process to that of *secondary revision*.) Freud finds that "the delusion owes its convincing power to the element of historical truth which it inserts in the place of rejected reality." We might reasonably suppose that, in the brecciated memory pictures of Taranger's narrators, actually experienced events would lend credibility to the fictional passages. In fact, Taranger finds that the cinema serves not only as a source of memory images but also as a source of authority. She notes that, often, it is as if the narrator says: "What I am telling you is worth saying because it's what you can see at the cinema," or alternatively, "It's not only in films that this is true." (Something analogous may be seen today in those signs that occasionally accompany a product on display in a department store: "As seen on television"—as if the object were rendered more real by having had its electronic image float before the assembled eyes of millions of viewers.) Authority is clearly to be derived from the broadly communal nature of an experience, as if the truth, "we all saw it," makes what was seen "the truth." Indeed, Taranger remarks, "The most striking thing is that the question of the status of films is practically never raised." On the empirical evidence of the interviews, Taranger concludes that we must put the question of authenticity otherwise than in the binary terms of "true or false." She writes:

> It is no longer conceivable to consider only the exactitude of facts or the sincerity of witnesses. It is also necessary to take into account in all their complexity the procedures which preside at the construction of the story [*récit*]. . . . Against the illusion of a simple past [*passé simple*], which would only have to be recovered [*retrouver*], there is thus imposed the necessity of bringing to light the multiple and changing relations which ceaselessly produce interference, in an infinite play of repetitions and variations, between the voices and the images of the individual and the group, of a past and of its futures.[165]

What Taranger is calling for here is nothing more or less than that of which psychoanalysis seeks to give its account. As Judith Butler has written:

> What are called "moments" are not distinct and equivalent units of time, for the "past" will be the accumulation and congealing of such "moments" to the point of their indistinguishability. But it will also consist of *that which is refused from construction, the domains of the repressed, forgotten, and the irrecoverably foreclosed* [my emphasis].[166]

An "infinite play of repetitions and variations"—Taranger's words almost exactly characterize the mediatic environment, especially television. More precisely, we might say: "repetitions *presented as* variations." Since Laura Mulvey's essay of 1974, "Visual Pleasure and Narrative Cinema," we have been aware of the voyeuristic and fetishistic character of our psychosexual relation to cinema. Voyeurism depends on the concealment of viewer from viewed: the man at the keyhole is a "voyeur" because the woman on the other side of the door does not know he is there, looking at her. This structure is repeated in the more general relation of the spectator in the cinema to the image on the screen: those involved in the events taking place on the screen act as if they did not know the audience is there, watching them. In the course of almost any session of TV viewing, however, there are likely to be instances of direct address to the audience (the most common instance is in TV news broadcasts). As a consequence of this, as John Ellis has argued, "Broadcast TV's lack of an intense voyeuristic appeal produces a lack of the strong investigatory drive that is needed alike for tightly organized narration and for intense concern with the 'problem' of the female."[167] Ellis goes on to note:

> Similarly, the regime of broadcast TV does not demonstrate a particular drift towards a fetishistic activity of viewing. Its forms of narration are not particularly repetitive in the fetishistic manner of

obsessive replaying of events. The series and the segmental form construct a different pattern of repetition that has much more to do with constructing a pattern of familiarity.[168]

The reassuring organizing principle of "patterns of familiarity" was no more strikingly applied to the production of memory than in the television spectacle of "Desert Storm." Trapped within the cold glass of the television screen, the hot lands of what the West calls the "Middle East," with their differing geographies and populations, were reduced to an irregular yellow shape divided by a grid of latitude and longtitude. Before these maps a variety of interchangeable men, in interchangeable suits and ties, interpreted the variously colored graphic symbols that represented bombing attacks and troop movements. If we had not been told what was happening, we could easily have taken these men for presenters of the nightly weather forecast. Later in the proceedings we were given, again in the comfort of our armchairs, pictures of "smart bombs" exploding on what, we were assured, were their targets. Here, the words of Lefebvre's critique of Western visualization may justly be applied: "All impressions derived from taste, smell, touch and even hearing first lose clarity and then fade away altogether, leaving the field to line, colour and light."[169] At certain moments even color was abstracted from the scene, leaving the field entirely to line and light: first, the grid and coordinate numbers that turned the television screens of tens of millions into a bomb-sight; then, the blossoming brilliance that overwhelmed the video camera's sensors and wiped the screen clean—an ultimate self-censoring erasure, in which destruction veiled itself. The more "realistic" images—that is, the minimally less abstract images—came even later. We saw Iraqi soldiers surrendering, we saw the blackened carcasses of their tanks and trucks—we saw, that is to say, the photographic negative of the "new world order" as it surveyed itself in its *total* power. However, for most of those who watched the

"Gulf War" on television, what was most conspicuously visible was the *absence* of substantive images: a real absence filled with a plenitude of simulacra—for example, the endless footage of anonymous airplanes taking off from unnamed airfields, and the endless recourse to "expert" commentators who talked endlessly to hide that they had nothing to say. This is what Baudrillard, in his book *La Guerre du Golfe n'a pas eu lieu,* refers to as "pure television, useless, instantaneous, exposing its primordial function, which is to fill the vacuum, to fill the hole of the screen where the substance of the event is escaping."[170] What Baudrillard finds he lives in real time, constructed by "all the techniques of war-processing," is not the event but "an involution of the event in the instantaneity of everything at once, and of its disappearance in the information itself."[171] In place of the real event, he finds only "post-synchronised events, which one never has the impression of having seen in the original version [*version originale*]. Bad actors, bad dubbing."[172]

Baudrillard's impression of watching "bad actors" suggests that, to the patterns of familiarity imposed by conventions of television presentation and programming, we must add those supplied by the viewers from their stock of narrative conventions and conventional narratives. Given the paucity of real information provided by television at the time of the Gulf War, viewers may easily have contextualized the news images by more or less unselfconsciously inserting them into memories of Hollywood war movies. Much in the ways identified by Taranger and her associates, such narrative investments would come to fill in the intervening spaces between actually observed images. Christophe Gallaz, a Swiss journalist newly returned from reporting on the conflict in Bosnia and Herzegovina, spoke of the "stroboscopic" effect of news images on our perception of the world. His tone is one of frustration and anger at what he sees as the futility of "press photography (and its televisual and cinematic avatars)." Such journalism presents us not with, in Godard's expression, "Truth, twenty-four frames per second," but rather with Truth *reduced* to a thousandth of a second exposure. As a consequence, Gallaz writes, "we

are brought to believe that, before [the photographic exposure], the orphan boy shot dead in the bus which was carrying him away from Sarajevo was probably as carefree as any child whatsoever on whatever bus; and that, after, he becomes so again."[173] The stroboscope is the negative of the zoetrope. In the basic cinematic apparatus, the gaps between frames are bridged by the persistence of vision. The stroboscope *isolates* frames by imposing a blindness to what comes before and after. Between the sixteenth and eighteenth centuries, a body of doctrine was assembled in response to the problem of how best to depict a narrative in a painting—which had only an isolated frame at its disposal. It was agreed that the painter would do best to isolate the *peripateia*—that instant in the story when all hung in the balance. The viewer of the painting would then most feel the moral weight of a momentous decision, in that instant before the scales of history tipped. It went without question, of course, that the viewer already knew the story. Television frequently relies on the same presupposition. Amongst the popular long-running television programs in the United States, at the time I am writing, is one called *Rescue*. Every week, one or two "ordinary people" become the TV stars of their own real-life dramas. As the audience watches, grim-faced rescue teams climb, crawl, dig, and dive to the rescue. One thing only is assured, these momentarily famous trapped and damaged bodies will be restored to their loved ones and to health. By the end of the evening's programming segment, the amalgam of horror and terror will have been transmuted into pure Joy through the alchemy of video editing. Even if the program had never existed, its single endlessly repeated story would be no less universally familiar. Not only is it the stuff of already existing fiction films, Vladimir Propp demonstrated that the story is as old as narrative itself.[174] In Jonathan Culler's summary:

> Propp's predecessor, Veselovsky, had, in a rudimentary structural analysis, argued that a plot was composed of *motifs*, such as "a dragon kidnaps the king's daughter." But, says Propp, this motif can be

decomposed into four elements, each of which can be varied without altering the plot. The dragon could be replaced by a witch, a giant, or any other villainous force; the daughter by anything beloved; the king by other fathers or possessors, and kidnapping by any version of disappearance.[175]

Such are the patterns of familiarity at work in the reality show: dragon's lair/storm drain; captured princess/trapped child; courageous prince/heroic fireman; evil demons/leaking gas; magic sword/breathing apparatus; anxious king/anxious mayor; loyal subjects/local residents and the parents. The always-already-familiar respects no programming boundaries. The zapping viewer may join any program at any moment. Cut from its own linear development, any moment of television may serve as a "stroboscopic" peripatean moment in a prior universal narrative (negating the possibility of a "repetition that is *initiatory*"). In a television context, the established expression for this moment is "sound bite." As the critic Norman Klein has observed, "The sound bite presents us with our own memory, not a story, or a plot. We are given displaced moments from shows we have seen, products we have bought. Our pool of consumer memories (movies, TV, shopping, driving, touring) make narrative vignettes where we are the central character."[176] Narrative abhors a vaccuum, the dark before and after the image is flooded with the light of the always already *known* of everlasting stories. Such stories need not contain only the sort of private content that Klein mentions. It may be that we encounter the return of communally elided contents: not only in the speech, actions, and dreams of individuals but also in various anonymous cultural productions found across the sites of ordinary everyday life. Browsing a rack of greetings cards, in a Minneapolis shopping mall, I came across a cartoon drawing of what is obviously the motorcade of a politician. What is equally obviously the figure of the politician's wife

is shown perched on the back seat of an open limousine, smiling and waving to the crowds lining the route and oblivious to the fact that her hapless husband is no longer at her side: the politician in whose honor the crowd has assembled has tumbled backward and is now lying in the road several feet behind her. What this image on a "humorous" greetings card in a Minneapolis mall immediately brought to my mind was Zapruder's footage of the assassination of John F. Kennedy.[177]

I have spoken of some of the various ways in which fragments from the everyday environment of the media may become incorporated into personal biography and public History. (One of the more hallucinatory moments of the 1992 US presidential election campaign came when the vice-president of the world's most powerful nation made a public speech attacking a fictional character.[178]) Taranger's research shows how "memories" may be composites of actual events and scenes from films (within the limitations of her empirical investigation, leaving out the unconscious that she nevertheless registers at every turn). It is largely a matter of contingency that Taranger and her colleagues recorded their narrators on audiotape. They might as easily have recorded the interviews on video, perhaps eventually to place them in a "documentary" for television. Memories may contain scenes from films, which may in turn be films of memory. As the documentary filmmaker David MacDougall remarks: "If memory itself is selective and ideological, films of memory redouble this and add further codes of cultural convention."[179] In his essay of 1992 about "Films of Memory," MacDougall is critical of that familiar "cinematic subgenre whose ritual ingredients are aging faces . . . fetish-objects from the past, old photographs, archival footage and music. . . . a subgenre which purports to tell us our 'true,' unwritten history through the testimony of both ordinary people and famous eyewitnesses."[180] He notes that the genre "has a tendency to be elegiac, as though remembering were in itself a virtue. [However] few films of this genre ask children what they remember about last week or last year, and few admit that the old may

be forgetful or devious."[181] Just as MacDougall criticizes the unreflecting recourse to "eyewitness narratives," he is equally critical of a no less unreflecting use of archival materials: "With the original sources of memory forever beyond reach, filmmakers are tempted to use the surviving photographic record *as if this were memory itself*. . . . Thus, among the variety of signs that films employ for the objects of memory, photographs and archival footage tend to be used the least critically and the most misleadingly."[182] As a consequence: "We end by filming . . . a mixture of dubious testimony, flawed evidence and invention."[183] In most documentary films, MacDougall finds:

> The fundamental link between constructing the past through reminiscence and constructing the audience's present experience through film is never made. . . . many films of memory are uncertain about their own discursive status: in making the assumption that their subject's reminiscences are worth knowing they somehow dispose of having to define, or speak from, their own particular interests. . . . It may well be that the common tendency to adopt a celebratory stance towards memory is a symptom, and a masking, of that uncertainty.[184]

For MacDougall, "films of memory" have very little to do with memory as such. If they have value, it is rather due to the ability of film "to leave representation behind and to confront the viewer once again with the primary stimuli of physical experience." He finds that:

> A residue of a clearly *physical* nature remains in film images which is not available in verbal narratives, and its importance should not be underestimated. Film images may be reinterpreted in a variety of new contexts, but the unalterable record of appearance and place contained in them may ultimately prove to have a more profound effect upon

our "memory" of history than the interpretations we attach to them.[185]

There is no shortage of examples that might be given of what MacDougall seems to mean by a "residue of a clearly physical nature" and an "unalterable record of appearance and place." I shall turn to Alain Resnais's film of 1955, *Nuit et brouillard,* as it is a "documentary" that is surely "certain of its own discursive status." One of the most striking things about this film about the Nazi concentration camps is that it contains not a single reference to the Jews. In a book of 1992, on the history of filmmaking in France, Alan Williams writes: "When, almost three decades after its release, Charles Krantz asked Resnais about the film's political intent, the director replied, 'The whole point was Algeria,' where French forces had already committed, and were continuing to commit, their own racially motivated atrocities."[186] Two years earlier, in 1953, Resnais had collaborated with Chris Marker on a film—*Les statues meurent aussi*—about the destruction of African art under French colonialism. The film had been shown only once before being banned by the French government. *Nuit et brouillard* was an attempt to speak about Algeria while avoiding the fate of the previous film. Nevertheless, as Henry Rousso has noted, in his book about French history after Vichy, "The film ran afoul of the censors. Resnais was forced to remove an offending gendarme's *képi,* which appeared in a shot of the transit camp at Pithiviers, a camp set up by the Germans but administered by the French. The censors thus obliterated not the filmmaker's words or images, but an actual historical detail, an incontestable fact."[187] It is with such "incontestable facts" that MacDougall claims "film could be said to leave representation behind." We may be reminded of Jameson's assertion of "the political logic which is already inherent in the raw material with which the film-maker must work." We are back, it seems, with Engels. However, the impression that

we may anchor our representations to the bedrock of the Real is illusory. This is not the place to resume the detailed critique of Realist empiricism which has been so important to the theory of visual representations and to which the work of Althusser was crucial. To extract a bald bottom line conclusion from one of the more influential of the post-Althusserian texts:

> If independently existing real objects are thought to exist in the form of actual or potential objects of discourses, then any theoretical discourse may be measured against what is thought to be known of those objects. [However] this mode of analysis merely measures the substantive distance between the objects specified in one discourse and those specified in another.[188]

This is to say: *representations cannot be simply tested against reality, as reality is itself constituted through the agency of representations.* This is not to say that what Freud called "reality testing" is not possible, we all do it everyday, merely that it is not *simple*. What it most emphatically means is that there is nothing that resides *within the image itself* as the guarantor of its truth. The image, as Barthes pointed out long ago, is "polysemic." Conflicting explanations might be given for the presence of the *képi* in the archival footage used by Resnais, the determination of their relative truth or falsity must be sought *beyond* the image. Until recently, such arguments were largely philosophical and therefore easily ignored. After all, the brute physical presence itself of the *képi* could not be in doubt. Today, however, to the phenomenon of the fragmentation of the Western image in the late-capitalist world, we must add an obviousness that none may ignore, and which few could have foreseen at the time Resnais made his film: the end of the evidential image in digitalization. For Barthes, the fundamental defining attribute of the photograph was its "attesting that the object has been real." The photograph unavoidably says "*ça à été,*"

"that has been."[189] In the era of the electronic image, this condition no longer applies.

V. THE WORLD BEYOND THE MIRROR

Mon monde aux épaules rondes.

Aimé Césaire[190]

The interviews conducted by the researchers at the Université de Provence attest to our ever available capacity to confuse ourselves with others, both fictive and real (again, the scenario of the mirror stage). Identification is the privileged mechanism by which other histories and memories become our own. I earlier cited a critic's observation that "our pool of consumer memories (movies, TV, shopping, driving, touring) make narrative vignettes where we are the central character."[191] "Movies, TV, shopping, driving, touring"—when performing the last three items on this (strangely partial) list of consumer exercises we are directly active, but in the case of the first two items we act only indirectly, through identification with characters on a screen. Nevertheless, if we are able to make a drama of such everyday events as our use of the automobile it is only via the relay of cinema and telefilms, newspaper photographs and advertisements. Only in this way may what appears beyond the windshield during the workday commute become the setting of a road movie, or a car chase sequence; only in this way may the FM channel of choice become a sound track. Much has been written in film theory about the way the cinematic apparatus works to "suture" the spectator into the narrative on the screen. As I have already said, the object of my own discourse is not the film as such but rather the shape-shifting hybrid objects that coalesce in psychical space from the mnemic debris of films, photographs, television shows, and other sources of images. Such complex objects, as Taranger's interviews illustrate, are situated partly in

imaginary worlds and partly in the real world. Let us begin by noting that identifications are intrinsic to our ordinary relationship to the everyday environment of real things.

Those familiar with Virginia Woolf's book *Orlando: A Biography* will know that when we first meet Orlando he is a young nobleman in Elizabethan England. By the time of the passage I shall cite, however, Orlando has long been a woman. She is now living in Victorian England and has recently married a sea captain who has just left on a long voyage. Orlando has been walking by the Serpentine—a lake in London's Hyde Park—and has just pushed a toy boat away from the bank with her toe:

> Now, the truth is that when one has been in a state of mind (as nurses call it)—and the tears still stood in Orlando's eyes—the thing one is looking at becomes, not itself, but another thing, which is bigger and much more important and yet remains the same thing. If one looks at the Serpentine in this state of mind, the waves soon become just as big as the waves on the Atlantic; the toy boats become indistinguishable from ocean liners. So Orlando mistook the toy boat for her husband's brig; and the wave she had made with her toe for a mountain of water off Cape Horn; and as she watched the toy boat climb the ripple, she thought she saw Bonthrop's ship climb up and up a glassy wall; up and up it went, and a white crest with a thousand deaths in it arched over it; and through the thousand deaths it went and disappeared—"It's sunk!" she cried out in an agony—and then, behold, there it was again sailing along safe and sound among the ducks on the other side of the Atlantic.[192]

In *The Interpretation of Dreams*, Freud uses the word *identification* in two ways: transitively ("identify as") and reflexively ("identify with"). The passage from *Orlando* may serve to illustrate the difference. In the former instance, Orlando identifies one place, the Serpentine, "as" another, the

Atlantic, and one thing, the toy boat, "as" another, her husband's ship. Freud notes that Aristotle believed that "the best interpreter of dreams was the man who could best grasp similarities."[193] Freud identifies the logic of similarity, the logic of "just as," as being "very highly favoured in dream formation." He writes:

> Parallels or instances of "just as" inherent in the material of the dream-thoughts constitute the first foundations for the construction of a dream. . . . Similarities, consonance, the possession of common attributes . . . may be described as identification.[194]

Orlando "thought she saw Bonthrop's ship climb up and up a glassy wall." Here the actual toy boat is suppressed and has given way to Bonthrop's ship. Orlando then rediscovers the object, now undecidably both Bonthrop's ship *and* a toy boat, "sailing along safe and sound among the ducks on the other side of the Atlantic." Together with the image of ducks paddling on the Atlantic, the boat has become a composite image, a "condensation" typical of those achieved by the dream work. Commenting on Sartre's discussion of an impersonation of Maurice Chevalier by the music hall artiste Franconay, Mary Warnock observes: "We arrive in the end in a kind of state between perception and imagination; for we still see the real Franconay, but we *see her as* Maurice Chevalier, and in some ways we are affected by her as we would be affected by him."[195] Sartre himself notes the agency of the existing, preconsciously available, corpus of media images in this process: "Franconay, without naming Chevalier, might suddenly put on a straw hat. Posters, newspapers, caricatures, have slowly built up a whole arsenal of signs. We need only draw upon it."[196] This observation is crucial—relations of identification are very rarely established on a basis of total similarity. The most apparently insignificant of "common attributes" may serve to bind a subject in the strongest of identifications. The second, "reflexive" sense

of the word *identification*—the idea of "identification with"—is the most important one in the work of Freud and in subsequent psychoanalytic work, including that of Lacan. In experiencing an anxiety that had no foundation in her own actual circumstances—in a park on a pleasant day, watching children at play—Orlando "identifies" herself with someone else, her husband, who is in a situation of real danger. Her identification with her husband is not total. She does not believe that she *is* her husband, as she might if she were psychotic. Hers is rather a case of partial identification. In his paper of 1928 on "Identification," Otto Fenichel writes: "Partial identifications in normal persons are of common occurrence. They reveal with particular clearness their character as a substitute gratification, since they usually follow immediately upon a real object loss."[197] In similar manner, Orlando's state of anxious partial identification is brought on by her husband's departure on a dangerous voyage.

Freud provides his most concise definition of identification in his book of 1933, *New Introductory Lectures on Psycho-Analysis:*

> an "identification"—that is to say, the assimilation of one ego to another one, as a result of which the first ego behaves like the second in certain respects, imitates it and in a certain sense takes it up into itself.[198]

The question of the various specific ways in which this process may take place is a complex one to which Freud returns throughout his work without arriving at a definitive account. Whatever their particular form, however, Freud sees all identifications as ultimately deriving from a single prototype: oral incorporation. The original object of the oral drive, the "breast," is incorporated along with the ingestion of the milk. In the oral organization of sexuality, Freud writes, "the object that we long for . . . is assimilated by eating and is in that way annihilated as such."[199] Elsewhere, with reference to cannibalism practiced by adults, Freud

observes: "By incorporating parts of a person's body through the act of eating, one at the same time acquires the qualities possessed by him."[200] At intervals throughout Jean-Luc Godard's film of 1959, *A bout de souffle*, the hero Michel (Jean-Paul Belmondo) is seen in the distinctive gesture of passing his thumb across his lips. In case we might be in any doubt as to the origin of the gesture, we are shown Michel in front of a cinema, looking at a portrait photograph of Humphrey Bogart among the lobby cards advertising the week's attraction. As Michel passes his thumb across his lips, his face alternates with the face of Bogart, in shot/countershot. Michel is betrayed by the woman he loves, Patricia (Jean Seberg). Patricia is tormented by self-doubt as to whether or not she loves Michel. It is to put an end to this doubt that she betrays him to the police. (Surely, she reasons—as she tells him what she has done—if she has been able to betray him, then she cannot love him.) In the final image of the film we see her face, in close-up, as she stands over the dead body of Michel. In this moment of loss, she passes her thumb across her lips—completing the relay of amorous identifications and removing any doubt as to the nature of her feelings toward Michel. Of all possible partial attributes, it is apposite that this brushing of the lips should have been chosen. The prototypical oral relation to the object guarantees that all subsequent identifications are ambivalently both loving and aggressive. In his essay of 1917, "Mourning and Melancholia," Freud notes the structural similarity between oral incorporation and the process of mourning, in which the lost object is internalized by the bereaved. In his book of 1923, *The Ego and the Id*, he remarks on the more general nature of this process:

> When it happens that a person has to give up a sexual object, there quite often ensues an alteration of his ego which can only be described as a setting up of the object inside the ego, as it occurs in melancholia . . . the process, especially in the earlier phases of development, is a frequent one, and it makes it possible to suppose

that the character of the ego is a precipitate of abandoned object-cathexes and that it contains the history of those object-choices.[201]

Identification, then, is now seen as the very process through which the human subject is constituted: *personal "identity" is an accretion of identifications*.

According to Freud, the most significant loss of the emotional tie to an individual is that suffered within the "Oedipus complex." Freud's original formulation of the Oedipus complex conforms to the schema of the Sophoclean drama after which it is named: the little boy loves his mother and wishes to dispose of his rival for the mother's love: his father. However, Freud recognizes that this simple form of the complex is rarely encountered in psychoanalysis. Nor is the "negative" form of the complex—in which the boy loves his father, and sees the mother as a rival—any more common. As Laplanche and Pontalis comment:

> In practice, a whole range of hybrid cases stretches between the two poles constituted by the positive and negative forms of the Oedipus complex. . . . The description of the complex in its complete form allows Freud to elucidate ambivalence towards the father (in the case of the little boy) in terms of the play of heterosexual and homosexual components, instead of making it simply the result of a situation of rivalry.[202]

Whatever the individual circumstances, social law demands that the parents be given up as objects of libidinal interest. According to Freud, "Narcissistic identification with the object then becomes a substitute for the erotic cathexis."[203] In his essay of 1924, "The Dissolution of the Oedipus Complex," he writes:

> The object-cathexes are given up and replaced by identifications. The authority of the father or the parents is introjected into the ego, and

there it forms the nucleus of the super-ego, which takes over the severity of the father and perpetuates his prohibition against incest.[204]

It is as if the same psychical mechanism is at work in both the process of dissolution of the Oedipus complex and in the process of mourning. What happens in both instances is that the greater part of the libidinal energy that was invested in the object is withdrawn and returned to the ego, where it now invests an idealized imago of the object. The ego is thereby enriched in a process of "propping" (*anaclisis*) upon the object of the drive, paradoxically conserving the object even in the act of renouncing it. It is as if a simulacrum of the object has been installed within the boundaries of the ego; specifically, one that seeks to satisfy narcissism by adding to the ego the perfection to which it imperfectly aspires. The elements that comprise the "ego-ideal" will henceforth be a source of examples that the ego will never succeed in emulating, of exhortations that it can never fully satisfy, and, in the form of the superego, a source of unrelenting self-reproach. This, then, is the primary mode of identification which Freud will variously call "melancholic," "totemic," and—in the now more commonly used term—"narcissistic." In terms of Freud's work taken as a whole, this mode (that, strictly speaking, of "secondary narcissism") may be seen as one of two fundamental modalities of identification. The other is that of "hysterical identification."

Comparing the two forms of identification, "narcissistic" and "hysterical," Freud observes that "narcissistic identification is the older of the two."[205] Although Freud came to view narcissistic identification as the more fundamental process in the formation of the ego, historically at the very origin of the subject, it is hysterical identification that first makes its appearance in his work. As already noted, the general concept of identification appears early, as one of the unconscious psychical mechanisms to be found in the dream, and in the formation of hysterical symptoms. The concept of hysterical identification makes its

first substantive appearance in *The Interpretation of Dreams*, with Freud's account of the dream of the "butcher's wife." Here, a woman identifies with her friend in order to receive *all* of the love she imagines her husband to have divided between her friend and herself. The mechanism by which her identification is achieved is analogous to that of condensation. Her identification is unconscious and is founded on a single common element (both women wish to have an unfulfilled wish).[206] The "eternal triangle" that figures in this case is, of course, also the diagram of Oedipal conflict. Freud gives the example of a little girl who develops the same tormenting cough as her mother: the symptom may be seen as the expression of the girl's identification with her mother, prompted by the hostile wish to take her mother's place in the affections of her father. (We can further see the influence of guilt in the formation of the symptom: the girl takes her mother's place only to suffer as she does.) If it had been the *father's* cough the girl had reproduced, as in the case of Dora, then the identification would have been with the loved object rather than with the rival. In this case, in response to the interdiction of incest, "object-choice has regressed to identification,"[207] which is to say that the identification in question would be of the narcissistic kind. Freud writes: "It is easy to state in a formula the distinction between an identification with the father and the choice of the father as an object. In the first case one's father is what one would like to *be*, and in the second he is what one would like to *have*. The distinction, that is, depends upon whether the tie attaches to the subject or to the object of the ego."[208]

An identification may take place between more than two people. Freud gives an example of women sharing a hospital ward who suffered the same kind of hysterical attack that one of their number had manifested when she received some bad news, because each individual patient felt that she too had "similar cause for an attack." Freud comments: "Thus identification is not simple imitation but *assimilation* on the basis of a similar aetiological pretension; it expresses a resemblance and is derived from a

common element which remains in the unconscious." Discussing a similar example, he remarks: "One ego has perceived a significant analogy with another upon one point . . . an identification is thereupon constructed on this point, and . . . is displaced on to the symptom which the one ego has produced."[209] The phenomenon of group identification is not necessarily hysterical in kind, it may also be narcissistic. In his book of 1921, *Group Psychology and the Analysis of the Ego*, Freud notes the similarities between hypnosis, the state of being in love, and the psychology of groups. In all such cases, in differing degrees, the hypnotist/loved one/ leader takes the place of the ego-ideal. The element of idealization of the object commonly found in erotic love is not fundamentally dissimilar to the devotion of the group to the leader, or to the idea—the "cause"—he or she represents. Freud writes:

> Contemporaneously with this "devotion" of the ego to the object, which is no longer to be distinguished from a sublimated devotion to an abstract idea, the functions allotted to the ego ideal entirely cease to operate. The criticism exercised by that agency is silent; everything that the object does and asks for is right and blameless. Conscience has no application to anything that is done for the sake of the object; in the blindness of love remorselessness is carried to the pitch of crime. The whole situation can be completely summarized in a formula: *The object has been put in the place of the ego ideal.*[210]

It is this common object, now installed in the position of ego-ideal, which provides the common point of attachment for the members of the group. In the case of certain groups, whose members have all undergone a replacement of the ego-ideal by the leader, there is a consequent effect of mutual identification between those individuals. Freud writes: "*A primary group of this kind is a number of individuals who have put one and*

the same object in the place of their ego ideal and have consequently identified themselves with one another in their ego."²¹¹

In *New Introductory Lectures on Psycho-Analysis,* Freud concludes a summary exposition of the concept of identification by saying that he is "far from satisfied with these remarks." We might nevertheless schematically resume what he has to say, across his work as a whole, as follows: i) identification is the primary mode of relation to the object, in that the neonate is unable to distinguish between that which is part of it and that which is not; ii) the relation of incorporation to the part-object "breast" is the libidinal derivative of the functional ingestion of nourishment and is therefore ambivalently both tender and destructive; iii) in later object-relations, loss of the object may provoke a regression to the original incorporative relation, with the imago of the object taken into the subject, as in mourning; iv) the interdiction of the parental object in the Oedipal complex results in a substitution of "being" for "having"; it is as part of this process that the censorious parental imago is internalized in the form of the superego; v) even where there is no libidinal relation, identification may take place on the basis of perceived similarities; and vi) identification between members of a group may be established on the basis of the perceived common attribute of a strong libidinal relation to the leader—and/or "the cause" he or she embodies—which has resulted in the object taking the place of the ego-ideal. In the course of a presentation of his theory of dreams, Freud compares the dream to "a piece of breccia, composed of various fragments of rock held together by a binding medium, so that the designs that appear on it do not belong to the original rocks imbedded in it."²¹² This metaphor might equally serve to picture the construction of identity. For example, we might think of the Watts Towers in Los Angeles: the individual identity of this building is totally unique, yet it is nothing but a composite of fragments taken from other individuals; moreover, although the work of construction came to an *end*, with the death of the builder, it could never have been considered *complete.*

The analogy of the brecciated building has one serious deficiency how-ever—it represents a static image: the disparate fragments that compose it are permanently and indissolubly bound together, moreover, they have been assembled according to a conscious intention. The human individual is less the product of intention than of accident; as a result, the constituent fragments of human identity are dynamic and contradictory: as when one may speak, for example, of being "at war with oneself."

There is more to the development of Freud's theory of identity than his account of identification. Although he consistently indicated that identity may be *nothing other than* an aggregate of identifications, he also tried to maintain, in his work after 1920, the concept of an ego that achieves independence from its early identifications. For Lacan, however, the idea that "the ego is a precipitate of abandoned object-cathexes" is what is most fundamental and far-reaching in Freud's discussion of human identity. Ellie Ragland-Sullivan writes:

> According to Lacan, because Freud lacked our current knowledge about ethnology and the role of mimesis in animal behaviour, he abandoned his insights about the importance of narcissistic identi-fication in ego development. . . . Lacan therefore views Freud's secondary narcissism, with its attributes of permanence as manifest in ego ideals (others), as the basic process of humanization, as well as the cornerstone of human relations. It lies at the heart of all social exchange.[213]

Lacan offers his own most concise general definition of identification in his paper of 1949 on the mirror stage: "*an identification,* in the full sense that analysis gives to the term: namely, the transformation that takes place in a subject when he assumes an image."[214] Following Freud, Lacan rejects the idea that human identity simply "unfolds" in a fundamentally biological process of maturation of the organism. He does not deny that

there are organic developmental stages; he simply points out that images and language are always already *there* before birth and that this ever-present environment of representations exerts its own determinations on identity at each successive organic developmental stage. The founding importance of looking and hearing derives from the fact that, in a sense, all human infants are born prematurely. Unlike other animals, they are not born with the necessary capacities—in particular, motor skills—with which to seek their own food. It is this infant, in Lacan's words, "the child at the *infans* stage, still sunk in his motor incapacity and nurseling dependency,"[215] which will assume the image. This "performance" of the mirror stage is possible because, albeit incompetent in motor terms, the *infans* ("without speech") is visually precocious. The neonate first incorporates its environment in a state of perceptual nondifferentiation. It is only gradually that the various perceptual modalities—tactile, olfactory, auditory, visual—are distinguished and that through these a sense of self and other is eventually acquired. René Spitz gives the following account of the passage from nondifferentiation, when tactile and visual perceptions merge, to differentiation, when seeing, no longer fused with touching, becomes "distance perception" proper:

> When the infant nurses at the breast, he *feels* the nipple in his mouth while at the same time he *sees* the mother's face. Here contact perception blends with distance perception. The two become part and parcel of one single experience. . . . when the infant loses the nipple and recovers it, contact with the need-gratifying percept is lost and recovered and lost and recovered, again and again. During the interval between loss and recovery of *contact . . . distance perception* of the face remains unchanged. In the course of these repetitive experiences visual perception comes to be relied upon, for it is not lost; it proves to be the more constant and therefore the more rewarding of the two.[216]

In this early phase of development, the neonate may be said to be taking in the milk not only through the buccal cavity but through the eyes and other sense organs. Seeing, as yet not differentiated from contact perception, participates here in the life-preserving activity of feeding. In this context we may recall Lacan's notion of the eye as an incorporative organ—thus, he speaks of "the eye filled with voracity."[217] The eye sucks in the milk as the visible is incorporated along with the gratification of the need. The visible is full (of milk) and filling. As the infant matures, the shift from contact perception to distance perception inaugurates a different modality of looking. The infant now fixes the mother's face in order to sustain the pleasurable experience denied to it by the interruption of tactile contact. We encounter, in this scenario of loss and displeasure, the first intimation of an extraneous object that the infant attempts to master, however tenuously, by "holding it" in view. (We may recall Freud's account of the "*fort/da*" game.) In this account of subjective development it is loss that inaugurates the infant's spectatorship. From the already interrupted experiences of fusion with the mother in its earliest moments of life, the infant must progressively move to the other side of the divide across which it views the maternal body as other than itself, as "image." This is the transition achieved, or not, in the mirror phase. The word *mirror* must be understood as a generic metaphor. The actual mirror is only one of a myriad reference images that the child may assimilate, introject, incorporate. Notwithstanding the privileged position occupied by the mother, any and all other human beings may serve as mirrors in which the child may recognize its own reflection—and so, we may assume, may those *images* of others seen, for example, on television. As a result, as Ragland-Sullivan puts it, "any human identity will later be highly personalized, since the conjuncture of images, effects, and objects that fundamentally compose it is variable and infinitely combinable."[218]

We may remember that Lacan's notion of the mirror stage emerged in the course of his clinical work with psychotic patients. In psychosis,

it is as if the earliest fantasmatic fusion with image fragments—in what Lacan calls "primary identification"—threatens to overwhelm the mirror-stage relation with others as objects in "secondary identification." Here is a woman given to psychotic episodes speaking, in analysis, about her mother: "She will look at a saucer and say it is beautiful. The cup is on the saucer like a man and woman, but it is not like me, a cup can't screw a saucer. I can screw and I am different."[219] As "normal" adults we know that we are different from (our) objects, but prior to such distinctions, spacing, there are only identifications, merging. We need not, however, be psychotic in order to experience the trace of such early identifications in everyday life. For example: I am reading, occasionally making notes with a pencil stub. I place the stub on a side table, from which it falls and rolls behind the couch. Inspection reveals it sharing a dark and narrow space with a ball of fluff and a desiccated spider. Without the labor of moving the furniture the stub is beyond my reach. I have another pencil at hand, a new one. I nevertheless move the furniture and "rescue" the stub, as I know how it must feel. Again, a reader writes to the *New York Times:* "I send out a lot of mail with 75 cents' postage. I combine a Hubert Humphrey 52-cent with a Mary Cassatt 23-cent. Mr. Humphrey and Ms. Cassatt look very nice together, but every time I stick them side by side I feel bad for Humphrey's wife, Muriel."[220] Or again, a jazz singer, complimented in a radio interview on her "instrumental phrasing," says that when she stands in front of the band she thinks of herself as one of the saxophone section. She says, "I feel like I'm a horn with eyes and a big belly." That primary and secondary identifications may form a continuum is indicated in this description by a psychoanalyst of the ritual his patient observes on going to bed:

> The patient would go through typical touching compulsions a given number of times; pillow arranging, etc. . . . Upon exploration it was ascertained that the various objects she touched were bits of herself

which she was quieting down and bringing together before she could go to sleep, to prevent loss of control.

But it was even more complex, since I learned that she fantasized that she was her mother putting her (the patient) to sleep as a child. At the same time, the objects were bits of her mother whom she was trying to quiet down. This patient would recount how her mother would touch objects. "My mother just loved objects. They are like alive for her. She speaks about them. 'Look how sad this vase looks. Isn't it beautiful? You should not neglect it. Turn it around and let it breathe a little.' She never treats me this way."[221]

The same analyst writes that another of his patients:

became very disturbed when both she and her child wore pink dresses. The common colour led to a fusion of herself and her child so that there was one pink object. Yet she was able to pull herself back and to realize that she was separate from her child. She had similar experiences that frightened her very much in relation to her mother. For example, when she embarked upon a buying spree, she felt it was her mother, who was not with her, who was making the selections.[222]

In an example provided by the psychiatrist Henri Grivois, a man traveling in a railway carriage notices that all of his fellow passengers are dressed in only two colors, green and gray—like himself. He is also aware that everyone is either looking at him, or studiously not looking at him (either way, he is the sole object of all their thoughts). This man took the uniformity of dress (which, no doubt, he had selectively abstracted from an actual *variety* of dress) as a sign that he was the center of the world. Everyone imitated each other, but most fundamentally they all imitated

him. What distinguishes him from the woman in the previous example is that whereas she is able to "pull herself back" to the real world of difference, he cannot. For him, truly psychotic, the space of his delusion is all the space there is. This is most basically what distinguishes psychosis from psychoneurosis, or "borderline" cases.[223] I have already summarized the course of the psychoanalytic understanding of psychosis which runs through Lacan's notion of the mirror stage.[224] In the psychiatric tradition, "incoherence" is a defining attribute of the disease. Lacan arrived at his idea of the mirror stage while searching for the underlying coherence in psychotic speech. Grivois does not mention Lacan but is implicitly scornful of Lacan's theory of the etiology of psychosis.[225] He nevertheless fully agrees that psychotic expression (very often nonverbal) has coherent meaning, and his own findings resonate most strikingly with those of Lacan in the fundamental role he ascribes to mimeticism. Grivois is emphatic: "Other people are the fuel of psychosis."[226] He also agrees that the world of the psychotic is continuous with normal everyday reality. For example, on boarding a bus we may feel looked at by the passengers already seated, and we may look at them. But apart from an occasional fleeting discomfort, or pleasure, we make nothing in particular of the exchange of glances. One of Grivois's patients found that people he smiled at in the *métro* smiled back at him. (Unusual, perhaps, but not yet abnormal.) But he then felt himself becoming the unique object of attention of all of his fellow commuters. At the next stop, he left the carriage he was traveling in and went into another. It was the same there. He left the *métro*, to find that everyone in the street was looking at him. Speaking from twenty-five years of experience as a psychiatrist at the Hôtel-Dieu hospital in Paris, Grivois offers a basic diagram of the world of the psychotic: "an individual at the center of a crowd, a point surrounded by little points which all converge towards that individual."[227] The psychotic experience is not simply one of being *at* the center of things, but of *being* the center through which all the things pass. The popular

stereotype of the madman who believes himself to be God is well founded; the encounter with, or assumption of, divinity is frequently encountered in psychosis. More recent images of omnipotence are available to the inhabitant of "developed" societies, not least the idea of absolute control by means of ultrasophisticated technologies. Grivois has occasion to mention television: "The globalization of information . . . intervenes in the speech [énoncés] of emergent psychosis [la psychose naissante]. It is a planetary phenomenon which finds an echo in our patients. One really noticed it at the time of the Gulf war."[228] In his analysis of the psychology of groups, Freud described how a group forms through their common identification with a single individual leader. In a formally symmetrical move, the psychotic elects himself leader through his own independent act of identification with all others. We now live in a world where the delusional omnipotence of the psychotic may be justified in reality. A bemused physician in the British film *The Madness of King George* asks how he can be expected to treat a madman who *is* King. How are we, now, to tell the difference between the omnipotent fantasies of madmen, and the military scenarios acted out in the foreign policy of national leaders?

Psychosis is most common amongst adolescents and young adults (in the period from about fifteen to twenty-five years of age), when the feeling of estrangement in transit from the pre-adult to the adult world is strongest. Grivois notes that many of the adolescents who come into his care have suffered the abrupt collapse of a close relationship—with friend, lover, or parent. But he remarks: ". . . travel abroad, solitude, certainly military service. There is no fundamental difference between these situations of dislocation [dépaysement] and the dual relations [situations à deux] which collapse. These are the practically experimental situations of brutal loss of identity with the difficulty of finding oneself in a framework which has brutally changed."[229] The feeling of alienation that accompanies passage from a familiar into an unfamiliar world is not confined

to the young. It is, for example, a universal condition of migrancy (in all its modalities: escape, deportation, exile, homelessness, forced relocation, etcetera), now experienced by ever increasing numbers of people. It may also attend travel across the divides of race, class, and gender. Under such circumstances, the mimeticism of the mirror-stage relation, latent in the structure of any subject whatsoever, becomes manifest, and takes on a defensive function. For example, in a novel by A. S. Byatt, the narrator voices some thoughts that a woman at Cambridge University in the 1950s has about two fellow undergraduates. One of them, Tony, from a privileged upper-class background, affected a working-class style of dress and living. The other,

> Alan, the chameleon, *was* working-class, and would say so, if asked, though he created situations in which he was not asked. . . . he could respond with skill to the behaviour of those around him. In the pub with Tony he was the real thing, the working-class beer drinker. With groups of musical . . . medievalists he became a mixture of . . . pedantry and scholarship with clear aesthetic pleasure. With those interested in painting he became easily knowledgeable and very delicately precious. . . . If she had more sympathy with the chameleon than with the fake it was because she concluded that women were naturally driven to that state.[230]

We may recall Joan Rivière's description of womanliness as a "masquerade"[231] and the behavior known as "passing." In speaking of "the real thing," Byatt implies that the chameleon, under favourable circumstances, might reveal its true colors. But if her narrator had tuned in to Alan's thoughts on his return to the parlors, streets, and pubs of his former life, she might have found that he had lost all sense of coincidence with himself, whatever the circumstances. Such adult loss of certainty is a fracture, under external strains, along the line of a primary fault. As

Ragland-Sullivan writes: "Identity is not one with itself, because it starts with a prior lack in it: loss of the mother as primary object of mental and physical fusion and, therefore, loss of certainty." The alternative to loss is bleak:

> The one who does not differentiate away from the mother never assumes an identity demarcated by having acquired its own name, "self" fictions, particular history and unique body images. This is the one Lacan calls psychotic: the one who learned no diacritical gender position in the first six years of life, and so in fundamental psychotic fantasy is *bothland;* man and woman.[232]

Those most marked by a border condition, a position at the rim—neither fully inside nor fully outside—are most likely to provoke abjection. Examples arrive daily: yesterday, at the university, a bisexual woman spoke of the hostility she encounters both in the "straight" world and in the lesbian community; today, on the radio, the child of a Vietnamese woman and an African American serviceman spoke of being rejected both in Vietnam and in the United States. This is ordinary everyday abjection, rooted in the primal necessity that the line must hold—the division that founds the subject, the categorical imperative of social taboos and individual psychosis. Like abjection, established earliest in the history of the subject, the mirror "stage" is not something that is superseded, in some quasi-biological "maturation" of the organism. As Malcolm Bowie remarks, noting a significant duality of meaning in the title of Lacan's essay: "The mirror stage [*stade du miroir*] is not a mere epoch in the history of the individual but a stadium [*stade*] in which the battle of the human subject is permanently being waged."[233] The *stade du miroir*, therefore, names not only a time—a moment in individual history—but also a space: the limitless field of images on and in which the contest of identity is endlessly fought. Bowie observes: "At the mirror stage an identificatory

mechanism is set going within the subject that will henceforth affect his every act of visual perception. The original impulse to self-identification is brought to bear indefinitely upon the world beyond the mirror."[234]

VI. THE IMAGE IN PIECES

At times we think we know ourselves in time, when all we know is a sequence of fixations in the spaces of the being's stability—a being who does not want to melt away. . . . In its countless alveoli space contains compressed time. That is what space is for.

Gaston Bachelard[235]

You destroy, you reduce to fragments, [Freud] is reproached, and so you leave your unfortunate patient disjointed, in pieces. To which Freud's reply was always that the individual has only too great a tendency to recompose a unity, to re-translate, to recast a synthetic vision of himself and his future.

Jean Laplanche[236]

Toward the end of his essay of 1953, "Stranger in the Village," James Baldwin writes: "The time has come to realize that the interracial drama acted out on the American continent has not only created a new black man, it has created a new white man, too. No road whatever will lead Americans back to the simplicity of this European village where white men have the luxury of looking at me as a stranger."[237] Baldwin concludes: "This world is white no longer, and it will never be white again." The cover image of a special issue of *Time* magazine, published in 1993, shows a young woman who has been "selected as a symbol of the future, multiethnic face of America." The "woman" has no physical existence, her image has been synthesized by computer. According to *Time* magazine, she is "15% Anglo-Saxon, 17.5% Middle Eastern, 17.5% African, 7.5% Asian, 35%

Southern European and 7.5% Hispanic." Although only fifteen percent Anglo-Saxon, the woman nevertheless has the appearance of a White woman recently returned from a holiday on the Mediterranean. James Gaines, managing editor of *Time*, writes:

> Little did we know what we had wrought. As onlookers watched the image of our new Eve begin to appear on the computer screen, several staff members fell promptly in love. Said one: "It really breaks my heart that she doesn't really exist." We sympathize with our lovelorn

colleagues, but even technology has its limits. This is a love that must forever remain unrequited.[238]

That which "heartbreakingly" does not exist here, of course, is a nation without division. The unrequited love is for the unfilled assimilationist dream of a melting-pot America: a democracy without differences, in which everyone could plausibly pass as a more or less legitimate child of the founding fathers. We might more accurately say "founding mothers," as the longing for undifferentiated bliss is infantile in origin. In Lacanian terms, it is nostalgia for ignorance of lack and of loss, for a time out of time, before "castration." In a book of 1991, the psychologist Stephen Frosh distinguished "between regressive and realistic solutions to . . . the crisis of identity. . . . between 'narcissistic' solutions built out of a regressive desire to return to the pre-natal state, and 'Oedipal' solutions forged through encounters with reality." Frosh writes:

> Characteristics of the former solution were denial of contradiction, desire for a state of conflict-free bliss, disavowal of anality, pursuit of purity, and absorption in a fantasy of completeness. Such lifeless but rigid Imaginary states can easily be seen to be characteristic of fascism and other ideologies opposed to the heterogeneity and contradictions of modernity—ideologies that protect people from the realities of the world by denying those realities, by offering a framework of total predictableness and by brooking no opposition.[239]

I have noted an increasing tendency of the electronic media environment to bear the imprint of primary process constructions. The image on the cover of *Time* exemplifies this tendency. It may be described in the same basic terms that Freud used to describe the dream. First, the image is constructed according to mechanisms that Freud identified in

the "dream work," and which he named "condensation" and "displacement." Images of several different individuals have been displaced from their sources and combined to form the image of a single individual—exactly in the manner of Francis Galton's composite photographs, to which Freud referred in explaining his notion of condensation. Secondly, the image such mechanisms have constructed represents the hallucinatory fulfillment of a wish. Here, the wish is to see a future American society in which all multicultural contradictions will have been finally subsumed under "Anglo-Saxon" cultural, political, and economic hegemony.

It may be objected that we do not actually dream when we look at a magazine. We are not asleep at such moments. Freud showed that the waking fantasies we call "daydreams" have much the same modes of construction, and unconscious motivations, as our nocturnal dreams. But we do not necessarily daydream, either, when we look at the cover of a magazine. Perhaps a more accurate description of our normal relation to such media images may be derived from the work of Winnicott. Winnicott urged "the value of keeping in mind the distinctions that exist between phenomena in terms of their position in the area between external or shared reality and the true dream."[240] From his close attention to such distinctions, Winnicott formed the concepts of the transitional object, other transitional phenomena, and transitional space. The phenomenon of the "transitional object" may be noted in the small child's intense attachment to a corner of a blanket, some preferred soft toy, or something else. The object is "transitional" in that it marks the passage of the infant, and small child, into that differentiated world in which it exists separately from its mother. Winnicott writes:

> Of the transitional object it can be said that it is a matter of agreement between us and the baby that we will never ask the question: "Did you conceive of this or was it presented to you from without?" The important

point is that no decision on this point is expected. The question is not to be formulated [italics in original].[241]

Winnicott himself was the first to apply his concepts to the cultural sphere. The transitional object, he writes:

> comes from without from our point of view, but not so from the point of view of the baby. Neither does it come from within; it is not a hallucination. . . . Its fate is to be gradually allowed to be decathected, so that in the course of years it becomes not so much forgotten as relegated to limbo. . . . It is not forgotten and it is not mourned. It loses meaning, and this is because the transitional phenomena have become diffused, have become spread out over the whole interme- diate territory between "inner psychic reality" and "the external world as perceived by two persons in common," that is to say, over the whole cultural field.[242]

I have already referred to Saint Augustine's *The Trinity*, and to Kristeva's commentary on it. In his introduction to a modern edition of Augustine's text, the Catholic scholar Stephen McKenna notes that, in Christian belief, sight is "the noblest of the five senses and the one most akin to internal vision."[243] In Kristeva's analysis, the image on the cinema screen—both dreadful and consoling—is situated "at the intersection between the vision of a real object and hallucination." In an essay of 1977, I remarked, "Desire needs no material darkness in which to stage its imaginary satisfactions; day-dreams, too, can have the potency of hyp- notic suggestion."[244] Now, following Winnicott, I may add that, whatever the frame of mind of the viewer, any image may in principle occupy this same space "between the vision of a real object and hallucination." This space is quite simply, in the title of one of Winnicott's essays, "The

Location of Cultural Experience." Virilio has observed that the space engendered by our contemporary information technologies "is not a geographical space, but a space of time."[245] The contemporary media have ensured that the experience of external reality is no longer confined to an individual's immediate geographical location. Global distances are collapsed in the temporal immediacy of the electronic image transmitted "live" by satellite. As I have noted, this has helped to change Western "commonsense" apprehension of its relation to its once distant others— not least, its former colonial subjects. But there is a further way to understand Virilio's observation. We may also acknowledge that the "space of time" of electronic images is a space of memory and of fantasmatic anticipation, and it may also be a space of pre-Oedipal regression, and consequently a space of ever-potential paranoia and aggressivity.[246] In this explosive electronic space, the "image" forms when digital "bits" of images in pieces collide at the speed of light. Nevertheless it forms according to the conservative principles of a subject for which there is no time. Althusser wrote: "I shall adopt Freud's expression word for word, and write *ideology is eternal,* exactly like the unconscious."[247] Kristeva remarks: "The symbolic order is assured from the moment there are images in which one unfailingly believes, for belief is itself image: each is formed on the basis of the same terms and procedures: *memory, sight* and *love* or will."[248] We may bring these words, formed in the penumbra of churches and the darkness of the cinema, to the digital composite on the cover of *Time*—an image so seamlessly convincing we might easily believe in it. "*Memory, sight* and *love* or will." Memory stands behind this cover image, the memory of other images: those composite ideals of small-town America that Norman Rockwell created for the cover of *Saturday Evening Post,* those screen images from a certain Hollywood cinema (I think, for example, of Frank Capra's *It's a Wonderful Life*). But most fundamentally there is also, the *Time*'s editor confirms it, the uncompromisingly hallucinatory force of *love*. Love at first

sight as "the image of our new Eve" begins to appear on the computer screen. The editor complains that "even technology has its limits," but as his biblical reference (with overtones of Villiers de l'Isle-Adam) may indicate, this image represents the hallucinatory fulfillment of the wish that technology should *not* have its limits, that through it the United States might return to the originary biblical scene of its creation—the wish that, raising itself from primal digital dust, from out of the shattered pixels of its self-image in pieces, America may make itself anew in its own mathematically "perfect" image.

VII. PECULIAR TIMES

> It is no longer possible to think the process of the development of the different levels of the whole in the same historical time. Each of these different "levels" does not have the same type of historical existence. On the contrary, we have to assign to each level a peculiar time, relatively autonomous, and hence relatively independent, even in its dependence, of the "times" of the other levels.
>
> **Louis Althusser and Etienne Balibar**[249]

In 1885, at the Prime Meridian conference in Washington, twenty-five nations formally divided the globe into twenty-four distinct time zones, organized with reference to a zero meridian in Greenwich. Stephen Kern has noted the historical proximity of this rationalization of world time—calibrated to London, the administrative center of the largest imperial power—to the Berlin Conference of 1884 at which fourteen Western nations divided the space of Africa amongst themselves as their colonies.[250] Today, there must now be restored to history, as Bhabha writes: "those whose very presence is both 'overlooked'—in the double sense of social surveillance and psychic disavowal. And, at the same time, 'overdetermined'—psychically projected, made stereotypical and symptom-

atic."[251] This project requires a work of historical scholarship: restoring elided passages, correcting falsifications in the written record. It also requires attention to that other field into which the symptomatic stereotype is projected: the field of representations, of globally dispersed media images. I began with two anecdotes about an award ceremony for the filmmaker Sembène. They illustrate the ordinary difficulty of escaping the hierarchical forms of rationality that permeate mediatic daily life—particularly the form "History," as the one story of North American and European progress and culture. African cinema, Sembène paradoxically declared in San Francisco, is a hundred years old *and* is newly born. The dream work, Freud notes, is indifferent to waking logic, replacing disjunction with conjunction, "or" with "and." If, ignoring hegemonic rationalism, we may now speak dreamily, it is in recognition that we inhabit *differing* times. Against the grain of "either-orism," we may tolerate the lamination of discourses, the tectonic overlapping of discursive strata from disparate times. Bhabha observes:

> The challenge to modernity comes in redefining the signifying relation to a disjunctive "present": staging the "past" as *symbol*, myth, memory, history, the ancestral—but a "past" whose iterative *value as a sign* reinscribes the "lessons of the past" into the very textuality of the present that determines both the identification with, and the interrogation of, modernity: what is the "we" that defines the prerogative of my present?[252]

It is the prerogative of the "we" which is at stake in the "two paradigms" debate resumed in my introduction to this book. It is through this "we" that political constituencies are formed by collapsing questions of individual identity into the question of belonging, of membership. Because of television (especially satellite television) and other forms of media production, all the contradictory otherness of the world is part of our

everyday experience. As the flow of "migrance"[253] from the imperial Western metropolis to its colonized "peripheries" is reversed, the very possibility of the distinction between margins and center is eroded as the former fold in upon the latter. The neocolonial capital has become a knot in a skein of diasporic threads, as each "we" spins its own yarn of origin. In this context, "identity politics" may confront the ideology of "nothing but the same" with the reality of alterity, in long overdue revendications of the human rights of minorities. Or it may sustain such murderously defensive historical fantasies as that of the "Aryan race" or "Greater Serbia." Of the paranoiac derivations of such imaginary addresses, Lacan observes:

> Defense . . . is said to be at the origin of paranoia. The *ego* . . . in effect having the power to bring the external world into play in various ways, is in the case of psychosis said to cause a signal, intended as a warning, to appear in the external world in the form of a hallucination. . . . a pressure [*poussé*] emerges which is perceived by the ego as dangerous.[254]

"Final solution" and "ethnic cleansing," slavery and racism, sexism and homophobia, all imply a collective ego, a "we" withdrawn to such a thickly armored distance from its hallucinated others—seen as a dangerous supplement to its own existence—that real individuals are reduced to dehumanized ciphers, to be rewritten or erased in the acting out of what Winnicott calls "fantasies of omnipotent control."[255] Today, nationalism (so often an expression of ethnic antagonism and racism) is the most prevalent political expression of the armored "we." Time, in the narrated concretion of History, is the essence of nationalism. It is time secreted as space which is circumscribed as "territory": "We've always been here," says the Serbian mayor, "and the Muslims have only been here since the 15th century." As Bhabha writes: "Nations, like narratives, lose their

origins in the myths of time."[256] But not inevitably. The Martiniquan writer Edouard Glissant speaks from within an *other* mode of belonging: "Time, for we Antilleans, is very important. But we would never have been able to conceive a Search for lost time [*Recherche du temps perdu*],[257] in truth, we never possessed it. Our time is beside itself [*réperdu*]. It is made of holes and insufficiencies [*manques*]. It's that, the gaping time of the Antilles."[258] There is nothing of *pathological* nationalism in Glissant's "we." He is a proponent of, in the title of his most recent novel, *Tout-monde*.[259] He notes: "The entire world is half-bred [*métissé*], but it doesn't know it. . . . That's why I'm hostile to creolity, which is a prison, like . . . frenchness or negritude. The chaos-world is going at such a speed that we can barely keep up with it."[260] It is unlikely that Glissant would disagree that the "gaping time of the Antilles" is both the marker of a unique identity—"we Antilleans"—*and* the common temporal condition of all subjectivity whatsoever. The inescapable condition of any history, personal or national, is that the story be "full of holes."[261] Narrative vacuities however may induce psychotic terror. In its narrative aspect, "ethnic cleansing" is the "middle" of a narrative of Aristotelian simplicity, whose "beginning" is intermixing, a confusion of histories, and whose "end" is separateness, the one mad story. Freud remarked on the inexhaustible inventiveness of paranoiacs, able to weave every detail of everyday life into the seamless perfection of a conspiracy narrative. Today's journalists, routinely interviewing psychotically "normal" people, would have no cause to disagree:

> And there are Muslims in Bosnia. So you see, the Green Axis!
> *Excuse me?*
> The Green Axis! Islam! It's aiming at the heart of Europe.[262]

Taranger was led to conclude: "The function of the film is clear: it completes life, it fills the holes [*manques*] in life." We may recall Mannoni's

remark that we are all "more or less cured" psychotics. It is perfectly "normal" for gaps in personal and communal histories to be bridged by identificatory investments in signifiers from the common environment of media images—signifiers that also, quite literally, "appear in the external world in the form of a hallucination."

In my summary account of the "two paradigms" debate, I mentioned Paul Gilroy's unmasking of Patricia Hill Collins's covert essentialism. I noted that political arguments can rarely afford to respect the rules of consistency we require (of our opponents) in theoretical debates. As Bertolt Brecht remarks, stating the obvious: "At times, it is necessary to speak harshly." To be silenced by this obviousness, however, is to nurture cynicism born of political despair. Against the monodic line of racial and ethnic absolutism—which as a political *principle* is manifestly indifferent to whether it makes or mends misery—Gilroy, like Glissant, takes pleasure in the mix. The dreamy painting by Aaron Douglas which graces the cover of Gilroy's book,[263] like the title above it, *The Black Atlantic*, combines previously separated historical tracks. Painting and book alike picture modernity *remixed*, with the previously subdued voice of the black experience now clearly prominent in the polyphony of Western history. Gilroy calls for "a redemptive critique of the present in the light of the vital memories of the slave past."[264] A space of painfully difficult questioning opens between the expression "vital memories" and the more usual "living memory." How *is* the past of slavery to be integrated into present memory, and in times that seem peculiarly beyond redemption? Beyond monophonic separatism, what might be the mode of an "identity politics" for an identity that, no longer asserted in its specious integrity, is acknowledged as full of holes? An identity neither bridged nor abridged. Not slogan but palimpsest, traversed by all the signifiers of a world in pieces. The recent work of Laplanche suggests the metaphor of "translation." Rather than speak of "holes" in identity, I might more appropriately speak of passages of history which have been *symptomat-*

ically translated, or remain incomprehensible. I have already noted that psychoanalysis began with the attempt to relieve hysterical symptoms by recovering the repressed memory of a traumatic event. And that subsequently Freud discovered that the repressed fantasy of something that did not actually happen could have as damaging an etiological consequence as the repressed memory of something that did happen. From this point, psychoanalysis definitively separates itself not only from medicine but from sociology and criminology. The field specific to psychoanalysis becomes "psychical reality," not the "real event."[265] The specter of recovery through recovery nevertheless haunts psychoanalysis to this day. This is a ghost Laplanche would lay to rest. According to Laplanche, it is not the *end* of an analysis to uncover either a repressed memory or an unconscious fantasy, for all that such items figure in the course of an analysis. He writes:

> The cure is not in the main the translation of a present scenario into a past scenario, from which point, and one knows not how, the patient would be required to fend for himself in attempting to integrate it into a project. The temporal movement of analysis in its exemplary and prototypical form is that of the splitting up of signifying sequences, be they present or past, into elements, isolated and, in the last resort, *enigmatic* elements, in order to permit the analysand to proceed spontaneously to a new synthesis or translation, one that is less partial, less repressive, less symptomatic.[266]

There is no ultimate inner chamber of being, in which the soul of the analysand lies spellbound, and toward which the analyst quests like a knight in a fairy tale. For Laplanche, the unconscious is a ramification of "enigmatic signifiers" implanted in the subject by others: it is *the place of alterity within identity*. Something in the behavior of the other—speech, glance, posture . . . *some thing*—seems laden with significance for me, but

I do not know what it is (as if I have encountered a hieroglyph on a stone in the desert). Nor does the other know (any more than the stone knows what is written on its face). Laplanche notes that the earliest and inescapably important instances of this type of communication take place between the infant and the adult world: "An infant is confronted by an adult world that from the beginning sends him messages, suffused with sexual meanings, unconscious meanings, which are unconscious for the transmitter of the message himself; messages perceived as enigmatic, that is as a 'to be translated.'"[267] For example, the child is witness to everyday domestic exchanges—a touch, a glance, a remark—which derive from the sexual relation between the adults who care for it. But the child has no way of knowing what this relation is. Such exchanges have "more meaning for the adult than for the child, the more being precisely the sexual part of it."[268] Moreover, Laplanche emphasizes: "The parents are not completely aware of what sexual pleasure means for them, of the sexual fantasy behind their own intercourse."[269]

Everyday language permits us to ask ourselves what "construction" we might put on this or that ambiguous message. In his important essay of 1937 on "Constructions in Analysis," Freud introduces a distinction between a "construction" and an "interpretation": "'Interpretation' applies to something that one does to some single element of the material, such as an association or a parapraxis. But it is a 'construction' when one lays before the subject of the analysis a piece of his early history that he has forgotten."[270] In this reformulation, "interpretation" becomes in effect the antonym of "construction." In Freud's changed understanding of the analytical procedure it names, "interpretation" means *deconstruction*. We live in accordance with the constructions we have made of events in our lives. Some of these constructions are symptomatic. The analyst does not aim to replace them; this is the task of the analysand. The aim is rather to dismantle symptomatic constructions in order that the reconstructive task may be undertaken. This is the idea of interpretation

which emerges in Freud's later work, and which Laplanche accentuates: the sense of "just pointing out the relationship between two elements, tracing them back to something deeper, element by element." It is this sense that Laplanche finds has been largely forgotten by analysts:

> Freud said analysis was first of all a method for getting access to phenomena which we would not have access to in another way. Now all analysts think if they give an interpretation (of a Kleinian or whatever kind) that is analysis: that is not analysis.[271]

What Laplanche means here by "an interpretation" is precisely that which Freud came to call a "construction," in this particular case, one produced ready-made from the corpus of psychoanalytic theory. Such constructions are better named for what they are: ideologies. I have noted that Barthes spoke of ideology as "the Imaginary of a time, the Cinema of a society." He remarked, "It even has its photograms: the stereotypes with which it articulates its discourse."[272] Attention to the ideological agency of the stereotype has been, and continues to be, integral to the project of cultural studies.[273] I have argued that, in teletopological space, the historical constructions that ground identity are "psychically projected, made stereotypical and symptomatic." Ragland-Sullivan's observations on the symptom are pertinent, she writes:

> Clinically speaking, the symptom is a metaphor for an untranslated unconscious message. Freud viewed the symptom as neurotic but also "correctable" through a remembering which would open a door and release repressed material. Lacan, on the other hand, taught that an individual will not reach any unconscious truth along the path of reminiscence (delving into the past), but along the path of repetition in the here and now. . . . Lacan distinguishes, therefore, between *reminiscence*, which partakes of memory (and thus of consciousness)

and *remémoration,* which belongs to the *moi* and drives human beings to relive unconsciously each instant of their history in the present. . . . Lacan here echoes Søren Kierkegaard's idea that the principle of identity is precisely that of repetition. But Lacan equates the *moi* and repetition so that the phenomenon is located somewhere between the unconscious and consciousness.[274]

This space "between the unconscious and consciousness" is the location of cultural experience. A fragment from a film, a teleplay, a photograph may be pasted over an untranslated passage of history, individual or communal. The fragment is the metonymic representative of already known narratives (the myths of time) which exceed the semantic compass of the fragment. Such fragments simultaneously face onto two dimensions of meaning—public and private, conscious and unconscious—and are symptomatically articulated.[275] Enigmatically incomplete fragmentary signifiers—from the real world, from media images, from memory and fantasy—may be woven into delusional constructions of convincing realism. In "Constructions in Analysis," Freud writes:

> I have not been able to resist the seduction of an analogy. The delusions of patients appear to me to be the equivalents of the constructions which we build up in the course of an analytic treatment. . . . Just as our construction is only effective because it recovers a fragment of lost experience, so the delusion owes its convincing power to the element of historical truth which it inserts in the place of rejected reality.[276]

Laplanche identifies the work of interpretation with "the splitting up of signifying sequences, *be they present or past*" (my emphasis), in order that the analysand may effect "a new synthesis or translation, one that

is less partial, less repressive, less symptomatic." He invokes the Homeric tale of Penelope. In the usual telling, Penelope is the avatar of the faithful wife, bound out of time to the siren call of memory. In Laplanche's exegesis, Penelope reweaves the fabric of her life, unraveling the knots of her past life with Odysseus to design a future without him, *without breaking the threads.*[277] The story serves as a metaphor for the process of unbinding and rebinding, of deconstructing and retranslating, in a psychoanalysis. As the analyst Adam Philips has written:

> People come for psychoanalysis when there is something they cannot forget, something they cannot stop telling themselves, often by their actions, about their lives. And these dismaying repetitions—this unconscious limiting or coercion of the repertoire of life-stories— create the illusion of time having stopped. . . . In our repetitions we seem to be staying away from the future, keeping it at bay.[278]

Forward movement in life is achieved through a backward movement in memory, but one that is more than a simple temporal regression. In place of the blocked nostalgia or nausea of the perpetual return, the past is transformed in such processes as "working through" and "deferred action."[279] This is what must be involved in Bhabha's *"performance* that is iterative and interrogative—a repetition that is *initiatory,* instating a differential history that will not return to the power of the Same." This is what must be included in Gilroy's "redemptive critique of the present in the light of the vital memories of the slave past."[280] Any other form of return can only engender the "nightmares" of which Marx spoke— leading the living to mimic the dead and impotently fight *their* defunct battles in place of their own real and present struggles. In an essay on Proust, Benjamin speaks of "the weaving of . . . memory, the Penelope work of recollection. Or should one call it, rather, a Penelope work of forgetting? . . . remembrance is the woof and forgetting the warp."[281] We

are accustomed to believe that *forgetting* is precisely that which it is most important to resist. (Are we to forget slavery, forget the Holocaust?) But if we understand Benjamin's "forgetting" to correspond to the unbinding of the "signifying sequence" that has become symptomatically knotted, to a process of reinscription of the past in the present, then we may allow that nothing is *lost* in the process.

Sembène situates himself in the West African tradition of the *griot:* the socially unfixed storyteller who weaves the present into each retelling of a traditional tale and "reinscribes the 'lessons of the past' into the very textuality of the present." As I remember Sembène speaking in San Francisco (and as I now look for a story of my own to exemplify Benjamin's "forgetting"), the spotlit stage of the Kabuki Theater dissolves into a sunlit street in Marseilles: the flowing garments of men and women from sub-Saharan Africa weaving amongst jellabas and blue jeans in the polyglot crowd. The ports of San Francisco and Marseilles are at opposite extremities of a space of Euro-American cultural hegemony. In this imaginary space, the intervening Atlantic represents little more than a large interior lake. The westerner who traverses the Mediterranean between the ports of Marseilles and Algiers enters an *other* space—that of Africa. But not yet definitively. Marseilles and Algiers, margin cities where others mingle, are entangled in mutual reflections, common histories. More than any French city, Marseilles lives in the shadow of atrocities committed on all sides during the the terrible war for Algerian independence.[282] It now lives in a time of the rise of the viciously racist "National Front" in France, and the murderously antiwestern "Armed Islamic Group" in Algeria. I was recently invited to Marseilles, by the Ville de Marseilles, to make a video about the city.[283] In a meeting with the city's *chargée d'affaires culturelles*, I mentioned that I wanted part of the "voice-over" narration to be read by a woman with an Arabic accent. The official replied that she was currently sharing her apartment with just such a woman, and I was invited to lunch at their home. We eat in the

kitchen, which contains a huge American refrigerator. Attached to the refrigerator door is a scroll with an inscription formed in Arabic characters. I ask what it means. I am told that it is, quite simply, the Arabic alphabet. I hear the following story: Christine (pale hair, light skin) was born in colonial Algeria, into a family of the administrative class. Inside and outside the home she spoke French. In keeping with the professional practice of her class she had learned to read, but not speak, Arabic. Dalila (jet hair, dark skin) was born in northern France, into a North African family who had left Algeria after independence. Inside the home she spoke Arabic, outside the home she spoke French. She had not learned to read Arabic, as there had previously seemed no reason to do so. Christine was teaching Dalila to read. Dalila was teaching Christine to speak.

NOTES TO PREFACE

1. Frederic Jameson, "Reading without Interpretation: Postmodernism and the Video-Text," in *The Linguistics of Writing*, Nigel Fabb et al. (eds.), Manchester, Manchester University Press, 202; quoted in Stephen Heath, "Representing Television," in Patricia Mellencamp (ed.), *Logics of Television*, Bloomington and Indianapolis, Indiana University Press, 1990, 302.

2. Victor Burgin, *The End of Art Theory: Criticism and Postmodernity*, London and Basingstoke, Macmillan, and Atlantic Highlands, New Jersey, Humanities Press International, 1986, viii.

3. Meaghan Morris, "Banality in Cultural Studies," in Mellencamp, *Logics of Television*, 14–15.

NOTES TO INTRODUCTION

1. Roland Barthes, *S/Z*, New York, Hill & Wang, 1977, 15–16.

2. Karl Marx, quoted by Guy Debord in "Theory of the Dérive," in Ken Knabb (ed.), *Situationist International Anthology*, Berkeley, Bureau of Public Secrets, 1981, 51.

3. Raymond Williams, *Keywords*, London, Fontana, 1983, 87.

4. Chris Baldick, *The Social Mission of English Criticism*, quoted in Terry Eagleton, *Literary Theory*, London, Blackwell, 1983, 23.

5. Clement Greenberg, "Avant-Garde and Kitsch," in *Art and Culture*, Boston, Beacon Press, 1961, 9.

6. The more general intellectual background against which the work of *Screen* emerged was created by the journal *New Left Review*, which was, for example, responsible for the first translations into English of the work of Althusser and Lacan.

7. The work of *Screen* during the first half of the 1970s in introducing a semiotic and psychoanalytically informed theory and criticism of film, within the framework of a mainly Brechtian Left cultural project, has since had a great

influence throughout Britain, Australia, and North America. For example, the US journal *Camera Obscura*, which published its first issue in 1976, developed and enlarged the theoretical project initiated by *Screen* within an explicitly feminist framework.

8. *New Left Review*, no. 51, (September–October 1968).

9. See *Screen* 17, no. 2, (Summer 1976).

10. See Rosalind Coward, "Class, 'Culture' and the Social Formation," *Screen* 18, no. 1, (Spring 1977). For a response to Coward's article from *Working Papers in Cultural Studies*, see "Marxism and Culture," *Screen* 18, no. 4, (Winter 1977–1978). The co-signatories to the reply are Iain Chambers, John Clarke, Ian Connell, Lidia Curti, Stuart Hall, and Tony Jefferson.

11. Louis Althusser, *For Marx*, Harmondsworth, Penguin, 1969, 233.

12. Stuart Hall, "Cultural Studies: Two Paradigms," in Tony Bennet et al. (eds.), *Culture, Ideology, and Social Process*, London, Open University, 1981, 29.

13. Ibid., 36.

14. Ibid., 33.

15. Stuart Hall, "New Ethnicities," in Kobena Mercer (ed.), *Black Film: British Cinema*, London, ICA Documents, no. 7, 1988.

16. Ibid., 28.

17. Colin MacCabe, "Memory, Phantasy, Identity: 'Days of Hope' and the Politics of the Past," *Edinburgh '77 Magazine*, no. 2, (1977), 13.

18. Stuart Hall, "New Ethnicities," 30.

19. Ibid., 27.

20. Stuart Hall, edited transcript of talk given at the symposium "Fantasy/ Identity/Politics," Institute of Contemporary Arts, London, 16 February 1989, in *The Center for Cultural Studies Newsletter*, Santa Cruz, University of California, (Winter 1990). (The other speakers were Homi Bhabha, James Donald, and Jacqueline Rose.)

21. Paul Gilroy, *The Black Atlantic*, Cambridge, Harvard University Press, 1993.

22. Ibid., 4.

23. Patricia Hill Collins, *Black Feminist Thought: Knowledge, Consciousness, and the Politics of Empowerment*, New York and London: Routledge, 1991.

24. Gilroy, *The Black Atlantic*, 232 n. 26.

25. Ibid., 52–53.

26. Homi Bhabha, "The Postcolonial and the Postmodern," in *The Location of Culture*, London and New York, Routledge, 1994.

27. I do not intend to imply that Gilroy's address is somehow *purely* theoretical, or apolitical. It seems to me to be an address to an emergent constituency, rather than the actually existing "majority of the minority." In this sense it is perhaps utopian, which is to say, most *purely* political.

28. "Lacan in Slovenia: An Interview with Slavoj Zizeck and Renata Salecl," *Radical Philosophy* 58, (Summer 1991), 31.

29. See Bertrand Badie, *L'etat importé*, Paris, Fayard, 1992.

30. *Le figaro*, 13 October 1967; cited in *Le petit Robert*, Paris, SNL, 1978, 619.

31. Stuart Hall, "The Emergence of Cultural Studies and the Crisis of the Humanities," *October* 53, (Summer 1990), 17–18.

32. Paul Gilroy, "Cruciality and the Frog's Perspective: An Agenda of Difficulties for the Black Arts Movement in Britain," *Art and Text* 32, (Autumn 1989), 108.

33. Tzvetan Todorov, "Some Approaches to Russian Formalism," *Twentieth Century Studies*, (December 1972), 10.

34. Gilroy, *The Black Atlantic*, 5–6.

35. Stalin himself, in fact, had to address precisely the notion that language is "a superstructure on a base." See J. V. Stalin, *Marxism and Problems of Linguistics* (1950), Peking, Foreign Languages Press, 1972. There are of course other important ways in which language remains an object of political struggle. For example: "Last November, 11 of the 26 member states of the Council of Europe, an organization that promotes democracy and human rights, signed a charter in which they pledged to encourage the use of indigenous languages in schools and in public life. . . . The charter does not apply, though, to languages brought to the Continent by African or Arab immigrants." See Marlise Simons, "A Reborn Provençal Heralds Revival of Regional Tongues," *The New York Times*, 3 May 1993, A6.

36. Hall, "The Emergence of Cultural Studies," 17–18.

37. Ibid., 11.

38. Henri Lefebvre, *The Production of Space*, Oxford and Cambridge (Massachusetts), Basil Blackwell, 1991, 416.

39. Edward W. Soja, *Postmodern Geographies: The Reassertion of Space in Critical Social Theory*, London and New York, Verso, 1989, 63 n. 12.

40. Ibid., 223.

41. Ibid., 191.

42. Mike Davis, *City of Quartz: Excavating the Future in Los Angeles*, New York, Vintage, 1992 (London, Verso, 1990), 84.

43. Ibid., 84.

44. Ibid., 86.

45. Frederic Jameson, "Postmodernism, or The Cultural Logic of Late Capitalism," *New Left Review* 146, (July–August 1984), 83–84.

46. Soja, *Postmodern Geographies*, 245.

47. Jameson, "Postmodernism," 81.

48. The Bonaventure Hotel was designed by the architect and developer John Portman.

49. Frederic Jameson, *The Geopolitical Aesthetic: Cinema and Space in the World System*, Bloomington and Indianapolis, Indiana University Press, and London, British Film Institute, 1992, 2–3.

50. Soja, *Postmodern Geographies* 41.

51. Lefebvre, *The Production of Space*, 8. (*La production de l'espace*, Paris, éditions anthropos, 1986, 15.) I have slightly modified the English translation in places where it tends to return Lefebvre's language from the concrete to the abstract. Here, for example, "*sur le terrain*" was rendered as "onto a (spatial) field."

52. Ibid., 413–414.

53. Ibid., 39.

54. Soja, *Postmodern Geographies*, 125. Where the issue of psychical space is not simply ruled out of consideration in Soja's book, it seems to be collapsed into that venerable category of social theory, "worldview" (*Weltanshauung*). For example, Soja describes an advertisement (for a Redondo Beach real estate development) as a "stereotypical caricature" of "the worldview from this highly engineered environment," 231–232.

55. Jean-Noël Blanc, *Polarville*, Lyon, Presses universitaires de Lyon, 1991, 19.

56. *Le nouvel observateur, spécial: Banlieus avant l'incendie*, no. 1389, 20–26 June 1991.

57. Soja, *Postmodern Geographies*, 125.

58. Gilbert Ryle, *The Concept of Mind*, Harmondsworth, Penguin, 1963, 14.

59. Jacques Lacan, *The Four Fundamental Concepts of Psychoanalysis*, London, Hogarth Press, 1977, 56 (italics in the original).

60. Lefebvre, *The Production of Space*, 413.

61. Ibid., 184.

62. Ibid., 405.

63. Ibid., 405.

64. "Beauty will be convulsive or will not be at all." See André Breton, *Nadja*, Paris, Gallimard, 1963, 190. (English transl., *Nadja*, New York, Grove Press, 1960, 160.)

65. Lefebvre, *The Production of Space*, 18.
66. Lacan died in 1981; Lefebvre died in 1991.
67. Lefebvre, *The Production of Space*, 431.
68. Debord, "Theory of the Dérive," 53.
69. Jameson, "Postmodernism," 83–84.
70. Ibid., 79.
71. Walter Benjamin, "The Work of Art in the Age of Mechanical Reproduction," in *Illuminations*, London, Fontana, 1973, 241–242.
72. Jameson, *The Geopolitical Aesthetic* 169.
73. Roland Barthes, *La chambre claire*, Paris, Gallimard/Seuil, 1980, 13.
74. Hollis Frampton, "For a Metahistory of Film: Commonplace Notes and Hypotheses" (1971), in *Circles of Confusion: Film, Photography, Video; Texts 1968–1980*, Rochester, New York, Visual Studies Workshop, 1983, 114.
75. Shoshana Felman, *Jacques Lacan and the Adventure of Insight*, Cambridge (Massachusetts) and London, Harvard University Press, 1987, 76.

NOTES TO CHAPTER 1

1. Gaston Bachelard, *The Poetics of Space*, Boston, Beacon, 1969, 212.
2. Louis Althusser, "Ideology and Ideological State Apparatuses (Notes Towards an Investigation)," in *Lenin and Philosophy and Other Essays*, London, New Left Books, 1971.
3. Roland Barthes, "Diderot, Brecht, Eisenstein," in *Image-Music-Text*, New York, Hill & Wang, 1977, 69.
4. Laura Mulvey, "Visual Pleasure and Narrative Cinema," *Screen* 16, no. 3, (Autumn 1975). (Reprinted in Laura Muvey, *Visual and Other Pleasures*, Bloomington, Indiana University Press, 1989.)
5. Michel Foucault, *Discipline and Punish*, London, Penguin, 1977.
6. F. M. Cornford, *Plato's Cosmology*, New York, Harcourt, Brace, 1937.
7. Michel Foucault, "Of Other Spaces," *Diacritics* 16, no. 1.
8. This remark is prompted by Panofsky's essay, "Die Perspektive als 'symbolische Form'"—today an unpopular article. For a summary of the debates, see Samuel Y. Edgerton, Jr., *The Renaissance Rediscovery of Linear Perspective*, New York, Harper & Row, 1976, 153 ff.
9. St. Augustine, *De Ordine*, chap. 15, 42, in A. Hofstadter and R. Kuhns, *Philosophies of Art and Beauty*, Chicago, University of Chicago Press, 1976, 180.
10. "Absolute space in its own nature, without relation to anything external,

remains always similar and immovable. Relative space is some movable dimension or measure of the absolute spaces; which our senses determine by its position to bodies; and which is commonly taken for immovable space." See Isaac Newton, *Mathematical Principles of Natural Philosophy*, quoted in F. Durham and R. Purrington, *Frame of the Universe*, New York, Columbia University Press, 1983, 156.

11. Hermann Minkowski, "Space and Time," in A. Sommerfeld (ed.), *The Principle of Relativity*, New York, Dodd, Mead & Co., 1923.

12. "For example, at extremely short distances, on the order of 10^{-33} cm, the geometry of space is subject to *quantum fluctuations*, and even the concepts of space and space-time have only approximate validity." See Durham and Purrington, *Frame of the Universe*, 191.

13. El Lissitsky, "K. und Pangeometrie," quoted in P. Descargues, *Perspective: History, Evolution, Techniques*, New York, Van Nostrand Reinhold, 1982, 9. It is necessary to distinguish between "non-Euclidean geometry" (or *metageometry*) and "n-dimensional geometry" (or *hypergeometry*). The former, initiated in the nineteenth century by Gauss and Lobachevsky, and developed by Riemann, is a geometry of curved surfaces—spaces that are boundless and yet finite; the latter, also developed in the nineteenth century, is the geometry of "hyperspace"—a hypothetical space of more than three dimensions. The idea of a fourth dimension as a *literal* fact gained much popularity from the close of the nineteenth century and into the 1930s and exerted some considerable influence on the early modern movement in painting, not least in its more mystical formulations (the fourth dimension as "higher reality"—for example, in the Theosophism of Kandinsky and Mondrian). Beyond the 1920s, however, after the popular dissemination of the ideas of Einstein and Minkowski, the idea of a fourth dimension of space largely gave way to the idea of a four-dimensional spatiotemporal continuum—with *time* as the fourth dimension. See Linda Dalrymple Henderson, *The Fourth Dimension and Non-Euclidean Geometry in Modern Art*, Princeton, New Jersey, Princeton University Press, 1983.

14. Dziga Vertov, "Film Directors, A Revolution," in *Screen Reader 1*, London, Society for Education in Film and Television, 1977, 286.

15. At this point, the necessary simplicity of my outline risks an injustice to Vertov. The industrial-materialist emphasis of some Russian Formalism was asserted against the mysticism that had entered early Russian Futurist art, primarily from the philosophy of P. D. Ouspensky. In *Tertium Organum* (1911), Ouspensky identifies the "fourth dimension" (see n. 11, above) as that

of the Kantian "noumena" and allocates to the artist the function of revealing that "higher" world, "beyond" phenomena. When, in 1913, the Futurist Matyushin translated extracts from Gleizes and Metzinger's *Du Cubism* (1912) for the journal *Union of Youth*, he accompanied them with passages from *Tertium Organum.* In the same year, Mayakovsky published "The 'New Art' and the 'Fourth Dimension,'" in which he counters the notion of a higher, nonmaterial reality with the assertion that the "fourth dimension" is simply that of *time:* "There is in every three-dimensional object the possibility of numberless positions in space. But to perceive this series of positions ad infinitum the artist can only conform to the various moments of time (for example, going around an object or setting it in motion)"; quoted in Charlotte Douglas, *Swans of Other Worlds: Kazimir Malevich and the Origins of Abstraction in Russia,* Ann Arbor, UMI Research Press, 1980, 31. Mayakovsky's observations adequately describe the program of French Cubism (which, in today's terms, we might say "shatters the object" rather than deconstructs the subject-object dichotomy). Further, his observations are in agreement with Eisenstein's subsequent thought, "the fourth dimension (time added to the three dimensions." See "The Filmic Fourth Dimension" (1929), in J. Leyda (ed.), *Film Form: Essays on Film Theory,* New York, Harcourt, Brace, 1949, 69. Vertov's "unmotivated camera mischief" (Eisenstein), on the other hand, often seems to point outside such accommodation of ideas from "n-dimensional geometry," and toward the "wraparound" spaces of non-Euclidean geometry. (Information in this note derived from Henderson, *The Fourth Dimension.*)

16. Paul Virilio, *L'Espace Critique,* Paris, Christian Bourgeois, 1984.

17. Paul Virilio, *Speed and Politics,* New York, Semiotext(e), 1986.

18. David Bolter, *Turing's Man,* Chapel Hill, University of North Carolina Press, 1984, 98.

19. Guy Debord, *Society of the Spectacle,* Detroit, Black & Red, 1983, paragraph 167.

20. Jacqueline Rose, "The Imaginary," in *Sexuality in the Field of Vision,* London, Verso, 1986.

21. Jacques Lacan, *Le séminaire, Livre I: Les écrits techniques de Freud,* Paris, Seuil, 1975, 90.

22. We should also, incidentally, bear in mind that Mulvey herself has continually denounced the widespread attempt to freeze her evolving argument—an argument to be traced through her filmmaking, as well as through her writing—at that particular, 1975, frame.

23. Rose, "The Imaginary," 182.

24. Ibid., 171.

25. Jacques Lacan, *The Four Fundamental Concepts of Psycho-Analysis*, London, Hogarth, 1977, 56.

26. Since writing this paper, I have come across the following notes by Freud: "Space may be the projection of the extension of the psychical apparatus. No other derivation is probable Instead of Kant's *a priori* determinants of our psychical apparatus. Psyche is extended; knows nothing about it." See *The Standard Edition of the Complete Psychological Works of Sigmund Freud*, London, Hogarth, 1955–1974, vol. 23, 300.

27. Freud, "'A Child Is Being Beaten': A Contribution to the Study of the Origin of Sexual Perversions," in *Standard Edition*, vol. 17, 175–204.

28. Rose, "The Imaginary," 210.

29. Jean-Paul Sartre, *Being and Nothingness*, New York, Washington Square Press, 1966, 369–370.

30. Laura Mulvey's article is clear in its insistence on the narcissistic, identificatory aspect of looking (see section II.B). However, in this article, identification is seen uniquely as "that of the spectator fascinated with the image of his like . . . , and through him gaining control and possession of the woman within the diegesis"; see Mulvey, "Visual Pleasure and Narrative Cinema," 13.

31. Maurice Merleau-Ponty, *The Visible and the Invisible*, Evanston, Northwestern University Press, 1968, 139.

32. Otto Fenichel, "The Scoptophilic Instinct and Identification," in Hanna Fenichel and David Rapaport (eds.), *The Collected Papers of Otto Fenichel*, first series, New York, Norton, 1953, 375.

33. Ibid., 377.

34. It has been proposed that the purpose of this experiment was to demonstrate that the vanishing point is equal in distance "behind" the picture plane to the distance of the point-of-view in front of it. A little "reflection" will reveal that the viewer of Brunelleschi's panel was, in effect, positioned "looking back at herself" from the "other" building at which she was looking.

35. A. Manetti, in Elana Tosca (ed.), *Vita di Filippo di Ser Brunellesco*, Roma, 1927, 11 ff.; quoted in John White, *The Birth and Rebirth of Pictorial Space*, London, Faber, 1972, 116.

36. Sarah Kofman, *Camera obscura de l'idéologie*, Paris, Galilée, 1973.

37. Catherine Clément, *The Lives and Legends of Jacques Lacan*, New York, Columbia University Press, 1973, 160.

38. Ibid., 161.

39. In a response to this paper (at a conference at the University of Warwick, May 1987) Julia Kristeva said she would "more cautiously" prefer the word *precondition*, rather than *origin*, here; she referred to abjection as the "degree zero of spatialization," adding, "Abjection is to geometry what intonation is to speech."

40. Julia Kristeva, *La révolution du langage poétique*, Paris, Seuil, 1974, 453.

41. Julia Kristeva, *Pouvoirs de l'horreur*, Paris, Seuil, 1980, 92.

42. Ibid., 93.

43. My thanks to Francette Pacteau for having shown this passage to me.

44. Plotinus, *Ennead I*, eighth tractate, "Beauty," quoted in A. Hofstadter and R. Kuhns, *Philosophies of Art and Beauty*, Chicago, University of Chicago Press, 1964, 152.

45. Anthony Shaftesbury, "The Moralists," part 3, sec. 2, in Hofstadter and Kuhns, *Philosophies of Art and Beauty*, 245–246.

46. Julia Kristeva, *Soleil noir: Dépression et mélancolie*, Paris, Gallimard, 1987, 107 ff.

47. Klaus Theweleit, *Male Fantasies*, Minneapolis, University of Minnesota Press, 1987.

48. Sartre, *Being and Nothingness*, 343.

49. Julia Kristeva, "Women's Time," in Toril Moi (ed.), *The Kristeva Reader*, New York, Columbia University Press, 1986, 209.

NOTES TO CHAPTER 2

1. Laura Mulvey, "Visual Pleasure and Narrative Cinema," *Screen* 16, no. 3, (Autumn 1975). (Reprinted in Laura Mulvey, *Visual and Other Pleasures*, Bloomington, University of Indiana Press, 1989.)

2. I am speaking strictly of writing about "static" visual representations— photographs, and so on. Mulvey's essay provoked a more nuanced debate among film theorists, but in terms very different from those of this essay.

3. *Self-Portrait with Wife June and Models*, Vogue studio, Paris 1981, in Helmut Newton, *Portraits*, New York, Pantheon, 1987, plate 14.

4. Ibid., 14. Is the similarity of this image to the *Las Meninas* of Velázquez also due to chance? Commenting on one of his own dreams, Freud remarks that the dream was "in the nature of a phantasy," which "was like the façade of an Italian church in having no organic relation with the structure lying behind it. But it differed from those façades in being distorted and full of gaps, and

in the fact that portions of the interior construction had forced their way through it at many points." See Sigmund Freud, *The Interpretation of Dreams* (1900), in *The Standard Edition of the Complete Psychological Works of Sigmund Freud*, vol. 4, London, Hogarth, 1955–1974, 211. In his essay of 1908, "Creative Writers and Daydreaming," Freud describes the production of works of literature, and by implication other forms of art, in analogous terms: the foundation of the work is in unconscious materials, in an opportunistic relation to the conscious plan of the artist they enter the surface structure by means of the primary processes. As Sarah Kofman observes, "For inspiration, a concept belonging to the theological ideology of art, Freud substitutes the working concept of the primary process. The artist is closer to the neurotic . . . and the child than to the 'great man.'" See Sarah Kofman, *The Childhood of Art*, New York, Columbia University Press, 1988, 49. Artistic activity in the adult, then, is made from the same stuff as fantasy and has its childhood equivalent in play. The child in play is serious. In Kofman's description, "The artist plays with forms and selects, among the preconscious processes, the structures which, in relation to his psyche and its conflicts, are perceived as the most significant" (113). The word *selects* here might encourage an overestimation of the role of self-conscious deliberation. In an essay on Freud's aesthetics to which Kofman refers, Ernst Gombrich gives this gloss of Freud's model of the joke: "Take the famous answer to the question: 'Is life worth living?'—'It depends on the liver.' It is easy to see what Freud calls the preconscious ideas that rise to the surface in this answer—ideas, that is, which are not unconscious in the sense of being totally repressed and therefore inaccessible to us but available to our conscious mind; in this case the joy in lots of alcohol which the liver should tolerate and the even more forbidden joy in the aggressive thought that there are lives not worth living. Respectability has imposed a taboo on both these ideas and to express them too boldly might cause embarrassment. But in the churning vortex of the primary process the two meanings of 'liver' came accidentally into contact and fused. A new structure is created and in this form the ideas cause pleasure and laughter." See E. H. Gombrich, "Freud's aesthetics" (1966), in E. H. Gombrich, *Reflections on the History of Art*, London, Phaidon, 1987, 230–231. The import of the collision of signifiers must be recognized, "selected," in order to be given form in a work of art. As such works are produced at the "interface" of primary and secondary processes, however, it is never clear to what extent such recognition and selection is conscious.

5. I am aware that we do not *see* that the photographer is Helmut Newton, we

must choose to believe what the caption tells us. We do not *see* that the camera is a Rolleiflex, this must be added from a store of specialist knowledge, and so on. But skepticism must end somewhere; after all we do not *see* that the "people" in this image are not in fact wax figures.

6. In the setting of psychoanalytic theory, "topographically," such connotations belong to the preconscious; to the extent that they are commonly available we might therefore speak of a "popular preconscious."

7. In his classic paper, "Rhetoric of the Image," Barthes spoke of the "anchorage" of the connotations of the image by means of the written text. It can easily be demonstrated, however, that an image may anchor the connotations of a text, or the connotations of another image (or another signifier within the same image). It should also be obvious that a "text" may anchor another text.

8. CS: When you photographed yourself nude in 1976, your clothes were very neatly folded on a chair in the picture. But when you photograph women who are nude, their clothes are scattered everywhere . . .

 HN: I'm quite a tidy person. I would hate to live in disorder. . . . But this is interesting—I create that disorder—I want the model to take all her clothes off and just dump them.

 (Newton talking to Carol Squiers, in Newton, *Portraits*).

9. Freud, *Standard Edition*, vol. 7, 167.

10. Mulvey, "Visual Pleasure and Narrative Cinema," 13–14.

11. André Breton, *Nadja*, New York, Grove Press, 1960, 39.

12. *La révolution surréaliste*, no. 12, (15 December 1929), 73. In the very first issue of the journal a similar arrangement of portrait photographs, a surrealist guard of honor to which in this case Freud has been conscripted, surround the picture of the anarchist assassin Germaine Berton.

13. Jacques Lacan, *Le séminaire, livre I: Les écrits techniques de Freud*, Paris, Seuil, 1975, 90.

14. Roland Barthes, "Diderot, Brecht, Eisenstein," in *Image-Music-Text*, New York, Hill & Wang, 1977, 69.

15. Michel Foucault, *Surveiller et punir: Naissance de la prison*, Paris, Gallimard, 1975. (English trans. *Discipline and Punish: The Birth of the Prison*, London, Penguin, 1977.)

16. Victor Burgin, "Geometry and Abjection," *AA Files—Annals of the Architectural Association School of Architecture*, no. 15, (Summer 1987), 35 (chap. 1 of the present volume).

17. Ibid., 38.

18. Otto Fenichel, "The Scoptophilic Instinct and Identification," in Hanna Fenichel and David Rapaport (eds.), *The Collected Papers of Otto Fenichel*, first series, Norton, 1953, 375.

19. Ibid., 377.

20. Freud, "Instincts and their Vicissitudes" (1915), in *Standard Edition*, vol. 14, 122.

21. This account contradicts the hypothesis that the infant initially exists in an "objectless state" of autoerotism. As Laplanche and Pontalis write: "The self-preservative instincts have a relationship to the object from the start; consequently, in so far as sexuality functions in anaclisis with these instincts, it too must be said to have a relationship to objects; only after detaching itself does sexuality become auto-erotic." See Jean Laplanche and Jean-Bertrand Pontalis, *The Language of Psycho-Analysis*, London, Hogarth, 1973, 31.

22. René A. Spitz, *The First Year of Life*, New York, International Universities Press, 1965, 62.

23. Jean Laplanche, *La sublimation*, Paris, puf, 1980, 62. Whether described from within psychoanalysis or developmental psychology—"direct observation" can make no difference here—accounts of the psychical state of infants are unavoidably *inferential*. Here is one account of the benign origins of the fantasy of being eaten: "That the nursling 'wishes to be eaten' means merely that towards the end of the act of suckling, and with the gradual approach of sleep, the infant has certain perceptions and experiences of yielding, relaxing, and falling that leave a string of mnemonic impressions, and that later these memories and experiences serve as a nucleus for the cluster of ideas of being eaten in various forms." See B. Lewin, *The Psychoanalysis of Elation*, New York, W. W. Norton, 1950, 104; quoted in Peter Buckley (ed.), *Essential Papers on Psychosis*, New York, New York University Press, 1988, xxviii.

24. Jean Laplanche and Jean-Bertrand Pontalis, "Fantasy and the Origins of Sexuality," in Victor Burgin, James Donald, and Cora Kaplan (eds.), *Formations of Fantasy*, London and New York, Methuen, 1986, 25.

25. Ibid., 26.

26. Jean Laplanche, "The Ego and the Vital Order," in *Life and Death in Psychoanalysis*, Baltimore and London, Johns Hopkins University Press, 1976, 60.

27. Laplanche, *La sublimation*, 66. This account of the emergence of sexuality as inseparable from the emergence of fantasy works against the prevailing understanding of the fetishistic relation to an object as "frozen," motionless.

28. Ibid., 65.

29. I understand this idea much as I understand Barthes's notion of the punctum; see, "Diderot, Barthes, *Vertigo*," in Victor Burgin, *The End of Art Theory: Criticism and Postmodernity*, London, Macmillan, 1986 (also in Burgin, Donald, and Kaplan, *Formations of Fantasy*).

30. Laplanche, *La sublimation*, 102–103.

31. Freud, *Standard Edition*, vol. 7, 171.

32. Ibid., 146 n. 1.

33. Jean Laplanche, *New Foundations for Psychoanalysis*, Oxford, Blackwell, 1989, 23.

34. Freud explicitly noted that the clinical fetishists he encountered in his practice did not come to him because of their fetishism. They were content to be fetishists. Freud assumes this is to be explained by the ease with which the fetishist may obtain his object, but surely we can think of other perversions that are equally "facile" but which engender shame and the wish to be cured.

35. Laplanche, *New Foundations for Psychoanalysis* 29–30.

36. Jean Laplanche, *Noveaux fondements pour la psychanalyse*, Paris, puf, 1987, 125. (English translation: *New Foundations for Psychoanalysis* 126 [my translation differs].)

37. Catherine Johns, *Sex or Symbol*, London, British Museum, 1982, 72.

NOTES TO CHAPTER 3

1. Helmut Newton, *Portraits*, New York, Pantheon, 1987, 19.

2. Ibid., 14.

3. Jean-Paul Sartre, *Being and Nothingness*, New York, Washington Square Press, 1966, 369.

4. Newton, *Portraits*, 14.

5. Sigmund Freud, *Three Essays on the Theory of Sexuality* (1915), in *The Standard Edition of the Complete Psychological Works of Sigmund Freud*, vol. 7, London, Hogarth, 1955–1974, 167.

6. Newton, *Portraits*, 15.

7. Otto Fenichel, "The Scoptophilic Instinct and Identification," in Hanna Fenichel and David Rapaport (eds.), *The Collected Papers of Otto Fenichel*, first series, New York, Norton, 1953, 377.

8. Sigmund Freud, "Splitting of the Ego in the Process of Defence" (1940 [1938]), in *Standard Edition*, vol. 23, 276.

9. Newton, *Portraits*, 15.

10. Ibid.

11. Roland Barthes, *Camera Lucida*, New York, Hill & Wang, 1981, 92.
12. Newton, *Portraits*, 11.
13. Søren Kierkegaard, *Diary of a Seducer*, New York, Frederick Ungar Publishing Co., 1983, 167.
14. Newton, *Portraits*, 15.

NOTES TO CHAPTER 4

1. Octave Mannoni, "La part du jeu," *L'ARC* 69 (special issue on D. W. Winnicott—date of review unknown), 39.
2. Sigmund Freud, "The 'Uncanny,'" In *The Standard Edition of the Complete Psychological Works of Sigmund Freud*, London, Hogarth, 1955–1974, vol. 17, 237.
3. Michel de Certeau, *The Practice of Everyday Life*, Berkeley and Los Angeles, University of California Press, 1988, 94. The term *propre*, to which the translator alerts us here, means not only "own" but "clean," and "that which is proper." The term *pollution* that closely follows confirms that Certeau may be alluding to Julia Kristeva's *Pouvoirs de l'horreur: Essai sur l'abjection* (trans. *Powers of Horror, An Essay on Abjection*, New York, Columbia University Press, 1982) and/or to the book that so substantially contributes to Kristeva's argument, Mary Douglas's *Purity and Danger*. See chap. 1 in the present volume.
4. Ibid., 103.
5. Ibid., 105.
6. Ibid., 110.
7. Freud, "The 'Uncanny,'" 236.
8. Jacques Lacan, "Aggressivity in Psychoanalysis," in *Ecrits: A Selection*, New York, Norton, 1977, 20–21.
9. Melanie Klein, "Notes on Some Schizoid Mechanisms," in Juliet Mitchell (ed.), *The Selected Melanie Klein*, New York, Free Press, 1986, 51.
10. See Jean Laplanche and Jean-Bertrand Pontalis, "Fantasy and the Origins of Sexuality," in Victor Burgin, James Donald, and Cora Kaplan (eds.), *Formations of Fantasy*, London, Methuen, 1986.
11. Sándor Ferenczi, "Stages in the Development of the Sense of Reality" (1913), in *First Contributions to Psycho-Analysis*, New York, Brunner/Mazel, 1980, 227–228.
12. Freud, "Analysis of a Phobia in a Five-Year-Old Boy" (1909), in *Standard Edition*, vol. 10, 9.

13. Paul Schilder, "Psycho-Analysis of Space," *International Journal of Psycho-Analysis* 16, (1935), 278.

14. Sigmund Freud, *Totem and Taboo*, in *Standard Edition*, vol. 13, 85–86; the man to whom Freud refers is the "Rat Man" (see *Standard Edition*, vol. 10, 233 ff.).

15. André Breton, *Nadja*, New York, Grove Press, 1960, 91.

16. Klein, "Notes on Some Schizoid Mechanisms," 179.

17. Edith Jacobson, *The Self and the Object World*, New York, International Universities Press, 1964, 47.

18. Jean Laplanche and Jean-Bertrand Pontalis, *The Language of Psycho-Analysis*, Hogarth, 1973, 370.

19. See Harold F. Searles, "The Sources of the Anxiety in Paranoid Schizophrenia" (1961), in *Collected Papers on Schizophrenia and Related Subjects*, London, Hogarth Press, 1965.

20. Mannoni, "La part du jeu," 39.

21. Breton, *Nadja*, 136.

22. See Georges Didi-Huberman, *Invention de l'hystérie: Charcot et l'iconographie photographique de la Salpetriere*, Paris, Macula, 1982.

23. *La révolution surréaliste*, no. 11, (15 March 1928), 22.

24. Laplanche and Pontalis point out that Freud, at an early stage in his work, did entertain the idea of an hysterical *psychosis*. See Laplanche and Pontalis, *The Language of Psycho-Analysis*, 195.

25. Jacques Lacan, "Le problem du style et la conception psychiatrique des formes paranoïques de l'expérience," *Minotaure*, no. 1, (1 June 1993), 69.

26. *Le surréalisme au service de la révolution*, no. 5, (1933), 28.

27. Ibid., 28.

28. Breton, *Nadja*, 63–64.

29. Ibid., 113.

30. Ibid., 101.

31. Schilder, "Psycho-Analysis of Space," 282. Harold Searles speaks of "the draining off into the outer world, through projection, of much affect and ideation which belong to [the schizophrenic's] self." See Searles, "The Sources of the Anxiety," 467.

32. Breton, *Nadja*, 85.

33. Ibid., 89.

34. Lacan, "Le Problem du Style," 69.

35. Louis Aragon, *Le paysan de Paris*, Paris, Gallimard, 1978; quoted in Peter Collier, "Surrealist City Narrative: Breton and Aragon," in Edward Timms

and David Kelley, *Unreal City*, Manchester, Manchester University Press, 1985, 221.

36. Freud, "The 'Uncanny,'" 249.

37. Freud, "Fausse Reconnaissance (Déja Raconté) in Psycho-Analytic Treatment," *Standard Edition*, vol. 13, 204.

38. Jean Laplanche, *Noveaux fondements pour la psychanalyse*, Paris, puf, 1987, 125 (English trans. *New Foundations for Psychoanalysis*, Oxford and Cambridge (Massachusetts), Blackwell, 1989, 126 [my translation differs].)

39. Breton, *Nadja*, 50.

40. Ibid., 39.

41. Ibid., 143.

42. Laclau and Mouffe have imported Lacan's notion of *points de capiton*, "buttoning down" the otherwise endless sliding of meaning in discourse, into a discussion of the social order. They remark that "a discourse incapable of generating any fixity of meaning is the discourse of the psychotic"; by implication, a society that would be totally "free" would be a psychotic society. See Ernesto Laclau and Chantal Mouffe, *Hegemony and Socialist Strategy*, Verso, 1985, 113. Lacan similarly admits the necessity of the Law as "anchorage" in his article on the Papin sisters, where he remarks, "The adage 'to understand is to forgive' is subordinate to the limits of each human community . . . beyond these limits, to understand (or to believe that one understands) is to condemn." See Jacques Lacan, "Motifs du crime paranoïaque (le crime des soeurs Papin)," *Minotaure*, no. 3, (15 Décembre 1933), 27.

43. Breton, *Nadja*, 152, n.

44. Lacan, "Motifs du crime paranoïaque" 27.

45. Laplanche, *Noveaux fondements pour la psychanalyse*, 126 (English trans., 127).

46. Breton, *Nadja*, 154.

NOTE TO CHAPTER 5

1. Walter Benjamin, *Charles Baudelaire: A Lyric Poet in the Era of High Capitalism*, London, NLB, 1973, 54.

NOTES TO CHAPTER 6

1. Edward Said, "Reflections on Exile," *Granta*, 161.

2. Ibid., 162.

3. Ibid., 162.

4. Indeed, in what Freud termed the "compulsion to repeat" the subject repeats what it does not remember precisely in order to avoid bringing it to consciousness.

5. Julia Kristeva, *Etrangers à nous-mêmes*, Paris, Fayard, 1988, 25.

6. See Paul Virilio, *L'espace critique*, Paris, Christian Bourgeois, 1984.

7. The word *psychosis* was introduced into medical psychology by Feuchtersleben in 1845. See Ida Macalpine and Richard Hunter, introduction (1955) to Daniel Paul Schreber, *Memoirs of My Nervous Illness*, Cambridge and London, Harvard University Press, 1988, 24–25.

8. Peter Buckley (ed.), *Essential Papers on Psychosis*, New York and London, New York University Press, 1988. The everyday use of the word *schizophrenia* has little to do with psychiatric definitions of the term. The common idea of schizophrenia as involving a "split personality"—usually, dual—has more to do with what are known to psychiatry as "multiple personality disorders." Symptoms likely to evince the diagnosis of a schizophrenic psychosis include apparently incoherent and delusional thinking, and hallucinations.

9. William G. Niederland reports that "the expression 'soul murder' is used by Strindberg, whose essay 'Själamord' (Soul Murder), originally published in France in 1887, also appeared later in the Swedish and German literature." It is possible that Schreber was familiar with Strindberg's essay. See William G. Niederland, *The Schreber Case*, New York, New York Times Books, 1974, 28 n. 2.

10. In his essay on Schreber of 1911, Freud writes: "We are . . . driven by experience to attribute to homosexual wishful phantasies an intimate . . . relation to this particular form of disease. Distrusting my own experience on the subject, I have during the last few years joined with my friends C. G. Jung of Zurich and Sándor Ferenczi of Budapest in investigating upon this single point a number of cases of paranoid disorder which have come under observation. The patients whose histories provided material for this enquiry included both men and women, and varied in race, occupation, and social standing. Yet we were astonished to find that in all of these cases a defence against a homosexual wish was clearly recognizable at the very centre of the conflict which underlay the disease."

11. Sigmund Freud, "Psycho-Analytic Notes on an Autobiographical Account of a Case of Paranoia (Dementia Paranoides)" (1911), in *The Standard Edition of the Complete Psychological Works of Sigmund Freud*, vol. 12, London, Hogarth, 1955–1974, 63.

12. Ibid., 63.

13. Ibid., 64.

14. Ibid., 65.

15. See Jean Laplanche and Jean-Bertrand Pontalis, "Fantasy and the Origins of Sexuality," in Victor Burgin, James Donald, and Cora Kaplan (eds.), *Formations of Fantasy*, London, Methuen, 1986.

16. René A. Spitz, *The First Year of Life*, New York, International Universities Press, 1965, 62.

17. Jean Laplanche, *La sublimation*, Paris, puf, 1980, 62.

18. Juliet Mitchell, *The Selected Melanie Klein*, New York, Free Press, 1987, 116–117.

19. Ibid., 116.

20. Catherine Clément, *The Lives and Legends of Jacques Lacan*, New York, Columbia University Press, 1983, 76.

21. Ibid., 90.

22. Jacques Lacan, "Aggressivity in Psychoanalysis," in *Ecrits: A Selection*, New York, Norton, 1977, 18.

23. Ibid., 22.

24. Quoted in Elisabeth Roudinesco, *Histoire de la psychanalyse en France*, vol. 2, Paris, Seuil, 1986, 128–129.

25. Jacques Lacan, "Motifs du crime paranoïaque (le crime des soeurs Papin)," *Minotaure*, no. 3, (15 December 1933). (Lacan's first presentation of the idea of the mirror stage was in 1936).

26. *Le surréalisme au service de la révolution*, no. 5, (1933), 28.

27. Clément, *The Lives and Legends of Jacques Lacan*, 74.

28. Freud, "Psycho-Analytic Notes," 71.

29. In their 1955 introduction to the English translation of Schreber's *Memoirs of My Nervous Illness*, 24–25, Macalpine and Hunter write, "We showed that projection of unconscious homosexuality, though playing a part in the symptomotology, could not account for the illness . . . aetiologically. [Schreber] . . . showed what we have come to regard as the two pathognomonic features of schizophrenia: doubt and uncertainty in sex identity. . . . If such confusion about sex identity is termed homosexuality then of course schizophrenic 'homosexuality' is of a different order [from that] implied in Freud's use of the term. This last presupposes certainty in one's sex identity which Schreber had so obviously lost from the beginning of his illness."

30. Jacques Lacan, "On a Question Preliminary to Any Possible Treatment of Psychosis," in *Ecrits*, 190.

31. Elizabeth Grosz, "Space, Time, and Bodies," *On the Beach*, 13 April 1988 (Sydney).

32. Lacan, "Aggressivity in Psychoanalysis," 11.

33. Edith Jacobson, *The Self and the Object World*, New York, International Universities Press, 1964, 47.

34. Schreber, *Memoirs of My Nervous Illness*, 131–134.

35. Lacan, "Motifs du crime paranoïaque," 27.

36. Roland Barthes, "Myth Today," in *Mythologies*, New York, Hill & Wang, 138.

37. Hélène Cixous, "Sorties," in Hélène Cixous and Catherine Clément, *The Newly Born Woman*, Minneapolis, University of Minnesota, 1986, 70. I offer the following as a depressingly typical example of the ordinary racism inscribed in everyday connotations of the black/white opposition: "Black usually indicates death, misfortune or evil, or simply opposition to white's yielding and acceptance and purity." See James Stockton, *Designer's Guide to Color*, San Francisco, Chronicle Books, 1984, 34.

38. See Phyllis Rose, *Black Cleopatra: Josephine Baker in Her Time*, New York, Doubleday, 1989, 67.

39. Jacques Lacan, *The Four Fundamental Concepts of Psycho-Analysis*, London, Hogarth, 1977, 95–96.

40. *The New York Times Magazine*, 10 September 1989.

41. *The New York Times*, 25 August 1989.

42. Ibid., 19 December 1989.

43. See Spike Lee, "Do the Right Thing" (script), in Spike Lee with Lisa Jones, *Do the Right Thing*, New York, Simon & Schuster, 1989, 184–185.

44. Jean Laplanche and Jean Bertrand Pontalis, *The Language of Psycho-Analysis*, London, Hogarth, 1973, 144.

45. We may recall that Schreber similarly "split" his object: turning his doctor both into a God, in order that he might adopt a feminine attitude toward him without conflict, and also into a hated "soul murderer," so that he might be protected from acknowledging the homosexual nature of his own feelings.

46. I have appropriated (or misappropriated) the idea of "reinscription" in the space of the "caesura" from Homi Bhabha. See "Postcolonial authority and postmodern guilt," unpublished paper, 1990.

NOTES TO CHAPTER 7

1. Susan Buck-Morss, *The Dialectics of Seeing: Walter Benjamin and the Arcades Project*, Cambridge and London, MIT Press, 1989, 8.

2. Ibid., 11.
3. Benjamin submitted his completed dissertation in 1925 and was "advised to withdraw his petition . . . rather than suffer the embarrassment of rejection." See Buck-Morss, *The Dialectics of Seeing*, 22.
4. In Walter Benjamin, *Reflections*, New York and London, Harcourt, 1978.
5. It lists seven items of advice—advice that I suspect is still, to this present day, widely offered to graduate students. For example, the first item advises that: "The whole composition must be permeated with a protracted and wordy exposition of the initial plan"; the final item urges: "A number of opponents all sharing the same argument should each be refuted individually." See "One Way Street," in Benjamin, *Reflections*, 79.
6. Asja Lacis, *Revolutionär im Beruf: Berichte über proletarisches Theater, über Meyerhold, Brecht, Benjamin und Piscator*, Munich, Regner & Bernhard, 1971, 43–44; quoted in Buck-Morss, *The Dialectics of Seeing*, 15.
7. Walter Benjamin and Asja Lacis, "Naples," in Benjamin, *Reflections*, 165–166.
8. Ibid., 167.
9. Ibid., 171. So, for example: "If the father of a family dies or the mother wastes away, close or distant relatives are not needed. A neighbour takes a child at her table for a shorter or longer period, and thus families interpenetrate in relationships that can resemble adoption" (172).
10. We may moreover recall that the circle and the square are the diagrams of, respectively, the *orbis terrarum* and the *castrum*—the subject territories of the Roman empire and the Roman military camp.
11. Françoise Choay, "La ville et le domaine bâti comme corps dans les textes des architectes-théoriciens de la première renaissance Italienne," *Nouvelle revue de psychanalyse*, no. 9, (Spring 1974).
12. Ibid., 248.
13. Ibid., 244.
14. Indeed, the Renaissance idea of the corporeal city included not only the external appearance of a body seen in Vitruvian terms of harmony of proportions, but also the idea of the body as an ensemble of mutually dependent organs; albeit, Choay remarks, no part of the city is seen as equivalent to the genitals.
15. Henri Lefebvre, *The Production of Space*, Oxford and Cambridge (Massachusetts), Basil Blackwell, 1991, 271.
16. *De Re Aedificatoria*, written about 1450 and published, after his death, in 1483.
17. Lefebvre, *The Production of Space*, 201.

18. Luce Irigaray, *Ethique de la différence sexuelle*, quoted in Margaret Whitford, *Luce Irigaray: Philosophy in the Feminine*, London and New York, Routledge, 1991, 53.

19. Lefebvre, *The Production of Space*, 25–26.

20. Ibid., 25–26.

21. Walter Benjamin, *Charles Baudelaire: A Lyric Poet in the Era of High Capitalism*, New York and London, New Left Books, 1978, 37. (This "essay" is actually part of Benjamin's larger, unfinished Paris arcades project. At the time of its completion, in 1938, Benjamin intended that it should form part of a longer book about Baudelaire which he planned to extract from his *Passagen-Werk*.)

22. It might be objected that Benjamin would not write about Haussmann until the *Passagen-Werk*, but Benjamin himself reminds us that for historians, as for psychoanalysts, what comes before may be determined by what comes after.

23. Richard Sennett, *The Conscience of the Eye: The Design and Social Life of Cities*, New York, Knopf, 1990, 104.

24. Benjamin saw the Paris arcades as "the mold from which the image of 'the modern' is cast."

25. Walter Benjamin, *Gesammelte Schriften*, vol. 5, Frankfurt am Main, Suhrkamp Verlag, 1972, 292; quoted in Buck-Morss, *The Dialectics of Seeing*, 303.

26. "How are we to imagine an existence oriented solely toward Boulevard Bonne-Nouvelle, in rooms by Le Corbusier and Oud?" See Benjamin, "Surrealism: The Last Snapshot of the European Intelligentsia," in Benjamin, *Reflections*, 189.

27. Kenneth Frampton, *Modern Architecture: A Critical History*, London, Thames and Hudson, 1987, 155.

28. Lefebvre, *The Production of Space*, 175–176.

29. Benjamin, *Reflections*, 154.

30. Beatriz Colomina, "Intimacy and Spectacle: The Interiors of Adolf Loos," *AA Files*, no. 20, (1990).

31. My thanks to Peter Wollen for suggesting this metaphor.

32. Lefebvre, *The Production of Space*, 93.

33. Jean-François Lyotard, *Économie Libidinale*, Paris, Éditions de Minuit, 1974, 10–11.

34. In the perspectival "prospect," which in the Renaissance became the dominant form of organization of urban space.

35. Lefebvre, *The Production of Space*, 99.

36. Ibid., 184.

37. Paul Schilder, "Psycho-Analysis of Space," *International Journal of Psycho-analysis*, 16 (1935).

38. Ibid., 295.

39. Sigmund Freud, *The Standard Edition of the Complete Psychological Works of Sigmund Freud*, vol. 23, London, Hogarth, 1955–1974, 300.

40. Paul Schilder, *The Image and Appearance of the Human Body*, New York, International Universities Press, 1950.

41. Schilder, "Psycho-Analysis of Space," 295.

42. Schilder, *The Image and Appearance of the Human Body*, 172.

43. Frances Tustin, *Autism and Childhood Psychosis*, London, Science House, 1972, 106.

44. Octave Mannoni, "La part du jeu," *L'ARC* 69 (special issue on D. W. Winnicott—date of review unknown).

45. Paul Thévenin and Jacques Derrida, *Antonin Artaud—Dessins et portraits*, Paris, Gallimard, 1986. My thanks to Lindsay Waters for having brought this essay to my attention.

46. Ibid., 79.

47. Ibid., 63.

48. Ibid., 70.

49. Freud, "Inhibitions, Symptoms, and Anxiety" (1926), in *Standard Edition*, vol. 20, 137. (Since first giving my paper—at the conference, "The Visual Arts in a Technological Age: A Centennial Rereading of Walter Benjamin," Wayne State University, 4 April 1992—I have come across an essay by Patricia Mellencamp in which she makes precisely the same point: see her "TV Time and Catastrophe, or *Beyond the Pleasure Principle* of Television," in Patricia Mellencamp, *Logics of Television*, Bloomington and Indianapolis, University of Indiana Press, 1990.)

50. See Didier Anzieu, *The Skin Ego*, New Haven, Yale University Press, 1989.

51. Klaus Theweleit, *Male Fantasies*, Minneapolis, University of Minnesota Press, 1987 (vol. 1), 1989 (vol. 2).

52. Paul Virilio, *Lost Dimension*, New York, Semiotext(e), 1991, 79.

53. Octave Mannoni, "Je sais bien, mais quand même," in *Clefs pour l'imaginaire ou l'autre scène*, Paris, Seuil, 1969.

54. Victor Burgin, "Photography, Phantasy, Function," in Victor Burgin (ed.), *Thinking Photography*, London, Macmillan, 1982, 190–191.

55. Laura Mulvey, "Visual Pleasure and Narrative Cinema," (1975), in *Visual and Other Pleasures*, London, Macmillan, 1989.

56. I am thinking of the type in which a Sternberg frames a Dietrich.
57. Virilio, *Lost Dimension*, 69–70.
58. Benjamin, *Charles Baudelaire*, 132.
59. Walter Benjamin, "The Work of Art in the Age of Mechanical Reproduction," *Illuminations*, London, Fontana, 1973, 238.
60. Virilio, *Lost Dimension*, 71.

NOTES TO CHAPTER 8

1. Hollis Frampton, "For a Metahistory of Film: Commonplace Notes and Hypotheses" (1971), in *Circles of Confusion: Film, Photography, Video; Texts 1968–1980*, Rochester, New York, Visual Studies Workshop, 1983, 116.
2. John Donne, "Loves Diet," in *The Complete Poetry of John Donne*, New York, Doubleday, 1967, 135.
3. Jean-Luc Godard, *La paresse*, episode of *Sept péchés capitaux* (1961), Eddie Constantine (Eddie Constantine), Nicole Mirel (the Starlet). (Other episodes by Claude Chabrol, Edouard Molinaro, Jacques Demy, Roger Vadim, Philippe de Broca, and Sylvain Dhomme.)
4. Alain Bergala, note on "La paresse" in *Cahiers du cinéma, spécial Godard: Trente ans depuis*, Paris, 1990, 114.
5. Christian Metz, "Le film de fiction et son spectateur," *Communications*, no. 23, (1975), 119.
6. Roland Barthes, "En sortant du cinéma," *Communications*, no. 23, (1975), 104–107.
7. Ibid., 104.
8. Roland Barthes, "Diderot, Brecht, Eisenstein," in *Image-Music-Text* (1973), New York, Hill & Wang, 1977.
9. Ibid., 76–77.
10. Ibid., 71–72.
11. Barthes, "En sortant du cinéma," 106.
12. Barthes, "En sortant du cinéma," 104. (Breuer and Freud refer to "the semi-hypnotic twilight state of day-dreaming, auto-hypnoses, and so on"— See Sigmund Freud, *The Standard Edition of the Complete Psychological Works of Sigmund Freud*, London, Hogarth, 1955–1974, vol. 2, 11.)
13. Barthes, "En sortant du cinéma," 105–106.
14. Barthes plays on various senses of the verb *décoller*, which can mean not only to "unstick" but also to "take off" (in the aeronautical sense) and to "get high" (in the drug use sense).

15. Barthes, "En sortant du cinéma," 106–107.

16. Ibid., 106.

17. Giuliana Bruno, *Streetwalking on a Ruined Map: Cultural Theory and the City Films of Elvira Notari*, Princeton, New Jersey, Princeton University Press, 1993, chap. 3.

18. Barthes, "En sortant du cinéma," 105.

19. Roland Barthes, "Au palace ce soir," in *Incidents*, Paris, Seuil, 1987, 65.

20. Ibid., 68.

21. Roland Barthes, *Le plaisir du texte*, Paris, Seuil, 1973, 19.

22. Charles Baudelaire, "The Painter of Modern Life," in *The Painter of Modern Life and Other Essays*, New York, Garland, 1978, 10.

23. Roland Barthes, *Roland Barthes par Roland Barthes*, Paris, Seuil, 1975, 98.

24. Barthes, *Incidents*, 86.

25. In French, a *lieu commun* is a platitude (cf. English: "commonplace"); at the same time, taken word for word, it may mean "common place," in the sense of "public space."

26. Barthes, *Incidents*, 104.

27. See Victor Burgin, "Diderot, Barthes, *Vertigo*," in *The End of Art Theory: Criticism and Postmodernity*, London, Macmillan, 1986.

28. Roland Barthes, *La chambre claire*, Paris, Gallimard/Seuil, 1980, 177.

29. Ibid., 181.

30. Ibid., 181.

31. Ibid., 177.

32. Barthes, *Roland Barthes par Roland Barthes*, 90.

33. Barthes, *La chambre claire*, 13.

34. Barthes, "En sortant du cinéma," 106.

35. Roger Caillois, *Méduse et Cⁱᵉ*, Paris, Gallimard, 1960, 71 ff.

36. Jacques Lacan, *Le séminaire, livre XI: Les quatres concepts fondamentaux de la psychanalyse* (1964), Paris, Seuil, 1973, 98.

37. Ibid., 99.

38. Ibid., 99.

39. Christian Vincent, *La discrète* (1990), with Fabrice Luchini and Judith Henry.

40. Lacan, *Le séminaire*, 104.

41. Siegfried Wenzel, *The Sin of Sloth: Acedia in Medieval Thought and Literature*, Chapel Hill, University of North Carolina Press, 1960.

42. Ibid., 13–14.

43. Ibid., 35.

44. Barthes, *Incidents*, 87.

45. Ibid., 87.
46. Metz, "Le film de fiction et son spectateur," 112.
47. Barthes, "En sortant du cinéma," 107.
48. Barthes, *Le plaisir du texte*, 30.
49. Freud, *Standard Edition*, vol. 6, 140, 142, 150.
50. Lacan, *Le séminaire*, 53.
51. Ibid., 55.

NOTES TO CHAPTER 9

1. Sigmund Freud, *Introductory Lectures on Psycho-Analysis*, lecture II, "The Dream-Work," in Sigmund Freud, *The Standard Edition of the Complete Psychological Works of Sigmund Freud*, vol. 15, London, Hogarth, 1955–1974, 181–182.
2. (*The landscape, child of modern terror.*) See Louis Aragon, "Tapisserie de la grande peur," in Georges Sadoul (ed.), *Aragon*, Paris, Seghers, 1967, 113.
3. The 36th San Francisco International Film Festival, 1993. The ceremony took place on 1 May 1993.
4. When US president Bill Clinton came to office, Zoe Baird was his first choice for attorney general. She withdrew her candidacy for the position following the revelation that she and her husband had employed an illegal immigrant couple to provide child care and chauffeur services and had failed to pay social security taxes on their behalf.
5. "Welcome to Africa!," Sembène replied, adding: "My great-grandfather may have sold your great-grandfather."
6. Kadiatu Kanneh, "Place, Time, and the Black Body: Myth and Resistance," *The Oxford Literary Review*, 13, nos. 1–2, (1991), 140.
7. W. E. B. Du Bois, *The Souls of Black Folk*, New York, Vintage, 1990. I owe my particular understanding of this concept to Paul Gilroy. See Paul Gilroy, *The Black Atlantic*, Cambridge, Harvard University Press, 1993, especially chap. 4.
8. Homi Bhabha, "'Race,' Time, and the Revision of Modernity," *The Oxford Literary Review* 13, nos. 1–2, (1991), 193–194.
9. Michel Foucault, "Nietzsche, Genealogy, History," in *Language, Counter-Memory, Practice*, Oxford, Blackwell, 1977, 142.
10. John Armost and Peter Wright, *Manzanar*, New York and Canada, Times Books, 1988, xi.
11. Lizbeth Malkmus and Roy Armes, *Arab and African Film Making*, London and Atlantic Highlands, New Jersey, Zed Books, 1991, 186–188.

12. Ibid., 189–190.

13. Ibid., 190.

14. Ibid., 191. See also Alain Robbe-Grillet, *Snapshots and Towards a New Novel*, London, Calder and Boyars, 1985, 151.

15. Ibid., 196.

16. Ibid., 192.

17. Paul Virilio, "Improbable Architecture," in *The Lost Dimension*, New York, Semiotext(e), 1991, 83.

18. D. W. Winnicott, "The Location of Cultural Experience," in *Playing and Reality*, Harmondsworth, Penguin, 1982, 118.

19. Jacques Lacan, "Aggressivity in Psychoanalysis," in *Écrits: A Selection*, New York, W. W. Norton, 1977, 25.

20. "Darwin's success seems to derive from the fact that he projected the predations of Victorian society and the economic euphoria that sanctioned for that society the social devastation that it initiated on a planetary scale, and to the fact that it justified its predations by the image of a laissez-faire of the strongest predators for their natural prey." See Lacan, "Aggressivity in Psychoanalysis," 26.

21. William Severini Kowinski, *The Malling of America: An Inside Look at the Great Consumer Paradise*, New York, William Morrow, 1985, 51; quoted by Margaret Morse, "An Ontology of Everyday Distraction: The Freeway, the Mall, and Television," in Patricia Mellencamp (ed.), *Logics of Television*, Bloomington and Indianapolis, Indiana University Press, 1990, 221.

22. Mary Ann Doane, "Information, Crisis, Catastrophe," in Mellencamp, *Logics of Television*, 236.

23. *Another Girl, Another Planet* (Michael Almereyda, 1992).

24. Walter Benjamin, "Theses on the Philosophy of History," in *Illuminations*, London, Fontana, 1970, 259–260.

25. Brian Hall, "A Holy War in Waiting," *The New York Times Magazine*, 9 May 1993, 52.

26. Stephen Kinzer, "Two Major Mosques Blown Up By Serbs," *The New York Times*, 8 May 1993, 1.

27. Chuck Sudetic, "Mostar's Old Bridge Is Finally Battered to Death," *The New York Times*, 10 November 1993, A7. (Footage of the bridge in peace time, and of its bombardment and collapse, are contained in Dustan Makavejev's film *A Hole in the Soul* [1994]. Answering questions following the screening of this film, at the 1995 San Francisco Film Festival, Makavejev said that the military rationale for the bombardment was that the bridge supported pipes

that carried drinking water to the Muslim side of the river. He said that the commander in charge of the artillery battery that destroyed the bridge was a filmmaker who had made two feature films.)

28. Robert Young, "Neocolonial Times," *The Oxford Literary Review* 13, nos. 1–2, (1991), 1–3.

29. Ibid., 1–3.

30. See Frances A. Yates, *The Art of Memory*, London, Routledge & Kegan Paul, 1966.

31. John Kifner, "Through the Serbian Mind's Eye," *The New York Times*, 10 April 1994, sec. 4, 1.

32. John Darnton, "We Suffer, Too, Serbs in Bosnia Cry," *The New York Times*, 22 April 1993, A8.

33. Karl Marx, *The 18th Brumaire of Louis Bonaparte*, in Robert C. Tucker (ed.), *The Marx-Engels Reader*, New York, W. W. Norton, 1972, 437.

34. John Kifner, "A Longing By Muslims in Sarajevo," *The New York Times*, 15 December 1993, A10.

35. Jean Baudrillard, *La Guerre du Golfe n'a pas eu lieu*, Paris, Galilée, 1991, 12.

36. St. Augustine, *The Trinity*, book 14, chap. 4, Washington, The Catholic University of America Press, 1963, 414 (2 Cor. 5, 6–7.) The passage from Corinthians echoes an idea from classical antiquity. In the *Phaedo*, Plato has Socrates propound the doctrine of two worlds: the earthly one in which our mortal bodies move, and a perfect "upper world" of light, where all truth is revealed to sight.

37. Julia Kristeva, "Ellipse sur la frayeur et la séduction spéculaire," *Communications*, no. 23, (1975), 73. (English trans., "Ellipsis on Dread and the Specular Seduction," in *Wide Angle* 3, no. 3, [1979].) The citation is from St. Augustine, *The Trinity*, 418.

38. Kristeva, "Ellipse sur la frayeur et la séduction spéculaire," 77–78.

39. I repeat this example from my essay of 1984, "Diderot, Barthes, *Vertigo*," reprinted in Victor Burgin, *The End of Art Theory: Criticism and Postmodernity*, London, Macmillan, 1986, 136–137.

40. Jean-François Lyotard, *La condition postmoderne*, Paris, Les Editions de Minuit, 1979. (English trans. *The Postmodern Condition: A Report on Knowledge*, Minneapolis, University of Minnesota Press, 1984.)

41. Jacques Lacan, "Aggressivity in Psychoanalysis," In Lacan, *Écrits*, 27.

42. Kanneh, "Place, Time, and the Black Body," 140.

43. A term derived from the work of Gramsci (see Antonio Gramsci, "On the Margins of History: History of the Subaltern Social Groups," in *Selections*

from Prison Notebooks, London, Lawrence & Wishart, 1971) and used today of a variety of oppressed minorities who are not necessarily united in any equivalent of a "class consciousness."

44. Ranajit Guha, "On Some Aspects of the Historiography of Colonial India," in Ranajit Guha (ed.), *Subaltern Studies*, vol. 1, Delhi, Oxford University Press, 1982, 3; quoted in Robert Young, *White Mythologies: Writing History and the West*, London and New York, Routledge, 1990, 160.

45. Roland Barthes, "En sortant du cinéma," *Communications*, no. 23, (1975), 106.

46. Frederic Jameson, "Postmodernism, or The Cultural Logic of Late Capitalism," *New Left Review* 146, (July–August 1984), 66.

47. Ibid., 72.

48. Ibid., 66–72.

49. Ibid., 72.

50. Ibid., 71.

51. Michel Foucault, "Of Other Spaces," *Diacritics* 16, no. 1, (Spring 1986), 22. Foucault first gave the paper as a lecture in 1967, but it was not published until 1984.

52. For example, Young's *White Mythologies* may be read as an extended argument that poststructuralist and deconstructionist theory is the most appropriate methodology for (re)writing history in the postcolonial world.

53. For example, in the same year that Young's *White Mythologies* was published, Teresa Brennan begins her essay "History After Lacan" with the observation: "Over the past twenty years it has become exceedingly difficult to think about how broad history intersects with the psyche, because a post-structuralist or postmodern sensibility berates generality. We can think about little alterations in time and space, micro-historical shifts, but the generality necessary for tracing a guide to action on a larger scale is inhibited." Brennan here voices much the same anxiety that Jameson expresses when, in his "postmodernism" essay of 1984, he writes: "The breakdown of temporality suddenly releases this present of time from all the activities and the intentionalities that might focus it and make it a space of praxis." Brennan's response is to read Lacan, against the grain of poststructuralism, for the "little known historical dimension to his theory of the imaginary" through which a historical content may be reinstated to a body of work often indicted as "ahistorical." Specifically, Brennan locates the motor of Western history in the "psychical phantasy of woman specific to the West."

54. To say "the contemporary field of images" is not to say "the field of

contemporary images." Giotto's frescoes are no less part of the contemporary field than is an MTV video, for all that they are *differently* part of it.

55. The films Jameson discusses include *The Parallax View* (Alan Pakula, 1974), *All the President's Men* (Alan Pakula, 1976), and *Videodrome* (David Cronenberg, 1983).

56. Frederic Jameson, *The Geopolitical Aesthetic: Cinema and Space in the World System*, Bloomington and Indianapolis, Indiana University Press and London, British Film Institute, 1992, 1–2.

57. Ibid., 5.

58. Ibid., 3.

59. Jameson takes the expression "cognitive mapping" from Kevin Lynch's book of 1960, *The Image of the City*. In its original formulation, "cognitive mapping" names the process by which city dwellers orient themselves within their urban environment. The "map" is an evolving complex of mental representations, which include not only the sort of formal knowledge that might be derived from a printed street-plan but also enactive memories of individual bodily displacements within the city. Jameson writes: "There is . . . a most interesting covergence between the empirical problems studied by Lynch in terms of city space and the great Althusserian (and Lacanian) redefinition of ideology as 'the representation of the subject's *Imaginary* relationship to his or her *Real* conditions of existence.' Surely this is exactly what the cognitive map is called upon to do: to enable a situational representation on the part of the individual subject to that vaster and properly unrepresentable totality which is the ensemble of the city's structure as a whole." See Jameson, "Postmodernism," 90.

60. Colin MacCabe, preface to Jameson, *The Geopolitical Aesthetic*, xiv.

61. Jameson, *The Geopolitical Aesthetic*, 3. This structure, it may be noted, is implicitly Hegelian. For Hegel: "Each nation or people [*Volk*] has its own mind or spirit [*Volksgeist*]. Each 'mind of a people' has a history of its own, a history of development, maturity and decline. But history as a whole forms an intelligible pattern; each mind of a people is a link in a chain of progress, the culmination of which is the 'world-mind' [*Weltgeist*]." See Antony Flew (ed.), *A Dictionary of Philosophy*, London, Pan/Macmillan, 1979, 132.

62. Jameson, *The Geopolitical Aesthetic*, 3. The implicit hierarchical effect of Jameson's distinction between the Hollywood films in part 1 and the non–US films in part 2 is to attribute a global perspective to America and a more narrowly national perspective to the rest. This harmonizes unhappily with the

tendency of the self-elected leaders of the new world order to judge that the narrow national self-interest of other nations prevents them from seeing what is best for them and for the world as a whole. Once again, the history of the United States is the history of the world.

63. Ibid., 5.

64. It is a space that resists contraction. No more than a written synopsis of a film can contain its visual grain, nor can a summary of Jameson's "arguments" comprehend the connotational texture of his condensed language. The speed at which ideas fly by can be dizzying, if not sickening. For example, in the first few pages of the book, Jameson writes: "The shift from the visual to the auditory has the (very postmodern) effect of annulling Antonioni's Heideggerian and metaphysical dimension, since it can no longer offer some bewildering Bazinian field of Being for desperate inspection." (See Jameson, *The Geopolitical Aesthetic*, 20.)

65. Ibid., 3.

66. In the passage to which Jameson alludes, Althusser writes: "What is represented in ideology is . . . not the system of the real relations which govern the existence of individuals, but the imaginary relation of those individuals to the real relations in which they live." See Louis Althusser, "Ideology and Ideological State Apparatuses (Notes Towards an Investigation)," in *Lenin and Philosophy and Other Essays*, London, New Left Books, 1971, 155.

67. These foundations are worth considering, quite apart from my particular project here, as they are also implied by much recent work in "Cultural Studies" on the products of mass culture.

68. Engels was writing to Harkness about her novel *A City Girl*, which she published in 1887 under the pseudonym "John Law."

69. Engels's position on *Tendenʒkunst* may be measured against what would eventually harden into the official Soviet aesthetics of Zhdanov, by way of Lenin: "Down with non-partisan writers! . . . Literature must become part of the common cause of the proletariat, 'a cog and a screw' of one single great Social-Democratic mechanism set in motion by the entire politically conscious vanguard of the entire working class." See V. I. Lenin, "Party Organisation and Party Literature," in *On Literature and Art;* Moscow, Progress, 1970, 23.

70. Quoted in Frederic Jameson, *The Political Unconscious: Narrative as a Socially Symbolic Act*, London, Methuen, 1981, 162.

71. Friedrich Engels, letter to Margaret Harkness (April 1888), in David Craig (ed.), *Marxists on Literature and Art*, Harmondsworth, Penguin, 1975, 271.

72. Frederic Jameson, *Fables of Aggression: Wyndham Lewis, the Modernist as Fascist*, Berkeley and Los Angeles, University of California Press, 1981, 21.

73. A similar invocation occurs in Jameson's book of the same year about the literary work of the Fascist sympathizer Wyndham Lewis. Jameson writes: "However embarrassing the content of his novels may be for liberal or modernist establishment thought, it cannot but be even more painful for protofascism itself." See Jameson, *Fables of Aggression*, 23.

74. Frederic Jameson, "Class and Allegory in Contemporary Mass Culture: *Dog Day Afternoon* as a Political Film," *Screen Education*, no. 30, (Spring 1979), 77–78.

75. Jameson, *Fables of Aggression*, 21.

76. Louis Althusser, "A Letter on Art in Reply to André Daspre" (1966), in *Lenin and Philosophy*, 204.

77. I cannot resist remarking on the consistently bad taste exhibited by most of our most influential theoreticians in matters of modern visual art.

78. Althusser, "Cremonini, Painter of the Abstract" (1966), in *Lenin and Philosophy*, 219.

79. Jameson, *Fables of Aggression*, 22.

80. Jameson is no doubt aware of this. As Robert Young has written, "What [Jameson] attempts to bring about is something which from the perspective of European Marxism is truly scandalous, namely, a rapprochement between the two antithetical traditions of Sartre and Althusser, incorporated within a larger Lukácsian totality." See Young, *White Mythologies*, 92.

81. For an only slightly less summary account of the debate around Althusser and "representation," see my introduction to Victor Burgin (ed.), *Thinking Photography*, London, Macmillan, 1982, 4–10.

82. Althusser, "Ideology and Ideological State Apparatuses," 155.

83. Jameson, *The Geopolitical Aesthetic*, 192.

84. Frederic Jameson, "Class and Allegory in Contemporary Mass Culture," 86.

85. Ibid., 87.

86. Ibid., 88.

87. Erwin Panofsky, "Style and Medium in the Motion Pictures" (1934), in D. Talbot (ed.), *Film: An Anthology*, Berkeley, University of California Press, 1966, 25. Panofsky judges that allegory in the cinema was "virtually abolished by the invention of the talking film." Clearly, he turned out to be wrong.

88. Jameson, *The Geopolitical Aesthetic*, 196.

89. Ibid., x.

90. Ibid., x–xi.

91. Melanie Klein, "Notes on Some Schizoid Mechanisms," in Juliet Mitchell (ed.), *The Selected Melanie Klein*, New York, Free Press, 1986, 51.

92. See, for example, "The Symbolism of the Bridge," and "Bridge Symbolism and the Don Juan Legend," both in Sándor Ferenczi, *Further Contributions to the Theory and Technique of Psycho-Analysis*, New York, Brunner/Mazel, 1926.

93. I owe my thanks for this information to Johanna Poethig.

94. I do not mean to say that Tahimik found the device as a result of reading psychoanalytic theory. Freud never claimed to have *invented* the mechanisms of poetry.

95. Freud explicitly rejects the term *subconscious*. He writes: "If someone talks of subconsciousness, I cannot tell whether he means the term topographi-cally—to indicate something lying in the mind beneath consciousness—or qualitatively—to indicate another consciousness, a subterranean one, as it were. He is probably not clear about any of it. The only trustworthy antithesis is between conscious and unconscious." See "The Question of Lay Analy-sis" (1916), in *Standard Edition*, vol. 20, 198.

96. Jameson, *The Geopolitical Aesthetic*, 1–2.

97. Frederic Jameson, "Imaginary and Symbolic in Lacan," in *The Ideologies of Theory: Essays 1971–1986*, vol. 1, Minneapolis, University of Minnesota Press, 1988.

98. Jameson, *The Geopolitical Aesthetic*, 30–31.

99. Shoshana Felman, *Jacques Lacan and the Adventure of Insight*, Cambridge, Harvard University Press, 1987, 21–22.

100. Homi Bhabha and Victor Burgin, "Visualizing Theory," in Lucien Taylor (ed.), *Visualizing Theory: Selected Essays from V.A.R., 1990–1994*, New York and London, Routledge, 1994, 455.

101. Friedrich Nietzsche, "On the Uses and Disadvantages of History for Life," in *Untimely Meditations*, Cambridge, Cambridge University Press, 1983, 91.

102. St. Augustine, *Confessions*, book 11, London, Heinemann, 1913, 239.

103. Modern philosophy, for the most part, has inclined to the latter pole. Bergson, for example, privileges the lived experience of time as "duration" over the abstract concept of time that, by analogy with space, is derived from it. Husserl accepts the independent existence of time but believes knowledge of time may be gained only through recovery of the "pure" phenomenological data of time—subjective perceptual experiences—from their distortions in the "natural attitude" that is shared by both common sense and science.

Russell separates the subjective "internal" time of individual memory from the objective "external" time of common history, while demarcating both from a somewhat absolute "mathematical time" of science.

104. Marie Bonaparte, "Time and the Unconscious," *International Journal of Psychoanalysis* 21, (1940), 467.

105. Henri Lefebvre, *The Production of Space*, Oxford and Cambridge (Massachusetts), Basil Blackwell, 1991, 170.

106. Arnaud Lévy, "Devant et derrière soi," *Nouvelle revue de psychanalyse*, no. 15, (Spring 1977), 93–94.

107. Ibid.

108. Ibid., 95. (Something similar is implied in Henri Bergson's observation: "Practically we perceive only the past, the pure present being the invisible progress of the past gnawing into the future." See *Matter and Memory*, New York, Zone, 1989, 194.)

109. Lévy, "Devant et derrière soi," 101.

110. Ibid., 101–102.

111. Ibid.

112. See, for example, Calvin A. Colarusso, "The Development of Time Sense— From Birth to Object Constancy," *International Journal of Psychoanalysis* 60, (1979), 243–251.

113. Jean Laplanche, "Psychoanalysis, Time, and Translation," in John Fletcher and Martin Stanton (eds.), *Jean Laplanche: Seduction, Translation, Drives*, London, Institute of Contemporary Arts, 1992. ("Temporalité et Traduction," *Psychanalyse à l'université*, no. 14, [1989].)

114. Ibid., 162.

115. Ibid., 162.

116. Ibid., 162.

117. Ibid., 164. See, however, this working note by Freud: "Space may be the projection of the extension of the psychical apparatus. No other derivation is probable. Instead of Kant's *a priori* determinants of our psychical apparatus. Psyche is extended; knows nothing about it." See *Standard Edition*, vol. 23, 300.

118. Freud, "A Note upon the Mystic Writing Pad," in *Standard Edition*, vol. 29.

119. Freud, *Totem and Taboo*, in *Standard Edition*, vol. 13; *Civilisation and its Discontents*, in *Standard Edition*, vol. 21; *Moses and Monotheism*, in *Standard Edition*, vol. 23.

120. There are, of course, other elements of temporal structuring in Freudian theory which are not immediately relevant to my interests here—not least

the vexed issue of "stages," with their associated notions of "fixation," "regression," and so on.

121. Josef Breuer and Sigmund Freud, *Studies on Hysteria*, in Freud, *Standard Edition*, vol. 2, 7.

122. Octave Mannoni, *Freud: The Theory of the Unconscious*, London, New Left Books, 1971, 88.

123. Freud, *The Interpretation of Dreams* (1900 [1898]), in *Standard Edition*, vol. 4, 20.

124. Jean Laplanche and Jean-Bertrand Pontalis, *The Language of Psycho-Analysis*, London, Hogarth, 1973, 247.

125. Ibid., 248.

126. Jacques Lacan, "The Unconscious and Repetition," *The Four Fundamental Concepts of Psychoanalysis* [1964], London, Hogarth, 1977, 25.

127. Freud, *The Psychopathology of Everyday Life* (1901), in *Standard Edition*, vol. 6, 2.

128. Ragusa is today called Dubrovnik. In 1898, Bosnia and Herzegovina were adjoining provinces of the Austro-Hungarian empire. Close geographical and historical ties between the two provinces had led to the custom of referring to them jointly. Following the First World War (in September of 1919), Austria signed a treaty with the Allies, relinquishing the territories. It was in the subsequent restructuring of Central Europe by the Allies that Bosnia and Herzegovina became incorporated into "Yugoslavia."

129. Freud, "The Psychical Mechanism of Forgetfulness" (1898), in *Standard Edition*, vol. 3, 292.

130. Ibid., 292.

131. Jacques Lacan, "Les formations de l'inconscient," *Bulletin de psychologie*, (1956–1957), quoted in Anika Lemaire, *Jacques Lacan*, London, RKP, 1977, 209.

132. Jean Laplanche, "The Kent Seminar," in John Fletcher and Martin Stanton (eds.), *Jean Laplanche: Seduction, Translation, Drives*, London, Institute of Contemporary Arts, 1992, 23.

133. Jacques Lacan, *The Seminar of Jacques Lacan: Book 1: Freud's Papers on Technique, 1953–1954*, New York, Norton, 1988, 48.

134. I have discussed this idea at some length in my essay, "Photography, Phantasy, Function," *Screen*, no. 1, (1980); reprinted in Burgin, *Thinking Photography*.

135. Freud, *The Psychopathology of Everyday Life*, 5.

136. Freud, "The Psychical Mechanism of Forgetfulness," 295.

137. Freud, *The Psychopathology of Everyday Life*, 44.

138. Ibid.

139. Ibid.

140. Freud, "Screen Memories" (1899), in *Standard Edition*, vol. 3, 303.

141. Ibid., 305.

142. Ibid., 311–312.

143. Ibid., 313.

144. Ibid., 316.

145. Freud, *The Psychopathology of Everyday Life*, 49.

146. We may note the "delicious taste" of the bread received from the woman at the cottage. Kisses, of course, are customarily described in such terms in popular songs and in poetry (e.g., "kisses sweeter than wine"). For a discussion of the violent orality within the kiss see Adam Phillips, "Plotting for Kisses," in *On Kissing, Tickling, and Being Bored: Psychoanalytic Essays on the Unexamined Life*, Cambridge, Harvard University Press, 1993.

147. See Jean Laplanche and Serge Leclaire, "The Unconscious: A Psychoanalytic Study," *Yale French Studies* 48, (1975). The unconscious is the result of "the capture of drive energy in the web of the signifier" (169).

148. Freud, "Screen Memories," 322.

149. Freud, *The Psychopathology of Everyday Life*, 49 n. 2.

150. Lacan, *The Seminar of Jacques Lacan*, 49.

151. Freud, "Family Romances" (1909 [1908]), in *Standard Edition*, vol. 9, 240.

152. Freud, *The Psychopathology of Everyday Life*, 48.

153. Homi Bhabha, "Introduction: Narrating the Nation," in Homi Bhabha (ed.), *Nation and Narration*, London and New York, Routledge, 1990, 1.

154. John Kifner, "Through the Serbian Mind's Eye," *The New York Times*, 10 April 1994, sec. 4, 1.

155. Michel Foucault, "Nietzsche, Genealogy, History," in *Language, Counter-Memory, Practice*, Oxford, Blackwell, 1977, 144.

156. Salman Rushdie, *Midnight's Children*, London, Pan Books, 1982, 211. The midnight's child who narrates Rushdie's book was born on the stroke of midnight on 15 August 1947, "the precise instant of India's arrival at independence" (9).

157. Marie-Claude Taranger, "Une mémoire de seconde main? Film, emprunt et référence dans le récit de vie," *Hors Cadre* 9, (1991).

158. Ibid., 43.

159. Ibid., 45.

160. Ibid., 54 (*goudron* = "tar").

161. Ibid., 55–56.

162. Ibid., 47.

163. Ibid., 51.

164. Ibid., 48.

165. Ibid., 57.

166. Judith Butler, *Bodies That Matter: On the Discursive Limits of "Sex,"* New York and London, Routledge, 1993, 245.

167. John Ellis, *Visible Fictions*, London, Boston, Melbourne, and Henley, Routledge & Kegan Paul, 1982, 142.

168. Ibid.

169. Lefebvre, *The Production of Space*, 286.

170. Jean Baudrillard, *La Guerre du Golfe n'a pas eu lieu*, Paris, Galilée, 1991, 21–22.

171. Ibid., 46–47.

172. Ibid., 86.

173. Christophe Gallaz, "Les images peuvent-elles encore nous sauver?" *Libération*, 18 August 1992, 6.

174. Vladimir Propp, *Morphology of the Folktale* (1928), Bloomington, Indiana University Press, 1958.

175. Jonathan Culler, *Structuralist Poetics*, London, Routledge & Kegan Paul, 1975, 207–208.

176. Norman M. Klein, "Audience Culture and the Video Screen," in Doug Hall and Sally Jo Fifer, *Illuminating Video*, New York, Aperture/Bay Area Video Coalition, 1990, 402.

177. I was also aware, during my visit to the "twin cities" that I moved through a space thick with the ghosts of Native Americans—and that their historically "erased" images and names seemed symptomatically to return everywhere: on the labels of products on supermarket shelves, in corporate logos, on automobiles, and so on. See Victor Burgin, "Minnesota Abstract," in Taylor, *Visualizing Theory*, 464–467.

178. I refer to Dan Quayle's admonition of the eponymous heroine of the television show *Murphy Brown* (played by Candice Bergen), who had offended Quayle's sense of "family values" by deciding, unmarried and alone, to have a baby.

179. David MacDougall, "Films of Memory," in Taylor, *Visualizing Theory*, 261.

180. Ibid.

181. Ibid., 263–264.

182. Ibid., 261–262.

183. Ibid., 261.
184. Ibid., 267.
185. Ibid., 267–269.
186. Alan Williams, *Republic of Images: A History of French Filmmaking*, Cambridge and London, Harvard University Press, 1992, 369.
187. Henry Rousso, *The Vichy Syndrome: History and Memory in France since 1944*, Cambridge and London, Harvard University Press, 1991, 229–230.
188. Barry Hindess and Paul Hirst, *Mode of Production and Social Formation*, London, Macmillan, 1977, 14.
189. Roland Barthes, *Camera Lucida*, New York, Hill & Wang, 1981, 79. (French ed., *La chambre claire*, Paris, Gallimard Seuil, 1980, 124.)
190. (My round shouldered world.) See Aimé Césaire, *Et les chiens se taisaient*, Paris, Présence Africaine, 1962, 126.
191. Klein, "Audience Culture and the Video Screen," *Illuminating Video*, 402.
192. Virginia Woolf, *Orlando: A Biography*, London, Hogarth, 1928, 258.
193. Freud, *Standard Edition*, vol. 4, 97 n. 2.
194. Ibid., 320–321. N.B. Editor's note: "Identification" here "is evidently being used in a sense different from that discussed on p. 149 ff."—i.e., in respect of "butcher's wife" and "hysterical identification."
195. Mary Warnock, introduction to Jean-Paul Sartre, *The Psychology of Imagination*, London, Methuen, 1972, xiv.
196. Sartre, *The Psychology of Imagination*, 27.
197. Otto Fenichel in Hanna Fenichel and David Rapaport (eds.), *The Collected Papers of Otto Fenichel*, first series, New York, W. W. Norton, 1953, 107.
198. Freud, *New Introductory Lectures on Psycho-Analysis*, in *Standard Edition*, vol. 22, 63.
199. Freud, *Group Psychology and the Analysis of the Ego*, in *Standard Edition*, vol. 28, 105.
200. Freud, *Totem and Taboo*, in *Standard Edition*, vol. 13, 82. We may here see the distinction to be made between "incorporation," which involves the real or fantasized passage of the object into the body, and "introjection," where the object or qualities of the object are imagined to pass into some other subjective locus, such as the mind or "personality."
201. Freud, *The Ego and the Id*, in *Standard Edition*, vol. 19, 29.
202. Laplanche and Pontalis, *The Language of Psycho-Analysis*, 284.
203. Freud, "Mourning and Melancholia," in *Standard Edition*, vol. 14, 249.
204. Freud, *The Ego and the Id*, in *Standard Edition*, vol. 19, 176–177.
205. Freud, "Mourning and Melancholia," in *Standard Edition*, vol. 14, 250.

206. Freud, *The Interpretation of Dreams*, in *Standard Edition*, vol. 4, 146 ff. Freud notes: "Identification is most frequently used in hysteria to express a common sexual element. A hysterical woman identifies herself in her symptoms most readily—though not exclusively—with people with whom she has had sexual relations or with people who have had sexual relations with the same people as herself. Linguistic usage takes this into account when two lovers are described as being 'one'" (ibid., 150).

207. Freud, *Group Psychology*, 107.

208. Ibid., 106. Elsewhere, Freud writes: "The difference . . . between narcissistic and hysterical identification may be seen in this: that, whereas in the former the object-cathexis is abandoned, in the latter it persists and manifests its influence." See "Mourning and Melancholia," 250.

209. Freud, *Group Psychology*, 107.

210. Ibid., 113.

211. Ibid., 116.

212. Freud, *Introductory Lectures on Psycho-Analysis*, lecture 11, "The Dream-Work," in *Standard Edition*, vol. 15, 181–182. (*Oxford English Dictionary*, s.v. "breccia": a composite rock consisting of angular fragments of stone, etc., cemented; s.v. *brecciated*, adjective: formed into a breccia; of the structure of a breccia.)

213. Ellie Ragland-Sullivan, *Jacques Lacan and the Philosophy of Psychoanalysis*, London and Canberra, Croom Helm, 1986, 35.

214. Jacques Lacan, "The Mirror Stage as Formative of the Function of the I as Revealed in Psychoanalytic Experience" (1949), in *Ecrits*, 2.

215. Ibid., 2.

216. René A. Spitz, *The First Year of Life*, New York, International University Press, 1965, 65. It is assumed that the neonate gazing at the mother's face does not yet have a sense of distance as we understand the term; this it will gradually acquire as its motor capacities develop. Nevertheless, the infant experientially distinguishes between touch and sight as it is repeatedly subjected to the displeasure that accompanies the withdrawal or loss of the nipple.

217. Jacques Lacan, 'What Is a Picture?,' in *The Four Fundamental Concepts of Psycho-Analysis*, London, Hogarth Press, 1977, 115.

218. Ragland-Sullivan, *Jacques Lacan*, 19.

219. John Frosch, "Psychotic Character Versus Borderline. Part I," *The International Journal of Psycho-Analysis* 69, part 3, (1988), 352.

220. Letter from G. Kaye Holden in Ron Alexander, "Metropolitan Diary," *The New York Times*, 16 February 1992, 18.

221. Frosch, "Psychotic Character Versus Borderline. Part 1," 352.

222. John Frosch, "Psychotic Character Versus Borderline. Part 2," *The International Journal of Psycho-Analysis*, 69, part 4, (1988), 450.

223. One should add, as Winnicott writes: "Of course, in psychiatry there are no clear borderlines between clinical states, but in order to get anywhere at all we have to pretend that borderlines exist." See D. W. Winnicott, "Psycho-Neurosis in Childhood," in *Psycho-Analytic Explorations*, Cambridge, Harvard University Press, 1989, 64.

224. See chap. 6 in the present volume.

225. Grivois must have Lacan in mind when he says: "I do not believe that disorder in the public behaviour of young psychotics are calls to the absent father . . . or a call to the police to effect the return of the Law with a big L. . . . I think that comes straight out of absolutely traditional puritan education. . . . The cure effected through the desire to return to legality: it's a pious wish [*vœu pieux*]!" See Henri Grivois, *Urgence folie*, Paris, Les Empêcheurs de Penser en Rond, 1993, 77. In my earlier account of Lacan's notion of "foreclosure" I omitted to mention that, for him, such foreclosures ultimately devolve on the "Name-of-the-Father," or "paternal metaphor"—the ultimate symbol of authority in society, that which guarantees the "Symbolic" order. I did not mention it because I find the idea unconvincingly reductive and could make no use of it.

226. (*Le carburant de la psychose c'est les autres.*) See Grivois, *Urgence folie*, 48.

227. Ibid., 44. (Schreber found that his powers of attraction went beyond the land of the living. He noted: "An ever growing number of departed souls felt attracted to me.")

228. Ibid., 73.

229. Ibid., 17.

230. A. S. Byatt, *Still Life*, New York, Collier, 1991, 135.

231. Joan Rivière, "Womanliness as a Masquerade," in Victor Burgin, James Donald, and Cora Kaplan (eds.), *Formations of Fantasy*, London, Methuen, 1986.

232. Ellie Ragland-Sullivan, "Jacques Lacan," in Elizabeth Wright (ed.), *Feminism and Psychoanalysis: A Critical Dictionary*, Oxford and Cambridge (Massachusetts), Basil Blackwell, 1992, 206.

233. Malcolm Bowie, *Lacan*, London, Fontana, 1991, 21.

234. Ibid., 36.

235. Gaston Bachelard, *The Poetics of Space*, Boston, Beacon, 1969, 8.

236. Laplanche, "Psychoanalysis, Time, and Translation," 171.

237. James Baldwin, "Stranger in the Village," in *Notes of a Native Son*, Boston, Beacon, 1975, 175.

238. James R. Gaines, "From the Managing Editor," *Time*, special issue, vol. 142, no. 21, (Fall 1993).

239. Stephen Frosh, *Identity Crisis: Modernity, Psychoanalysis and the Self*, Basingstoke and London, Macmillan, 1991, 192–193.

240. D. W. Winnicott, "Transitional Objects and Transitional Phenomena," in *Playing and Reality*, Harmondsworth and New York, Penguin, 1982, 30.

241. Ibid., 14.

242. Ibid., 6.

243. Stephen McKenna, introduction to St. Augustine, *The Trinity*, xi.

244. Victor Burgin, "Looking at Photographs" (1977), in Burgin, *Thinking Photography*, 153.

245. See Paul Virilio, *L'espace critique*, Paris, Christian Bourgeois, 1984.

246. Jacqueline Rose has observed that, in *Powers of Horror*, Kristeva could be seen as "feeding back the issue of pre-oedipal sexuality into the theorisation of cultural origins which Freud . . . had himself failed to do." Kristeva "makes the point that discussions of the incest taboo have concentrated on the place of the father together with the forms of disorder . . . associated with his prohibitory role, leaving the mother precisely as the idealised relic of what comes to be forbidden, a kind of lost territory which says nothing of the psychic ambivalence of that early relation, nor of the disorders (psychosis and paranoia) with which it can be clinically linked." See Jacqueline Rose, "Julia Kristeva—Take Two," in *Sexuality in the Field of Vision*, London, Verso, 1986, 155.

247. Althusser, "Ideology and Ideological State Apparatuses," 152.

248. Kristeva, "Ellipse sur la frayeur et la séduction spéculaire," 77.

249. Louis Althusser and Etienne Balibar, *Reading Capital*, London, New Left Books, 1970, 99.

250. Stephen Kern, *The Culture of Time and Space, 1880–1918*, London, Weidenfeld and Nicolson, 1983, 141.

251. Bhabha, "'Race,' Time, and the Revision of Modernity," 193.

252. Ibid., 206–207.

253. I take this term from Emile Temime, who has coined it in preference to the word *migration* as it is "unmarked" by implications of original belonging ("from"/"to"). See Emile Temime et al., *Migrance: Histoire des migrations à Marseille*, 4 vols., La Calade, Aix-en-Provence, Edisud, 1989–1991. My thanks to Christine Breton for bringing this work to my attention.

254. Jacques Lacan, *The Psychoses—The Seminar of Jacques Lacan, Book 3, 1955–1956*, London, Routledge, 1993, 144.

255. Winnicott, "The Location of Cultural Experience," 118.

256. Bhabha, "Introduction: Narrating the Nation," 1.

257. The reference is of course to the title of Marcel Proust's novel *A la recherche du temps perdu*. In the English translation the title has been rendered as *Remembrance of Things Past*, but it literally means "In Search of Lost Time."

258. Edouard Glissant, interviewed in *Le nouvel observateur*, no. 1517, 2–8 December 1993, 58.

259. Edouard Glissant, *Tout-monde*, Paris, Gallimard, 1993.

260. Glissant, interviewed in *Le nouvel observateur*, 59.

261. In this connection, Judith Butler writes: "The 'betweenness' that differentiates 'moments' of time is not one that can, within Derridean terms, be spatialized or bounded as an identifiable object. It is the nonthematizable *différance* which erodes and contests any and all claims to discrete identity, including the discrete identity of the 'moment.' What differentiates moments is not a spatially extended duration, for if it were, it would also count as a 'moment,' and so fail to account for what falls between moments. This 'entre,' that which is at once 'between' and 'outside,' is something like non-thematizable space and non-thematizable time as they converge." See Judith Butler, *Bodies That Matter*, 245.

262. Brian Hall, "A Holy War in Waiting," *The New York Times Magazine*, 9 May 1993, 44.

263. Aaron Douglas, *Building More Stately Mansions*, 1944. Collection of Carl Van Vichten Gallery of Art, Fisk University, Nashville.

264. Gilroy, *The Black Atlantic*, 71.

265. For a succinct account of the concept of "psychical reality" as it relates to Freud's abandonment of the "seduction theory," see Teresa Brennan, "Psychical Reality," in Elizabeth Wright (ed.), *Feminism and Psychoanalysis: A Critical Dictionary*, Oxford and Cambridge (Massachusetts), Blackwell, 1992.

266. Laplanche, "Psychoanalysis, Time, and Translation," 170.

267. Ibid., 175. In the work of Laplanche, "message" or "signifier" stand in the place of Lacan's "Symbolic." With these terms, Laplanche and Lacan both seek to add a third category to Freud's fundamental distinction between actual "reality" and "fantasy." In such terms, Laplanche has radically reformulated the idea of "seduction" in psychoanalytic theory. Perhaps Laplanche's most succinct presentation of the idea is on the page that contains the sentence I have quoted here. See also Elizabeth Cowie, "The Seductive Theories of Jean

Laplanche: A New View of the Drive, Passivity, and Femininity," in the same volume; and Jean Laplanche, *New Foundations for Psychoanalysis*, Oxford and Cambridge (Massachusetts), Blackwell, 1989.

268. Jean Laplanche, "The Kent Seminar," in John Fletcher and Martin Stanton (eds.), *Jean Laplanche: Seduction, Translation, Drives*, London, Institute of Contemporary Arts, 1992, 22.

269. Ibid., 23.

270. Freud, "Constructions in Analysis" (1937), in *Standard Edition*, vol. 23, 261.

271. Jean Laplanche, interviewed in Fletcher and Stanton, *Jean Laplanche*, 76. I began this book with a brief account of how, in the 1970s, psychoanalytic theory came to be imported into cultural studies. Psychoanalytic terms (such as "scopophilia"), and pseudo-psychoanalytic expressions (such as "male gaze") have since become commonplace in the study of visual culture. Periodically in this book, I have stressed that if psychoanalytic theory is to be *meaningfully* employed in cultural studies, then it is essential that psychoanalytic concepts be employed in their psychoanalytic sense, as a means of "getting access to phenomena which we would *not have access to in another way.*" As such a means, psychoanalytically informed analyses in cultural studies offer a way to an interpretive undoing of what is stereotypical and symptomatic—including, one might hope, that which is stereotypical and symptomatic in cultural studies itself.

272. Barthes, "En sortant du cinéma," 106.

273. Not only in the arena of critical writing—I think, for example, of Marlon Riggs's film of 1987, *Ethnic Notions*.

274. Ragland-Sullivan, *Jacques Lacan*, 110–111.

275. For a discussion of this idea, see Victor Burgin, "Diderot, Barthes, *Vertigo*," in *The End of Art Theory: Criticism and Postmodernity*, London, Macmillan, 1986.

276. Freud, "Constructions in Analysis," in *Standard Edition*, vol. 23, 268.

277. Jean Laplanche, "Le temps et l'autre," *Psychanalyse à l'université* 16, no. 61, (January 1991), Paris, puf, 47 ff.

278. Adam Phillips, "Futures," in *On Flirting*, Cambridge, Harvard University Press, 1944, 153.

279. The importance of the concept of "deferred action" (*Nachträglichkeit*) in Freud's work has been emphasized by Jean Laplanche, who has given most thought to its exposition and development. The idea may be summarily indicated with reference to an anecdote Freud tells in *The Interpretation of Dreams*. He writes: "A young man who was a great admirer of feminine

beauty was talking once—so the story went—of the good-looking wet-nurse who had suckled him when he was a baby: 'I'm sorry,' he remarked, 'that I didn't make a better use of my opportunity.' I was in the habit of quoting this anecdote to explain the factor of 'deferred action' in the mechanism of the psychoneuroses." See *Standard Edition*, vol. 4, 204–205. The expression *après-coup* is the customary French translation of Freud's *Nachträglichkeit* and *nachträglich*. Of the English translation in the *Standard Edition*, Laplanche comments: "You find 'nachträglich' translated sometimes as 'later,' sometimes as 'belatedly,' sometimes by 'subsequently,' and sometimes by 'in a deferred fashion.' This means that the unity of 'nachträglich' is lost." See Jean Laplanche, interviewed in Fletcher and Stanton, *Jean Laplanche*, 16. Laplanche used the English expression "deferred action" in the 1973 *Vocabulaire de la Psychanalyse* (see Laplanche and Pontalis, *The Language of Psycho-Analysis*, 111–114) but now proposes the English neologism "afterwardness." Deferred action is not always benign. An advantage of the French *après-coup* is that it contains intimations of the traumatic which are absent from the other terms. For example, I cite Nicole Müller's novel *Ce qui est affreux dans l'amour*. "At the point of impact [dum-dum bullets] leave small, insignificant marks. However, once they have entered, they spin and tear terrible holes in the flesh. Memories are like dum-dum bullets."

280. Gilroy, *The Black Atlantic*, 71.

281. Walter Benjamin, "The Image of Proust," in *Illuminations*, 204. (In Homer's *Odyssey*, Odysseus [Roman name: Ulysses], the husband of Penelope, had been absent many years and was presumed dead. Many suitors sought Penelope's hand. She told them they would hear her decision when she had finished what she was weaving. But each night she would secretly undo the day's work, and the decision was indefinitely postponed.)

282. The Algerian war for liberation from French colonial rule was waged from 1954 to 1962. In the final year of the war, both the Algerian FLN (National Liberation Front) and the French government of Charles de Gaulle came under terrorist attack from the French right-wing extremist OAS (Organization of Secret Armies). The French formally recognized the independence of Algeria in July 1962.

283. Victor Burgin, *Venise*, 1993 (French, English subtitles); PAL U-matic SP, color, 29 mins. (First US screening, Museum of Modern Art, New York, 15 April 1994.)

Facade, 150–151

Fanon, Franz, 180–181, 185

Fantasy, 30, 96–97; child's, 224–225; dream as, 285–286 n.4; memory and, 216–217, 223, 224–225, 269; as negative of reality, 29; repressed, 269

Felman, Shoshana, 35–36, 211

Fenichel, Otto: on identification, 242; on looking/voyeurism, 49, 50, 67, 68, 81

Ferenczi, Sándor, 97–98

Fetishism, 62–63, 64–66; in film, 157, 162–163, 164–165, 230; Freud on, 67, 113, 163; object of, 86; in photography, 73–74, 75–76, 82, 157; in television, 230–231

Film, 21, 196–202, 210, 243, 267; African, 179–180, 181–182, 183–184; allegory in, 203–204, 206–207, 209; authority of, 229; Barthes on, 35, 162–163, 164–165, 167, 169–170, 171–172, 175; commercial, 199–200; conspiracy, 196–197; documentary, 235–237; eroticism in, 166; fetishism in, 157, 162–163, 164–165, 230; identification within, 239; as lure, 170, 171–172; memory in, 235–237; memory replaced by, 226–228, 229, 232, 235; novelistic, 174; v. photography, 35; politics of, 237; psychoanalysis of, 161; semiology of, 9; space in, 39, 165, 166; spectator's role in, 161–162, 163–164, 165, 166, 169, 175, 230, 239; v. television, 34–35; time in, 179–184; as visually pleasurable, 45, 46; as voyeuristic, 230

Foreclosure, 315 n.225

Foreigners, 118, 119

Foucault, Michel, x, 36, 39, 66; on origin, 181; on space, 40–41, 195; on structuralism, 195–196; on truth, 225

Frampton, Hollis, 35, 160

Frampton, Kenneth, 146

Freud, Sigmund, 20, 54, 55, 99, 107, 144, 218, 258, 263; on analogy, 272; on association, 219–220, 221; on certainty, 174–175; on child's learning, 96, 98; on condensation, 208, 261; on conscious, 175, 204; on construction v. interpretation, 270–271; on daydreams, 261; on death, 84, 219–220; deferred action of, 318–319 n.279; on delusions, 229; on disavowal, 82; on displacement, 261; dream analysis of, 178, 205, 206, 219–220, 221, 228–229, 240–241, 246, 248, 260–261, 265; on drive, 71, 84, 242–243; on ego, 125–126, 129, 247, 249; on exhibitionism, 81; on fantasy, 216–217, 224–225, 269, 285–286 n.4; on fetishism, 67, 113, 163; on hysteria, 216–217; on identity/identification, 240–249, 255; on lack of penis, 83; on memory, 216–225, 269; on mourning, 243; on narcissism, 70–71, 245–246, 247, 249; on normal v. abnormal, 153, 221; on object, 68–69, 70–71; on Oedipal complex, 244–245, 246, 248; on other locality, 117; on paranoia, 122–124, 127–128, 267; on perception, 175; on primary processes, 208; on psychical reality, 47; on psychoses, 122–124, 152; on repression, 103–104, 127–128, 269; on separation anxiety, 154; on sexuality, 72–73, 74, 88, 219–

220; on similarity, 241; on space, 47, 151–152, 175, 217; on subconscious, 308 n.95; on symbols, 96, 205–206; on time, 118, 216, 217; on uncanny, 93–94, 95–96, 103, 104; on unconscious, 118, 204, 208, 209; verbal bridge of, 207; on voyeurism, 62
Frosch, John, 122
Frosh, Stephen, 260

Gaines, James, 259–260
Galileo, 40–41
Gallaz, Christopher, 232–233
Galton, Francis, 261
Gaze, 170, 171. *See also* Looking; Voyeurism
Geometry, 40–42, 52, 143
Germany, changing borders in, 156
Gilroy, Paul, 15, 16, 17, 19, 268, 273
Glissant, Edouard, 267
Godard, Jean-Luc, films of, 90, 114, 161, 168, 169, 197, 243
Gombrich, Ernst, 285–286 n.4
Gordon, George, 3
Gramsci, Antonio, 10, 21
Greenberg, Clement, 3–4
Grivois, Henri, 253, 254–255, 315 n.225
Gropius, Walter, 145, 146, 150
Grosz, Elizabeth, 129
Guha, Ranajit, 194

Hall, Stuart, 5, 6, 7–8, 10, 18–19; on cultural studies, 20–21; on culturalism v. structuralism, 11–15; on images, 20
Harkness, Margaret, 198
Haussmann, Baron Georges-Eugène, 145
Hawkins, Yusuf K., 133

Hegel, G. W. F., 305 n.61
Hess, Rémi, 31
Hill Collins, Patricia, 16, 17, 268
Hindess, Barry, 238
Hirst, Paul, 238
Historicity, 195, 196
History, 264; differential, 180–181; gaps in, 267, 268; identification with other, 239; official v. subaltern, 193–194; time as, 216; time in, 265
Hitchcock, Alfred, 50
Hoggart, Richard, 5, 7
Homosexuality, 123, 127–128
Humanism, v. determinism, 42
Hunter, Richard, 128
Husserl, Edmund, 41, 308–309 n.103
Hybrid/hybridization, 182–183, 188–189
Hyperspace, 24, 25
Hypnosis, 247
Hysteria, 100–101, 204, 216–217; in identification, 245–246, 247

Identity/identification, 1, 129, 239–249, 271–272; and abjection, 56; and alienation, 68; assimilation in, 246–247; black, 16, 17, 180–181; boundaries in, 193; by child, 129; crisis of, 193, 195, 260; defined, 242; ego and, 245, 249; feminist, 16, 17; with film characters, 239; group, 247–248, 255; holes in, 268; hysterical, 245–246, 247; and loss, 257; loss of, 188, 190–191, 192; mirror stage of, 10, 30, 32, 46, 49–50, 52, 68, 97, 119, 120, 125, 126, 128–129, 136, 151, 152, 163, 239, 249, 250, 251–252, 254, 256, 257–258; narcissistic, 245, 246, 247, 260; object, 68, 99–100; Oedipal, 260; oral drive in,

10, 30, 32, 46, 49–50, 52, 68, 119, 125, 128–129, 151, 152, 163, 249, 250, 251–252, 254, 257–258; on optics, 45, 66; on Papin sisters, 106–107, 127, 130; on paranoia, 101, 103; on place between perception and consciousness, 47, 117–118; on psychoses, 128, 252, 254, 257, 266; on space, 56, 192; topological models of, 51; on unconscious, 218

Lacis, Asja, 139, 140, 141, 144, 145, 155

Laclau, Ernesto, 292 n.42

Laplanche, Jean, 69, 70, 71, 73, 100, 124, 223, 268, 288 n.21; on deferred action, 318–319 n.279; on enigmatic signifiers, 75, 104, 107; on Freud, 217–218, 258, 318–319 n.279; on goal of analysis, 269; on infant's communication, 270; on interpretation, 271, 272–273; on memory, 217–218; on metaphors, 125; on Oedipus complex, 244; on seduction, 75, 104, 317–318 n.267; on sexual drive, 74, 84; on slips, 220; on time, 215–216; on touching v. looking, 71–72; on unconscious, 269

Le Corbusier, 146

Lee, Spike, 135–136, 137

Lefebvre, Henri: on city, 142; on facade, 150–151; on permeable barriers, 147, 148–149; on space, 23, 26–28, 30–32, 36, 143, 144, 146, 151, 213; on surrealism, 31; on visualization, 231

Leonardo da Vinci, 156

Lévy, Arnaud, 213–215

Lewis, Wyndham, 199, 200

Lissitsky, El, 43

Longinus, Dionysius Cassius, 54

Looking, 48, 49, 50, 55, 67, 68, 71–72, 170, 172. *See also* Voyeurism

Loos, Adolf, 148

Lumet, Sidney, 199, 201

Lynch, Kevin, 305 n.59

Lyotard, Jean-François, 149, 150

Macalpine, Ida, 128

MacCabe, Colin, 13, 197, 204

MacDougall, David, 235–237

McKenna, Stephen, 262

Makavejev, Dustan, 302–303 n.27

Malkmus, Lizbeth, 183–184

Mannoni, Octave, 92, 100, 153, 267–268; on disavowal, 157; on Freud's therapeutics, 217

Mao Tse-Tung, 144

Mapplethorpe, Robert, 88

Margin. *See* Border/boundary

Marx, Karl, 2, 190, 273

Marxism, 36, 209–210; on culture, 4, 6; on ideology, 11; v. psychoanalysis, 10

Medakovic, Dejan, 225

Memory: in dreams, 217; failure of, 218–219, 220–221; fantasy's role in, 216–217, 223, 224–225, 269; film replaces, 226–228, 229, 232, 235–237; Freud on, 216–225, 269; photograph as, 236; in preconscious, 217; psychoanalysis on, 216; recollected, 222–223; repressed, 269; screen, 221–223, 224, 225, 228; sexuality in, 223; truth and, 225–239; as unconscious, 217

Merleau-Ponty, Maurice, 48, 49

Metz, Christian, 9, 21, 162, 163, 174

Meyer, Adolf, 145, 146, 150

Migrance, 266

Miller, Lee, 112

Mimeticism, 254

Designer: Nola Burger
Sponsoring Editor: Edward Dimendberg
Compositor: Braun-Brumfield
Text: 10.75/16 Fournier
Display: Fournier, Fournier Expert, Univers
Printer & Binder: Braun-Brumfield